History & Women, Culture & Faith
Volume 5

History and Women, Culture and Faith
Selected Writings of Elizabeth Fox-Genovese
David Moltke-Hansen, General Editor

*For Roger,
what Aristotle
meant by a
genuine friend.
Bob*

8/5/2012

History & Women

Culture & Faith

Selected Writings of
Elizabeth Fox-Genovese

David Moltke-Hansen, General Editor

Volume 5
Unbought Grace: An Elizabeth
Fox-Genovese Reader

Edited by Rebecca Fox and Robert L. Paquette

The University of South Carolina Press

© 2012 University of South Carolina

Published by the University of South Carolina Press
Columbia, South Carolina 29208

www.sc.edu/uscpress

Manufactured in the United States of America

21 20 19 18 17 16 15 14 13 12 10 9 8 7 6 5 4 3 2 1

Library of Congress Cataloging-in-Publication Data

Fox-Genovese, Elizabeth, 1941–2007.
 History and women, culture and faith : selected writings of Elizabeth
Fox-Genovese / David Moltke-Hansen, general editor.
 p. cm.
 Includes bibliographical references and index.
 ISBN 978-1-57003-990-4 (cloth : alk. paper)—ISBN 978-1-57003-991-1
(cloth : alk. paper)—ISBN 978-1-57003-992-8 (cloth : alk. paper)—
ISBN 978-1-57003-993-5 (cloth : alk. paper)—**ISBN 978-1-57003-994-2
(cloth : alk. paper)** 1. Women—History. 2. Culture. 3. Feminism.
4. Fox-Genovese, Elizabeth, 1941–2007. I. Moltke-Hansen, David. II. Title.
 HQ1121.F64 2011
 305.409—dc22 2010048764

This book was printed on a recycled paper with 30 percent postconsumer waste content.

Publication of *History & Women, Culture & Faith* is made possible in part by
the generous support of the Watson-Brown Foundation.

Contents

General Editorial Note

This is one of five volumes of the selected essays and reflections of Elizabeth Fox-Genovese. First conceived a week after Fox-Genovese's funeral service, the project received generous support from the Watson-Brown Foundation, on whose Hickory Hill Forum advisory board Fox-Genovese served. Also making this edition possible was the collaboration of a dozen of her former colleagues and students, as well as her sister. Helping this diverse group keep on schedule, the Institute for Southern Studies of the University of South Carolina provided administrative support and the superb assistance of history graduate student Ehren K. Foley, compiler of the selected bibliographies for the first four of the five volumes of the edition.

Because the essays and chapters included were published in some seventy-five different venues, spelling and punctuation vary. No effort was made to standardize either these things or the forms of citation. English spellings are not as common as American but do occur. The editors did correct an occasional, obvious error silently or did insert in brackets missing words or elements of citations. In addition they put all original notes at the ends of pieces. The few editors' notes are placed as footnotes.

Each volume stands on its own, covering an area of Fox-Genovese's long-term scholarly and intellectual involvements. The fifth volume, the reader, is drawn largely from the others to give a broad sampling of the range of her work. It does, nevertheless, also include a couple of items by Fox-Genovese not found in the first four volumes, together with a number of remembrances of her.

The decisions about the contents of individual volumes were the responsibility of the editor or editors of each volume. The editors of the first four volumes nominated items for inclusion in the reader. They were guided in the selections for their own volumes by principles to which they all subscribed at the outset or, in a couple of cases, when joining the project a bit later on. Selections from the books Fox-Genovese wrote, co-wrote, and saw through publication are excluded. These titles are widely known and available. The editors also generally tried to choose more substantial over more popular

pieces and limited each volume to a little over one hundred thousand words of her writings and some thirty thousand words of apparatus, including notes and bibliography. These decisions necessitated exclusion of at least a third of her fugitive writings. As a result the present edition includes no more than roughly 20 percent of her total published work.

For background to these materials and for related correspondence, readers are directed to the Southern Historical Collection of the University of North Carolina at Chapel Hill, repository of Elizabeth Fox-Genovese's papers. A finding aid to the papers is currently available at http://www.lib.unc.edu/mss/inv/f/Fox-Genovese,Elizabeth.html.

Introduction

Beyond Self—Reading Elizabeth Fox-Genovese

Robert L. Paquette

> But the age of chivalry is gone. That of sophisters, economists, and
> calculators has succeeded; and the glory of Europe is extinguished
> forever. Never, never more shall we behold that generous loyalty to
> rank and sex, that proud submission, that dignified obedience, that
> subordination of the heart which kept alive, even in servitude itself,
> the spirit of an exalted freedom. The unbought grace of life, the
> cheap defense of nations, the nurse of manly sentiment and heroic
> enterprise, is gone!
>
> *Edmund Burke,* Reflections on the
> Revolution in France *(1790)*

Persons imply relations; relations precept obligations. In the age of the
aggrandized self, Elizabeth Fox-Genovese (1941–2007), a prizewinning
scholar and conspicuous public intellectual, never forgot her personhood.
In the last days of her life, lying supine, gaunt, and emaciated in a railed
metal bed at Emory University Hospital, Betsey, as she was known to her
friends, insisted on putting the finishing glosses to a chapter of a dissertation
under construction by one of her many graduate students. Complications
from a long-running battle with multiple sclerosis and several other diseases
cut short a brilliant and controversial career that produced works of lasting
value on an impressive array of subjects.

This reader represents the fifth and final volume of *History and Women,
Culture and Faith: Selected Writings of Elizabeth Fox-Genovese.* It consists of
two sections. The first contains sixteen essays that best represent the quality
and range of Betsey's scholarship as chosen by the editors of this volume in
consultation with David Moltke-Hansen, the general editor, and with the
editors of the previous four volumes. Part 2 features ten remembrances of
Betsey by colleagues and former students. Each remembrance speaks in its
own way to Betsey's impact on the mind and spirit of others as friend and
educator. Both sections rely on chronology as the organizing principle,

which for the first section can be justified by her much-discussed "evolution" or "intellectual odyssey" from Marxist feminist at the start of her professorial career in 1973 to her conversion to Roman Catholicism in 1995. A careful reading of these essays suggests, however, that her itinerary reflected far more continuity than change. As Betsey herself acknowledged in explaining her conversion, "It was a natural stage in the journey rather than a new departure."[1]

Trained as a multilingual historian with a Ph.D. from Harvard, Betsey traveled comfortably with dual passports in such fields as sociology, economics, psychology, political theory, religion, and literature. From her mother, Elizabeth Simon Fox, the well-educated daughter of a real estate magnate, she acquired a love of literature; from her father, Edward Whiting Fox, a Cornell University professor, she acquired a love of history. She confessed early on to liking the taste of intellectual history, and indeed her first book, *The Origins of Physiocracy* (1976), explored a school of political economists in eighteenth-century France who, in grappling with the capitalist transformation of estates into classes, helped usher in modern economic theory.

Her marriage in 1969 to Eugene D. Genovese, one of the most influential historians of his generation, entailed responsibilities that shifted her scholarly focus, and she eventually moved into southern history and women's studies. After more than a decade of teaching at the University of Rochester and the State University of New York at Binghamton (now Binghamton University), she accepted an offer from Emory University in 1986 to create a program in women's studies. Under her auspices it became in 1990 the first doctoral program in women's studies in the United States. Conservative as well as liberal women entered its ideologically open doors. Publication the following year of Betsey's *Feminism without Illusions,* a powerful, multifaceted critique of the predominant individualist gestalt that informs modern feminism, coincided, however, with a movement at Emory by activist faculty to wrench the program leftward by toppling Betsey from the directorship. In the unlit, arcane corridors of the multistoried postmodern campus, cloak-and-daggery has found warm surroundings, and Betsey possessed the kind of presence that elicited pettiness and jealousy from some as well as respect and admiration from others. She resigned the position in 1991.

Throughout her career Betsey interrogated issues of ideology and power, particularly as they related to the cultural consequences of capitalist development on various strata of society. The editors of each volume in this series identify, in chorus, Betsey's critique of radical or possessive individualism, the ideology enshrined in the rise of capitalism, as a central thread that bound

together the corpus of her work. In the foreword to volume 1, *Women Past and Present*, Peter N. Stearns notes in Betsey's scholarship a sharpened sensitivity, which belied her privileged upbringing, to the needs of the laboring poor and of different groups and classes of women. However sophisticated her class analysis as a Marxist, she always recognized the limitations of Marxist theory for understanding certain kinds of human experience. In her introduction to volume 1, Deborah Symonds remarks on how Betsey applied her characteristically nuanced thinking to the historical origin and evolution of radical individualism as an ideology that affected "in all of its material and cultural manifestations" men and women of different classes at different times in different ways.[2] Middle-class women, for example, reaped disproportionate benefits from their liberation by modern feminism as individuals with equal rights. But implementation of the theory of radical individualism throughout modern culture also weakened community life, thereby leaving many lower-class women stripped of customary familial and communal protections.

Human societies have divided themselves by gender from time immemorial. The application of gender as a category of analysis opened the past to necessary and insightful reconstructions. But Betsey worried about gross distortions from abuse of the tool. Not all women are alike; persons have multiple identities; the rank order of those personalities in any individual changes with time and is revealed by behavior at moments of crisis. Political sisterhood, like political antislavery, emerged in the West within a historically specific set of social and economic conditions. If radical feminists speak today as if with one voice to insist on which identity should always speak loudest, Betsey in her historical scholarship looked beyond sisterhood to demonstrate forcefully how race and class typically trumped gender in the interpersonal dynamics that constitute the quotidian reality of social life. Betsey would have agreed with Flannery O'Connor, whom she much admired, that wisdom on the subject of identity lies beyond the mean and below the surface, often deeply repressed in concealed places. Identity "is not made from what passes," O'Connor observed, "but from those qualities that endure, regardless of what passes, because they are related to truth."[3] Betsey believed in truth, that it was accessible by the human mind, and she relentlessly directed her scholarly prowess to distinguish it from cliché and slogan.

Mark Bauerlein, in the foreword to volume 2, *Ghosts and Memories: White and Black Southern Women's Lives and Writings*, sees Betsey not only as a perceptive literary critic, but also as a potent literary theorist, defending the Western canon and the Great Tradition from the onslaught of radical individualism. The very concept of a Western canon, she explained, "took

shape in tandem with a monumental attempt to reclaim nature and human society as the legitimate province of the human mind."[4]

The humanism embodied in this noble endeavor by the most self-critical culture in history posited an ideal of public citizenship and, with it, the embodiment of a collective judgment that asserted, contra the individual, a meaningful standard of excellence and hierarchical value. As the self underwent reconstitution by radical individualism, personal valuation—the validation of one's own experiences and stories—became, as Bauerlein writes, "a method of undoing."[5] As, say, *I, Rigoberta Menchu* replaces *Hamlet* in English 101, radical personalization of the canon precedes disintegration through trivialization. Whatever the weaknesses of the canon, it served as a vital context and standard by which to judge the claims of those seeking entry to it. Destroying the canon by exploding the collective tradition on which it rests must inevitably discount the worth of individual stories offered up in the classroom as substitute readings.

Once radical feminists and other activists reached critical mass on the faculty, they could enlist democratic process to subvert traditional hierarchical structure and authority within higher learning. Established criteria for the determination of excellence and quality came under attack, as being arbitrary and discriminatory, from those who would substitute an ideologically ladened, totemic diversity that actually endorsed new forms of privilege. Craven or sympathetic administrators, lacking any liberal arts conviction, allowed the demolition. The core curriculum, which paid homage to a collective culture and a collective good, capitulated to the open or near-open curriculum based on consumer preference. Grades inflated and academic standards declined as a result. In the postmodern classroom, well-directed sentiment in the service of a feminized social justice could earn students more stripes from a professor in a humanities course than the configuring of evidence by argument into a meaningful pattern with explanatory power. Instead of foundational courses rooted in traditional disciplines that taught undergraduates how to think by exposing them to different approaches to the acquisition of knowledge, the postmodern campus was increasingly serving, cafeteria-style, an abundance of specialized dishes concocted to teach students what to think by first titillating their appetite. Professors were exhorting their students in, for example, black history and women's history to act on a consciousness of oppression without an honest or adequate understanding of the historical conditions that produced it. History as a discipline, Betsey warned, was losing its privileged position in the liberal arts curriculum, with frightful consequences for the capacity of the current generation to achieve a critical distance on its own culture.

While acknowledging the slipperiness and mysteries of textual representation, Betsey rejected the nihilistic implications of much that passes for postmodern literary theory, instead calling for a higher responsibility of managed interpretation through "sound principles of reading appropriate to the genre," as Bauerlein puts it.[6] As a historian who understood literary criticism and as a literary critic who practiced history, she spoke unfashionable truths. The tension between difference and sameness, between the permanent things that hold persons together in society and the impermanency of individual lives, produced the tragic sense to which Betsey was so attuned in her finest flourishes. Introducing Betsey's writings on white and black women in volume 2, Kibibi Mack-Shelton and Christina Bieber Lake laud Betsey's investigation of both the "special problems of self-representation for all women" and "the unique problems of self-representation for African American women writers."[7] Betsey showed her respect for women as writers and historical actors by not caricaturing them. No person can ever escape ties of dependency of some sort, and Betsey, as a learned historian with broad reach, knew that for most of human history the very notion of humanity itself was inextricably intertwined with the idea of social belonging rooted in the family. Peoples of the past had not lifestyles, but lives, and they spent a good deal of those lives in corporatist dependency on the wills of others, attempting to bridge differences to carry out common purposes. In an imperfect world of flawed beings, she insisted, "the experience of oppression does not inevitably transform fallible men and women into saints, any more than the exercise of domination inevitably transforms decent men and women into monsters."[8]

Betsey's eclectic mind had a pronounced and consistent communitarian sensibility. Thomas L. Pangle, in the foreword to volume 3, *Intersections: History, Culture, Ideology,* detects Betsey's "distinguishing insistence on the political structure of all history."[9] As if to underscore the point, she repeated one of her favorite quotes, "The order of history emerges from the history of order," from the exordium in the first volume of Eric Voegelin's multivolume magnum opus, *Order and History.*

The human condition expresses endlessly the antagonism between the claims of the individual and the claims of society. No viable order can exist without an ethical dimension. Morality is inherently authoritarian. Radical individualism was not only dissolving prescriptive moral standards, but undermining within communities the very possibility of reaching moral consensus outside of some sort of market determination. Betsey never confused efficiency with virtue.

Both David Moltke-Hansen, in the introduction to volume 3, and Pangle speak to Betsey's sophisticated understanding of ideology. Modern ideologies imply a theory of liberation. They do not triumph by brute force as mere expressions of the needs and interests of a particular group or class in power. Ideologies, to be successful, must appeal to the masses by simultaneously looking backward and forward. Inhabitants of all civilizations have established patterns of behavior articulated by language and written deep into their psyche like hidden transcripts to educe accepted ways of emoting, thinking, and seeing. Negotiation and dialogue between society's constituent elements pattern ideology.

With growing concern Betsey warned that the ideological "self" that was being realized under the statist, managerial, consumer-driven capitalism of a postmodern Western world, increasingly inhabited by "decentered subjects," was undermining the very possibility of establishing a firm moral basis for social order and citizenship. "Sexual liberation and narrowly personal selfhood," she declared, "may not be the freedom of the people, but their new opiate."[10]

Self-indulgence was replacing self-sacrifice as the lodestar of being. Betsey sought to forward the quest of the dispossessed for justice by bridging difference rather than positing the politics of a family-eroding, socially sapping androgyny. The measured repression necessary for civil freedom and any meaningful social life could not easily withstand the radical leveling of those who claimed the existence of no standard outside of themselves, who claimed that "the world consists in nothing but a system of discourses or patterns of naming that are driven by a ubiquitous will to power."[11]

In history wage labor, not slavery, qualified as the peculiar institution in the sense of being uncommon. Capitalist social relations had triumphed by abstracting the economic from the human condition and elevating it from subservience to predominance in the remaking of society. Betsey never discounted the value of the material abundance generated by capitalism, nor of the "bourgeois" freedom that attended it. Capitalism, whatever its ups and downs, had delivered human societies from the clutches of Malthusian cycles into self-sustained economic growth. Technological innovation advanced political feminism by lessening the value of male physical strength in a competitive labor market and by freeing women's sexuality from reproductive duties. Like Marx, Betsey discerned in capitalism the most revolutionary force humanity had unleashed on the world; like Joseph Schumpeter she marveled at the solvent power of capitalism's "creative destructionism" on tradition; like the economist Hernando de Soto, she understood capitalism as a worldview that translated human assets into commodities by first fixing

them with a particular kind of representational validity; like Allen Tate she lamented in that representation the loss of aesthetic and ethical values as the capitalist mind carried out its reductionist abstract valuations, converting the whole horse into horsepower, man into a better-dressed, better-equipped scarecrow.

Liberal capitalism in rising to global sway in the nineteenth century had glorified a rigid, defining line between public and private; postmodern states were eviscerating the line in carrying out the logic of "the personal is political." "If the personal is political," Betsey noted, "then, by an implacable logic, the private must be public."[12]

As the state empowered individuals with bundles of rights, it simultaneously disempowered them by empowering itself. The middle levels of society, which once boasted a rich, private associational life, suffered, leaving individuals in lonely crowds ever more vulnerable against the state. Because of her taste for intellectual history acquired by engagement with the great books, Betsey could trace the lineage of the problem to the social contract theorists, especially Hobbes and Locke, who rooted their new systems of politics in an ahistorical state of nature. If straying from ancient wisdom by positing self-preservation as the highest law of nature, then how could society sustain a meaningful ethics of obligation? Bertrand de Jouvenel, in the capstone book of his trilogy on political philosophy, spoke of the "intellectual delusions" perpetrated by "the views of childless men who must have forgotten their own childhood."[13] Betsey would have seconded the remark.

In her maturity Betsey grew ever more discomfited by the rampant hubris among the campus clerisy. For her, as for the antebellum southern novelist Augusta Jane Evans Wilson, whose work Betsey carefully dissected, reason alone could not unlock all the mysteries of the universe. Faith filled the void for Betsey. She credited her mother for directing her at an early age to read the Bible. Pangle suspects that Betsey's increasing frustration and dissatisfaction with the "intellectual vacuum on the left"[14] moved her toward Catholicism, and he discerns in her first book a noteworthy "foreshadowing"[15] of her conversion when she explores François Quesnay's metaphysics, which operated under the premise that a divinely inspired "natural law determines the proper rules of life."[16] Mark A. Noll, in the foreword to volume 4, *Explorations and Commitments: Religion, Faith, and Culture,* adds to Pangle's discussion. He sees Betsey as a consistent moralist, grappling throughout her career with, as she herself described it, "the appropriate relations between civil and moral law."[17]

In the process of reconciliation, Betsey took a memorably costly and courageous stand against abortion and the radical individualist premises, serviceably encapsulated in the slogan "My body, my right," that were justifying

the freedom—the "right"—of a mother to kill her unborn child. The very "success of the capitalist West in securing unprecedented freedom for the bourgeois individual" had for Betsey, as Noll writes, "created a moral monster."[18] Abortion, she argued, confronted women with fundamental questions about their essence, their personhood as mothers, the "ought" of their existence. What more nightmarish expression of the transformation of a market economy into a market society than the relegation of an unborn child to the status of inconvenience or obstacle to a woman's freedom to pursue some undefined happiness instantiated as transitory pleasure? Since Betsey regarded human beings as quintessentially social beings who build communities that must have claims on individuals, neither men nor women had any absolute or presocial right to their bodies.

One would be hard pressed to find a more fundamental concern of society than how it reproduces itself. Abortion raised nothing less than the question of the meaning of life itself and who gets to define it. Making abortion a matter of an individual woman's lifestyle choice had demeaned motherhood and, along with it, the attendant joys and responsibilities of child rearing. Women's sexual liberation had also conveniently liberated men from the duties and responsibilities of fatherhood consequent on their own sexual activities. Ann Hartle and Sheila O'Connor-Ambrose, in their introduction to volume 4, reference Betsey's exposition of the resulting contradiction: modern feminism, in asserting the principle of the personal as political, was draining with remarkable alacrity the moat that separated public from private. Yet the predominant defense of a woman's right to choose rests on the claim of a right to privacy so extreme as to make it almost hermetically sealed from public purview. To such "liberation," Betsey counterposed a corporatist understanding of freedom that stood outside the "freedom from" (negative liberty) and "freedom to" (positive liberty) dichotomy most famously posited by Isaiah Berlin. For Betsey, it seems, the Marxist understanding of freedom, strangely enough, had helped prepare the way for her acceptance of Saint Paul's Christian freedom, and in the peroration of *"Feminism Is Not the Story of My Life"* (1996), she called for the recognition of "that rare and precious freedom that too few women enjoy," the "freedom for" service to others, "without which there is no freedom at all."[19]

The contents of this reader and the preceding four volumes make clear Betsey's intellectual and moral commitments. They led her to compose a remarkably broad and deep corpus of work. Betsey remained a person who displayed in her scholarly projects and in her everyday life the recognition that only in our relations with other persons—and with God—do we realize the fullness of our personhood. On her journey to faith, she acquired a sense

of humility about the limits of the intellectual endeavor and about the dangers of intellectual pride. In turn humility provided her with an interior peace, freeing her to appreciate and deepen her bonds with others. Betsey the academic seemed to the manner born. Betsey the person found fulfillment in her marriage, comfort in her friendships, reward in her students, and certainty in her faith. In dedicating her first book to her beloved husband, Gene Genovese, Betsey cited Ecclesiastes 4:9: "Two are better than one; because they have a good reward for their labor." An appropriate epigraph for Betsey's life and work might be Ecclesiastes 4:10: "For if they fall, the one will lift up his fellow: but woe to him that is alone when he falleth; for he hath not another to help him up." May the essays in this volume express adequately the unbought grace of her well-lived life.

Notes

1. Elizabeth Fox-Genovese, "A Conversion Story," in *History & Women, Culture & Faith: Selected Writings of Elizabeth Fox-Genovese,* gen. ed. David Moltke-Hansen, vol. 4, *Explorations and Commitments: Religion, Faith, and Culture,* ed. Ann Hartle and Sheila O'Connor-Ambrose (Columbia: University of South Carolina Press, 2012), 217.

2. Mark Bauerlein, "Foreword: A Literary Theorist of the Positive Kind," in *History & Women, Culture & Faith: Selected Writings of Elizabeth Fox-Genovese,* gen. ed. David Moltke-Hansen, vol. 2, *Ghosts and Memories: White and Black Southern Women's Lives and Writings,* ed. Kibibi Mack-Shelton and Christina Bieber Lake (Columbia: University of South Carolina Press, 2011), xxii.

3. Flannery O'Connor, "The Regional Writer," in *Mystery and Manners: Occasional Prose* (New York: Farrar, Strauss & Giroux, 1969), 58.

4. Elizabeth Fox-Genovese, "The Feminist Challenge to the Canon," in *History & Women, Culture & Faith,* 4:102.

5. Bauerlein, "Foreword: A Literary Theorist of the Positive Kind," in *History & Women, Culture & Faith,* 2:xiv.

6. Ibid., 2:xiii.

7. Kibibi Mack-Shelton and Christina Bieber Lake, "Introduction: A Vision and a Voice—Women Who Wrote the South," in *History & Women, Culture & Faith,* 2:xix, xxii.

8. Elizabeth Fox-Genovese, "Slavery, Race, and the Figure of the Tragic Mulatta, or, The Ghost of Southern History in the Writing of African-American Women," in *History & Women, Culture & Faith,* 2:250.

9. Thomas L. Pangle, "Foreword: Marxist Social and Political Theory, Americanized," in *History & Women, Culture & Faith: Selected Writings of Elizabeth Fox-Genovese,* gen. ed. David Moltke-Hansen, vol. 3, *Intersections: History, Culture, Ideology,* ed. David Moltke-Hansen (Columbia: University of South Carolina Press, 2011-12), ix.

10. Elizabeth Fox-Genovese, "The Crisis of Our Culture and the Teaching of History," in *History & Women, Culture & Faith,* 3:73.

11. Elizabeth Fox-Genovese, "From Separate Spheres to Dangerous Streets: Postmodernist Feminism and the Problem of Order," *Social Research* 60 (Summer 1993): 244.

12. Elizabeth Fox-Genovese, *Feminism without Illusions: A Critique of Individualism* (Chapel Hill: University of North Carolina Press, 1992), 99.

13. Bertrand de Jouvenel, *The Pure Theory of Politics* (Cambridge: Cambridge University Press, 1963), 45.

14. Pangle, "Foreword: Marxist Social and Political Theory, Americanized," in *History & Women, Culture & Faith,* 3:xvi.

15. Ibid., 3:xvii.

16. Elizabeth Fox-Genovese, *The Origins of Physiocracy* (Ithaca, N.Y.: Cornell University Press, 1976), 47.

17. Elizabeth Fox-Genovese, "Abortion and Morality Revisited," in *History & Women, Culture & Faith,* 4:146.

18. Mark A. Noll, "Foreword: From Marx to Jesus," in *History & Women, Culture & Faith,* 4:xiv.

19. Elizabeth Fox-Genovese, *"Feminism Is Not the Story of My Life": How Today's Feminist Elite Has Lost Touch with the Real Concerns of Women* (New York: Nan A. Talese, 1996).

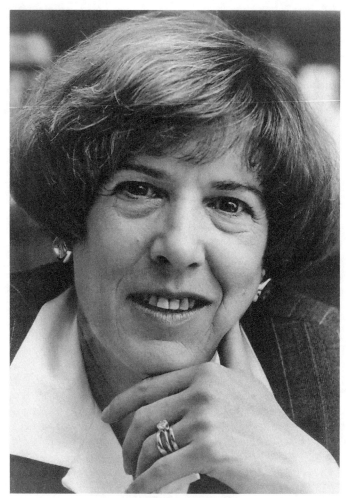

Elizabeth Fox-Genovese. Courtesy of Eugene D. Genovese.

Part One

Intellectual and Moral Commitments

One

Yves Saint Laurent's Peasant Revolution

Thursday, July 29, 1976. A scant month after the bicentennial celebration, the front page of the *New York Times* announced the outbreak of another revolution: the new peasant collection of Yves Saint Laurent. Front page status, unusual for fashion events, continued to herald the new look through the summer and fall. *Time* and *New York Magazine* rivaled the fashion magazines of Western Europe and the United States in lengthy speculations. European fashion magazines, led by the French, had a field day. Opinions diverged wildly: Women will not buy such garb; women will dabble with occasional pieces of the line but reject the totality; the garments, at $400 for openers, will not be kept in the stores. The reasons advanced for the collection's potential and influence ran as wide a gamut: the peasant look itself; the element of costume; the artistry; the return to femininity; and, for *L'Officiel* (would you believe?), the warmth.

Everyone, to be sure, agreed that success would turn on the market—the women who did or did not buy. The significance of their buying or not—the elusive psychology of fashion—remained subject to vague speculation. And the structural and cultural, if much impoverished, legacy of the look seems, as of spring 1978, to have escaped attention. Saint Laurent's recent collection figures, once again, as one among many.

One thing seems clear: The firmament set ablaze in Paris on July 28 confirmed Yves Saint Laurent's position as "the king," undisputed heir of those other monarchs of *haute couture,* Charles Frederick Worth and Paul Poiret.

His current status as *primus inter pares* rather than that of absolute monarch, which he enjoyed last year, testifies merely to momentary disorder in the world of fashion and should not distract from his considerable triumph in shoring up the fortunes of *haute couture* as a whole. Like his illustrious predecessors, Saint Laurent has proved himself both genial artist and consummate business man. The unerring aesthetic virtuosity, the sense of color, of drama, of spatial configuration single him out as *maestro extraordinario*. Quite simply, Saint Laurent's harshest critics could not fairly deny that his peasant creations, taken on their own terms, were startlingly beautiful. And the entrepreneurial acumen, so indispensable to modern royalty, has extended his domain from the cutting rooms of Paris, to the boutiques bearing his name that dot the globe, and even to the counters of the "democratic" department stores where his perfumes, soaps, scarves, ties, sheets, shower-curtains, and belts titillate mass purchasing power.

Saint Laurent's "Peasant Revolution" combined the two predominant, if superficially opposed, trends of recent fashion in a masterful and breathtaking synthesis. In one superb outflanking maneuver, he skirted the world of work-a-day fashion to marry the pop-culture themes of the street to high fashion itself. Thus—hardly by accident coming from one of Saint Laurent's talent—he appears to have provided the hard-pressed domain of high fashion with a new lease on life, just as, along the way, he crystallized a new image of femininity and coopted the growing ethnic consciousness and pastoral nostalgia for the guardians of multinational finance and class stability.

I.

However mediated or ambiguous the ultimate outcome, the reception of Saint Laurent's *coup de main* commands attention. His designs have not triumphed in precisely their original form, but the interest they aroused testifies to their creator's uncanny feel for cultural and social trends. Much talk has circulated in recent years about the street influences on designing in the fashion industry: Popular models in expensive fabrics and expensive cuts in popular fabrics have been with us for a while. Lately, the more alert could have discerned a return to more complex, delicate, and stylized models in the pages of *Vogue* and elsewhere. These expensive-to-buy, costly-to-maintain, and difficult-to-copy creations have suggested that a radical break between elite and common apparel might lie just around the bend—a cultural equivalent of the rich getting richer, the poor poorer, and the middle classes floundering in between. Fifth Avenue (increasingly supported by wealthy Europeans in flight from communist and socialist threats at home) and 125th Street. With no one left to pay the taxes. Although one can fantasize the army of laundresses required to keep the new models fresh. And the French

Communist Party has spoken out in favor of luxury—shades of Cantillon and Graslin—on the grounds of employment for seamstresses.

Saint Laurent's genius lay in costuming the rich as peasants, and thus in restoring to wealth the prerogatives of cultural hegemony that the young, the ethnic, and the reform-minded had threatened to usurp. His fabrics, colors, and cut defied cheap emulation; yet, his models suggested a lost social harmony, a simpler past, and even echoed the rising tide of regionalism from Scotland, to the Basque country, to the Italian-American League. The year 1975 had, after all, seen Emanuel Leroy Ladurie's scholarly *Montaillou, village occitan* scale the heights of bestsellerdom; and a popular occitanian theatre still draws enthusiasts from all over France while the local meridional population cultivates its archaic regional language and produces poetry in the mode and tongue of Mistral. Capitalizing in innumerable subtle and sensitive ways on the aspirations of so many during the past decade, Saint Laurent's pageantry could have been taken as boding ill—for those who take cultural barometers seriously—for the future of the woman's movement and of the related social gains of the 1960s.

The peasant gambit is not new. One thinks of William Morris and the ascendancy of Liberty's. The original peasant look, however, inaugurated precisely the birth of modern fashion itself and coincided with the American Revolution and the publication of *The Wealth of Nations*—those twin pillars of individual freedom and individual enterprise, the celebration of whose birthdays mirrored Saint Laurent's extravaganza. The initiative for the elite's pursuit of peasant simplicity has been attributed to Jean-Jacques Rousseau, prophet par excellence of domestic sentimentality, confessional self-exploration, and the problematical nature of political democracy. And not coincidentally, Rousseau's more esoteric concerns with the origins of language and society have returned to vogue under the pen of the structuralist anthropologist Claude Lévi-Strauss, who has done so much to popularize primitive cultures and the use of anthropology in all the social sciences. No more than Saint Laurent invented ethnicity, folk-culture-nostalgia, or the peasantry did Rousseau "invent" nature, the self, or self-mirroring women. English gardens, pastorals, conjugal domesticity, and the obligation to nurse one's own children had been percolating towards broad cultural consciousness. But like Saint Laurent, Rousseau codified, articulated, and popularized; his uncanny sensitivity made him something of a conduit for cultural tensions and aspirations, and his unusual talent formulated the disparate strands in a recognition-commanding image.

Rousseau's legacy hangs heavy indeed, but Rousseau did not himself model women's fashions. That role fell to the lot of the fragile, childlike, self-indulgent queen of France, Marie Antoinette, who tiring of the formal

demands of Versailles, retired to the rustic simplicity of the palace grounds, where she and her court pursued unpretentious, Rousseauesque tranquility, appropriately dressed as milkmaids.

Marie Antoinette's quest for the simple life did not noticeably reduce the royal budget, avert impending political upheaval, nor yet reflect a commitment to social leveling. It did, however, incidentally help to solidify the rising career of one Rose Bertin, who, in that fateful year 1776, had established the milliners' guild in Paris, thus launching modern couture. It also provided subject matter for the infant business of women's magazines and models for the celebrated dolls that carried the image of Parisian fashion to the backward courts of Eastern Europe.

Weighty political events cut short Marie Antoinette's romping and eventually her head as well. Revolution forced, temporarily, a drastic simplification of fashion for all. But the fledgling fashion industry survived the Terror so many of its customers did not, and emerged fortified both by rudimentary political individualism and the beginnings of industrialization. For, the great Revolution that destroyed divine-right monarchy paved the way for the emergence of Society. Such kings and emperors as returned to grace the nineteenth century did so as individual Frenchmen among many. Like their English "cousins" of the same period, they, no more than American presidents, could afford to confuse their wishes with the will of God. Commerce in general, and industrial production in particular, began to contribute major fortunes and new faces to the social lives of the various countries. Parliamentary governments, however restricted their constituencies, conducted their business away from the royal courts.

Social gatherings centered more and more on theatres, assemblies, and private homes. Matrons of substance (frequently corporal as well as financial and social) established the network of rules, of "knowing" and "not knowing," of inviting and not inviting, of dressing and redressing for each hour of the day. And, after the brief outbreak of bared female flesh and general exuberance that characterized the Directory and Empire—the Emperor, altogether Rousseauesque in his notions of female modesty and submission, did not approve, but continued to have extra logs piled on the fires at the Luxembourg to protect his scantily clad guests from chill—their ideas of dressing tended more and more towards the ample, the covered, and the laced.

The now-derided and prudish behavior of our early Victorian ancestors might seem irrelevant to the present scene, were it not that underlying their outmoded notions of fashion lurked powerful forces. The industrial revolution and the beginnings of mass consumption contributed much to setting fashion on its course. Based upon the production of textiles, early industrialization fed upon each extension of that textile market: new fabrics for

different seasons, occasions, hours of the day, and mere chic; new consumers for the new fabrics. Prior to the invention of the sewing machine in the 1840s, and ever less easily thereafter, merchant and industrial capital managed a mutually tolerant and beneficial division of the market in such a way that artisanal, neodomestic, and mass production coexisted in relative peace. Indeed, the great extension of French luxury production, from lace, to Lyon silks, to artificial flowers paralleled the emergence of factory-produced textiles. The appearance of department stores, one thinks of Stewart's and *Bon Marché,* in the 1830s similarly intertwined with the development of *haute couture,* the career of Worth for example. The popular, middle-class, and luxury markets unfolded within an intersecting cultural network but without serious internecine struggles.

In the new world of the bourgeoisie, bathing, laundry, change of clothes became *de rigueur.* The proliferation of a universal cultural norm of sobriety, cleanliness, industry, and thrift, including the more highly articulated sexual division of labor, sought to contain disorder within a normative framework as well as to mobilize everyone for their appropriate market roles. The wide marketing of fabrics, and later of ready-to-wear clothes, carried certain risks of overzealous emulation on the part of the lower classes. No woman relished seeing her servant in her dress, or even a mediocre copy. But increasing wealth continued to provide means and opportunity for its own display quite beyond the means of ordinary folk. It has been claimed that when servants too enthusiastically took to wearing bonnets their mistresses switched to hats.

Society sparkled in a veritable crystal palace of conspicuous consumption. For fashion, as Thorstein Veblen long ago pointed out, took much of its glory and prestige from its embodiment of leisure—the manifest inability of its exponents to do anything. The exigencies of class society, as well as the vanities of individuals, fostered the notion that the lower classes should aspire to imitate their betters. No sooner did they approach success (in the words of Georg Simmel, thereby both "crossing the line of demarcation [that] the upper classes have drawn and destroying the uniformity of their coherence"), than "the upper classes turn away from this style and adopt a new one, which in its turn differentiates them from the masses; and thus the game goes merrily on." And, as Simmel also noted, with implicit reference to the specific developments of the nineteenth century, the same process can obtain between different sets within the upper classes so that "the more nearly one set has approached another, the more frantic becomes the desire for imitation from below and the seeking for the new from above." The increase of wealth, Simmel insists, can only accelerate the process and render it more visible. The acceleration and the visibility of fashion since the

beginning of the nineteenth century reflected, however, not merely increasing wealth, but revolutionary changes in the production of wealth. If quantitative increase at first masked qualitative change, by the end of the century the shift could no longer be called in doubt. Nor can its significance.

Nineteenth-century fashion meant, overwhelmingly, female fashion. The industrial age was not built by those whose corsets promised them vapors at best and ribs piercing their livers at worst (for such was the cause of death of one twenty-three year old, zealously corseted beauty). Indeed, the same age that brought us political and economic liberalism brought us a renewed emphasis upon the special role and nature of women—another legacy of Rousseau. A recent debate in the pages of *Signs* over tight-lacing—who submitted to or indulged in it, how frequently, and why—risks obscuring the inescapable truth of tight-lacing as model, as standard of femininity. Many women undoubtedly shirked the extreme rigors of tight-lacing, even as they observed the general dictates of which it constituted the image of excellence. That their clothes never fit quite the way they looked as if they should, probably passed lightly over the strongest egos, and probably left the psychologically frailer with nothing more than a pervasive feeling of guilt, inferiority, or inadequacy. The motives of those who accepted the discipline and met the standard probably ranged from robust narcissism to displaced eroticism to outright masochism. The tight-laced vision of femininity long withstood the breaches, excesses, illness, and pain in its observance. And it proved a powerful conduit in disseminating the model of the woman-belle ideal, as well as the centrality of a particular female self-construction to the forward march of civilization and the assimilation of working people to the ranks of respectability. Nowhere more clearly than in fashion was the essence of the sexual division of labor displayed. And the fashionable display underscored the sexual division of labor as the *sine qua non* of social harmony.

As the price for the worlds of business and politics in the new age, men forsook their time-honored sartorial parity with women and settled comfortably into the sober garb that has characterized real power ever since. What sartorial aspirations they retained were channeled, following the prescriptions of that quintessential dandy George Brummel, into perfection of cut, cleanliness of linen, and subtlety of tone. Their loss in splendor went a long way towards freeing them from treating themselves as objects of beauty—from one potentially consuming facet of narcissism—thus releasing their energies for what Sigmund Freud dubbed sublimation. Whatever its eventual fate, the original dandy impulse, however self-centered, arose from an impulse to wield power from a position of autonomy, self-possession, and individual superiority: Brummel's two-pronged condemnation of aristocratic, including regal, *laissez-aller* and bourgeois philistinism had little in common with

the role of retiring dependence offered women. Brummel may have made a career—even something of a crusade if crusades had not demanded too much visible earnestness—out of antiutilitarianism, but the self-containment, the cleanliness, the fanatical sobriety betray a purposeful individualism less far removed than one might think from the purposefulness of Manchester magnates.

In *The Theory of Moral Sentiments* Adam Smith had roundly castigated the frivolity and moral dependency of the "foolish thing called a man of fashion," contrasting them with "the solid and masculine virtues of a warrior, a statesman, a philosopher, or a legislator." In Smith's view, all "the great and awful virtues, all the virtues which can fit, either for the council, the senate, or the field, are, by the insolent and insignificant flatterers, who commonly figure the most in such corrupted societies (the courts of princes, the drawing-rooms of the great), held in the utmost contempt and derision." Brummel informed male fashion with an appropriately masculine seriousness. Dependency and flattery were allocated to women.

Women gained on the narcissism front. The point did not escape Mary Wollstonecraft who reported in her *Vindication* that in "Dr. Smith's Theory of Moral Sentiments, I have found a general character of people of rank and fortune, that, in my opinion, might with the greatest propriety be applied to the female sex." And Wollstonecraft's resounding condemnation of the fostering of debilitating female narcissism includes the pernicious role of clothing. "Men order their clothes to be made, and have done with the subject; women make their own clothes, necessary or ornamental, and are continually talking about them; and their thoughts follow their hands. It is not indeed the making of necessaries that weakens the mind; but the frippery of dress." And again: "The thoughts of women ever hover round their persons, and is it surprising that their persons are reckoned most valuable? Yet some degree of liberty of mind is necessary even to form the person. . . ." Women remain in "slavery" to their first, most dependent and immature, emotions—to that childhood to which their lives ever draw them back.

Provided that they were wealthy enough, women could devote most of their lives to the adornment of their own persons. And since the new mystique of womanhood denied their sexuality, and the new social codes hedged them round with a barrier of gentility, they could settle down to a lifetime of objecthood. Custodians of religion, the home, sartorial brilliance, consumption in all its forms, and chastity, they took upon themselves those social responsibilities which hindered the forward march of rational progress. That dressing the part cost increasing amounts of money and thus actually contributed to the oiling of the expanding market can be seen as one more miraculous proof of the existence of the Invisible Hand. The connection is

not fortuitous. For the same Adam Smith who lauded the virtues of the market also explained that the psychological ease of any male engaged in the wonders of a market economy required a female who would prefer him to all others and, by her preference, fortify his spirit against the competitive pressures of entrepreneurship. Rousseau, less enamored of modernity and economic progress, while even more attuned to the regressive pulls towards dependency that threatened men [who are] prey to the psychological market of competition, concurred wholeheartedly.

To be sure, many women never became fashionable women. Preoccupied with homes that even with the assistance of a servant required constant attention and effort, confined by frequent pregnancies, and engaged in a range of charitable and religious activities, they fell short of the perfection propagated by the increasing number of women's magazines. During the course of the century, however, the expanding function of consumption rather than domestic production in women's lives drew them more and more into the market. That women's appointed market role confirmed their passivity and dependency did not figure prominently in their assigned role. The dominant cultural messages cultivated their needs and desires in a language that emphasized every plausible note from social and familial responsibility to merited self-reward.

Dress reformers protested, in the tradition of Wollstonecraft. But their case for health and functionalism too frequently smacked of eccentricity and overseriousness. Life had not changed sufficiently, nor had social crisis appeared so ominous that the language of moral reform could compete, at least with respect to female dress, with sophistication, brilliance, and wealth. But the price must have been high for many. Emile Zola, in *Au Paradis des Dames,* evokes the magical new world of the department store. The glittering array of goods sparkles and shimmers, reflected in the eyes of women whose desires and compulsions constitute their value. The hands itch, the pulse quickens, the fever of possession takes hold. A nameless anxiety forces ever more purchases to ease its cutting edge, to fill the terrifying emptiness within. Zola, prefiguring modern psychiatric wisdom, links kleptomania to the endless possibilities of buying—and portrays it as a female disease.

II.

Fashion ranks as the most fickle and elusive of deities—a demon to some— and all embroiled in her tentacles instinctively look for the genius or villain establishing her sway. For fashion does dictate. Women have been known to blame the great taste-setters, the Mephistophelean couturiers—in recent mythology, those sadistic homosexuals. The couturiers claim to be as putty in the hands of their clients or the spirit of the age. And, in fact, the great

Worth could not decree the end of the crinoline when he chose, nor could his star client, the Empress Eugenie, abandon it prematurely. More sophisticated women will readily charge the fashion industry with forcing the pace of their consumption. But retailers and manufacturers retort with equal certainty that they have no such power. The failure of the maxi must still burn in many minds.

Fashion defies the neat and tidy, necessary and sufficient, kind of definition tailored to the needs of dictionary precision: Fashion is . . . The extensive literature circles and weaves, rarely committing itself to hard-and-fastness. The discussions themselves follow the paths of intellectual fashion, emphasizing in turn the universal and the particular, the behavioral and the symbolic, the expressive and the hierarchical, the artistic and the economic, *ad infinitum*. Notions of individual and collective identity figure in most discussions. In one of the few attempts at straightforward definition, Kurt and Gladys Lang assert that fashion "is a process by which the taste of a mass of people is collectively redefined." This sensible discussion further takes account of the importance of novelty and of the continuing tension between self and collectivity. The authors situate fashion in the realm of "all those market decisions in which individual preferences are reflected and those of others affirmed or rejected." Choices of fashion "express a need for individuation without the risk of group disapproval." So far, so good. Fashion mediates, in some way, between self and society, or between some aspects of self and some aspects of society. All the good recent treatments of fashion lean towards one or another variant of the socio-cultural approach.

And as a catchall, society and culture do nicely for a first approximation. Unrefined, however, the concepts beg the most difficult and tantalizing questions, not least of which must be the relationship between society and culture. Fashion raises every intractable question about the nature of collective human social existence. It can be interpreted from the economic, the psychological, the sociological, the historical, the aesthetic, or the religious perspective. Within each perspective it can be addressed under a range of theoretical rubrics. A comprehensive study of fashion, moreover, would touch upon almost every facet of human experience. For fashion is cultural, social, economic, psychological, and historical. In this respect, thinking fashion requires thinking complexity, indeterminancy, subjectivity, and hard theory. In the first instance, fashion might be conceived of as a social cement, a form of communication, a social representation. Ritual and metaphor, no matter how *au courant* as modes of designation, remove fashion too far from its solid foundations in commodities. Overly spiritualizing the day-to-day of dressing, for example, risks committing the psychoanalytic fallacy of intellectualization, which drains the experience of its lived content. And fashion has

become a mundane and recurring fact of most people's lives, spanning the continuum from minor purchase to self-representation. Yet, fashion cannot be identified with the commodity purchased. The commodity remains dress, or chain, or blue jean, or car, or waterbed, no matter what aura fashionability may lend. Nor, one hopes, is the self, him-herself, fashion. Although here pessimists may be inclined to doubt.

Fashion is, or better qualifies, social interconnectedness, social relationship, the mode of connecting and relating. It is, in fact, adjective and, above all, adverb rather than noun, much less verb. The strength of fashion, however, can best be captured in its ability to figure as noun or verb. From its origins, fashion has sought to fashion isomorphism between its objects, its manifestations, and itself. It invariably aspires to totality and identity. Even fashion as mode of social differentiation, as encoded in sumptuary laws, affirmed the importance of its custodians in a manner that comprehended the negation of those excluded. The exclusion itself offered an identity, a social being, based on a nonbeing. Such language merely points towards fashion as a qualification, accentuation, articulation of prevailing social relations of production. It is neither coterminous with those social relations of production nor extraneous to them. Nor can it be reduced to direct emanation of them. Its undeniable links with artistic expression and production, its elements of symbolization and of play, of craft and of artifact, invite a more nuanced appreciation. It remains, nonetheless, art with a particular social function. And in contemporary society it is tending more and more towards a barely mediated ideology of commodities.

Thomas Carlyle spoke readily of the philosophy of clothes. His phrase evokes the realms of metaphysics, ethics, and epistemology. Philosophy, in his sense, referred to elements of motivation and meaning, intentionality and causation, origins and ends. Communications theory and semiology— society as language, society as text—attempt to dis-embed the teleological legacy of philosophy in Carlyle's sense and to reconstitute social discourse as a system of signs or messages. Roland Barthes' *Système de la Mode* provocatively applies semiotics to the language of fashion and lays bare the internal, circular, and psychologically dictatorial logic of women's fashion magazines. He brilliantly demonstrates the consistency with which such magazines batter their readers with the message that they will become what they wear, that fashion dictates what they wear, that they must be fashionable to be. In this respect, although he does not put it this way, he underscores the notion of fashion as mediation between commodity and self—a mediation that, in denying female consciousness and choice, tends towards identifying commodity and self. His virtuosity nonetheless ends with his own admission that a full discussion of fashion, in contradistinction to its verbal signs, would

require moving beyond the words to their referents. And the referents, in their multiplicity, defy tidy cataloguing.

As Edward Sapir, in what remains one of the finest treatments of fashion, argues, it "is emphatically a historical concept. A specific fashion is utterly unintelligible if lifted out of its place in a sequence of forms." Sapir further insists on the special danger of rationalizing or psychologizing "a particular fashion on the basis of general principles which might be considered applicable to the class of forms of which it seems to be an example." The point, well taken, would be better taken yet if Sapir were calling attention not merely to the sequential development of form but to the historical development of social relations of production and reproduction as well. Mary Douglas' general caveat to broad interpretations of culture, *qua* culture, obtains: Culture can only be understood in relation to discrete societies. Moreover, Sapir's own extremely useful negative delineation of fashion as neither custom, taste, nor fad should have led him to dwell more specifically on its historical context and substance.

Sapir does, nonetheless, recognize the substitution of an "aristocracy of wealth" for one of rank as a critical element in the emergence of modern fashion, and he underscores the importance of "a psychological if not an economic leveling of classes because of the feeling that wealth is an accidental or accreted quality of an individual as contrasted with blood. In an aristocracy of wealth everyone, even the poorest, is potentially wealthy both in legal theory and in private fancy." Indeed, one critical strategy of bourgeois culture has been its encouragement of private fancy—not to say fantasy—as a substitute for public—not to say political—consciousness. Thus, Sapir's hasty dismissal of psychology as a valid tool for interpreting fashion may be related to his resounding silence on the hard economic questions. The very notion of an aristocracy of wealth blurs the specific characteristics of class society.

Reigning psychoanalytic interpretations of fashion also tend to blur such distinctions. Even such sensitive analysts as J. G. Flugel fall into something like banality in expounding on the sexual symbolism of any fashion. However valid the general insights, their universalism leads them perilously close to archetypal formulations. And they singularly fail to explain the predominance of one particular form of sexual symbolism in a given period, much less the change from one to another. In this respect, psychoanalytic interpretations tend to apply the basic stages of individual psycho-sexual development to a society as a whole, thereby ignoring the compelling terrain of social psychology as interaction. The important territory that should indubitably fall to a psychological reading of fashion lies in the realm of the mobilization, containment, and distortion of fundamental intrapsychic conflicts

rather than in the simple unfolding of sexual symbolization. For, fashion clearly holds its sway in the relationship between consciousness and social being. Kleptomania or anorexia nervosa constitute socially rooted intrapsychic disorders.

Nor can any consideration of fashion afford to neglect the objective conditions of social being. The mode of production, the prevailing social relations of production and reproduction, the extent of the market, even the relative levels of accumulation and profit impinge upon that social life and social consciousness which fashion seeks to order and encompass. If fashion as convention in part obeys an internal sequential logic—if waists having risen so high must drop, if skirts having become so wide must narrow—it does so within the contours of its social and economic possibilities. If social history and social psychology cannot alone account for the development of an art form, much less the variable of individual creation, art for art's sake and the myth of creativity cannot alone account for the vagaries of so socially corrupted an art as fashion.

III.

Historians and theorists of fashion frequently discuss their subject as if it pertained equally to all times and places. And all historical peoples seem to have had preferred modes of dress, adornment, artifacts. Such modes do not, in themselves, constitute fashion. Traditional peasant dress may reflect custom rather than fashion: Fashion itself can neither be understood independent of notions of change and novelty nor identified with passing fads perceived as such. One of the peculiar elements of fashion lies in its quality of presenting change or novelty as necessary, hence endowing the temporary with a psychological illusion of permanence. Indications of what the modern world understands as fashion can be found throughout European history, particularly at courts and in cities. These imitative, restrictive, and conventional modes of dress, adornment, and furnishing cannot be dismissed. Nor should they be allowed to shape our understanding of modern fashion completely. They qualified and gave expression to traditional social arrangements, much as fashionable goods resulted from precapitalist forms of production. Such goods circulated on the markets constructed by merchant capital, which sought more to organize existing social relations of production than to transform them. In this perspective, the fashion that characterizes modern capitalist society, although not without historical origin and antecedent, constitutes as new a phenomenon as does capitalist society itself.

The pervasiveness and elusiveness of fashion have acquired particular intensity since the American, French, and industrial revolutions. And that market society of which we are all members notoriously lacks a single center

of gravity. If our world is anything, it is a web, a texture, a system of inter-locking and mutually interdependent relationships. It is a fair or a meeting place—a society in which we all look to each other for the reflection and measure of who and what we are. A department store, as Zola suggested. And, quintessentially, Bloomingdale's on Saturday afternoons when anxious glances at mirrors, at the faces, forms, and appearance of others shade off into the compensatory fixation on the glitter of objects and garb, each promising to relieve the anxiety by creating a self through possession of commodities. In such a world, fashion becomes the external manifestation of our belong-ing and our individualism, our persona, our identity, although the "our" of display, as against that of attainment, has been primarily assumed by women in this democratic market.

Too fickle to be fully controlled or manipulated, fashion did play an important role in the development of capitalist society. In particular it lubri-cated the transformation of luxuries into necessities, thus facilitating eager, individual commitment to the unceasing expansion of commodity produc-tion. It helped to draw ever wider segments of the population into full mar-ket existence. It mirrored the emergence of labor-power as a commodity and eased the pain of alienation by recasting loss of autonomy as the realization of fantasy. Fashion mediated production and consumption, economic exi-gency and individual self-perception. The growth of advertising as the com-manding form of social discourse publicized and codified aspirations to comfort, dignity, and respect. That along the way it substituted consump-tion for politics, passivity for action, simply testifies to its strength in recast-ing individual aspiration and in extending alienation to the realm of fantasy itself.

Originally, the bourgeoisie had sought to enforce social discipline through harsher means. Emphasizing thrift, hard work, repression, it pro-moted fashion in the sense of cleanliness, modesty, decorum. In the same vein bourgeois culture exaggerated the social import of the sexual division of labor, which it stringently defended in the name of lost harmony and social order. But by the beginning of the twentieth century, if not sooner, the un-precedented economic success of capitalism permitted a certain relaxation of traditional values in the interests of increased consumption. Increasingly, the commodities themselves—named, valued, and bedecked by the advertising discourse—could be counted on to identify selfhood with consumption. Ultimately, as Stuart Ewen has argued, the corporation proposed itself, rather than the family, paternal wisdom, or female domesticity, as the source of reassurance and nurture. This recent development suggests a decisive erosion of bourgeois culture and may portend a real shift in the nature and function of fashion. For, the fashion of bourgeois hegemony must be understood as a

counterpart of bourgeois etiquette—an attempt at ordering and regulating. The bourgeoisie recognized the personal as political and sought to repress it. In so doing, it carved up human psyches, allocating achievement to men and narcissism to women.

IV.

Bourgeois fashion has shaped women—and with their complicity. Slavery did not long survive the advent of wage-labor. Voluntary servitude better flatters the image of the upstanding, independent, democratic citizen, even if his need to submit casts doubts on his pretensions to autonomy. A thoroughly convincing psychology, much less a social psychology of women, has yet to be elaborated. For, if Freud gave us the indispensable building blocks, he failed to assemble them in a manner that articulated the interaction between the subjective and objective elements of female selfhood. The woman's movement may already be recasting the terms of the debate to such an extent that when the psychology of the contemporary woman is formulated it may differ in important particulars from that of her Victorian forerunner. But, the modern woman is a relatively recent and fragile creation: the newborn product of the efforts of a multitude of women who refuse to be excluded from the world of selfhood (socially validated subjective existence), production, activity, and power, and yet refuse to sacrifice what they deem the essence of their femininity. It has already become clear that femininity can no longer be defined as the opposite of male norms or as the mere satisfaction of male needs. Nor can it be reduced to narrow waists flanked by welcoming curves. Nor to domesticity. Nor to the restoration of traditional family life. Nor even to the voluptuous display of ethnic yearnings, artistic relief from the depressing aspect of contemporary civilization—a blaze of warmth and comfort from an earlier time. Nor to fantasies of personal liberation independent of social fabric.

Saint Laurent's peasant garb, in its happy unification of the streets and the salons, promised small place for the working woman who has emerged during the past decade. His visual imagery highlights contradictory messages of predatory female sadism and masochistic female submission. The steel-sharp clack of the gold boot taps across the psyches of men like a Cossack dancing on a marble floor. The nurture and warmth promised by the inviting décolletage of the bodice and the seductive volume of the petticoats evoke sirens and Laurelei as much as nurturing acceptance. And the costliness of the fabrics denies the very ethnic simplicity the models seem to embody. The element of costume may entrance, but costume invariably refers to artificial or constructed persona. To the extent that such dress suggests female power, it suggests the power of female ruler—of the tsarist princess. It thus

brings the image of explicit hierarchy to embellish the mere fact of conspicuous consumption. It caricatures, in a word, feminist notions of legitimate female power and independence. And it implicitly challenges, even as it mocks, feminist notions of femininity. From that perspective, Saint Laurent makes Diane von Furstenberg, however inflated her publicity and openly capitalist her allegiance, look very, very good.

Nothing forced women to buy the peasant look. Few could afford the real thing in any case. And many did not buy it, although lack of alternatives may soon force them into buying its heirs. Be that as it may, surface cultural phenomena, particularly fashion, have had a way of taking their toll on even the best integrated female psyches. And Saint Laurent has ominously earned his standing by an uncanny sensibility that picks up the vibrant elements in the culture and recasts them in original creations which influence the way the members of the culture think about themselves. Women's contribution to the social good lies all too frequently in their role as consumers, and fashion remains one of the prime commodities that they can be persuaded to consume as much out of psychological as economic need.

Fashion plays its role in the many forces that encourage women to see themselves less as productive beings and more as the objects of others' desires, or as the saintly custodians of values necessary to decent human life but incompatible with market competition—not uncommonly represented intrapsychically as sexual competition. Not coincidentally, recent changes in fashion have paralleled the massive entry of women into and their departure from the labor force. Particularly the entries and departures of women socially represented as middle class or normative.

During the twentieth century traditional female dress in its various stylistic embodiments has gradually given way to more utilitarian, if less inspiring, garb. The complex progress, most evident in the improvement of underwear, the shortening of skirts, and the acceptability of pants, has included a marked and superficially confusing trend away from mature (voluptuous and maternal) femininity and toward varying degrees of boyishness. The revolutionary increase in the exposure of bared female flesh should not in itself be taken as an acceptance of female sexuality. For, if women favored less restrictive underwear, or none at all, the fashionable and pornographic—and at the upper reaches of fashion the two merge more closely than one might expect—depiction of the liberation of the female body looks more like a distorted male fantasy of female sexuality as threat than a natural acceptance of the female body and being. How else are we to read the pictorial allusions to female masturbation or the photograph in a recent *Vogue* that portrayed a white, blond-haired woman in a skimpy red bathing suit between two extraordinarily large, tribally-garbed, black men?

These confusing trends hopelessly complicate any appraisal of Saint Laurent's peasant collection. Few, even among feminists, will begrudge a return to an appreciation of a properly female identity and the acceptance, for women, of maturation. (Be it not naively romantic to think such ever existed.) A female adulthood would come as a blessing. It would provide a welcome relief from the dilemma of manifest female masochism versus female-denying masculinity (a higher form of masochism). But Saint Laurent's collection, in its innuendos and implications, did not resolve that dilemma: It boldly sketched a return to full nineteenth-century femininity of a kind none have dared for decades. Its evocation of organic restoration could not, however, fully mask its inescapable engagement with contemporary problems. The fantasy of bliss it proposed has rapidly decomposed, revealing more sinister cultural and social dispositions.

V.

Dior's celebrated "new look" of 1947 attempted nothing so sweeping, although it too favored the small waist and the floating skirt over petticoats. In 1947, of course, sensible women, still mindful of their independence and war work, insisted that they were not about to throw out entire wardrobes for such a trivial matter as fashion. Throw them out they did. But then, the factories were throwing out the women in order to make room for men. Dior's new look, in other words, coincided with the beginning of the years dominated by what Betty Friedan termed "the feminine mystique." Those poor frustrated housewives (our mothers, the voluntary homemakers) trapped in the suburbs, married to the men in the grey flannel suits, raising unnecessarily large families under intense psycho-cultural pressures, buying the image of themselves dished out by the *Ladies Home Journal,* Doctor Spock, et. al., wore the new look.

Remember Audrey Hepburn, Debbie Reynolds, Doris Day, and, quintessentially, Kim Novak in *Strangers When We Meet?* They all had tiny waists and undulating skirts: None of them had jobs, at least not jobs they kept after Mr. Right came along. The new look should not be held responsible for their plight. They may only have bought it out of boredom and self-doubt. The world of work was hardly offering them substantive alternatives. The advertising phalanx was doing its best to persuade them to free themselves for the serious business of consumption. Yet, they probably found the new look charming and gracious. And more likely than not it helped seduce them into finding a "meaning" in domestic self-abnegation that transcended the crass material values of the world outside. The essence of mystification lies in the sad truth that in their wistful pursuit of a meaning that would

transcend the materialism of the cash nexus they performed the most essential economic function.

The postwar economy benefited from the increased domestic consumption characteristic of the new suburban life, and even then had its eyes on the child market. The advertising industry did its bit in bolstering the image of this sweet custodian of traditional values, but, having long since proved its ability to pitch its message at almost any cultural stereotype, it is now happily peddling "liberation" and "black is beautiful." Had the half-conscious yearnings for a new stability and a new prosperity-at-any-cost not permeated the culture, Dior's venture might well have died stillborn.

Yet, no Machiavellian manipulator perpetrated the new look and its attendant cultural syndrome on women. The worst of it is that the values the new look subtly enshrined are not all bad. No more are those captured in Saint Laurent's phantasmagoric peasants. The reaction against scandal, corruption, impersonality, bureaucratization, the erosion of personal bonds, the loss of community, and on and on, runs rife through the Western world.

The various quests for a simpler, more organic past abound: Crafts flourish from the American suburbs to the Scottish highlands; American historians, so long the apostles of our individualistic and inherently entrepreneurial origins, are hot on the trail of the peasant character of colonial society; young people, facing the glutted job market, set up in communes, or bake bread, or sport long flowered skirts; the celebration of ethnic origins and identity prevails where only recently assimilation predominated; religious cults of all varieties are on the rise; and Claude Lévi-Strauss' structural anthropology, with its avowed preference for cold (unchanging or "primitive") societies over their hot (growth-oriented) counterparts, sets the tone for the most sophisticated intellectual work. The peasants are in.

But the peasant community so many seek constitutes a myth. The essential dynamic in this cultural explosion remains the reaction against the excesses, the depersonalization, the alienation of advanced industrial society. The reaction testifies to the extent of disillusionment with the values of our liberal, individualistic tradition and its political, social, and economic institutions. But our technology and our awesome interdependence are here to stay. A vast, collective fantasy, however compelling, will solve nothing. The exigencies of running the world reduce this cultural revolution to a blind delusion that may actually perpetuate the evils it thought to protest.

However brutal those realities of peasant existence which the fanciful re-creations staunchly deny, peasant societies did form communities and did embody genuine social and economic relationships. The social relations of production, upon which the current peasant mystique rests, remain

intractably those of advanced capitalist society—of alienation and extreme individualistic fragmentation. And corporate capitalism, particularly in its multinational variant, seems prepared to live with an extraordinary variety of cultural forms and individual predilections. As the ethic of consumption steadily usurps the once privileged ethic of work, business adapts to selling anything to anyone. It even seems flexible enough to substitute personal and sexual liberation for religion as the opiate of the people. The order of multinational capitalism has moved so far from its original class and national roots as to tolerate seemingly endless quantities of disorder in daily life. The merciless logic of the computer can coexist with dizzying light shows of cultural pluralism. All business requires is a mounting tide of personal anxiety and dependency that can only be assuaged by ever-renewed purchase. Of fashion, it requires novelty, not meaningful or ordering cultural symbolism. Hence, the seven-billion-dollar-a-year cosmetics industry that feeds off the time-honored quest for beauty, but even more off the panicky fear of aging: a fear constantly exacerbated by stern reminders that retaining a job depends upon the appearance of youth. Women, long habituated to such self-eroding demons, may well wonder whether to gloat or to moan at their current assault upon men.

The peasant look turned explicitly to women to embody—to display— those values which cannot be assimilated into the nitty-gritty of modern life and must therefore be left to culture. Like children playing house, women may yet be persuaded to return to their dolls. And if the ERA goes down or the right to abortion is further compromised, or if the equilibrium of capitalist economies necessitates the abstinence of women from salaried and wage labor, perhaps those engaged in creating the new traditionalism will not notice.

The peasant look itself schizophrenically straddled the disparate tensions of multinational cultural anarchy and bourgeois class reaction. Unlike corporate permissiveness, the right-wing reaction has serious ideological commitments. Its vision of social order includes a full-scale assault on the substantive gains made by human liberation movements during the past decade, in particular the woman's movement. But its assault on so-called cultural disorder rests upon firm class commitments and an attempt to retain the social space appropriated by the bourgeoisie during the nineteenth century. In this respect, it has more sharply attacked the political and social dimensions of the women's movement than the cultural. The personal careers of the female leaders of the anti-ERA battalions constitute no secret. Only an implicit class position can reconcile the career performance with the ideological pronouncements. The sexuality of the "total woman" figures as the

object of celebration, provided it remains contained within a traditional domestic role. The opposition to abortion flies for the jugular of working-class women on the assumption that their middle-class sisters can afford a few mistakes. Given individuals within the right-wing camp indisputably take the ideological questions with deep seriousness. Life would be much simpler if all or even most adherents of the traditional family, the domestic role of women, the right to life, and the sanctity of the free market and the American way of life could be dismissed as hypocrites, fools, or dupes. They cannot. Elements of sincerity and commitment notwithstanding, the reaction of traditionalism constitutes an objective class position, albeit at odds with that of other elements of the ruling class. And present cultural trends, those of fashion especially, suggest that class distinctions may be about to stage a real comeback.

VI.

The new look is said, to wit Bernadine Morris in the New York *Times* (July 29, 1976), to have succumbed only at the presentation of Saint Laurent's peasant collection. And by the logic of fashion itself, the analysis makes sense. The conventional or formal life of any fashion allows a given style to develop to a certain point, exhaust its paradigmatic possibilities, and ultimately give way to something new. The aesthetic dynamic cannot be unilaterally reduced to psychological, economic, or social determinants. In part, the survival of fashion with a capital F turns on surmounting context, on preserving the hegemony of high style against the mounting tide of utilitarianism.

By this logic, the most serious blow to the new look, *qua* Fashion, came not from Saint Laurent but from the early 1960s, from Jackie Kennedy's reign in the White House, and from the early glimmerings of the women's and other protest movements. Jackie's impact could easily be dismissed by those more preoccupied with deep social and cultural forces—all the more since she herself has moved on to pursue the extravagances of high fashion with all the avidity of an addict. But the A-line skirt, Chanel suit and bag, and relatively easy hairdo, in their deceptive simplicity, permitted successful copies in easy-to-wear, easy-to-care-for fabrics. A woman could wear them to the office with no cost to femininity or professionalism. They at least opened a bridge to the middle and lower-middle classes. As they gave way to pants suits, blunt-edged haircuts, and turtleneck sweaters, they opened the causeway across which the blue jeans, long hair, and beads of the street culture could pass. The meeting of the two created an easy, wearable fashion for women that owed little to the cutting rooms of Paris, which in turn went *prêt-à-porter*, adopting accepted practice along the way.

Those brief halcyon years, in which the heretofore extravagant *Times Magazine* fashion supplement, to say nothing of *Vogue* and *Harpers,* featured "the life and clothes of a woman like you," may now have run their course. But they, not Saint Laurent's brilliant counterattack, constituted the revolution. And these days, *Vogue*'s idea of the life and clothes of the working woman focuses on Mary Wells Lawrence with her "millions-of-dollars clout in a 'man's world,'" jetting home to Dallas from New York to spend the weekend with her husband, chairman of the board of Braniff International, or jetting off to recuperate at their hideaway, La Fiorentina, "the most beautiful house in the south of France." The MWL story is offered to reassure us all that a woman can make it to the top "without damage to husband, children, job, or self; without coming, finally, to resemble the career-driven neurotic of old Joan Crawford movies." Thus interpreted, the woman's movement should not require the ERA or abortion. You've come a long way baby, and all it took was a little cash. Such a woman can work in appropriately feminine designer creations and easily sport the latest extravaganzas in her leisure hours. How absurd to argue that reasonably simple and utilitarian clothes made any difference to a woman's position. And maybe they did not, to a woman. But what of women collectively?

Many could be found to argue that the dress of the 1960s and early 1970s sacrificed much of the style, glamour, and panache characteristic of true fashion—that the loss impoverished our culture as a whole. They may even have a point. But, they fail to explain why women should be held responsible for providing society as a whole with the illusion of grace and charm.

The so-called fashions of the late 1960s and early 1970s may actually have heralded the death of fashion as the bourgeois world had known it. The aesthetic cost of such an event would be high, but there should be ways other than a blind restoration of the past to meet the bill. Art, film, urban architecture, graffiti, parks: the possibilities for aesthetic expression are endless. Presumably, the point of such delights is to enhance human experience, not to constrict it—to experience self as perceiving self and object as object of perception—not to be trapped into the paralyzing experience of self as object. Women as the custodians of fashion differ less than they would like to think from women as the victims of rape. From Meg in *Little Women,* caught in the tentacles of *Vanity Fair,* to Gertrude Stein being fitted for her Chanel suit, to the memorable chapter on Jane's despairing shopping (her mother remembered years according to the clothes she had worn) in Gail Godwin's *Odd Woman,* women's literature abounds with women's delighting, anxious, desperate, compulsive relationships to their clothes. The visible self. But what if that facade becomes the only self? Well might *Ms.* and

Spare Rib both ask why women hate their bodies. As apparently all, or at least most, women do.

VII.

"Never a failure of taste, no rift in the deployment of nuances, but a communicative joy in living, an enchanting dynamism for a winter of radiating happiness." So spoke Paris *Vogue*. And *L'Officiel* promised its shiver-prone readers that they would spend "an exquisite winter." The subsequent issue of that prestigious organ of the *Syndicat de Couture* elaborated on the promise while reassuring its readers that the revolutionary upheaval would not be violent. New looks apparently not being enough, it proudly announced the new woman. "The new woman" appropriately lacks a verb—she does nothing, is subject of nothing. She exists as the reference point of fashion in a closed system that transforms her as potential subject into object. *L'Officiel*, undaunted, proceeded to inform its readers that "the enthusiasts—by far the most numerous"—were trumpeting far and wide: "Long live novelty!" (the *vive* of the French clearly echoing the traditional acclamation of monarchs). "Here is something that throws last year's models totally out of fashion." But should any have qualms, they may rest easy: The revolution "is not that of October, but rather that of July, very pacific, the most important since the 'New Look.'"

Bless those literate and savvy French journalists for having made it all so explicit. The ghost of the Bolshevik October Revolution hung heavy over Europe in the fall of 1976. The Italian elections, marked by notable Communist gains, sobered everyone with something to protect. The French bourgeoisie was regrouping to forestall, yet again, any income tax for the propertied. Class lines of a kind not visible in the United States seemed to get sharper every day. In the midst of the general malaise, to predict a radiant winter of joy was to display a willingness to ignore reality worthy of the magic of fairy tales. Joy was to come hard to those hit by the drought, to budgets crippled by inflation, to politicians facing falling currencies and mounting strikes. It was to come harder yet to the increasing unemployed, particularly the women being pressed out of the job market or denied advancement to make room for men. The 25% rise in fuel prices did not help, although it does help to explain the desperate insistence with which the new fashions promised warmth. The coy artificiality of fashion reporting has been with us for a long time, but rarely have those trivial phrases carried so much cynicism. And in preparation for dealing with it all, Valéry Giscard d'Estaing had his chair raised higher than those of his ministers and set about polishing up the emblems of royalty.

The Revolution of July, after all, was a bourgeois revolution. Altogether pacific: Bankers and entrepreneurs encouraged the Parisian working population to take to the streets for a couple of days of almost bloodless barricade-tending in order to permit a more tractable monarch, the mild businesslike Louis-Philippe, to replace his reactionary cousin. The change permitted a smoother functioning of French government and economic development with no threat to the social order. It inaugurated a period of solid bourgeois dominance in which the rich were encouraged to enrich themselves further, while their wives attended to dress and polite society, and the poor stayed in their place.

But the Revolution of July did not adequately do the job. Full industrial development and serious social choices exceeded the capabilities of the French bourgeoisie, which turned to Napoleon III. And Marx, in a book admired even by his harshest critics, explained Napoleon's relationship to the peasantry and the peasantry's relationship to plebiscitary dictatorship. Marx taunted "Napoleon The Little" with presiding over a farce, whereas his uncle had presided over a tragedy. Alas, not even Marx's genius could predict that a third go-round would threaten us with tragedy once again.

At present, with last year's victories in the municipal elections to encourage them, the French Communist and Socialist Parties stand poised on the threshold of national victory. That challenge goes far towards explaining the persisting validity of class consciousness in French society. It also helps elucidate the elements of cynical class consciousness in Saint Laurent's usurpation of popular sensibility. Domestically, French fashion mirrors the centralization of the French State. A strategy of restoring hierarchy haunts the French imagination. In this context, Saint Laurent's display of high fashion rejoins a political sensibility. But to the extent that *haute couture* increasingly serves less to dress individuals and more to sell the name of the designer as trademark for innumerable and disparate commodities, the peasant look also has a multinational dimension.

The United States is not France, nor yet England. For all its injustices, our democracy functions better, our people live better, and our women know a freedom and opportunity still denied to their European sisters. At the very moment of Saint Laurent's revolutionary collection, American fashion seemed to be asserting its own claims against the dominance of Paris. "The Year of the American Woman" fluttered across the pages of fashion magazines and the displays of the big New York stores. A discussion in *New York Magazine* referred to the increased participation of socialites in the organization and aspirations of Seventh Avenue and pointed to a trend towards quiet elegance and exclusive labels. If, as they claimed, everyone was to dress alike, then the name and quality of the model would become the distinguishing

features. The trend echoed, although the article did not mention it, the trend in men's clothing inaugurated by Brummel.

Assuredly, the elegance of line and fabric, the subdued and functional apparel did not hinder the class divisions of nineteenth-century society. In such garb the white male bourgeoisie came close to conquering the world and spawned the technology and industrial production that did conquer it. The dress, in a sense, reflected the strength and weakness of the liberal ideology and democratic institutions of its wearers: It offered a model of human dignity (male) and the promise of individual freedom and advancement. Not everyone profited equally from the opportunity—a bitter recognition much with us today. But, the formal equality, whatever its limitations in practice, was better than anything else history had afforded. And a fashion that would embody women's possibility of joining that functional, work- and power-oriented mainstream has more to offer than the reactionary peasant alternative.

More, but perhaps no longer enough. The current fashion scene is so disordered as to defy simple prediction or interpretation. The important political questions, particularly the ERA, still hang in the balance. Spring fashion proposes two major themes: wanton and provocative rumpledness (a caricature of a workingman's fantasy of the female activists of the New Left) or prim and proper femininity. *Vogue* features wrinkled, ill-fitting jackets, with nothing underneath—and everyone knows nakedness teases more effectively under a coat than a nightgown; the most recent Bergdorf Goodman catalogue offers contemporary facsimiles of the pastel shirtdresses of the 1950s and short-sleeved, high-necked blouses with full skirts reminiscent of the late 1940s. The wary, however, would do well to think twice about the promises of individualistic diversity. The common theme of the disparate styles can be found in the return of spike heels for all occasions. The structural legacy of Saint Laurent, once the peasants are gone, lies in the return to waists, curves, longer skirts, and even padded and underwired bras. Without the brilliance of the peasant costume, the structure can easily support an insipid, neodomestic femininity.

Such clothes do not necessarily exclude women from the labor market. Indeed, *Glamour* recently ran an article elaborating the results of its poll of major businesses concerning their preferences in female attire. Preference may be too mild a word. For *Glamour* published the results along with five pictures of diversely dressed young women. The heading ran: Who got the Job? The winner who, should you have missed the point, owed her job to the way she was dressed, wore a soft, contemporary suit with a skirt. The runner-up wore a Diane von Furstenberg dress, identified as simply unexceptionable. The losers were dismissed as too severe (read: masculine)—in a

pants suit, what else?—too trendy, and too informal. So much for the acceptance of diversity.

Corporate capitalism can assuredly adapt to female employees, even well-paid female employees, and all the more if they owe their jobs to their appearance rather than their ability. It may not be able to adapt so smoothly to full female employment. Buying off a sufficient number of middle-class women and attributing their success to special individual qualities might work as an antidote to the broad demands of the women's movement. And, in one of those strange historical coincidences in which ruling classes seem to specialize, it might also shore up the American class structure against the international epidemic of socialism. For, with the erosion through taxation and inflation of the professional bourgeoisie—doctors may constitute an exception, and a new magazine is projected to help doctors' wives spend their money—the new rich will be the two-salaried couples, salaried, of course, at a level high enough to justify the wife's working at all. With the rising cost of education and the decline of social services, especially day-care, such an arrangement will hardly benefit workingclass, much less minority, women. And bereft of a united movement backed up by constitutional guarantees, even successful women will remain more vulnerable, than they will want to acknowledge, to the dependency death-traps of female social identity.

VIII.

The peasant fantasy is not new. In 1938 a world, as yet barely recovering from the Depression, faced the acceleration of Hitler's aggression. Women were called upon to do their part: The fashion proposed them included a bunched, or "peasant" skirt and the first hint of a corset. In the words of James Laver, the historian of fashion, the new look pointed "at a new conception of woman, at the end of the woman-as-comrade ideal which had reigned ever since the emancipation of the First World War. Perhaps it is hardly necessary to add that the peasant skirt in question was an Austrian peasant skirt. It was the faint but unmistakeable echo of Hitler's '*Kirche, Kinder, Küche*.'"

Saint Laurent's vision has older and more noble origins: Like that enchanting but frivolous queen, his gilded cooption of harsh peasant experience might be read as telling increasingly unemployed professional and working women, worried about equality for themselves and bread for their families, that they, too, may eat cake.

Gender, Class, and Power

Some Theoretical Considerations

Gender, class, and power are three abstract nouns that refer to social rela-
tions, but whereas gender and class refer to socially specific sets of relations,
power—the ability to impose one's will—refers to an ingredient in all such
sets. Power can vary from hegemony, perceived as legitimate, to violence or
the threat of violence. Class is the relation to the means of production, espe-
cially the right of direct access to the fruits of production. Gender has been
used to mean the social form of biological sexuality, but is best understood
as the relations between men and women. The three together constitute the
fundamental social, economic, cultural, and political relations that deter-
mine any social system.

Power, the firstborn of historical and social analysis, has long figured as
an object of celebration or castigation. Too frequently it has been presented
as _sui generis,_ as imposed on society and susceptible to analysis independent
of social relations as a whole. Marx introduced class as a systematic category
and argued that class relations determine the decisive relations of power in
society. Recently, feminist politics and scholarship have challenged the pri-
macy of class as an explanation for or even the most prevalent manifestation
of power, understood as the domination of the many by the few. Men's
domination of women, it is argued, is more ancient and remains more per-
vasive than class domination. This claim mocks the commonsensical evi-
dence that some women have profited marvelously from class position, even
if not as marvelously as the men of their class. Similarly, exclusive attention

to class mocks the evidence of all women's domination by the men of their own class and others. This domination of even the most privileged women has left a crippling legacy. Little is gained by pressing the primary claims of either class or gender, although either may be more important in a given instance, and, ultimately, both must be evaluated in relation to ethnicity or race. The great contribution of the new feminist scholarship has been to insist that gender is social, not biological, and to separate it from what we take to be our instinctive knowledge of sex. The next step is to insist that gender is not merely social, but a social relation that interacts in every conceivable way with class relations.

For most people, it is difficult to separate the sense of one's person or of one's humanity from one's sexuality, broadly construed. Sexuality figures prominently in art and other forms of symbolization. Even when specific forms of culture do not make explicit sexual references, they frequently draw upon an underlying concept of sexuality to encourage identification with or acceptance of their non-sexual messages. Yet no human culture or society rests upon the direct experience or expression of sexuality in the sense of innate biological characteristics. Cultures and societies transform biology into gender. It could, in fact, be argued that the primary responsibility of any society or culture is to perform this transformation in such a way that infants naturally develop as integral members of the community into which they have been born. Cultures and societies must, therefore, simultaneously transform instincts into drives, sexuality into gender, and deny the act of transformation so that members of the community experience their gender as if it were their biology. In short, the social identities of individuals must appear to them as their natural identities. This process of mediation between biology and society may vary considerably from group to group and, especially, may rest upon exhibitionist or inhibitionist attitudes towards sexuality.

At least since Freud called attention to the sexual power struggle that underlay the bourgeois civilization of his day, it has become commonplace to describe bourgeois civilization as sexually repressive. Michel Foucault, in a wondrously provocative if wrong-headed essay, has recently challenged this received wisdom that "repression has indeed been the fundamental link between power, and knowledge, and sexuality since the classical age. . . ."[1] His critical point is stunningly obvious once stated, although it reverses most of what had previously been taken for granted: Bourgeois society did not repress sexual awareness; it brought sexuality to the center of social consciousness. In other words, Foucault claims that the very preoccupation with the repression of sexuality disguised the compulsive elaboration of a dense and variegated sexual discourse. By noisy and repeated denials, bourgeois society managed to spend a lot of time talking about sex. Foucault's insight

is keen: not approval or disapproval is at issue, but the amount of time and energy devoted to a subject. But Foucault presses further. The foregrounding of the sexual discourse, in his view, accompanied a radical reformulation of the concept of power, which moved from a model based on law to one based on strategy. And this reformulation gradually influenced relations of power themselves, "which for a long time had found expression in war . . . in the order of political power."[2]

The History of Sexuality, as a whole, constitutes a running argument with—the polite formulation for attack on—Freud. Foucault's thesis rests upon an explicit repudiation of the psychoanalytic view of sexuality as "a stubborn drive, by nature alien and of necessity disobedient. . . ." Sexuality, according to Foucault, "is not the most intractable element in power relations, but rather one of those endowed with greatest instrumentality. . . ."[3] He thus portrays sexuality as an unusually plastic or pliant mediator of power relations, especially in the modern period during which its older custodians, such as families and their systems of alliance, crumble before the growing power of the states. Foucault's apparently unorthodox view of sexuality as plastic, rather than intractable, provides an important contribution to historians who are more comfortable with social forms than biological structures. But here, as elsewhere in his work, he falls short of realizing that contribution because he restricts his attention primarily to the epistemology or discourse of sexuality. Although worthy, Foucault's project does not illuminate the complex relations between sexuality and power that permeate all relations between men and women. For, to link sexuality to the various ways in which established power is wielded, we must also look at the way in which gender wields power and how it acquired its dominance. In other words, it is all very well to look at the power of say, the state, and at the ways in which it manipulates sexuality. But it is not very helpful to leave out the different relations of males and females to power, or the different ways in which male and female sexuality are manipulated. In fact, it is rather like presenting a statistical view of marriage based on the mean of undifferentiated male and female experience. For example, on the average, men married at 28, women at 20, therefore the average age at marriage was 24. And the problems are compounded when power and sexuality are not considered with reference to class differences.

Foucault contributes in fresh and important ways to the rising criticism of the failures of contemporary capitalist society. He finds the power of the state the more alarming for its growing reliance on veiled manipulation and its growing evasion of forthright politics. Yet more significantly, perhaps, he takes sharp issue with the various schools, especially the Reichian, that look to personal, sexual liberation as the glorious future of the peoples. In short,

he correctly argues that sexual liberation has no necessary relation to politics, and may even facilitate new and sinister forms of domination. Foucault has long been engaged in developing a new language and method of social analysis that will avoid the rigidities of bourgeois social science and Marxism alike. He has chosen to address primarily epistemological problems. His reflections on power thus question our ability to recognize the true nature and sources of our oppression. He is not alone in regretting what he takes to be a more honest and, ultimately, less oppressive precapitalist world. His arguments about the forms of contemporary power and the misperceptions that inform contemporary resistance are acute. Nonetheless, even in his own framework, his unwillingness to consider seriously the class and gender relations that comprise both old and new forms of power compromises his analysis of power as a whole. The undermining of hierarchical and familial forms of power has surely benefitted many, especially women and working people. Even if they too now confront the dangers of rampant manipulative power, they have little to regret in the older, more honest forms of domination that cast them as natural subordinates.

Foucault primarily wishes to underscore an omnipresent attention to sexuality. He cogently argues that repression does not adequately capture the complex attitudes of bourgeois society toward sexuality. He highlights a series of important questions and forces us to look at familiar assumptions in a fresh perspective. But by not differentiating between genders and classes, he remains silent about the dynamics of power as distinct from its manifestation.

Foucault arbitrarily equates sexuality as stubborn biology to sexuality as the most intractable element in power relations. This equation permits him to dispose unilaterally of innate, or presocial sexuality. For, if he can demonstrate, or merely argue attractively, that sexuality is plastic rather than intractable in power relations he can then assert, with apparent logic, that sexuality is not stubborn biology. In short Freud was wrong. There is no such thing as presocial sexuality. But there is a large practical and theoretical gap between sexuality as innate biology and sexuality as resistance to oppression or power. Gender provides the link between these two very different concepts of sexuality. The sexuality that figures in resistance to or manipulation by power has long since been organized as gender. But the important social component that informs all gender cannot, *ipso facto*, prove that gender itself is not anchored in the body. To the contrary, it is more than likely that the very force of biology accounts for the deep roots of gender identity in individual consciousness and, hence, for the vulnerability of the individual, to the domination of the powerful. For the gender identity and expectations into which a male or female child is reared are themselves systemically

linked to the prevailing relations of power. And since gender is presumably so closely tied to the body and to the deepest human identity, violating the relations of power can easily be interpreted as violating the relations of a person.[4]

Sexuality is an individual and essentially biological experience, of which gender is the social organization and representation. Gender provides the epistemology, or language, through which members of society name and experience their sexuality. In this respect, as Gayle Rubin among others has insisted, gender is essentially a social construct. It builds upon the primary experience of sexuality, but cannot be equated with its simple unfolding. Gender, unlike sexuality, is not individual, however personally individuals may interpret it. Nor do social groups simply construct gender in the abstract: They inherit, elaborate, and adapt gender systems.[5]

The concept of gender, like that of its social construction, calls attention to the role of social groups in transforming sexuality into prevailing views of male and female. The concept of gender thus calls into question Foucault's implicit identification of sexuality with social males and females. But even the concept of gender, *per se,* does not adequately emphasize gender as a system of social relations nor the interdependence of genders in all societies and cultures. The gender system as a whole, rather than isolated gender roles or the degree of repression, contributes most directly to an understanding of the relations of power in a society. In this respect, Foucault's insistence on repression, in isolation from gender systems, reveals little about the dynamics of power. For societies can promote general or selective repression: the repression of male and female sexuality or both or neither. And the repression can be associated with the denial or the display of power. In short, the presence or absence of repression may indicate something about the quality of a culture, but it does not necessarily indicate anything about the social and gender relations that the culture articulates.

In classless societies, as anthropologists have insisted, gender or kinship systems provide the fundamental social classification. This basic classification by gender simultaneously provides the rules that govern reproduction and organize the essential cognition and experience of otherness. It thus pervades notions of power and clemency, explanations of natural phenomena, and articulations of hierarchy. Although such systems take sexual difference as the essential raw material of all social representation and classification, they should not be interpreted as necessary extensions of individual biology. They do not, in other words, simply transform female reproductive powers into a female gender role. Rather, they take two genders, the notion of polarity, as the decisive data and attribute characteristics to the genders as a function of the differentiation of the social universe. Power thus functions as a cause of the representation of the gender system, not merely as a consequence

of innate biological difference. It is the existence of difference within a community group that is to be explained, not biological or sexual difference that can be assumed to determine the shape of the gender system.[6]

Gender systems thus codify the sexual division that constitutes the primary social organization. In their purest form, in classless societies, such gender systems frequently constitute the public expression of relations of production and of subordination and superordination, which they subsume unto themselves. In this respect gender constitutes a privileged but by no means an exhaustive discourse. Gender merely affords the most visible and convincing language of classification. Since the assumption of a gender identity is, moreover, so directly linked to the individual's earliest social experience of social participation, the attachment to gender identity and the willingness to interpret other social relations through the prism of gender remains strong.

Gender overdetermines the investment of any individual in what he/she takes to be social order precisely because of the tendency to identify personal identity with the social system into which one was inducted. Gender thus links residual biology to ideology in the most encompassing sense. But the core of this personal identity remains charged with a representation of gender as a system. To assume a female gender identity means to repudiate or renounce a male gender identity. To participate in a gender system—to participate in a society and a culture—as a female means to accept the related but differential participation of males in the same system. The sexual division of labor thus does more than encode the systemic differentiation between genders: it actively contributes to the prevailing relations of power.

Understood in this fashion, the sexual division of labor transcends what one might call the division of labor by sex, namely the specific allocation of tasks by gender in specific social formations. However awkward my terms, the distinction remains important to the relations between gender systems and power relations in complex societies. For, with the emergence of classes and states—if not before—a legally structured and militarily enforced hierarchy allows unequal access to resources and prestige as well as class—and state-based command over the labor of others. In all instances such transformations include shifts in the relations of power and dominance between the genders. But the shifts are far from uniform. Normally class-specific, the shifts in the division of labor by sex can range from the relative "liberation" to the quasi-total seclusion of upper-class women and can result in a wide variety of gender-specific allocation of tasks among lower-class women. The performance of various kinds of (productive) labor may correspond more or less closely and positively or negatively to the exercise of power or the ascription of status within the society and within the specific social class. On

a spectrum of social labor from child-bearing and infant care on the one end to warfare on the other, the former group of tasks normally accrues to women and the latter to men. And the rule obtains most strictly in societies in which all men and women participate directly in the labor ascribed to their gender group at the appropriate stage in their respective life cycles.[7] (Purchase or command of substitutes for direct participation in social labor, which is common in class societies, introduces significant complications, although with respect to infant care and warfare substitutes are likely to be drawn from the same gender group.) The variations in the division of labor by sex can only coexist in a cohesive society or polity if the normative representations of the sexual division of labor of the constituent social groups or classes are not violated. In other words, the prevailing sexual division of labor—the explicit articulation of the dominant gender system—must not merely be compatible with group-specific practices, but indeed must mediate and facilitate the relations of power that permit ruling classes, or states, to command the labor of others.

From Sumer to ancient China and India, from the classical world to the feudal monarchies, the consolidation of classes and states has normally favored and strengthened male dominance over women, has normally confirmed women's exclusion from warfare and unequal access to the control of basic resources. Dominant religions and, as they appeared, political ideologies, set forth universal principles of the gender system for the various groups within their sway. But within states or other general forms of organization, the patterns of male dominance could vary significantly between classes and groups. The principles of the dominant gender system could encompass considerable variation in the ways component groups allocated tasks by sex and leave considerable ambiguity in the relations between men of one social class and women of another, or between women of different classes. In Europe and elsewhere, formal political organization long remained heavily dependent upon family and lineage, or what Foucault calls alliance-based systems. The men of different social groups frequently exchanged women among families as a way of solidifying their mutual interdependence. In addition, men of the upper classes could proclaim their right—at least symbolically—to the women of lower classes as a means of underscoring their political and economic power over subordinate men. And women of the upper classes could, at least in principle, command the labor, or the fruits of the labor of lower-class men. But normally, both the exercise of and the subjection to power were ascribed not to individuals, but to the appropriate delegates of families. Thus the purported ritual access of lords to serf or peasant women was taken to occur on the woman's wedding night and was, accordingly, a reminder to her husband in a way that the subsequent

practice of trifling with servant girls was not. The oppression and degra-
dation of women is common to both cases, but its place in prevailing class
relations differs considerably. In both instances, it binds dominance and
subordination into a common ideology through respect for shared as-
sumptions about gender relations. There is no question of the right of the
upper-class woman to assume a sexually aggressive role with respect to
lower-class men.

However much examples could be multiplied and debated, the gender
and class systems intersected. And the patriarchalism that characterized
both similarly pervaded the dominant political relations of the state. Thus,
for example, property was more a title to a bundle of sovereign rights than
it was absolute possession in the modern sense. Rights in the land, however
partial, entailed rights to the labor to cultivate it. Labor, or work, under
these conditions, was an object of command, rather than a confirmation of
individualism. And the gender-specific ascription of tasks was not common
to the society as a whole. Under these conditions, the prevailing representa-
tion of the sexual division was not specifically anchored to the division of
labor by sex.

The force of patriarchalism derived from its successful conflation of gen-
der identity, family position, and the right to rule. It enunciated the legiti-
macy of gender and generational hierarchy. It would appear to have been a
particularly successful model when rule included the unmediated command
of labor, as in slave societies or in situations of indentured service, pro-
longed apprenticeship, or other instances of adult males' extended residence
in the households or under the control of other adult males designated as
superior. By drawing on the status of father as the title to sovereignty, it
meshed gender and political dominance and reinforced the legitimacy of
political dominance as natural or organic. But the patriarchal model of sov-
ereignty did not perfectly reflect the complexities of class relations. The
dominant metaphor of fatherhood, as legitimation of [the] sovereignty it
propounded, constituted a form of symbolic action—a figurative binding
of the polity to the immediate experience of individuals through analogy.
As the father dominated the members of the family or household, so the
monarch dominated his subjects. As the authority of fathers was legitimate,
so was that of sovereigns. The force of the analogy depended upon the con-
gruence between patterns of gender identity formation and the dominant
representation of patriarchy. If public patriarchy closely mirrored the intimate
experience of individuals of various social groups it would appear a natural
emanation of their own culture and experience. But a public representation
of patriarchy could also privilege features of the practices of different groups
and, in turn, influence the ways in which those practices developed.[8]

Throughout the early modern period the inescapability of dependence reinforced the plausibility of the metaphor as a general representation of authority. Those who escaped dependence on their own families of origin normally were forced into dependence on others through one or another form of patronage or clientage. This model of patriarchalism, however, co-existed with class relations that promoted more complex models of inter-dependence between genders and families. With respect to class, patriarchal sovereignty commonly coexisted with explicitly hierarchical and legally structured class relations. Law, as a forthright social classification, identified individuals as members of defined social classes. Within such legally articulated social hierarchies, families retained tremendous importance. In principle, one belonged to a social class by birth as a member of one's family. Membership in the first estate resulted from vocation, but did not include biological reproduction. For other estates and for the sub-classifications organized largely around membership in the complex urban communities, laws were intended to control appropriate modes of dress, permissible occupations and other attributes of class status. For all these groups, family alliances provided an important element of class cohesiveness, especially among the ruling classes which in Europe tended to favor the maximum endogamy tolerated by church and state.

Under these conditions generalized representations of gender roles were seriously constrained. If both Church and patriarchalism favored a concept of male dominance based on masculine superiority, their models of gender relations concerned gender identity in the broadest sense rather than specific attributes of gender role. Thus the common representations of womanhood, as captured in the Virgin Mary, for example, emphasized woman as female of the species—sexuality, reproduction, incomplete man—rather than as social actor. To the extent that women enjoyed public opportunities and status, they did so as delegates of families, hence as members of specific class functions rather than as individuals. In large measure, the same can be said of men. But men were also represented as generic social types: the monarch, the priest, the laborer, the craftsman, or the soldier. Women in fact participated in almost all the functions and occupations conventionally identified as male. Hence, a heated debate has been raging over the purported losses or gains in status by women with the advent of capitalism and industrialization, but the debate has so far missed the intersection of class and gender relations.[9]

Gender systems, however disparate their specific content, constitute the most accessible common denominator of the social and cultural relations of various groups. The function of classes and states, as they developed, was to establish the power of some groups over the political destinies and labor, or

its fruits, of others. The patriarchalism that figured so prominently in the formation of Western European states emphasized gender, and seniority within gender, as the legitimation of rule. It encouraged the perception of the state as the mirror of the family and the reverse. In so doing, it attempted to codify a variety of patterns of male dominance in a single authentic ("natural") model. And in the process, it influenced the subsequent development of those patterns of male dominance through forms of inheritance, the necessity of providing labor or paying taxes and other institutions that pressed, at least indirectly, upon subordinate groups. The development of class and state institutions was also hostage to, or influenced by, the variety of prevailing gender systems. By espousing the familial model of authority, patriarchal institutions left much of those gender systems intact, including cultural traditions of male and female space, egalitarian inheritance patterns for male and female children among the peasantry and popular traditions of female strength and malevolence.[10] The patriarchal model invited a minimum degree of identification on the part of all fathers, whatever their class position, but it also permitted an organic differentiation between rulers and ruled: The adult male could, simultaneously, be father at home and "child"— that is, dependent—in the polity. The existence of the family legitimated the privileged position of its head: He was its delegate, its political representative. But, in important respects, even his special prerogatives depended on it and were ultimately subordinate to its interests. He was explicitly the steward, the one who had access to a special role. He did not owe his status to his merits as an individual. The rights he exercised were not individual rights, but special cases of collective rights.

Debates rage over the extent to which this patriarchalism and the feudalism into which it sank its roots penetrated the experience of peasant and servile populations. Alan Macfarlane claims to find individualism at the dawn of English history. But the emergence of class and state formations encouraged hierarchy and relied upon a representation of the father in the family to provide its popular roots. This political strategy contributed as much to the formation of the concept of the family and the generalization of attendant gender identities as it drew from some semipaternal "natural" family. The gender systems proved mutable and important in the formation and transformation of class and state relations.[11]

The primacy of the adult male father in the articulation of political relations and their attendant ideologies did not preclude the existence of other delegates of the family. The very notion of delegation, or representation, the sense of representing the interests of, opened the possibility that a variety of individuals might on given occasions occupy a particular social role. In the English tradition, for example, a woman could succeed to the highest

political office in the kingdom, although in France she could not.[12] At lower social levels, it is likely that the concept of delegation merged with common law traditions of partible inheritance to facilitate the succession of women to their husbands' crafts and shops, even to their guild memberships. In addition, the quasi-absence of the idea of work from dominant representations simultaneously reflected the aristocracy's distancing of itself from any work and the extremely variegated patterns of the division of labor by sex among other groups. In principle, work did not afford a source of positive identity or entitlement to privilege for any group of either gender. Participation in sovereignty, the right to command, did, and it was actively identified as male. But the family still took precedence over the male as individual so, failing male delegates, women could and did step into a variety of roles as the delegates of the group. A litmus test here is the frequency with which males from outside the family were adopted in preference to recognizing female heirs. Any thorough analysis would have to take account of the complexities of preferred succession as between nephews and daughters.

The complexities and regional variations themselves testify to the importance of gender systems in shaping concepts of delegation and the predominant definitions of the family. The foundations of patriarchy in legally codified hierarchy and in a strong commitment to the primacy of the family or household could, in regions subject to random waves of high mortality, be more closely identified with the house *per se* than with biological relations.[13] The identification permitted the subordination of qualifications derived from gender to those of group membership. Attitudes towards perpetuating conventional gender systems within groups have remained, but group survival, including the survival of a hierarchical social structure and the hard-won position of specific families, would, at least at the margin, permit women to serve as delegates. This attitude and these strategies largely account for the positions of status occupied by women in precapitalist and pre-industrial societies. As a rule, the evidence of female activity should not be interpreted as evidence of higher status or greater power for women as women or as individuals. Women experienced no golden age before the great bourgeois revolutions or the advent of capitalism or industrialization; neither did women experience improvement in their status with the glorious advent of "modernization."

In precapitalist systems women, in addition to having occasional access to a variety of social roles as delegates, enjoyed a range of powers and status that accrued to them by virtue of their monopoly of, or association with, specific tasks or bodies of knowledge. But the emergence of states had tended to confirm women's unequal access to the control of basic resources and to appropriate or attack many of their customary powers. Whatever the

variety of custom, the law of the state and the lords favored male heirs. And law and custom concurred in favoring the legal and economic subordination of women to their husbands. A generous share of the paternal inheritance, frequently advanced as a dowery, might permit a girl to marry as well as possible, but it was not intended to set her up on her own with possibly a consort to assist her.

The emergence of capitalism as the dominant mode of production in European and North American society included fundamental if complex and gradual transformations in the relationships among class formations, gender systems, and power. One way to understand individualism, which can be taken as the dominant ideology of capitalism, took shape around the twin poles of the wage and property, linked by the notion of work. Work carries special connotations in capitalist societies. Capitalist cultures have granted the concept of work unusual prestige as a good, practically a moral value in its own right, and as an external manifestation of individual worth. This privileging of work as a positive attribute of the individual roughly accompanied—to borrow loosely from the late Karl Polanyi—the disembedding of the market from social process and the individual from the collectivity. In the process it associated work with the essence of what it is to be an individual and subordinated all the specific activities in which different laborers had engaged to the generic concept. This new generalized notion of work was itself deeply bound to the legitimation of work as property in oneself and, by extension, property in general. Thus the wage and the property could be equated as simply different manifestations of the common attribute of individualism—work.[14]

The emergence of bourgeois individualism as a dominant ideology, like the transformation of the concept of work that was so central to it, coincided with substantive changes in the nature of class relations and the ideological foundations of political authority. In brief, the individual was taken to be the indivisible unit of sovereignty and all legitimate government was taken to emanate from him. The extra-individual, hierarchical organization of classes was swept away first by the great bourgeois revolutions and subsequently by reforms. Class differences were acknowledged in practice, but increasingly denied in principle—especially in the United States—which lacked a genuine aristocratic tradition. Differences in wealth and status were presented more as accidental than as innate and attributed to the failure of individuals to better themselves through work. Obviously this simplistic model distorts the complexities of historical process, but it is faithful enough at the level of generality at which the ideology was promulgated. Capitalist ideology simultaneously raised the sexual division of labor to a governing principle of social order.

The cultural and social trends that encouraged the emergence of work as the foundation for male identity and integrity found echoes in the dawning self-consciousness about women's appropriate gender role. As for men, these early attempts to construct a positive representation of work occurred mainly among the urban middle class and reforming segments of the aristocracy. They were closely tied to changing ideas about family and the household with a new ideology of propertied individualism. They were especially associated with religious and moral questions and with education. The various strands coalesced slowly, but by the end of the eighteenth century they had produced the contours of an ideology of women's proper work that corresponds closely to Linda Kerber's picture of Republican motherhood. The general model integrated the idea of work as a socially necessary contribution and an extension of the individual in a general representation of modest and dutiful womanhood. The referents of such work include solicitous motherhood, orderly domestic economy, tasks for idle hands to keep the devil at bay and education. Some writers even allow for the economic benefit or possible necessity of such work. But by and large, all concur in presenting women's work as the proper organization of the female personality in the service of husband and children.[15]

In fact, during the earliest phases of industrial capitalism women were already working in factories. The early experiments with female factory labor, especially those in France and in the United States, revealed considerable flexibility in such work and the lack of a strong ideological position or an accepted practice with respect to factory employment. Although wage-labor, this early female factory work was not taken to legitimate or provide the economic foundations for female social independence. The experiment with female wage-labor did not alter the dominant representation of the sexual division of labor nor validate a division of labor by sex that would include independent female wage-earners with economic autonomy and an independent identity.[16]

The participation of female labor in early industrialization was most common in societies in which agricultural producers, not yet fully dispossessed, retained some claim on their holdings and therefore still perceived the plot of land as the foundation of the family's resources. Unmarried daughters constituted the most disposable labor force. But with the spread of industrialization and the increasing inability of men to retain a bit of land, the wage gradually came to substitute for the agricultural holding as the basis of the family's resources. Survival for many working class families still required more than the wage of the father alone, but the participation of women and children in wage labor was not officially legitimated. And even where children and young female adults were sent to work, there seems to

have been a decided preference to avoid participation of married women in the labor force. Only protracted class struggle and the gradual organization of the working class would produce a genuine family wage adequate to the maintenance not merely of the male worker but of his dependent children and his wife as well, but the ideal preceded the realization.[17]

During the period of early capitalism indentured servitude in various forms gave way to what has been called the "feminization" of domestic service. The combined impact of economic, ideological and political change in Western Europe and the United States discouraged overt servitude for able-bodied men, just as it increasingly discouraged partial rights in the labor of another. Labor, like the land, came increasingly under the aegis of outright ownership, which at least in the early stages meant that slavery could be accepted along with the sale of labor-power, but that partial forms of dependence or control of the life of another free man became ever less acceptable. Similarly, the collapse of the household into the home and the gradual withdrawal of political function and "productive" work from its interstices encouraged the emergence of women as full-time domestic economists and helped to establish the special appropriateness of female servants as their auxiliaries. However complex and protracted, these trends yielded a sexual division of labor that would, by the middle of the nineteenth century, be so firmly ensconced as to look "natural" in the principal capitalist nations.[18]

The new ideology of work, like the new generalized sexual division of labor, reinforced for women precisely that dependency and those notions of personal service they were attempting to repudiate for men. This process, which had firm roots in economic, political and legal institutions, could not be adequately explained by the simple notion that men followed productive work from the home while women remained behind to pick up the pieces. It included a transformation of women's lives as well as those of men. For men, the generalized representation of work was intended to obscure the sharp class lines that characterized the social division of labor and to promote a common identity as a man. For women, the generalized representation of motherhood and housewifery was intended to fulfill a similar function. Capitalism fostered a universalization of the division of labor by sex in such a way as to make it seem a direct extension of innate sexual difference under conditions in which the sexual division of labor was carrying an increasing responsibility for social and moral order in general.

Perhaps this is what Foucault is calling attention to in his insistence on the ubiquity of a sexual discourse in modern society. But Europeans and Americans were obsessed with sexuality in the context of their search for viable class relations and a viable gender system. Smith-Rosenberg has cogently argued that the various reform movements of the Jacksonian period should

be interpreted as a manifestation of anxiety with respect to social purity, and indeed social order, threatened by the increased numbers of what Hobbes would have called "masterless" men. She also argues that the forms of behavior celebrated in the Davy Crockett Manuals represented an alternate path of induction into male individualism, appropriate for other circumstances in the same period. It would be possible to place greater emphasis on the class and regional variations in the elaboration of these attitudes and others, but her main point is telling. The anxiety about sexuality betrayed concern with binding individuals to a changing social and symbolic order.[19]

Capitalist class relations and the modern state long cooperated in promoting a universal gender system, based on the identification of gender identity and gender role, or sexual differentiation in general and the gender-specific allocation of tasks in particular. The pervasive sexual discourse to which Foucault has called attention measured the importance attached to the gender system as the custodian of repudiated notions of hierarchy and dependency, and measured the perceived necessity for individuals to internalize universal gender identities that would anchor social order.

Gender, as the primary articulation of differentiation, acquired special importance in capitalist societies. For the general tendency of capitalism was to promote standardization in the production process, rationalism in epistemology and cosmology, and the functional interchangeability of individuals in politics. In other words, those social and ideological relations most explicitly grounded in the dignity and integrity of the individual carried within themselves the potential disavowal of individual difference. The strengthening and generalizing of the forms of male dominance facilitated the long induction of peasant populations and different ethnic groups into the mainstream of industrial capitalism and bourgeois ideology. Labor market segmentation, reinforced by the ideology of domesticity, encouraged the withdrawal of married women from the labor force. Working-class men themselves organized on the basis of excluding women from the most remunerative employment. The interests of bosses and workers converged, whether by agreement or as a result of struggle, to promote the dominance of men over the women of their own group. This solution removed the possible struggle over the same women as yet another cause of discord between men of different classes. The control of women helped to obscure the gulf between classes. The standardization of the gender system mightily strengthened the myth of individual mobility. Class power was not defined to include any rights to the labor or sexuality of the men of lower classes, although relations between the races in the United States present a very painful special case. Even the real power, often brutally exercised, of men over their wives was culturally denied. Marriage was based on love and undertaken by the

choice of participants. But gradually capitalism reinforced the economic power of the husband over the wife. The conquest of the male "family wage" finally consolidated the possibility for male survival independent of the family and consigned women to ever greater dependence on the economic power of a man.

The dominant forms of power under capitalism were veiled. Bourgeois individualism originally included an explicit repudiation of upper and lower class violence. Celebrations of male power as the sign of masculinity persisted, especially among military groups and in parts of the United States, but the prevailing current ran towards the denial of power as physical force. Cultural norms and social etiquette favored civility as the governing principle of gender relations. Power became ever more economic, bureaucratic and intellectual. The state, class relations and individual men continued to exercise determining power over the lives of women. But violent manifestations of that power, such as blows, physical abuse and rape, were frowned on in theory, however widespread their practice. If power can be understood as running a gamut from violence to legitimate authority, those who wielded it increasingly preferred authority, depicted as the emanation of individual worth. Science and anthropology contributed much to transforming older, frequently religious, invariably hierarchical views of men and women and the proper relations between the them. But however much they altered the terms in which gender relations were described, they reinforced the commitment to the authority of men over women. Women's unequal access to political life and economic participation provided firm foundations for the ideology of gender difference. The dominant representations of gender relations stressed the naturalness and legitimacy of male authority and minimized the role of coercion. Yet coercion, and frequently its violent manifestation, regularly encouraged women to accept their subordinate status.

Not all women were beaten and raped, although many more may have been than the complacent self-image of bourgeois society would suggest. But even the most self-serving celebrations of the progress of chivalry and civility allowed that the inviolability of women depended upon male protection and female compliance with the prescribed female roles. Violence descended upon women who "asked for it," upon women who lacked male protection, upon women who transgressed on male turf. Male violence against women was accepted as unfortunate perhaps, but nonetheless understandable. And male violence against women who deviated from the accepted path served as a constant, if frequently unspoken, reminder of the risks of deviation. This undercurrent of violence that informed purportedly legitimate male dominance says much about the elements of that legitimacy, even as it helps to explain women's apparent acceptance of male authority.

The obsessive concealment of sexuality like the obsessive discourse about its exhibition are surely related. But they cannot be understood in terms of sexuality alone. Both testify to the centrality of the gender system in the elaboration of the social, economic, and political relations of capitalist society. All societies elaborate gender systems that link intimate experience to collective life, but as a general rule precapitalist class societies spawned a multiplicity of discourses on class and power even as they tolerated the persistence of local variations. Capitalism, with its inherent impulse to generalize and standardize social and economic relations and institutions, placed a disproportionate weight upon the gender system both as custodian of hierarchical and religious values and as agent for forging a viable social and political order.

Notes

1. Michel Foucault, *A History of Sexuality* (New York, 1980), 5. For a feminist critique of Foucault which appeared after this article had been submitted, see Monique Plaza, "Our Damages and Their Compensation—Rape: The 'Will Not to Know' of Michel Foucault," *Feminist Issues,* I, no. 3 (Summer 1981): 25–36.

2. Ibid., 102.

3. Ibid., 103.

4. Ibid., *passim.* See also his, *Les Mots et Les Choses. Une Archeologie des Sciences Humaines* (Paris, 1966).

5. Gayle Rubin, "The Traffic in Women: Notes on the Political Economy of Sex," in Rayna Reiter, ed., *Towards an Anthropology of Women* (New York, 1976).

6. Michelle Rosaldo, "The Use and Abuse of Anthropology: Reflections on Feminism and Cross-cultural Understanding," *Signs* 5, no. 3 (Spring 1980): 389–417, esp. 394. See also, Robin Fox, *Kinship and Marriage* (Baltimore, 1967); Rodney Needham, ed., *Rethinking Kinship and Marriage* (London, 1971); Meyer Fortes, *Kinship and the Social Order* (London, 1969); Jack Goody, *Production and Reproduction* (Cambridge, 1976); Claude Meillassoux, *Maidens, Meal and Money. Capitalism and the Domestic Community* (Cambridge, 1981); Karen Sacks, *Sisters and Wives: The Past and Future of Sexual Equality* (Westport, Conn., 1979).

7. I am using sexual division of labor to designate the prescriptions of the gender system, the normative representations of male and female roles and responsibilities, whereas I am using division of labor by sex to designate the specific allocation of tasks in particular communities: the two need not be isomorphic. Cf. Judith K. Brown, "An Anthropological Perspective on Sex Roles and Subsistence," in Michael S. Teitelbaum, ed., *Sex Differences. Social and Biological Perspectives* (Garden City, N. Y., 1976), 122–37, and her, "A Note on the Division of Labor by Sex," *American Anthropologist* 72 (1970): 1073–78, and "The Subsistence Activities of Women and the Socialization of Children," *Ethos* 1 (1973): 413–23; George Peter Murdock, "Comparative Data on the Division of Labor by Sex," *Social Forces* 15 (1937): 551–53; George P. Murdock and Caterina Provost, "Factors in the Division of Labor by Sex: A Cross-Cultural Analysis," *Ethnology* 12 (1973): 203–25. See also Martin King Whyte, *The Status of Women in Preindustrial Societies* (Princeton, 1978); Peggy Reeves Sanday, *Female Power and Male Dominance: On the Origins of Sexual Inequality* (Cambridge, 1981); Ernestine Friedl, "The Position

of Women: Appearance and Reality," *Anthropological Quarterly* 40 (1967): 97–108; Susan Carol Rogers, "Women's Place: A Critical Review of Anthropological Theory," *Comparative Studies in Society and History* 20, no. 1 (1978): 123–62.

8. Elizabeth Fox-Genovese, "Property and Patriarchy in Classical Bourgeois Political Theory," *Radical History Review* 4, Nos. 2–3 (Spring–Summer 1977): 36–59; Gordon Schochet, *Patriarchalism in Political Thought: The Authoritarian Family and Political Speculation and Attitudes Especially in Seventeenth-Century England* (New York, 1975); Peter Laslett, ed., *Patriarchia and Other Political Works of Sir Robert Filmer* (Oxford, 1949).

9. See, for example, Joan Hoff Wilson, "The Illusion of Change: Women and the American Revolution," in Alfred F. Young, ed., *The American Revolution: Explorations in the History of American Radicalism* (De Kalb, Il., 1976), and the critique by Mary Beth Norton, "American History," *Signs* 5, no. 2 (Winter 1979): 324–37, and her, "'What an Alarming Crisis Is This': Southern Women and the American Revolution," in Jeffrey J. Crow and Larry Tise, eds., *The Southern Experience in the American Revolution* (Chapel Hill, 1978), 203–34. See also, Marylynn Salmon, "Equality or Submersion? Feme Covert Status in Early Pennsylvania," in Carol Berkin and Mary Beth Norton, eds., *Women of America. A History* (Boston, 1979), 92–113; and her, "'Life, Liberty, and Dower': The Legal Status of Women after the American Revolution," in Carol Berkin and Clara Lovett, eds., *Women, War & Revolution* (New York, 1980), 85–106; Richard T. Vann, "Toward a New Lifestyle: Women in Pre-industrial Capitalism," in Renate Bridenthal and Claudia Koonz, eds., *Becoming Visible: Women in European History* (Boston, 1977), 192–216; Alice Clark, *Working Life of Women in the Seventeenth Century* (London, 1919; repr. 1968); Margaret George, "From 'Goodwife' to 'Mistress': The Transformation of the Female in Bourgeois Culture," *Science and Society* 37 (Summer 1973): 152–77; E. Lousse, *La Société d'ancien régime: organisation et représentation corporatives* I (Louvain, 1952); Gustave Fagniez, *La Femme et la société française dans la premierè moitié du XVIIe siècle* (Paris, 1929); Mervyn James, *Family, Lineage & Civil Society: A Study in the Society, Politics, and Mentality of the Durham Region* (Oxford, 1974); Jean-Louis Flandrin, *Families in Former Times: Kinship, Household and Society,* trans. Richard Southern (Cambridge, 1976); Nicole Castan, "La criminalité familiale dans le ressort du Parlement de Toulouse (1690–1730)," in A. Abbiateci, ed., *Crimes et criminalité en France 17e–18e siècles* (Paris, 1971); Marina Warner, *Alone of All Her Sex: The Myth and Cult of the Virgin Mary* (London, 1976); Geoffrey Ashe, *The Virgin* (London, 1976).

10. Ronald Trumbach, *The Rise of the Egalitarian Family: Aristocratic Kinship and Domestic Relations in Eighteenth-Century England* (New York, 1978); James Traer, *Marriage and the Family in Eighteenth-Century France* (Ithaca, N. Y., 1980), and his, "From Reform to Revolution: The Critical Century in the Development of the French Legal System," *Journal of Modern History* 49, no. 1 (1977): 73–88; Ralph Giesey, "Rules of Inheritance & Strategies of Mobility in Prerevolutionary France," *American Historical Review* 82, no. 2 (1977): 271–89; Janelle Greenburg, "The Legal Status of Women in Early Eighteenth-Century Common Law and Equity," *Studies in Eighteenth-Century Culture* 4 (1975): 171–82; Lawrence Stone, *The Family, Sex and Marriage in England 1500–1800* (New York, 1977); Emmanuel Le Roy Ladurie, "A System of Customary Law: Family Structures and Inheritance Customs in Sixteenth-Century France," in R. Forster & O. Ranum, eds., *Family and Society* (Baltimore, 1976); Jacques Lafon, *Les Époux Bordelais, 1450–1550* (Paris, 1972); Jack Goody, Joan Thirsk, & E. P. Thompson, eds., *Family*

and Inheritance. Rural Society in Western Europe, 1200–1800 (Cambridge, 1976); Andre Burguière, "De Malthus à Max Weber; le mariage tardif et l'esprit d'entreprise," *Annales E. S. C. 27,* nos. 4–5 (July–October): 1128–38.

11. Alan Macfarlane, *The Origins of English Individualism: The Family, Property and Social Transition* (Oxford, 1978); Eleanor Searle, "Merchet in Medieval England," *Past and Present* 82 (1979): 3–43; Yves Castan, *Honnêteté et relations sociales en languedoc, 1715–1780* (Paris, 1974), esp. 162–251; Roland Mousnier, trans. Brian Pierce, *The Institutions of France Under the Absolute Monarchy: Society and the State* (Chicago, 1979), esp. 48–95.

12. The so-called Salic Law was invented by Medieval French jurists to prevent transmission of the throne through the female line. See Edouard Perroy, trans. W. B. Wells, *The Hundred Years War,* (London, 1959).

13. Nancy Fitch, "The Effects of the Development of Rural Capitalism on the Form of Male Dominance in the Bourbonnais Region of France: Some Analytical Considerations," Paper delivered at the annual meeting of the American Historical Association (Washington, D.C., 1980), and her dissertation in progress, "Paternalism and Power: The Effects of Capitalist Development on the Formulation and Implementation of Class Authority in the Bourbonnais Region of France." See also, Nancy Fitch, "The Demographic and Economic Effects of Seventeenth Century Wars: The Case of the Bourbonnais, France," *Review* 2, no. 2 (Fall 1978): 181–206.

14. Karl Polanyi, *The Great Transformation* (New York, 1944); Ronald Meek, *Studies in the Labor Theory of Value* (London, 1973); J. E. Crowley, *This Sheba, Self: The Conceptualization of Economic Life in Eighteenth-Century America* (Baltimore, 1974); C. B. MacPherson, *The Political Theory of Possessive Individualism from Hobbes to Locke* (Oxford, 1962); E. J. Hundert, "The Making of Homo Faber: John Locke between Ideology and History," *Journal of the History of Ideas* 33 (1973)[: 3–22]; Louis Dumont, *From Mandeville to Marx: The Genesis and Triumph of Economic Ideology* (Chicago, 1977); Daniel T. Rogers, *The Work Ethic in Industrial America 1885–1920* (Chicago, 1974); Edna Lemay, "La Notion du travail à travers la litérature de voyages au XVIIIe siècle," in Roland Mortier & Hervé Hasquin, eds., *Études sur le XVIIIe siècle 3* (Bruxelles, 1976). Cf. John Dunn, *The Political Thought of John Locke* (Cambridge, 1971).

15. Linda K. Kerber, *Women of the Republic: Intellect and Ideology in Revolutionary America* (Chapel Hill, 1980). For early manifestations of this attitude in France, see Carolyn Lougee, *Le Paradis des femmes: Women, Salons, and Social Stratification in Seventeenth-Century France* (Princeton, 1976), esp. 173–208. See also "Ideological Bases of Domestic Economy," in Elizabeth Fox-Genovese and Eugene D. Genovese, *Fruits of Merchant Capital* (New York: Oxford University Press, 1983). The chapter on women in Rogers, *Work Ethic,* does not deal with these questions systematically. See also Barbara Corrado Pope, "Revolution and Retreat: Upper-Class French Women After 1789," in Berkin & Lovett, eds., *Women, War & Revolution*; Mary Wollstonecraft Godwin, *Thoughts on the Education of Daughters* (Clifton, N. J., 1972; 1787); M. G. Jones, *Hannah More* (Cambridge, 1962); Hannah More, *Coelebs in Search of a Wife* (London, 1809); Catherine Hall, "The Early Formation of Victorian Domestic Ideology," in S. Burman, ed., *Fit Work for Women* (New York, 1979); Miriam J. Benkowitz, "Some Observations on Women's Concept of Self in the Eighteenth Century," in Paul Fritz & Richard Morton, eds., *Woman in the 18th Century and Other Essays* (Toronto & Sarasota, 1976); Marilyn Butler, *Jane Austen and the War of Ideas* (Oxford, 1975). For novels that especially

embody these notions, see Jane Austen, *Mansfield Park*; Samuel Richardson, *Sir Charles Grandison*; Maria Edgeworth, *Belinda*; Mme. Gacon Dufour, *De la Nécessité de l'instruction pour les femmes*.

16. Bettina Eileen Berch, *Industrialization and Working Women in the Nineteenth Century: England, France and the United States* (Ann Arbor: University Microfilms, 1976); Yvonne Forado-Cubeno, "Les Ateliers de charité de Paris pendant la révolution française 1789–1791," *La Révolution Française* 86 (1933): 317–42, & 87 (1934): 29–123; Shelby T. McLoy, "Charity Workshops for Women, Paris, 1790–95," *The Social Service Review* 11 (1937): 274–84; Gary B. Nash, "The Failure of Female Factory Labor in Colonial Boston," *Labor History* [20 (Spring 1979): 165–88].

17. Thomas Dublin, *Women at Work* (New York, 1980); James R. Lehning, *The Peasants of Marlhes: Economic Development and Family Organization in Nineteenth Century France* (Chapel Hill, 1980). Cf. Mark Selden, "The Proletariat, Revolutionary Change and the State in China and Japan, 1850–1950," *Fernand Braudel Center Working Papers*, Seminar I (February 1981). See also Louise Tilly and Joan Scott, *Women, Work and Family* (New York, 1977); Léon Abensour, *La Femme et le féminisme avant la Révolution*, repr. (Geneva, 1977), 204–209.

18. Cissie Fairchilds, "Masters and Servants in Eighteenth-Century Toulouse," *Journal of Social History* 12, no. 3 (Spring 1979): 368–93; Richard Cobb, "A View on the Street: Seduction and Pregnancy in Revolutionary Lyon," in his *A Sense of Place* (London, 1975); R. W. Malcolmson, "Infanticide in Eighteenth-Century England," in J. S. Cockburn, ed., *Crime in England* (London, 1976); Theresa McBride, *The Domestic Revolution: The Modernization of Household Service in England and France, 1820–1920* (London, 1976), and her, "The Long Road Home: Women's Work and Industrialization," in Bridenthal & Koonz, eds., *Becoming Visible*; J. Jean Hecht, *The Domestic Servant in Eighteenth-Century England* (London, 1956; repr. 1980); Abel Chatelain, "Migrations et domesticité féminine urbaine en France, XVIIIe siècle," *Revue d'histoire économique et sociale* 17, no. 4 (1969): 506–28; Pierre Guiral & Guy Thullier, *La Vie quotidienne des domestiques en France au XIXe siècle* (Paris, 1978); David Katzman, *Seven Days a Week: Domestic Service in Industrializing America* (New York, 1978).

19. Carroll Smith-Rosenberg, "Sex as Symbol in Victorian Purity: An Ethnological Analysis of Jacksonian America," in John Demos and Sarane Spence Boocock, eds., *Turning Points: Historical and Sociological Essays on the Family* (Chicago, 1978), S212–S247.

Three

The Rise of Bourgeois Individualism and Autobiography

Selections from the Introduction to The Autobiography of Du Pont de Nemours

I. The Rise of Bourgeois Individualism

An emergent individualism—the sense of the self—did not appear as something new in the eighteenth century. Classical, Christian, and Renaissance individualism, to name but the most obvious forms, had all testified to awareness of the excellence or responsibilities of the self. There is something rash, even condescending, in assuming that peoples in all times and places have not taken account of the perceptions and stimuli experienced in the individual body and mind. The recent and widespread tendency among scholars to point to the modern personality as qualitatively different in some way from its predecessors easily leads into such related and offensive propositions as that until the fairly recent past parents did not love their children. At its mindless worst, it suggests that premodern personalities did not attain the autonomy and maturity of modern personalities. Such attitudes easily explain the reactions of other scholars who insist upon the individualism of, say, the Middle Ages.

The debate, as it has been cast, frequently misses the point, in ways analogous to debates over economic acquisitiveness or the sense of property. Only blind condescension or romanticization can explain the view that medieval and early modern peoples displayed no sense of acquisitiveness or

Introduction to Elizabeth Fox-Genovese, trans., *The Autobiography of Du Pont de Nemours*, 1–74. Wilmington, Del.: Scholarly Resources, 1984. Copyright 1984 by Scholarly Resources, Inc. All rights reserved. Used by permission of SR Books, an imprint of Rowman & Littlefield Publishers.

no sense of possession. The turbulent history of the violent quest for personal advantage clearly stamps such an idea as silly. But the reverse position that, upon recognizing a struggle for plunder and possession, one discovers the spirit of capitalism and of absolute property throughout history serves us no better. Acquisitiveness, the desire to increase one's own even at the expense of others, like the desire for domination over others, appears an ubiquitous dimension of human history. The interesting question concerns how those feelings changed over time, how social relations and the dominant language shaped and endowed them with different kinds of historical and personal implications.

Bourgeois individualism did not introduce the self into human experience, but it did register a changing perception of the self, its legitimacy, and its relation to the fundamental values of society. With the triumph of bourgeois individualism, the self—individual right—became the basic unit of social organization, the source of political legitimacy, and the self-conscious locus of, first, knowledge and, ultimately, of truth. This transformation of the accepted view of the nature and role of the individual occurred in tandem with momentous changes in the social organization of economic production that were themselves consolidated by the development of staggering advances in the material forces of production: the transformation we call capitalism, which preceded but was made irreversible by the industrial revolution.

The novelty of the modern world that was visibly coming into being by the second half of the eighteenth century has impressed most of its celebrants and detractors ever since. The growing numbers of political economists and sociological historians in England, Scotland, and France, especially those now known collectively as the Scottish Historical School, were among the first to chart the emergence of the distinctive new social forms they associated with succeeding stages in social organization.[1] Almost as soon as intellectuals began to reflect on these changes, they engaged in drawing lines of transformation and emphasizing distinctions between societies, understood to include values, theories, and personal and political relations as well as social and productive relations.

Early in the first half of the nineteenth century, John Stuart Mill and his contemporaries were pointing to the demise of feudalism, which they took to have occurred in the recent past; by the second half of the century, Ferdinand Tönnies was distinguishing between *gemeinschaft* and *gesellschaft*, or societies based on community and those based on economic contract.[2] Before the century reached its close, Max Weber had sketched a bold outline of the new personality of the capitalist, which he linked to Protestantism and to the triumph and internalization of an ethic of work, thrift, and accumulation.[3]

Weber dissociated the spirit of capitalism as manifest in the discrete personality from the rigid categories of class he attributed to Marxism, but in any case his own analysis reflected a more subtle appreciation of values and ideology than had been current among Marxists of his day.

In our own time, theorists of "modernization" have insisted upon the emergence and significance of a modern personality type, which they take to be more autonomous, goal-oriented, and rational—among other stellar attributes—than its ancestors.[4] The central debates have more directly concerned the character of this new personality and the date and causes of its emergence than they have disputed its existence. But in large measure, the discussion has unfolded as a function of the spread of what we might call the objective conditions of modernization or, better, the emergence of capitalism. Modernization theories have primarily considered the spread of modern social, political, and economic institutions and have projected, on the strength of such aggregate evidence as voting behavior, the existence of a Modern Personality. The tools of social science upon which these students of the modern world rely lend themselves poorly to the close investigation of changes in specific personalities, the transmission of new, or subtly altered, values between generations in specific families, or the language and culture through which people represent new values to themselves.

Freudian theory has much more to offer, but has not normally provided a compelling alternative to the implicit or explicit behaviorism of the modernization theorists. . . . Freudian theory has reflected the two principal tendencies in this historical study of individualism in general. Freudian theorists have tended either to adhere to the most rigid strain in Freud's thought and to postulate identity of psychodynamics across time and space, or to adhere to a largely American neo-Freudianism that discerns progress in personality formation across time and space.[5] In this respect, the modern individual of neo-Freudianism differs only in having the semblance of an unconscious life from the modern personality type of the modernization theorists.

There can be no dispute about the massive social changes attendant upon the rise of capitalism, however ferocious the disputes about terminology and timing may remain. Nor can there be serious dispute about the emergence of what I call bourgeois individualism, and what others call modernity. But important disputes persist about the relation between aggregate social and economic change; the relation of these changes to political change, especially revolutionary change; the distinctiveness of modern subjectivity and its form of expression; and the relation between social and personal change. The issues assume specific form in the debates about the nature and significance of the French Revolution in relation to the development of capitalism and individualism in France. . . .

Marxists, conservatives, and liberals long concurred in identifying the Revolution as a watershed in French history.[6] They also tended to converge in portraying the Revolution as the product of enlightened thought, fiscal and social irresponsibility on the part of the monarchy, and administrative inefficiency. They even concurred in a general social analysis: the Revolution heralded the triumph of the bourgeoisie, the France of the politicians, the place seekers, and the notables. They diverged in their assessment of the result. For the conservatives, especially the more reactionary ones, the Revolution destroyed the nobility, the king, and the Church; destroyed organic social relations; and ushered in the world of competition, greed, and illegitimate exploitation. For the liberals, the Revolution opened the door to responsible political institutions, career based on talent, and the triumph of a socially responsible class of propertied citizens. The Marxists also saw the Revolution as the triumph of the bourgeoisie, but they muted their enthusiasm for this outcome, which they recognized as of world-historical significance for the triumph of capitalism and thus its ultimate overthrow, but which they also recognized as having been accomplished over the bodies of the popular classes that had made it possible in the first place.

Recent scholarship has challenged the older consensus about the nature of the Revolution on every front. . . . Against the notion that the Revolution accurately reflected the concerns of identifiable social classes, it has argued that no prerevolutionary bourgeoisie existed to make the Revolution. Against the notion that postrevolutionary France departed in any significant particulars from prerevolutionary France, it has argued that the monarchy— shades of Alexis de Tocqueville—had been effecting administrative reform and that the nobility remained as powerful after the Revolution as before. And against the notion that enlightened thought, whatever it might be, reflected the concerns of a specific class, much less a bourgeoisie that did not exist as a class, it has been argued that the nobles were as, if not more, likely than non-nobles to figure among the propagators of the Enlightenment.

Each point of contention suffers from a lack of clarity. Discussions of class in the Revolution generally confuse the subjective intentions and self-perceptions of a clearly defined group of individuals with objective changes in social, political, and legal institutions that would favor the interests of a specific social class—of a group of individuals prepared to identify with new values, new forms of acquisition, and new ways of ordering society. To take the example of property . . . the emotional force of the individual's devotion to the distinction between thine and mine can be equally intense under a system of decomposing feudal property relations, in which possession or disposition of the surplus is determined by customary reciprocal obligations and

joint rights in a piece of land, and a system of bourgeois property relations in which possession is theoretically absolute and control of the surplus is determined by the free exchange of all goods, including property and human labor power. But the different forms of property have vastly different implications not merely for social and economic relations, but for the individual's sense of self in relation to society.

The violence of the French Revolution crystallized in political struggle the general tendency that dominated the entire Western world in the eighteenth century to transform archaic, collective, albeit rigidly hierarchical relations into modern individualistic relations. The most portentous aspect of this transformation lay in the triumph of absolute bourgeois property and its principal corollary, the absolute right to dispose of one's own labor power, itself frequently viewed as just another form of property. This transformation ensured the triumph of bourgeois individualism as a dominant ideology, or better, the dominant ideological tendency, since it long jostled with persistent collective and hierarchical views. But in establishing the foundations for institutions that would promote the generalization of individualism as a practice and in providing the dominant justification for social, political, and economic relations, it inaugurated a social system that differed fundamentally from its predecessors.

Bourgeois individualism in this sense does not refer to personal feelings, but to the forms of property; to sovereignty's deriving from the sovereignty of individuals in contradistinction to individuals' having rights as members of the collectivity; to the abolition of guilds and the attendant coercion of labor via the market, rather than via custom; to the existence of civil legitimation and registration of marriages and births, which effectively allowed some degree of freedom in choice of religious affiliation; to the election of representatives on the basis of individual if not yet universal suffrage; and more. Changes of such magnitude entail comparable changes in the response of individuals to their circumstances, which is to say an adaptation of personalities to meet new conditions. It is hard to believe that a revolution in objective conditions does not engender—if it does not result from—a revolution in the perception and representation of the self, not merely in isolation, but in relation to others. Recent work on changes in the nature of family relations belongs to this current of thought. But we are still far from a clear picture of the relation between objective change and subjective life. The hegemony of bourgeois individualism not merely as a theory of social and political relations, but as a world view that helped to explain the individual to himself or herself in relation to others, can hardly be understood without some knowledge of its subjective dimension.

Unilinear theories of the bourgeoisie's rise and triumph in the Revolution have proved easy marks for their critics. The events, ideas, and struggles that led to the Revolution bore the marks of their origin under the *ancien régime*. Those who would become revolutionaries once the Revolution broke out pursued a variety of occupations, held a variety of opinions, and had belonged to different social groups. The calling and initial meeting of the Estates General in 1789 mobilized the enthusiasm of vast numbers of people, who would begin to differ among themselves as events began to give political substance to ubiquitous wishes for reform. Language itself would be honed in the revolutionary struggles. The fate of the monarchy, the status of the Church, the abolition of feudal dues and services, the disposition of the estates of the *émigrés,* the floating of the *assignals,* and the many other issues that culminated in the ultimate test posed by the execution of the king presented choices that would gradually give shape to political groups. If initially individuals decided on discrete issues according to their conscience, increasingly issues were recognized as interrelated. If it is deceptive to speak of political parties in a modern sense during the Revolution, it is no less deceptive to ignore the emergence of political tendencies and groups.

For many . . . the Revolution provided the test, the winnowing, and the distillation of their prerevolutionary views. Only after the fact could they recognize themselves as members of a new bourgeois elite. Before the Revolution, their opinions lacked the social and institutional foundations that would permit them to identify with any specific class consciousness or even any putative will to revolution. They invariably sought reform within the existing social, political, and institutional system. And when, as frequently occurred, their goals implied something more than minor tinkering, they hid the implications from themselves.

Physiocracy . . . offers a nice example. . . . As the first modern analysis of the circular flow of economic life, it presented a comprehensive view of production that, in retrospect, can only be called capitalist. Yet the physiocrats staunchly refused to recognize the productive force of industry. Drawing on time-honored pastoral tradition, they asserted the unique productivity of agriculture and the special value of the rural, as against the urban, sector. In addition, although they developed a theory of the individual's presocial right to absolute ownership and of property as the sacred foundation of any legitimate social order, they insisted with equal force on the absolute power of the monarch, a theory of sovereignty they dubbed "legal despotism." In short, having cogently outlined the economic and social structure of bourgeois individualism, they repudiated its possible political consequences: political representation, they held, could only lead to the disorder that would

inevitably result from the irresponsible pursuit of individual self-interest. They had their eyes on the nobility's disquieting tendency to defend archaic, anti-economic forms of property—and on the mob of landless laborers.

The physiocrats argued that the realization of the potential wealth of agriculture depended upon complete freedom of trade for the products of agriculture, notably grain.[7] This superficially innocuous policy recommendation contravened the received wisdom that had governed the growth of cities and the monarchy itself throughout the early modern period. All municipal and royal officials, like the urban residents with whom they were concerned, had argued that urban peace depended upon the regular availability of grain at a regular and manageable price. To achieve this end, they had hedged in the growing urban markets with a wall of restrictions to govern the buying and selling of grain from farmer to final consumer, and the export of grain from the kingdom. The physiocrats' modest proposal to restore natural freedom to this trade appeared to many as the most wanton possible disregard not merely for the well-being of numerous individuals, but for the social peace of the kingdom as a whole. They retorted that these policies of provisioning violated the justice due to property as well as the natural order of free exchange and actually decreased the aggregate supply and optimal distribution of grain within the kingdom, not to mention that they deprived the monarchy of the revenues it could expect from a free and healthy economy.

Physiocracy . . . contained important elements of what subsequently would be called liberal thought. But its liberalism blended with a denial of the potential of industry and a disquieting political authoritarianism. Members of what would be called the "sect" yielded nothing to the sensibilities of their potential converts: they cast their views in a rigid, formulistic language. . . . For them, the truth was an all-or-nothing proposition. They had scant patience with those who wanted to trim on the margin, to compromise with popular sensibilities, or to appeal to the more sophisticated and less dogmatic Paris fashions. . . .

In recent years social history, and especially the history of "*mentalités,*" has increasingly explored the changes in culture and attitudes that characterized the eighteenth century. This work, which attempts to reveal the changes in the ways in which people lived in and perceived the world and their specific societies, shows how the impersonal forces of the economy and ideology were perceived by ordinary people in everyday life. Social history and the history of *mentalités* almost inevitably consider the external traces of collective habits and perceptions; they constitute, as it were, a kind of history of collective behavior, of social patterns and group culture. Collective

behavior and values appear to change very slowly, especially before the modern period, but they do change. In some periods, evidence for a constellation of apparently disparate incremental changes permits historians to speak of a recognizable shift in *mentalité*.

Michel Vovelle has identified the shift that appears to have occurred sometime around 1760 as a "*tournant des mentalités.*"[8] The work of Vovelle and others suggests that shortly after the middle of the eighteenth century ordinary French people manifested a congeries of new attitudes and new forms of behavior. Among the more significant of these changes there figured a decline in formal religious observance for at least some men; the beginnings of a feminization of domestic service; a growth in literacy in urban and developed regions, especially a more rapid growth in the rate of literacy of women relative to men; an increase in the habit of letterwriting among the urban, notably Parisian, population; an increase in the number of unwed mothers, again particularly in urban areas where such births were registered; a growing insistence, at least among the well-to-do, that women should nurse their own children; a related emphasis on the special role of women as mothers and on the importance of proper mothering for the development of children; a dissemination, again primarily among the well-to-do, of new ideas of the family as an affective unit; a new interest in marriage for love; and even, as Robert Darnton has shown, a dissemination of the ideas of the *Encyclopédie* among the middling urban population.[9]

Although social history provides insight into the function of belief and collective life among social groups that normally do not leave autograph evidence of their concerns and perceptions, it provides little direct evidence of the subjective perceptions of discrete individuals. Yet the social changes point in the direction of what is known as modernity, to the emergence of a modern personality. In very different ways, they contribute to the social and cultural relations that would encourage at least some, still primarily men, to think self-consciously of themselves as individuals. But in important ways these various changes remained tendencies which, as such, might have been reversed before the Revolution. Only the political and institutional changes of the Revolution grounded the tendencies on solid foundations that could shape their future development. And even thereafter they jostled with contrary tendencies. The ideology of motherhood doubtless penetrated the urban petty bourgeoisie which, at least in Paris, was close to totally literate, which habitually corresponded, and which had access to the latest books. But among the members of that class the practice of putting children out to wet nurses actually began to increase during this period. . . .[10] The mother's work at a trade or craft was necessary to the economic position of

the family: her valuable time could not be spared for the nursing and intimate care of her children. . . .

II. Bourgeois Autobiography

Autobiography as a genre has generated heated debates in recent years. According to a minimal consensus, autobiography consists of a first-person narrative in which the author, the same as the narrator of the text, writes about his or her own past experience in conformity with some accepted standard of veracity. Beyond that minimum lies deep disagreement about the character, significance, literary standing, and historical specificity of autobiographical texts.

Each autobiography privileges a specific narrative: I became myself.[11] In this respect, autobiography might be considered the ego's—or author's—history of himself or herself. To write one's autobiography is to confer meaning on one's life, to protect that life in some measure against the dissolvent effects of time, against oblivion. Yet autobiography as a history can exist only in or through time. So the effort of preservation belongs precisely to the medium it is trying to defend against. And like all history, autobiography constitutes an act of interpretation. Moments of being in time are ordered, from the perspective of a specific moment in time, with a view to creating a meaning that will survive the further passage of time.

The related issues of time and history govern any understanding of autobiography and are invoked not merely as an aid to the understanding of specific autobiographies, but also to provide a precise understanding of the genre in contrast to other forms of first-person narrative. Philippe Lejeune especially has insisted that autobiography be recognized as a distinctly modern phenomenon. By modern, he means that pivotal second half of the eighteenth century. Like those who share his perspective, he would take the posthumous publication of Rousseau's *Confessions* in 1782 as the inauguration of autobiography in the strict sense.[12] In this view, autobiography departs decisively from older forms of first-person narrative, especially such didactic religious texts as Augustine's *Confessions* and various forms of memoirs. This view of autobiography emphasizes its character as the individual's interpretation of his or her self as an individual and without reference to determining external values or communities. Autobiography, in this sense, requires the disembedding of the individual from the surrounding social, cultural, and ideological terrain. The author of a true autobiography assumes the primary responsibility of constructing a self—an interpretation of the self—as an end in itself, not as illustrative of the life of a community or the truth of a doctrine. In stark contrast to memoirs, an autobiography

addresses the consciousness of its observing subject, not the swirl of life and personalities around him or her. In contrast to a journal or a diary, an autobiography presents the sequence of a life from the perspective of a specific moment in time and as a whole, not as a sequence of impressions and responses.

The insistence upon the intimate links between individualism and autobiography invites a variety of challenges. It is child's play to recognize authoritative and flamboyant individuals in the Middle Ages, not to mention the Classical period and the Renaissance. Georg Misch's massive history of autobiography documents the prevalence of first-person accounts throughout history and around the world.[13] Western culture alone has been characterized from its origins by first-person accounts of persons and events, including the life of the author. It is not merely absurd, but ethno- and temporo-centric as well, to claim the individual as the splendid and unique product of modern Western culture. But to claim a special relation between systematic individualism and that culture is something altogether different, and probably accurate.

In the most general sense, this association means simply that autobiography constitutes a distinct genre, a historically and stylistically specific way of presenting and understanding the individual under conditions in which the individual is taken to constitute the fundamental unit of truth and of consciousness. The necessary historical, psychological, and ideological conditions for autobiography in this specific sense include assumptions about the primacy of the individual over the group, the possibility and authority of self-knowledge, and the dominance of rationalism over tradition. Historically, the growth of these assumptions as a coherent, or at least plausible, picture of society accompanied the triumph of capitalism and constituted the essence of bourgeois individualism. Lejeune apparently has these or analogous considerations in mind when he defines autobiography as a "retrospective narrative in prose that a real person makes of his own existence, when he places the accent on his individual life, in particular on the history of his personality."[14]

No discussion of autobiography has managed to avoid entirely some emphasis on the self or the personality of the autobiographer, if for no other reason than autobiographers, from Rousseau on, have been mesmerized by their own personalities. There is no small irony in bourgeois culture's having so dramatically privileged the notion of the self in this sense, for the underside of the promise of self-realization inherent in bourgeois individualism has been the growing interchangeability of bourgeois individuals. The possibility of escaping external social and ideological definitions of one's self results inescapably in the possibility of confusion among all selves; thus,

it should not cause surprise that the rise of bourgeois individualism has prompted a gnawing concern with the self as distinct from the external and uniform condition of the individual.

It is understandable that concern with self—in Rousseau's formulation, that one is different but no better or worse than others—has plagued auto- biographers who try by that very act of writing to distinguish themselves from the throng of their competitors. Also understandable, but much less justifiable, is the preoccupation of scholars of autobiography with that same self. Many have apparently experienced an overwhelming temptation to view the self as in fact essential, if not eternal, and immune to time. In the most extreme cases they offer autobiography as a window on the true self hidden beneath the imposed mask of the historical actor. Georges Gusdorf, a lead- ing and usually insightful scholar of autobiography, has argued that auto- biography subordinates the truth of facts to the truth of the man, that it can be called a theodicy of the individual, that it attempts to construct an eschatology of the individual life.[15] Gusdorf's remarks remain ambiguous: he does not commit himself to the notion that there exists a truth of the man independent of the life of the man or his account of it. And elsewhere he allows that the significance of autobiography lies less in its "literary func- tion" than in its "anthropology."[16]

Other commentators have shown less caution. Even Roy Pascal, in a gen- erally fine, sensitive account, writes that autobiography is "inspired by a rev- erence for the self . . . the self in its delicate uniqueness," and informed with the "consciousness that the self escapes definition. . . ."[17] James Olney and others yet more warmly embrace the idea of a self distinct from other selves and the world, a presocial self that resists the incursions of time and events and embodies its own truth.[18] These and other critics have established the claims of autobiography as a genre, but they accept uncritically this myth of the self which autobiographers have promoted as a defense against insecuri- ties and anxieties—against their own lives in history. Recent criticism, espe- cially deconstructionist, has treated the infatuation with the self harshly.[19] But the indisputable importance of understanding the historical and psycho- logical dynamics that informed the concept of the eternal or essential self should not lead us to dismiss the value that autobiographers placed upon that self. The compelling question remains that of how, when, and why auto- biographers attempted to substitute a concept of identity for one of location. As Janet Varner Gunn has written, the "real question of the autobiographi- cal self then becomes *where do I belong?* not, who am I? The question of the self's identity becomes a question of the self's location in the world."[20]

Whatever their differences, all critics of autobiography concur that the genre poses a special case of the problematic relation between truth and

fiction. Historians may profitably read autobiography for information about an individual or even about a social class or a historical epoch, but woe betide the reader who expects an autobiography to rest entirely upon verifiable fact. Memories fail. Authors deceive. Making a point sharply seems to require some tampering with facts. There are those who, impressed by the elusiveness of facts, would identify all narratives with fictions. The complex and fascinating issues which directly engage the most compelling problems concerning the nature of texts, truth, and reality far exceed our present concerns. But the general problem of truthfulness affects autobiographies in two important ways.

First, there is the question of accuracy of information. The autobiographer asks the reader to accept the narrative as an accurate record of events and people. We should be offended by flagrant departures from a verifiable history. And autobiography, being inherently referential, demands a plausible relation to its purported setting. But occasionally an autobiographer like Du Pont can be shown to have altered verifiable facts. If, as with Du Pont, the alteration does not invalidate the essential meaning of the narrative but reinforces a central theme or psychological influence, we need not take offense. For example, Du Pont writes that his mother gave him a book she could not have given him. The book, Richardson's *Sir Charles Grandison,* became his favorite novel, its hero his model. By having her give it to him, he overdetermines its emotional significance to him and establishes a link between her influence and his own ideals. The liberty he takes is all the more interesting for *Sir Charles Grandison's* corresponding more closely to the values she instilled in him than many of the books we can be fairly certain she did read with him. This slight violation of strict truth—and it is always possible that he misremembered, that he came to believe that she had given it to him—does not destroy our confidence in his narrative and underscores one of its most important themes. The lapse in historical accuracy does not justify a charge of general untruth. The autobiography is not identical to what happened: it is a subjective account of what happened, and thus an interpretation. But it should not, for this reason, be classified as fiction in the normal sense of the term.[21]

Second, we have the problem of the truth of the autobiography as a narrative. Earlier critics of autobiography coped with this problem by falling back on the idea of the self. The autobiography embodies the truth of the self, against which standard lapses in accuracy count for little. But surely we need not accept the individual's feelings, aspirations, fantasies as the truth of autobiography unless they are identified as such. And the moment they are so identified, others, society, and history return through the back door, if only because the identification of fantasy implies an acknowledgment of

the reality from which it departs. We do not, in fact, have very good standards for a reasoned level of truth in autobiography. If we accept *a priori* the absolute primacy of subjective experience over external conditions, we abandon the tension of the individual-in-history, which presumably accounts for the sense of the self in the first place. Yet we can hardly require a personal history to cast itself purely as a function of objective conditions. The truth of the autobiography would seem to depend in the first instance on the authenticity of the picture of the self as an individual-in-history, in the second on the plausibility of the relation of the present self who is writing to the earlier selves who are being evoked and interpreted.

Critics of autobiography increasingly argue that the truth of the autobiography depends upon the relation between the text and its reader. This criterion for truth solves little, for the recognition of the reader's importance can be taken to mean anything from the most sophisticated hermeneutical relation to the simplistic and unacceptable proposition that each reader creates his or her own text. Obviously, succeeding generations read texts through different lenses and for different purposes. But the changing response to texts cannot alone suffice as a standard of truthfulness for the author of the text. Currently, some try to solve that problem by banishing the author from the discussion entirely. The text must stand on its own. Let us grant the salutary effect of this insistence on the integrity of the text, which, after all, the New Criticism of the 1950s had forcefully reminded us of. But to focus exclusively on the reader while denying the author means arbitrarily to destroy the dynamic tension of the text as a mediation between two consciousnesses. The intractable problem of the relation of author to text permits no easy solution. Lejeune proposes the concept of "autobiographical pact" to ease it. If, he argues, autobiography can be defined by "something external to the text, it is not towards the interior, by an unverifiable resemblance with a real person, but beyond, by the type of reader that it engenders, the credibility that it secrets. . . ."[22] Yet even this proposal does not allow sufficient weight to the role of the author who produced his or her text, at least in part, to attract or engender certain kinds of readers. . . .

The decisive historical moment for any autobiography is the moment at which it is written. The remembrance of things past, in the memorable phrase of the Scott Moncrieff translation of Marcel Proust's title, is, like the original of that title, the search for lost time. That enterprise bears the stamp of the hour of remembering more clearly than that of the hours the rememberer is seeking to recover. The moment of remembering shapes the choice of feelings and events to be recorded as it shapes the choice of the elements of the personality that are to be emphasized. In this respect the moment of closure that the moment of writing inescapably represents is also the

moment of beginning. For the life represented in the autobiography cannot
be given from the outset: it is, in Roy Pascal's words, "not simply the narra-
tive of the voyage but the voyage itself. There must be in it a sense of dis-
covery, and where this is wanting, and the autobiography appears as an
exposition of something understood from the outset, we feel it is a failure, a
partial failure at any rate."[23] Pascal seeks to underscore the creative dimen-
sion of the act of remembering. His insight can be pushed further, for the
writing and remembering self, in effect, produces a history of the self at a
particular moment in time. To recognize this process of self-creation must
be to acknowledge that the self cannot be considered an ahistorical, absolute
entity. It not merely exists in history, its self-consciousness is doubly histori-
cal: it has existed in a succession of specific historical moments, and its rec-
ollection of its own history, and hence its identity, occurs under specific
historical conditions.

Gunn has argued that autobiography as a form could only emerge "when
men and women began to experience what Mircea Eliade has called 'the
terror of history.'"[24] She means in essence that autobiography results from
people's experience of their finitude. The absence of absolute transcendent
values or of defining communities exposes the self to its own mortality, with-
out protection or mediation. Facing that void can spur the mind to make
sense of apparently random events and to endow one's life with meaning. If
it can engender a feeling of nothingness, it can also generate a quest for au-
thorship and agency. . . .

The threat of impending execution might lead to a denial of reality and
an escape into fantasy. Not for Du Pont. His return to his childhood cannot
be dismissed as a retreat to idealization or pastoralism. Significantly, his
account lacks those evocations of the sights and sounds and smells of rural
life, those evocations of flowers that bloomed brighter or of food that
although simpler tasted better. Here is no enclave of country-fresh milk or
flavorful bread. Marmontel would indulge in such idealizations of his child-
hood in the Auvergne; writing after the Revolution had spent its fury, he was
seeking to evoke the special charm of the *ancien régime,* albeit without
directly celebrating its hierarchical institutions.[25] Du Pont avoids such dis-
placements, just as he avoids romanticization of the old order. He fears the
current course of the Revolution and regrets its excesses, but he never repu-
diates its moderate and legitimate goals. If he turns to the personal, he does
so in part because of his pressing concern about his relation with his sons—
his own identities as son and as father—and in part because he seeks the per-
sonal roots of his own identity as a mature political man.

Du Pont's autobiography remarkably blends the personal and the politi-
cal as they intertwined in the lives of men and women of his generation. He

draws upon the language of politics—of bourgeois individualism—to make sense of his own early life and even to justify his rebellion against his father. Political terms and categories help him to make sense of personal feelings and to evaluate the influences on his life. He invokes the concept of property to label as unjust his father's harsh discipline. He reproves the restrictive privilege of the rector of the university who prohibited his second public performance as a learned child. But, perhaps most tellingly, he explores and criticizes the privilege and the ideology of nobility. He brilliantly evokes the hegemony of nobility as it penetrated the life of the *ancien régime:* from the right to wear a sword, to the lure of a military career, to his mother's claims of noble descent and her attempt to inculcate in him noble values. He succeeds in sketching the transition of a world in which nobility of soul essentially followed noble status—at least in ideology—to one in which nobility of soul can be recognized as the attribute of the character and work of the individual and in which pretensions to nobility must be dismissed as mere smoke.

We know from extratextual sources that as late as the 1780s Du Pont remained imprisoned by the self-inflating claims of nobility. He valued highly his own patent of nobility as well as the distinctions he had received from various foreign princes. More significantly, he could still write in this period to the Marquis de Mirabeau, by then a friend, "you who are noble. . . ." He remained, in short, awed by nobility. And we can safely assume that he still responded to the allure of his mother's noble descent. It seems likely that his thoughts about nobility remained conflicted. He seems to have resented covertly that to which he was also drawn, and on some level he must have experienced its abolition by the Revolution as a release. Certainly, he mentions the disappearance of noble status in his autobiography. He even counterposes noble descent to natural descent when he writes that his claims to nobility through the female line had been worthless, since women did not transmit nobility "although their descent is much more certain." But if personal resentments and political events encouraged his growing criticism of nobility, its more destructive illusions must already have been painfully impressed on him by his son Victor's extravagant pursuit of a leisured, noble life, for which he expected his father to pay the bills. Du Pont's correspondence with Victor during this period, and even passing references in the autobiography, reveals his difficulty in disciplining and restraining his son. That experience must have led him to reconsider not merely noble pretensions, but also his own relations with his father. His treatment of nobility in the autobiography would appear to reflect his serious thinking on all these matters and his attempt to weave his thoughts about himself, about Victor, and about the political implications of noble status into a coherent interpretation.

The language and values of bourgeois individualism permit Du Pont to reinterpret his past in a way that simultaneously affirms legitimate authority, including the authority of fathers, and validates responsible individualism. Work and property emerge as the principal anchors both for authority and for the self. Via work, the individual internalizes authority and acquires property which becomes the external manifestation of the self. By insisting upon the presocial character of property and upon its role as the foundation of any legitimate social order, Du Pont provides a material anchor for the sense of self. In this respect, it appears that his sense of himself, which grew in his conflicts with his father before he had encountered physiocracy or other writings on political and social theory, doubtless informed his appropriation of those theories. His personal experience led him to embrace a theory that stressed the sanctity of property as external confirmation of himself and, when the time came to write his autobiography, the theories that were already informed with his personal feelings helped him to interpret and to name his own development.

Du Pont, like all other autobiographers, drew for his narrative of his life upon what Michael Polanyi has called the "system of acceptances."[26] He formulated his sense of himself from the language and concepts his culture offered him. His choice among the alternatives available in the culture at large reveals much about both his early history and his subsequent interpretation of it. Used with caution, his autobiography permits us to reconstruct something of the possible education of a child and young man of his class and generation. Yet the achievements of his adult life, compounded by the upheaval of the Revolution, forced him to reassess those early acceptances. Du Pont's use of political language provides the best example of how he reinterpreted the past in the light of his more recent past and his present. Other choices reveal both stages and disjunctures in his personal and intellectual development that resulted at least in part from changes in the culture at large.

Like Franklin, Morellet, and Marmontel, among other early bourgeois autobiographers, Du Pont emphasizes the importance of books in his development and even uses the titles of books he assumed would be generally familiar as signs of his own interests. The books he mentions include the obvious milestones in the development of eighteenth-century liberal thought: Rousseau's *Discourse on Inequality, Social Contract,* and *Emile;* Montesquieu's *Spirit of the Laws;* and Defoe's *Robinson Crusoe.* He also treasures classics, like Caesar's *Commentaries.* But his intellectual references, especially for the period of his struggle with his father when he has begun to launch out on his own, bear little relation to the system of references in which he was enmeshed prior to his mother's death. For her examples of

greatness—the models she offers to his emulation—derive from a noble and military tradition; she appears to have read and to have spoken to him of Turenne's *Mémoires,* and perhaps also those of the Duc de Rohan and Montecucolli.[27] The autobiography strongly suggests that his early models of greatness derived from military careers, and his early castles in Spain all concerned military renown.

Du Pont may have tried to cope with this disjuncture when he wrote that his mother, shortly before her death, gave him three books—*Robinson Crusoe, Sir Charles Grandison,* and Montaigne's *Essays*—and bade him ponder and emulate them. The books share a concern with the education of a man and with responsible individualism. They clearly represent an alternative to aristocratic notions of heroism and grandeur. Since Du Pont's mother could not have given him *Sir Charles Grandison,* she may not have given him the others either, but he seems to be using those books as a way of transforming his mother's legacy—of transforming nobility of condition into nobility of soul, military daring into solid bourgeois accomplishment.[28] In the autobiography, he will show his own consciousness to have been lagging behind her new message, or the message he attributes to her. But he draws upon the culture of his time to point to the new direction he will take as he comes to maturity.

Du Pont's use of the culture offers us a privileged view of the shaping of a mind in a period of changing *mentalité.* He grows up with the legacy of seventeenth-century heroism and matures to preromanticism, anglomania, and affective domesticity. It is uncommon to see those values shading into each other. Yet for those of Du Pont's generation it appears to have been so. If different individuals interpreted their relation to that transition differently, most literate people apparently experienced it. Raising his sons can only have sharpened Du Pont's awareness of his own experience, his awareness of the continuities and differences between the system of acceptances that dominated his childhood and theirs.

The contrast between the world as it was and the world as it had become at the moment of his writing must have heightened Du Pont's sense of self. Confronting momentous changes and risk of death, he attempts to distinguish between the permanent and the contingent in his own life and personality. He does not fall into the trap of postulating an essential self, but he does seek and find constancies—primarily traits of personality. He regularly reminds his sons of his own obstinacy and opinionatedness, which he calls a family trait. We Du Ponts are a stubborn lot, he reminds them, and cautions them to monitor the failing in themselves. He takes comfort in one of his ancestor's having sired children when in his seventies. That inheritance augurs well for his own advanced years. The individual, he recognizes,

comes into the world with the legacy of his forebearers. But Du Pont does not restrict the constant self to genetic inheritance. His mother, he recounts, had said to him after he had fallen for a young married lodger in their house, "my son will be transparent like a lantern throughout his life." And he complacently acknowledges that she was correct. "I am too free, too proud, too frank, too assured in my conscience for any evil principle to sway me." In this instance, under the guise of gentle self-mockery for lack of sophistication, Du Pont is congratulating himself. His face invariably betrays his soul. He is essentially honest.

Throughout the autobiography he periodically refers to such constant character traits. But he balances them against the role of events, even accidents. His self emerges from this interplay of character and contingency. And he does not dwell more heavily on introspection than on assessment of the external world. In this respect, Du Pont's autobiography more closely resembles that of Franklin than that of Rousseau, although he may offer a more sensitive picture of the social world of childhood and adolescence than either. He surely recognizes that his history and his success depend upon his relations with and ability to understand the world. His self-knowledge exists in direct relation to his knowledge of others, of the world, and of his possible place in it. He would have applauded, even if he could not himself have formulated, Goethe's wise observation:

> I must confess that I have always been suspicious of that great and so fine-sounding task, 'Know Thyself,' as something of a stratagem of a secret conspiracy of priests who wanted to confuse men by making unrealisable demands of them, and to seduce them from activity directed towards the outside world to an inner and false contemplativeness. Man knows himself only in so far as he knows the world, and becomes aware of the world only in himself and of himself only in it.[29]

Du Pont's autobiography can be read as an exercise in growing self-knowledge, but not self-knowledge in the service of itself. Written under the sword of history, it constitutes an effort of recollection and self-understanding in the service of future generations, especially his own sons. For modern readers, the autobiography offers a special view of a culture in transition, of the making of a bourgeois individual, and of the interplay of the personal and the political—of society and ideology—in the transformation of *mentalités* and the period of the Revolution. Roy Pascal has written that the true purpose of autobiography must be "'Selbstbesinnung,' a search for one's inner standing. It is an affair of conscience. . . ."[30] He adds that the true quality of an autobiography ultimately depends on the quality of the spirit of its

author. Du Pont receives high marks on both counts. His autobiography depicts a man of generous spirit who holds himself accountable to others.

Notes

Editor's Note: Because the above two excerpts come from different parts of the introduction, the original endnote numbers are different than below (13–22 and 46–65).

1. See Ronald Meek, *Social Science and the Ignoble Savage* (Cambridge: Cambridge University Press, 1976), for the development of the theory of stages. Among the many works on the Scottish Historical School, see Gladys Bryson, *Man and Society: The Scottish Enquiry of the Eighteenth Century* (Princeton: Princeton University Press, 1945); William C. Lehmann, *John Millar of Glasgow 1735–1801: His Life and Thoughts and His Contribution to Sociological Analysis* (Cambridge: Cambridge University Press, 1960); Anand Chitnis, *The Scottish Enlightenment: A Social History* (London: Croom Helm, 1976); Ian Simpson Ross, *Lord Kames and the Scotland of his Day* (Oxford: Oxford University Press, 1972); N. T. Phillipson and Rosalind Mitchison, eds., *Scotland in the Age of Improvement* (Edinburgh: University of Edinburgh Press, 1970).

2. See in particular John Stuart Mill, *The Spirit of the Age*, ed. F. A. von Hayek (Chicago: University of Chicago Press, 1942), and for a general view Walter E. Houghton, *The Victorian Frame of Mind* (New Haven: Yale University Press, 1957), esp. Chapter I, "The Character of the Age"; Ferdinand Tönnies, *Community and Society (Gemeinschaft und Gesellschaft)*, trans. and ed. Charles P. Loomis (New York: Harper & Row, 1963).

3. Max Weber, *The Protestant Ethic and the Spirit of Capitalism*, trans. Talcott Parsons (New York: Charles Scribner's Sons, 1930).

4. See for example Alex Inkeles and David H. Smith, *Becoming Modern: Individual Change in Six Developing Countries* (Cambridge, MA: Harvard University Press, 1974).

5. See for example Lloyd de Mause, ed., *The History of Childhood* (New York: Psychohistory Press, 1974). For a critique of the application of the neo-Freudian theories of Erik Erikson to the historical study of personality, see David Hunt, *Parents and Children in History: The Psychology of Family Life in Early Modern France* (New York: Basic Books, 1970), esp. pp. 11–26. For a fine example of the use of psychoanalytic theory in historical biography, see Arthur Mitzman, *The Iron Cage: An Historical Interpretation of Max Weber* (New York: Grosset & Dunlap, 1969).

6. For a fuller development of my views on the history of the French Revolution, see Elizabeth Fox-Genovese and Eugene D. Genovese, *Fruits of Merchant Capital: Slavery and Bourgeois Property in the Rise and Expansion of Capitalism* (New York: Oxford University Press, 1983), esp. Chapters 8 and 11.

7. On the debate over the grain trade, there is also a voluminous literature. See for example Georges Weulersse, *Le Movement physiocratique en France (de 1756 à 1770)*, 2 vols. (Paris: Félix Alcan, 1910, repr. 1968); Steven L. Kaplan, *Bread, Politics, and Political Economy in the Reign of Louis XV*, 2 vols. (The Hague: Martinus Nijhoff, 1976); Georges Afahassiev, *Le Commerce des céréales en France au dix-huitième siècle* (Paris: Alphonse Picard, 1894); Léon Caben, "La question du pain à Paris à la fin du XVIIIe siècle," *Cahiers de la Révolution française* I (1934): 51–76; Guy Lemarchand, "Les troubles de subsistance dans la généralité de Rouen (seconde moitié XVIIIe siècle)," *Annales historiques de la Révolution française* 35 (1963). Among the voluminous physiocratic

writings in favor of the freedom of the grain trade, see Louis-Paul Abeille, *Faits qui ont influé sur la cherté des grains en France et en Angleterre* (Paris, 1768); Nicolas Baudeau, *Avis au peuple sur son premier besoin . . .* (Amsterdam and Paris, 1768); J. A. N. de Caritat, Marquis de Condorcet, *Du Commerce des bleds* (Paris, 1775) and his *Lettres sur le commerce des grains* (Paris, 1774); Guillaume-François Le Trosne, *La Liberté du commerce des grains, toujours utile et jamais nuisible* (Paris, 1765); and Pierre Samuel du Pont, *De l'exportation et de l'importation des grains* (Paris, 1764, repr. ed. Edgard Depitre, Paris, 1911).

 8. Michel Vovelle, "Le Tournant des mentalités en France 1750–1789: la sensibilité pré-révolutionnaire," *Social History* 5 (1977): 605–30.

 9. Michel Vovelle, *Piété baroque et déchristianisation en Provence au XVIIIe siècle* (Paris: Plon, 1973); Cissie Fairchilds, "Masters and Servants in Eighteenth-Century Toulouse," *Journal of Social History* 12 (1979): 368–93; J. P. Gutton, *Domestiques et serviteurs dans la France de l'Ancien Régime* (Paris: Aubier, 1981); Claude Delasselle, "Les Enfants abandonnés à Paris au XVIIIe siècle," *Annales. Économies, Sociétés, Civilisations,* 30, no. 1 (January–February 1975): 187–218; François Lebrun, "Naissances illégitimes et abandons d'enfants en Anjou au XVIIIe siècle," in *loc. cit.* 27, nos. 4–5 (July–October 1972): 1183–89; Cissie Fairchilds, "Female Sexual Attitudes and the Rise of Illegitimacy: A Case Study," *Journal of Interdisciplinary History* 8 (1978): 627–67; François Lebrun, *La Vie conjugale sous l'Ancien Régime* (Paris: Armand Colin, 1975); J.-L. Flandrin, *Families in Former Times,* trans. Richard Southern (Cambridge: Cambridge University Press, 1979); François Furet and Jacques Ozoul, *Lire et écrire: l'alphabétisation des françois de Colvin à Jules Ferry,* 2 vols. (Paris: Editions de Minuit, 1977), I, pp. 9–115, *passim;* Daniel Roche, *Le Peuple de Paris* (Paris: Aubier, 1981); George Sussman, *Selling Mothers' Milk: The Wetnursing Business in France, 1715–1914* (Urbana: University of Illinois Press, 1982), esp. pp. 19–35; Robert Darnton, *The Business of Enlightenment: A Publishing History of the ENCYCLOPÉDIE, 1775–1800* (Cambridge, MA: Harvard University Press, 1979).

 10. Sussman, *Selling Mothers' Milk,* pp. 36–72.

 11. Jacques-Louis Ménétra, *Journal de ma vie,* ed. Daniel Roche (Paris: Montalba, 1982), Daniel Roche's introduction, p. 12.

 12. Philippe Lejeune, *Le Pacte autobiographique* (Paris: Éditions du Seuil, 1975), his *Autobiographie en France,* and the discussion among him, Georges Gusdorf, and others in *Revue d'histoire litteraire de la France* 75, no. 5 (1975): 931–35.

 13. Georg Misch, *A History of Autobiography in Antiquity,* trans. E. W. Dickes, 2 vols. (Cambridge, MA: Harvard University Press, 1951). Only vol. 1 of the original German has been translated; for the remainder, see his *Geschichte der Autobiographie,* vols. 2–4 (Frankfurt-am-Main: G. Schulte-Bulmke, 1955–69). See also Karl J. Weintraub, *The Value of the Individual: Self and Circumstance in Autobiography* (Chicago: University of Chicago Press, 1978).

 14. Lejeune, *Pacte autobiographique,* p. 14.

 15. Georges Gusdorf, "Conditions and Limits of Autobiography," in James Olney, ed., *Autobiography: Essays Theoretical and Critical* (Princeton: Princeton University Press, 1980), pp. 24–48, *passim,* and his "De l'autobiographie initiatique à l'autobiographie genre littéraire," *Revue d'histoire litteraire de la France* 75 (1975), 974. See also his *La Découverte de soi* (Paris: Presses Universitaires, 1948).

 16. Gusdorf, "Conditions and Limits," pp. 33–34.

17. Roy Pascal, *Design and Truth in Autobiography* (Cambridge, MA: Harvard University Press, 1960), p. 181.

18. See for example James Olney, *Metaphors of Self: The Meaning of Autobiography* (Princeton: Princeton University Press, 1972), and his "Autobiography and the Cultural Moment. A Thematic, Historical, and Bibliographical Introduction," in Olney, ed., *Autobiography,* pp. 3–27.

19. For a recent critical review essay, see Candace Lang, "Autobiography in the Aftermath of Romanticism," *Diacritics* [12] (Winter 1982): 2–16. The issues are extremely complex and the debates heated. See also Michel Foucault, "Qu'est-ce un auteur," *Bulletin de la Société Française de Philosophie* 63, no. 3 (1969): 75–104.

20. Janet Varner Gunn, *Autobiography, Toward a Poetics of Experience* (Philadelphia: University of Pennsylvania Press, 1982), p. 23.

21. Cf. Albert E. Stone, *Autobiographical Occasions and Original Acts* (Philadelphia: University of Pennsylvania Press, 1982), and William C. Sengemann, *The Forms of Autobiography: Episodes in the History of a Literary Genre* (New Haven: Yale University Press, 1980).

22. Lejeune, *Pacte autobiographique,* p. 46.

23. Pascal, *Design and Truth,* p. 182.

24. Mircea Eliade, *Cosmos and History: The Myth of the Eternal Return,* trans. William R. Trask (New York: Harper & Brothers, 1959).

25. Marmontel, *Mémoires;* see for example I, p. 18.

26. Michael Polanyi, *Personal Knowledge: Towards a Post-Critical Philosophy* (Chicago: University of Chicago Press, 1974), p. 267.

27. On Du Pont's reading, see especially Chapters 6, 7, and 8 of the autobiography and accompanying notes.

28. See Chapter 6, note 7, of the autobiography.

29. Cited by Pascal, *Design and Truth,* pp. 46–7. The passage is from Goethe's *Maximen und Reflexiomen,* vol. VI.

30. Pascal, *Design and Truth,* p. 182.

Four

Two Steps Forward, One Step Back

New Questions and Old Models in the Religious
History of American Women

The study of the religious history of women has advanced with giant steps during the past few years, in no small measure as a result of the efforts of Rosemary Radford Ruether and Rosemary Skinner Keller, the general editors of the new documentary history, *Women and Religion in America*. Drs. Ruether and Keller's joint efforts here owe much to each of their discrete contributions both to the religious history of women and to contemporary theological debates. The volumes they have put together reflect a high level of scholarship as well as their informing purpose of establishing the religious past of American women. Each volume consists of groups of documents that are organized in thematic chapters: Volume 1 includes "Women and Revivalism," "Women in Utopian Movements," "The Leadership of Nuns in Immigrant Catholicism," "The Jewish Woman's Encounter with American Culture," "The Struggle for the Right to Preach," "Lay Women in the Protestant Tradition," and "Women in Social Reform Movements"; Volume 2 includes "American Indian Women and Religion," "Women and Religion in Spanish America," "Women in Colonial French America," "New England Women: Ideology and Experience in First-Generation Puritanism (1630–1650)," "The Religious Experience of Southern Women," "Black Women

and Religion in the Colonial Period," "Women in Sectarian and Utopian Groups," "Women and Revivalism: The Puritan and Wesleyan Traditions," and "Women, Civil Religion, and the American Revolution."

The editors have been well served by their contributors, each of whom has written an intelligent general introduction to her section as well as head notes to the documents she has selected. Yet the separate selections, even with introductions, do not add up to a history of American women and religion. Nor do the editors attempt to sketch such a history in their own general introductions to the two volumes. Those familiar with the general state of the history of American women and religion will not be surprised by their reticence. In fact, Drs. Ruether and Keller's documentary history will probably substitute for the general history that we are as yet unprepared to write for many years to come. Their work, and that of their contributors, constitutes the best overview of American women's relations to religion as well as the best introduction to the challenges that confront any attempt to make sense of those relations.

As with any such collection, the contributions vary in quality, but those variations do not substantively detract from the value of the documents and of their availability for scholars as well as for students. The initial choice of topics to cover is another matter. Although it would be difficult to fault the editors for any of their discrete choices, one is permitted to question their overall design or conception. Like many editors of collections, they unavoidably follow the lead of scholarly work in progress, although, to their credit, they also chart new territory. In particular, they make laudable attempts to include Native American, Afro-American, Jewish, and Catholic women as well as Anglo-American Protestant women. And if they do not make much progress in integrating the experiences of minority women with those of white Protestant women, they at least juxtapose them. This strategy invites readers to remember the religious pluralism that has prevailed in American society as well as to acknowledge the common tendencies of the various strands of the Judeo-Christian tradition to preach women's subordination to men. In short, it appears to invite a comparative perspective on the religious experience of American women. Unfortunately, the appearance of comparative vision exceeds its substance.

My admiration for and appreciation of the pioneering work of Drs. Ruether and Keller in these volumes and elsewhere leads me to challenge what appears to be their general strategy in opening up the religious history of American women. Both scholars embody the combined dynamisms that have informed feminist theology in particular and feminist scholarship in general during the past decade. In principle, the passion that has characterized the debates in feminist theology should bring new questions to the

history of American women. Dr. Ruether explicitly and, so far as I can tell, Dr. Keller implicitly, both espouse what, for lack of a satisfactory terminology, might be called a moderate feminist position on theological questions. Dr. Ruether in particular has pioneered in the attempt to establish the persisting meaning of religion for women as spiritually and morally responsible beings without succumbing to the excesses of a separatist feminist theology that would effectively throw out all previous religion on the grounds that its "patriarchalism" has nothing to offer contemporary women. She has, in short, admirably insisted on the responsibility of feminist scholars and theologians to understand the Judeo-Christian tradition in the vital tension between the integrity of its history and its possible meanings for women in the present, in what Dr. Keller has called "new worlds." This perspective has much to offer the history of American women, beginning with an insistence on recognizing women's own religious consciousness and going on to an insistence on the centrality of religion to the history of American women of different races, classes, and faiths. But the execution in these volumes falls far short of the promise.

The history of women and religion in general seems to have fallen between the stools of feminist theology and the new social history. Aspiring to be faithful both to contemporary feminist consciousness and the history of the inarticulate, it has failed to develop questions and methods specific to its own concerns. Ironically, one of the first casualties of this uneasy relation has been theology itself. A second and hardly less significant casualty has been fidelity to historical complexity, especially to the significance of class and racial differences. These failings become especially visible in attempts to reconstruct the religious history of American women, for that history belongs almost entirely to a period (the rise and triumph of capitalism and modern bourgeois society) in which religion itself as a comprehensive ideology or world-view was coming under mounting attacks. Drs. Ruether and Keller and their collaborators seem to have accepted uncritically the prevailing pieties of the consensus school of American women's history and, therewith, to have surrendered the cutting edge of their own potential contributions to questioning, deconstructing, and reconstructing that history. To be blunt, they seem to be "adding" religion to an almost finished picture rather than exploring the ways in which religion might refine and even radically revise the picture.

Martha Tomhave Blauvelt and Rosemary Skinner Keller conclude their essay on "Women and Revivalism: The Puritan and Wesleyan Traditions" as follows: "Eighteenth-century female evangelicalism was so limited largely because of ideological restraints. Women lacked a 'Cult of True Womanhood' to give them confidence in female moral superiority and to unite them

in a holy sisterhood." In addition, they insist, women had not yet appropriated the "implications of the Declaration of Independence—that they, too, had been endowed by their Creator with certain unalienable rights through the birthright of equality." Everything that requires proof is here assumed as given.

Specifically, the assumptions are 1) that women's religious consciousness derived from their entwinement in those "bonds of womanhood" that simultaneously shackled them to the private sphere—the "home" in the modern sense—and linked them emotionally, psychologically, and socially to other women; and 2) that women derived from the Declaration of Independence a compelling model of individualism and of their own potential equality with men. Both assumptions derive from the recent work in American women's history and contribute to our understanding of the experience of Northeastern and Midwestern middle-class white women in the nineteenth century. But, as any student of religion should know, they will not wash as explanations for women's relation to Evangelicalism. What about the galaxy of impressive eighteenth-century female Methodist leaders in Great Britain?

The attempt to tie the religious history of American women to the currently fashionable models of American women's history flies in the face of what we are learning through comparative study of women's relation to religion. Surely, the promise of spiritual equality at some level, or at least hereafter, has constituted one of the premier attractions of Christianity in general and a variety of radical or reforming Christian sects in particular throughout history. Dr. Ruether raises some of these issues in her introduction to the section on women in utopian movements (I, 46–53), but most of the movements she discusses remained peripheral to the mainstream of American Christianity.

The developments in feminist theology have prompted the contributors searchingly to examine the opportunities that religion offered women. The consensus model of American women's history has prompted them to associate those opportunities primarily with women's social activities in the name of religion and their access to positions of leadership within the churches. Parenthetically, the contributors' narrow espousal of the specific model of male dominance fostered by bourgeois society—within and without the churches—has also governed their assessment of the gender relations that predominated among other races. Notably, it has led them uncritically to celebrate appearances of female empowerment among Afro-Americans and Native Americans. I say parenthetically, because these observations remain peripheral to the implicit dominant interpretation of the sections on middle-class white women, and because a full examination of them would require a separate essay.

Neither the developments in feminist theology nor those in consensus women's history separately, or even together, open up the main questions in the religious history of American women, much less do justice to the possible contribution of the study of religion to American women's history. The religious history of American women badly needs renewed attention to the traditional objects of the study of religion—in the first place theology, in a close second the nature of religion as a system of belief.

The introductions in both volumes share a revealing tendency uncritically to associate women with religion, with morality, and with domestic values without ever examining the meaning of the terms or the reasons for their association. Ourselves heirs of bourgeois culture, we tend to take their interchangeability for granted. We find nothing surprising in the shading off of women's religious values into their roles in the world as "Protestant nuns" or temperance advocates or promoters of social reform. It is easy to accept the identification of religion with social housekeeping since so much institutionalized religion has identified itself that way. But that identification, among many others, remains the subject that requires discussion—not the answer. To accept the identification is tacitly to accept the demise of religion as a distinct realm of human experience, albeit one that could influence behavior in other realms. Religion cannot fruitfully be reduced either to a simple reflection or determinant of society, although different religions interact with different systems of social and gender relations. To understand those interactions, we must struggle to understand different religions as distinctive systems of belief.

Barbara Welter's insight about the "feminization" of American religion in the nineteenth century has by now become a commonplace. The refinements of it merely propose moving the origins of feminization back to the late seventeenth century. But simply to note that feminization does not suffice. If, as Ann Douglas has suggested, ministers—at least Northeastern ministers—became increasingly dependent upon the approval of predominantly female congregations, how did that dependence shape their treatment of religious problems? How did it shape their theology? These questions cannot be answered in isolation from the debates about the proper relation between Protestantism and science, or those about the extent of religious, especially biblical, authority in social matters.

The contributors to these volumes tend to agree that mainstream American Protestantism favored the subordination of women to men within the family and the churches, but that women also drew upon religious discourse and values to claim new forms of empowerment for themselves as women. At the very least, their ability to do so suggests that men had abandoned religion as a primary justification for their own class relations. Even in the

industrializing and capitalist Northeast, the divisions were not that simple, but the tendency was there. And the tendency reflected growing, if not always acknowledged, concern about the relevance of theology and the Bible as guides to social and political relations in a capitalist society. Confirmation of the tendency can be found in the persisting attachment of Southern men and women to both theology and the Bible as the proper foundation of all social and political order. Southern women, just as strongly as their men, found much contemporary relevance in the biblical justification of slavery, which they regularly linked to a divinely sanctioned hierarchy in society and in the family. These differences, which go unnoted in these volumes, point to the complexities that are here being homogenized.

These specific complexities point to the importance of theology as what we might call an objective picture of an ordered universe. Religion, as a system of belief, approaches, even if it should not be reduced to, ideology in the broadest sense. And as religions and ideologies differ, so do the possibilities for women's representations of themselves in relation to spirituality and society. So also do their possible languages of self-worth and strategies for the empowerment of themselves as women. Even within Protestantism, theologians differed sharply on essential questions.

The contributors to these volumes make much of women's special relation to Evangelicalism in general and to their appropriation of a religious discourse to their own purposes in particular. Yet nowhere is the unsuspecting reader led to question women's relations to the different Evangelical sects. The Presbyterians, Methodists, and Baptists—to mention only the most influential and numerous of the denominations—all manifested Evangelical tendencies. Of the three, two were, albeit differently, Calvinist, one Arminian. Yet these volumes offer no consideration of the possible attractions of Calvinism or Arminianism for women as women. Was the choice merely individual, or was it influenced by familial, social, or even gender concerns? Is the question of adult versus infant baptism relevant to women's choice of a church? In what ways can we explain women's devoted adherence to the Baptists who have generally remained until our own time the resolute opponents of women's preaching, ordination, and leadership in the church? Do we confuse or clarify the issues by lumping these Baptist women together with the Methodists, who displayed far more tolerance of women's religious leadership? And what about the women who remained with the non-Evangelical Presbyterians or the Episcopalians? Can their choices be explained by considerations of social status? And if so, how are we to balance the social and the properly religious in our assessment of the role of religion in the lives of American women? Where do the Quakers and the Unitarians fit? The complexity may appear overwhelming, but unless we attempt to

tackle it on its discrete religious terrain, how are we to understand the complexity of women's experience and, especially, how they viewed themselves in their world?

My respect for the editors of these volumes and their contributors has led me to be querulous. They have given us the best approximation of a religious history of American women to appear to date. That it is not good enough suggests the magnitude of the intellectual problem. But it also registers a puzzling retreat from the specific problems of religious history or studies. Religions played a vital role in the lives of American women. A fuller understanding of the specific meaning of different religions, as religions, for different women should force important revisions of and advances in American women's history, should help us to take American women's spiritual and intellectual lives with the seriousness they deserve, and should help us to construct a more faithful picture of American culture. With so much at stake, our leading scholars of women and religion cannot afford to accept a ready-made picture of American women's history. They must show us how their special skills and knowledge will help to paint a richer one. Beyond that, they must help us to understand how the religious experience of American women illuminates the specific and changing role of religion in American society. These volumes move beyond the instrumentalist concern with what "patriarchal" religion did to women by addressing the ways in which some women adopted religion as a language and practice appropriate to what they took to be their own distinctive values. There remains the possibility that this development corresponded to momentous changes in our society's view of the nature of and proper sanctions for morality as well as the nature and place of spirituality in our collective life. The changes cannot be understood without close attention to the role of gender—the personal, social, and imaginative relations between men and women as embodiments of our ideas and practices of both the profane and the sacred.

Five

The Claims of a Common Culture

Gender, Race, Class, and the Canon

Frantz Fanon, psychologist and theorist of revolution, once wrote movingly
of the feelings of black children on the island of Martinique who opened
their textbooks to read: "Our ancestors the Gauls. . . ." Such indeed is the
toll of imperialism and colonization. They appropriate the history and the
culture of those they dominate and replace them with metropolitan histories
and culture. To be worthy, to advance, is to think oneself white (or male)—
to accept a new identity, the identity of your conquerors. Fanon, who went
on from his Martiniquais beginnings to a French medical education and im-
mersion in Existentialist philosophy, came to believe that colonized peoples
must throw off European social, political, and, perhaps especially, cultural
domination through a purging violence. To be free—more, to be liberated—
the human spirit must rid itself of the shackles and manacles of other peoples'
traditions, histories, patterns of reasoning, languages. The canon, including
its epistemologies and standards of excellence, must be destroyed, or at least
uprooted from the minds of the colonized.

 Imperialism and colonization, as I think Robert Scholes might agree,
nicely capture the relations between many students and the official culture
that is taken to constitute a liberal education. He nonetheless rejects the idea
that liberal education is—as the conservatives, or reactionaries, would have
it—in crisis. Apparently, he sees no crisis because he distrusts the role of any
canon in a liberal education. Yet surely he would not deny that from the

 This essay originally appeared as part of a forum responding to Robert Scholes, "Aim-
ing a Canon at the Curriculum," *Salmagundi* 72 (Fall 1986): 101–17.

perspective of liberal education as the transmission of a canon—a common culture—crisis indeed there is, if only in the sense of fundamental change. Our culture as a whole suffers from a gap between words and things, between official discourses and the world. That gap has opened the space for the questions and revisions of those like Mr. Scholes who are challenging the status of the canon. The gap strengthens the case of those who view the canon as arbitrary, artificial, and politically biased. Perhaps more alarming, the gap strengthens the case of those who would abolish the canon, the idea of the canon, any canon at all.

The canon, in fact, has never been the true canon, never been the immutable body of sacred texts, that both its defenders and its detractors like to claim. Subject to "vision and revision," it has been modified by successive generations. Moreover, the canon we have inherited, and against which so many are warring, did not always appear so reactionary and repressive. It took shape as a body of privileged texts that encoded the rise and progress of the individual mind as the custodian of knowledge and of standards of excellence. It was closely tied to the notions of individual responsibility in politics. It encoded the triumph of rationality over superstition, of opportunity over acquired status, of universalism over particularism. It provided the common currency of what some called "the republic of letters." Its fashioners and contributors also assumed that membership in the republic would be restricted by gender, race, and class. The few who gained admission on the basis of individual talent were expected to embrace, so to speak, their "ancestors the Gauls."

These days, it does not require any special intellectual or political commitments to take pot shots at the canon. They are coming from all quarters. I do not count myself among those who would destroy it outright, although I do favor substantive revisions both in the canon and in the various survey courses that are intended to transmit it. But I also favor the defense of the idea of the canon, which is to say both the revision of its contents and the transformation of its teaching. For however narrow and exclusive the canon we have inherited, the existence of some canon offers our best guarantee of some common culture. In fact, the teaching of the canon probably offers the best possible way to expose the limitations of the ideals of individualism on which so much of our public life is based, and the best possible way to introduce some notion of collective standards and values.

There is no small irony here. The attacks on the canon derive primarily from the perception that it does not adequately represent the experience and identities of most of those who are expected to study it. The received notion of the responsible, autonomous, elite male individual seems alien to most white middle-class young men. What have Cicero, St. Thomas Aquinas,

Machiavelli, Descartes, John Locke, Voltaire, Dr. Johnson, Goethe, Cardinal Newman, and all the rest to do with J. R. Ewing and Sonny Crockett? And how much more alien to Afro-American and Hispanic-American men, not to mention to women of all classes, races, and ethnic groups? The attack on the canon owes much to the quest for relevance that has its roots not merely in the liberation movements of the nineteen sixties, but perhaps even more in the cynical instrumentalism that accompanied the political conservatism of the nineteen fifties which gave us Holden Caulfield as the alter ego of the man in the grey flannel suit long before we got Mike Nichols' and Dustin Hoffman's graduate.

On the face of it, the demand for relevance in education has its merits. After all, the initial function of the canon was to provide selected individuals with a collective history, culture, and epistemology so that they could run the world effectively. The canon emerged as the privileged texts of what functioned as a collective autobiography, as the foundation for identity. Individuals do require histories, cultures, and epistemologies to make informed choices and to act politically. But at some point the attack on the received canon shifted ground. Increasingly, the attack has been waged in the name of the individual's right to education as a personal history, a parochial culture, and a private epistemology. The worst of it is that the "radical" critics of the purportedly irrelevant canon have sacrificed the ideal of collective identity that constituted its most laudable feature. To settle for education as personal autobiography or identity is tacitly to accept the worst forms of political domination. Fanon was criticizing the substitution of French history for Martiniquais history, the substitution of the history of the imperialist power for that of the colonized people. He was invoking the right of colonized children to their own collective history.

In revising the survey courses in the Humanities, we face a delicate problem. The motivation for revision stems in large part from the alienation of students from the elite culture whose relevance to their own concerns seems obscure. Unless I am much mistaken, we succeed in engaging their imaginations by invoking their own experience. That first step is normally essential to establish any student's relation to the Humanities. But it is not enough. The Humanities, as a curriculum, must also offer the student perspective on his or her personal experience. The primary failure of the canon lies in its no longer appearing to offer that perspective.

Let me proceed by a detour through the problem of cultural crisis. There are those who bemoan the crisis in the interest of restoring lost forms of domination, in particular the public and private cultural domination of elite white men. This nostalgia especially plagues certain kinds of liberal male academics who formed their own sense of self respect from their identification

with a particular canon. Others, less wedded to the specific forms, are reject-
ing the explicitly anthropomorphic form of the dominant culture and are
pressing to substitute a higher level of abstraction and depersonalization.
These developments encompass a multitude of specific tactics: quantifica-
tion, analytic philosophy, deconstruction. They share an explicit distaste for
"bourgeois humanism" and for the personal subject or author. They are
offering us society as text and text as society and both as process or system.
They are contributing to the disillusionment with values that had been tai-
lored to the measure of man. Yet they have done little or nothing to reestab-
lish the accountability of the Humanities to a pluralistic society. In truth,
they resemble nothing so much as the spoiled child who refuses to play at
all if he cannot win. From the perspective of those previously excluded from
the cultural elite, the death of the subject or the death of the author seems
somewhat premature. Surely it is no coincidence that the Western white male
elite proclaimed the death of the subject at precisely the moment at which
it might have had to share that status with the women and peoples of other
races and classes who were beginning to challenge its supremacy.

The point for those who wish to revise the canon to take greater account
of gender, race, and class is that the foundations of the canon they wish to
revise are about as solid as quicksand. Conceivably William Bennett and his
colleagues will succeed in restoring the traditional surveys in something near
their pristine form, but the resistance even from within their own camp will
be strong. And they will find little agreement about which texts incontro-
vertibly belong to the canon. Growing numbers of humanists appear to find
the surveys more problematic than the claims of those the surveys have ex-
cluded. But they seem primarily to wish to attack the very concept of a legiti-
mate canon. In its place, they would prefer to see a thousand flowers bloom.

Yet unless we agree that there is a place for some canon, the apparent
issue of whether or not to introduce gender, race, and class is no issue at all.
We just do it, or refuse to do it—and our decision reflects our personal
whim, or perhaps our character or politics, but little else. Let me offer you
a paradox: It may well be those who reject the narrowness of the established
canon, but who remain committed to the validity of some canon, of some
collection of texts that reflects a common culture, who are the true custodi-
ans of liberal education or of the humanities. For those who insist on
expanding the canon and transforming the surveys take seriously the politi-
cal function of a humanistic education. They also probably believe that such
an education must be accountable to its constituents.

Myths serve poorly as foundations for identity, much less political action.
We do our students no favor by pretending that the past consisted in the
popular cultures of laboring people or the personal writings of elite women.

We do them no favor by ignoring kings and presidents and famous philosophers and those who earned reputations as great writers. A return to the metaphor and the reality of colonization will illustrate the point.

Fanon's emphasis on purging violence derived at least in part from his understanding of the compelling hold of European ideas and institutions on the minds of the colonized. As a psychologist, he believed that an outpouring of anger would help to restore the colonized's possession of their own minds—would exorcise the demons of centuries of domination and dependency. Mao Tse Tung acted on a similar insight when he encouraged the Chinese peasants to kill their former landlords. We could debate the value of such strategies for revolutionaries, but our conclusions would not necessarily apply to the teaching of surveys. And, in any event, developments around the world, notably in China, clearly demonstrate that social revolutionaries and ex-colonial peoples above all need control of Western, that is capitalist, technology and science. The challenge remains to appropriate those techniques, or that technical knowledge, without becoming mired in the social values with which they were initially entwined. However elusive the connections, Western society did engender the scientific and industrial revolutions: They did not, as has been argued for some other inventions, originate by spontaneous combustion in different parts of the globe.

Very likely, our students feel colonized in relation to that elite Western culture that has constituted the backbone of our humanistic education. Female and minority students in particular are, as it were, being asked to look at someone else's picture and acknowledge it as their own mirror image. To throw out the canon does not solve their problem any more than expurgating all traces of Western technology solves the problems of colonial peoples. From one perspective, throwing out the received histories and culture only makes things worse. For, if you do not include a heavy dose of the history of elite males, how do you explain why women and members of minorities are not running the world? One of the more difficult tasks facing those who have been excluded from the corridors of political and intellectual power is to accept the history of their oppression or exclusion and to transform it into a base for future action. In other words, to transform the canon and the surveys in response to changing constituencies has less to do with rewriting the story than with reinterpreting it.

All of the humanities address problems of values and human relations, problems of authority and freedom in society. The humanities as a canon, or a body of key texts, has taken shape in conjunction with the rising commitment to humanism as a form of individualism. The texts that have dominated the canon for at least the past century have privileged the ideals of responsible individualism, rationalism, and universalism. The emphasis on

generalization and universalism are decisive. They betray the extent to which the canon was developed as a weapon in the struggle against hierarchy, dependence, and particularism—the extent to which the canon we have inherited has been associated with the history of Western notions of individualism.

The texts that constitute the canon, like the narratives that structure the surveys, owe their status to a process of selection. Although discriminations remain difficult, the criteria for selection seem to involve some uneasy mix of assessment of quality, theme, and representativeness. Those who defend and oppose changing the inherited canon would doubtless insist primarily on the standards of quality. The texts, or at least the authors, included enjoy their position as a result of their incontestable superiority of craft, reasoning, and execution. They are the best. Next, they develop central themes in Western culture. Finally, they can be seen as representative of that culture.

In deep ways, these claims are untrue or at best only partially true. The problem of quality remains the most difficult, and should not be dismissed as trivial. But even if one accepts that there may be reasons of quality for reading Cervantes or Lope de Vega or Shakespeare or Kant, one should recognize that those standards of quality are not absolute, [but] result from cultural and social values. The problems of theme and representativeness are more socially corrupted yet. Theme probably offers the best avenue to the transformation of both the canon and the narrative. For if the rise of individualism does constitute a central theme in the development of both capitalism and modern culture, it hardly constitutes the only one. For openers, the theme of individualism invites a skeptical rereading. And with respect to representativeness, the canon fails woefully. It represented a small, sometimes minute, portion of the elite, which itself constituted a statistical minority of the population.

I agree entirely with Mr. Scholes' insistence on teaching the Humanities in historical context. Indeed, that context offers the best—indispensable—way to introduce students to the tension between the tradition and the society that engendered it. Some recent tendencies in scholarship, and not merely on the right, have frowned upon the reduction of texts to the putative influences that shaped them, and have favored a return to something resembling the new criticism that viewed texts as irreducible entities that should be taken on their own terms. But there is a broad ground between the purist view of the text and the reduction of text to the life of its author. Texts can, legitimately, be taught as articulations of the societies that produced them. The strategy rests on the assumption that all authors are, in some sense, hostage to the society and culture in which they live. In this respect, authors work with the images and questions that lie to hand. Consequently, it becomes legitimate to probe a text for what it does not say as

well as for what it does say. It also becomes legitimate to query the functions of the text in its broader context. Texts vary in their explicit indications of their own contexts and silences. In instances in which the familiar texts present a seamless front, in which they fiercely resist their own deconstruction, other texts can be substituted.

Take a couple of familiar texts: Thomas Hobbes' *Leviathan* and John Locke's *Second Treatise on Government*. Both explicitly address the notion of sovereignty during the period of the English Revolution. Both rank as classics of political theory. On the simplest level, Hobbes can be taught as an apostle of authority, John Locke as an apostle of reasonable freedom. Centuries of commentary have swathed the texts in conflicting readings, including conflicts about their authors' possible relations to specific political parties. Commentaries notwithstanding, both can be rendered compelling and even relevant to students. On the assumption that both Hobbes and Locke accepted the essentials of what C. B. Macpherson has called "possessive individualism," both can be shown to have responded differently to its implications. For Hobbes, the growth of individualism warranted an increase in centralized authority. Individuals sacrificed their sovereignty upon entering society in order to enjoy the benefits of peace. Locke saw individualism as grounded in labor, including the congealed labor of absolute private property, and, therefore, as presocial. In his reading, sovereignty resided in the individual and his property, which government could only represent. These familiar outlines acquire new meaning when subjected to an analysis of gender. Both Hobbes and Locke assumed that the individual was male. Both also openly discussed the relation of women to that individual and, perhaps more interesting, to individualism in general.

Both Hobbes and Locke repudiated the venerable notion that woman's inferiority to man derived from Eve's curse. To accept that religious justification for women's subordination would have been to accept the religious foundations for political sovereignty, as propounded by Sir Robert Filmer. Both also rejected the related argument from patriarchy. Hobbes pointed out that according to his model of the state of nature as the "warre of all against all," women, like weak men, could kill strong men through cunning. This argument for equality between the genders in nature did not lead him to advocate their equality in political society, although he came close to advocating a kind of equality in submission to absolute authority. But in addition to that submission, he suggested that women contractually subordinate themselves to men in the interests of protecting their children. Locke was less generous. Having also admitted an original equality of women with men, he rapidly passed to the assertion that "law and the customes of the country" had, in practice, instituted women's political subordination to individual men.

Hobbes' and Locke's texts on government meet every standard of quality. Their place in the most conventional version of the canon would hardly be contested. Yet, these texts lend themselves to a serious discussion of the relations between gender and political theory. It is not even necessary to stretch the intentions of the authors, since both Hobbes and Locke clearly viewed the relations between the genders as a cornerstone of any polity. More important, in contributing to a revolutionary bourgeois political theory, both thinkers found it necessary to postulate the theoretical equality of women to men—however rapidly they brushed that theoretical equality aside. To read their texts in the light of that theoretical necessity is to open up innumerable questions about the relations between gender relations and political relations. In effect, Hobbes and Locke were precociously attacking the time-honored notion of female inferiority. They did not repudiate the political and social necessity for the subordination of women, but they justified it on new grounds and, in so doing, opened the way to subsequent notions of female individualism and equality.

The case of Hobbes and Locke demonstrates that canonical texts frequently dealt with gender. But how representative were their concerns? Furious arguments have been waged over their specific political affiliations, but, however interesting, those potential affiliations do not exhaust the subject. For Hobbes and Locke probably did articulate important tendencies within their society. And the significance of those tendencies should not be reduced simply to how many others held their views. Hobbes and Locke both had an intuitive grasp of the nature and implications of emerging capitalism. They brilliantly perceived the erosion of traditional social and political relations and the pressing need for some new form of analysis. No, peasant men and women doubtless did not share their views, doubtless had not even heard of them, frequently were not even literate. Assuredly peasant and even artisanal men remained deeply attached to notions of female inferiority and subordination. The case of the Levellers during the Civil War further suggests that solid laboring people did not even believe that servants should be allowed to vote. But in their case too, changing discourses opened opportunities for discussion. For the Levellers did not tolerate outmoded notions of deference and hierarchy. They did not cotton to divinely or humanly ordained structures of social inferiority. They did believe that to be a responsible member of the community an individual must have a direct stake in it, must not depend upon the will of another man. The critique of dependence would have a long career and culminate in the campaign for the abolition of slavery. Hobbes' and Locke's ideas of individualism lay at the core of that ideological current. If Hobbes and Locke did not directly represent the thought of the common man or woman, they assuredly did both respond

to the social and political changes of their era and formulate the ideological currents in the name of which successive struggles for fuller social and political participation would be waged.

The representativeness of canonical texts can be addressed on various levels. We can adopt a version of the techniques of reader-oriented criticism and ask whom the authors of the texts thought they were addressing. An overwhelming percentage of our canonical texts have a polemical edge. Their authors are arguing in favor of one or another position. So what did authors argue for, whom did authors argue against, and who was likely to compose their readership? The next step concerns the more general relation of authors' ideas to the ideas of their epoch. Here, we can turn to an (admittedly less than precise) analysis of correspondence: Specific formulations of ideas relate to other formulations of ideas. We cannot establish a causal relation between the two but we can identify the correspondences and frequently even the likely paths of dissemination.

In this perspective, it may be rash to insist on too sharp a distinction between high and popular culture. The canonical texts of much of the Western tradition took shape against the backdrop of a predominantly oral popular culture. Indisputably, some intellectuals wrote only for other intellectuals— or clerics. But they did not write in isolation from the culture of the people amongst whom they lived.

The possible correspondences between the texts of the canon and the broader culture at best suggest only that elite culture had something to do with the society from which it derived. Elite culture did not express the intentions, feelings, or perceptions of laboring people and rarely those of women, even elite women. Especially from the Renaissance on, elite culture tended to generalize from the experience of a very small group of men whom it identified with humanity, or "man." Yet we can teach elite culture from the perspective of gender, race, and class if we are prepared to accept attention to issues of gender, race, and class as proxies for the subjective testimony of those excluded from the most exalted cultural roles. For some, that is a big "if." For some would, understandably, prefer to abolish the status of elite culture entirely.

Yet that elite culture functioned in relation to women, the lower classes, and some non-white races analogously to the way in which imperialism functioned for colonized peoples. At worst, it denied the values and perceptions of all others and imposed itself as an absolute standard. It also exercised a powerful hegemony. Since those who developed it spoke in the name of power, progress, and, increasingly, rationalism, it commanded emulation or excited envy merely by virtue of that power. Even those who most intransigently opposed the individuals or classes for which it spoke frequently

sought to claim its benefits for themselves. It is at least possible that significant numbers of intellectual women sought to "think like a man" because men had successfully identified themselves with the most sophisticated and compelling modes of thought. The successful identification is the point.

The canon, however we constitute it, can best be taught if it is recognized at least in part as a kind of political spoil. The canon, or the power to speak in the name of the collectivity, results from social and gender relations and struggles, not from nature. Those who fashioned our collective elite tradition were the victors of history. Their ability to write as authorities derived from their social and political position—not so much as individuals but as members of a gender, a class, a race. Their victory constitutes an important feature of all our histories. If we remain bound to their accomplishment, they remain bound to our subordination. Hegel's discussion of the master and the slave hits the mark.

No definition of the canon could fail to include authors who did not produce texts that can appropriately be subjected to the analysis of gender, class, and race. Gender remains the easiest to decode, for gender constituted a primary category of social and cognitive organization for most peoples. Class and race pose greater, but hardly insurmountable, challenges. We can, with little difficulty, select texts by standard canonical authors that address issues of gender, race, and class. We can, in the spirit of contemporary theory, view teaching as an exercise in hermeneutics: We reread our texts from the perspective of contemporary concerns. In addition, we can transform the entire focus of conventional courses by the themes we select. If one rejects all the pieties about the rise and triumph of the individual as the manifestation of progress and civilization, one can, for example, look closely at the tension between freedom and authority for society at large; one can focus on the shift from particularism to universalism; in short, one can present the individual as the problem rather than the solution.

In addition to reinterpreting or thematically reorganizing the canon, we can also expand it, although not necessarily by substituting, say, popular ballads for elite texts. Because access to literacy was so frequently limited by gender and class, we do not have a large pool of women, working people, and members of non-white races to draw upon. Furthermore, the case of lower class white men proves that the elite had enormous powers of absorption. To the extent that women were excluded from the organizations that engendered various professional discourses, especially philosophy, they were unlikely to have written much that could compete with the professionals. Or, to be blunt, women's opportunities more often than not led them to write in the margins of, when not in outright opposition to, the dominant culture. And when opportunity permitted them to write within it, they were

very likely to preach, as Queen Elizabeth I did, women's necessary subordination to their husbands—if not to ignore women and gender entirely. But the rare exceptions to these general trends deserve a general recognition that they too infrequently receive. Christine de Pizan, Mary Wollstonecraft, and Harriet Taylor Mill, to name only the most obvious, belong in the canon. As we move beyond 1850, the choices become more numerous. Virginia Woolf is a current favorite, and legitimately so. But we also have Harriet Jacobs, George Eliot, Charlotte Perkins Gilman, Simone de Beauvoir, and Rosa Luxemburg. And I am only picking at random. We also have Frederick Douglass, Richard Wright, Sembene, and Fanon.

Excluded and oppressed groups are, by definition, largely excluded from membership in the republic of letters. The excellence on which that republic has so prided itself remains profoundly bound by gender, race, and class. Its honorary members have normally been asked to leave their origins at the door. But it is in the nature of a vibrant culture to offer more than it intends. Modern criticism reminds us that even a reactionary text may raise contradictions that it imperfectly resolves.

Mr. Scholes, in a spirit that is hard to fault, concludes with an impassioned plea for the intrinsic interest of all forms of "human expressiveness" and for the claims of local conditions in determining the selection of texts. But if the spirit is touching, the politics are misguided. Mr. Bennett is, in this respect, correct. The status of the canon is of large political significance. The canon has faltered, in large measure, as a consequence of the unprecedented expansion of higher education in our time. The unpleasant implications of Mr. Bennett's proposals lie not in his attempt to shore up the canon, but in his related—and thinly veiled—determination to reverse that expansion and restrict access to higher education. To defend the claims of personal experience and local culture in the face of that attack is to fall victim to his sophisticated strategy. The challenge is not to condemn quality as anti-democratic (a sure formula for defeat), but to reclaim it for a reinvigorated national democracy.

Six

Strategies and Forms of Resistance

Focus on Slave Women in the United States

Harriet Tubman, Sojourner Truth, Linda Brent, Ellen Craft: History has preserved the names of women who resisted slavery in a variety of ways. Jane, "a mulatto woman, slave," who was indicted for the murder of her infant child, also may be taken to have resisted, albeit presumably at a high cost to herself. And her name is on record for those who are willing to seek it in the appropriate court records. Those records, like the diaries of such white women as Mary Boykin Chesnut, the narratives of slave men, and the various ex-slave narratives, also provide those who seek a poignant record of the varieties of female slave resistance.[1] Perhaps more telling yet, they bear witness to the resistance of women, whom the record keepers did not even deem worthy of being named at all: "the Rolling-house was maliciously burnt by a Negro woman of the Defts. [defendants] whereof she was Convicted . . . and Executed for it." The court was unwilling to convict the woman's master, deciding that he "is not Chargeable for the willful wrong of his servant."[2]

Such testimonies to women's opposition to enslavement, or to those who enslaved them, shed an invaluable light on the resistance of Afro-Americans as a people, as well as on slave women themselves. Not least, they help us to fill out the record of multiple forms of resistance—a subject to which I shall return. Perhaps more important yet, they demonstrate that the slaveholders, including, and indeed especially, those most deeply committed

to a paternalistic ideology, recognized on some level the intentional resistance of their bondwomen: The nameless female arsonist was "malicious" and "wilful." Perhaps the slaveholders knew in their hearts that she differed only in degree from the house servant, whom they dubbed "impudent" and "uppity." But the records provide, at best, an imperfect guide to the nature, extent, and meaning of slave women's resistance to their enslavement.

The fortieth anniversary of the publication of Herbert Aptheker's pioneering study *American Negro Slave Revolts* provides an especially appropriate context in which to consider the role of slave women in the resistance of Afro-Americans to their enslavement.[3] For Aptheker, long before the emergence of women's history in its contemporary guise, insisted upon recording the presence of women among slave rebels wherever he found it. He may rank among the few historians of his generation to have understood that any people includes both men and women, and to have written history as if it resulted from the combined efforts of men and women. I can find no place in *American Negro Slave Revolts* in which women should have been included and were not.[4] If anything, Aptheker errs in the opposite direction. One suspects that at least occasionally he added "and women" following "men" because his human instinct, knowledge of the world, and commitment to women's social significance told him that women must have participated in forms of resistance, even if the records did not mention them. His willingness to credit women's contribution to the resistance of the enslaved cannot, in short, be questioned. But even his determined quest for evidence of women's participation did not unearth a plethora of forgotten female leaders of revolts; in fact, he found few specific female names. Women figure primarily as members of groups of resisters, or embodiments of specific forms of resistance. Historians of Afro-American women have recently called attention to what we might call gender-specific forms of female resistance that Aptheker did not directly address.[5] But resistance, although an essential dimension of his work, was not his main story.

That main story concerned revolts. And in telling it, Aptheker demonstrated, beyond contention, that Afro-American slaves not merely resisted degradation and dehumanization but revolted against their enslavement. Aptheker's critics have suggested that he may have exaggerated the number and significance of slave revolts, but their very differences with him have implicitly underscored his central point, namely, that some slaves, under the most adverse circumstances, engaged in armed political struggle—armed class struggle, if you prefer. The point at issue between Aptheker and these critics concerns how best to distinguish full-scale revolts from ubiquitous acts of violent resistance. The very existence of this debate confronts historians of slave women with the problem of how to interpret the role of slave women

in the collective struggle of their people. For North American slave women appear not to have participated significantly in the direct planning and execution of the most explicitly political revolts of the nineteenth century, notably those of Gabriel Prosser, Denmark Vesey, and Nat Turner.[6] And women probably also did not participate in large numbers, if at all, in the smaller but explicitly military insurrections, or attempted insurrections, that punctuated the eighteenth and early nineteenth centuries.[7] Yet however we ultimately draw the line between revolt and non-insurrectionary resistance, the explicitly political and military revolts cannot be understood in isolation from the backdrop of steady resistance that could, at any moment, be both collective and violent, and in which women indisputably did not participate. Recognition of these two aspects of the struggle against slavery helps to establish a viable context for a preliminary assessment of the role of slave women in the resistance of Afro-American people.

It is impossible to discuss the specific roles of women in the general struggle of Afro-American slaves without taking account of male and female roles—gender roles—among the slaves. Gender roles, like gender relations, among the slaves remain a topic of considerable debate, and insufficient study. Scholars are slowly beginning to acknowledge that notions of what it means to be a man and what it means to be a woman, as well as the notion of appropriate relations between the two, are among the most sensitive and deeply rooted aspects of any individual's or any people's sense of identity. But to date, most of the attention to gender relations among Afro-Americans, under slavery and thereafter, has focused on discussions of family life. This ideologically charged literature has taken as its standard middle-class, Euro-American ideas of normal, in contrast to pathological, male and female roles and relations. Even at its best, and at its most appreciative of Afro-American cultural vigor, it has assumed that commitment to nuclear families and to companionate marriages under firm male leadership offers the most convincing evidence of health and stability. The Afro-Americans' struggle to defend these values under adverse conditions is presented as evidence of the slaves' successful resistance to the most brutal and dehumanizing aspects of enslavement.[8] But the discussion has not adequately assessed the perturbing problem of the extent to which these norms derived from African traditions, or the extent to which they reflected white values. Nor has it fully penetrated the yet more perturbing problem of the sources of and the links between behavior and belief: Masters could impose some forms of behavior on their slaves and encourage others, but the slaves retained considerable latitude to endow those forms that they adopted or observed with their own meanings. It remains extremely difficult to ascribe precise measures to the respective parts of African traditions and American conditions

in Afro-American practice and belief, all the more since the slaves' experience of American conditions led them to reinterpret African traditions.[9] It remains more difficult yet to determine the extent to which slaves appropriated any of the values of American culture and, to the extent that they did, the degree to which they modified them to conform to either their experience of enslavement or their transformed African values. If the discussion, at this level, appears abstract, it nonetheless casts a long shadow over the possible history of slave women in resistance and revolt. Let us consider a concrete example: If slave women can be shown to have been decisively more active in resistance and revolt than their white counterparts in time and place, should their activity be attributed to the survival of African patterns of female strength—and, if so, which ones—or to the demoralizing impact of enslavement on male leadership and authority? For the moment, the point is less to solve the problem than to recognize that it is highly charged.

The truth is that we have no comparative study of the role of slave women in resistance, and no consensus about what would constitute an appropriate comparative framework. Comparison of women's roles in the slave revolts throughout the New World would elucidate an additional dimension of those revolts, and of the various slave systems.[10] Comparison of the roles of slave women in revolts with the roles of women in the revolts of other oppressed peoples and popular classes would presumably add an important element to our understanding of the dynamics of popular rebellion in different societies, and assuredly contribute to our understanding of women's participation in different peoples' resistance to oppression. But this work has not yet received sustained attention. Some recent scholarship is beginning to compare the experience of Afro-American women to that of North American white women, but has not yet addressed specific outbreaks of violent class struggle.[11] Nonetheless, recent work on the multiple contributions of women to war, resistance, and revolution among various peoples at various times leaves no doubt that women have everywhere and at all times participated in the struggles of peoples for national liberation and self-determination. Analogous work on class struggles also reveals the ubiquity and importance of women's contributions. In any particular struggle, women can be found in almost any role, from leadership to armed combat to spying to providing a variety of support services. In struggles for national or class liberation, it is not uncommon for at least some women to depart radically from what are taken to be normal female activities among their people. It is uncommon, historically, for women to assume primary leadership of armed combat, or even to engage directly in combat on a regular basis—but women have done both. It is, in short, probably safe to say that there is no form of insurrectionary struggle in which some women have not, at some time,

engaged. But that being said, it is also true that historically, as in the con-
temporary world, women are less likely than men to assume the political and
military leadership of the struggles for liberation of their people and class.[12]

Whatever women's roles in the struggles of the oppressed against their
oppression have been, they have been singularly difficult to document, espe-
cially among nonliterate peoples. Sources on the role of slave women in
resistance and revolt have proved especially sparse, and those that exist must
be recognized as themselves the product of a continuing historical struggle.
Most of the early sources are white. In assessing them, we must take account
of the blinders that white assumptions imposed on white perceptions. White
commentators may well have missed many female contributions to resis-
tance because they did not expect them. Enslaved and oppressed peoples, as
Frantz Fanon so movingly demonstrates in "Algeria Unveiled," are quite
prepared to capitalize on the "invisibility" of their women in the interests of
a victorious struggle.[13] Many of the other sources on Afro-American slave
revolts derive from black men who were actively engaged in a total struggle.
For such men, their testimonies concerning events constituted part of that
struggle. It is not impossible that they borrowed more than the ideology of
revolution and democratic rights from the emerging Euro-American ideol-
ogy of their period. It is also not impossible that they have drawn especially
on those African traditions that emphasized the leadership of men in politi-
cal and military affairs. Whether drawing upon one or the other of these cur-
rents, or combining the two, black men may—consciously or unconsciously,
and for a variety of reasons—have made a political choice to prefer the lead-
ership of men in the struggles of the enslaved.

If the nature of the sources shapes our perceptions of slave women's
contributions to resistance and revolt, the conditions of enslavement, which
were also those of struggle, shaped the historical possibilities for slave men's
and women's actual contributions to resistance and revolt. And however
much we have learned to recognize the role of slaves in setting limits to their
oppression and in shaping their own lives, the master class did establish the
conditions. Those conditions varied according to time, place, and size of
plantation, but, overall, scholars concur that they never invited the kind of
massive rebellions or establishment of maroon societies that occurred else-
where in the Western Hemisphere.[14] I cannot in this essay begin to do jus-
tice to the impact of variations in size and location of plantations on women's
roles in resistance and revolt, although it must have been considerable. But
however much the conditions imposed by individual masters varied, they also
fell within the general structures of prevailing legal and political relations,
and of a society that can, in important respects, be viewed as a network of
households that included the decisive productive as well as reproductive

relations.[15] These general structural conditions changed significantly over time. From the perspective of slave revolts and resistance, the most important changes probably occurred toward the first third of the eighteenth century, as the fluidity and experimentation of early settlement gave way to more rigid structures that reflected the greater stability and will to ordered domination of white society, and following the wave of revolution that characterized the late eighteenth century. Both of these shifts confronted slaves with an increase in the resolution and sophistication of white society, but both—especially the second—also offered slaves new sources of collective identity and purpose as Afro-Americans. The net result can perhaps best be grasped in the tendency of nineteenth-century slave revolts to claim the explicit political purpose of realizing for Afro-Americans the promises of the new democratic ideology of individual freedom. And by the time that the slaves were claiming this message for themselves they indeed constituted a distinct Afro-American people—creoles who had become the only self-reproducing slave population in the New World.

The following preliminary discussion of the role of slave women in resistance rests on a series of working assumptions—all of which must be advanced tentatively. (1) However hard it may be to draw the lines, violent resistance and revolt should be distinguished. Revolt, to paraphrase Clausewitz, is the continuation of violent resistance by other means. (2) The relation between violent resistance and revolt changed over time, with the decisive shift occurring in the late eighteenth and early nineteenth centuries when the slaves appropriated for themselves the ideology of democratic revolution. (3) The African legacy, if difficult to identify precisely, made a central contribution to slave women's self-perceptions and hence to their patterns of resistance. (4) White culture and institutions constituted the conditions of oppression and hence shaped the patterns of resistance. (5) Although it is not uncommon that a cataclysmic struggle against oppression encourages the temporary disregard of prevailing gender roles, it is more than likely that a protracted struggle of resistance will build upon and shape the continuing life of a people, including its gender roles. In short, the resistance activities of women are likely to reflect their roles as women, as much as their commitment to resistance. Or, to put it differently, though women may fight as soldiers, they will normally resist as women. (6) Any attempt to understand the resistance of slave women as women must acknowledge the dreadful paucity of sources that testify directly to those women's self-perceptions. If we can make a preliminary attempt to identify women's patterns of behavior, we must simultaneously recognize that we have very limited evidence of the meaning that the women themselves attributed to their behavior. (7) Any assessment of slave women's resistance must make a

preliminary and cautious attempt to understand the complex relation between the resistance of the individual and collective resistance and to attempt to identify the institutions and movements through which women might have contributed directly, as opposed to indirectly, to collective resistance.

The fragmentary sources and partial, if growing, scholarship on the middle passage, the early period, and other New World slave societies strongly suggest that in the early periods of enslavement women were likely to participate in nearly direct proportion to their numbers—which were fewer than those of men—in revolt and violent resistance. Certainly on the slave ships, women, whom white slavers chose to see as more docile than men, enjoyed greater freedom of movement than men and were, consequently, well positioned to play important roles. Then, as later, their occasional betrayal of revolts can at least be taken as an indication of their participation in, or proximity to, the planning of them.[16] The fragmentary evidence from the early period of settlement further suggests that arrival in the New World did not dissipate the rebelliousness many women had evinced on the middle passage. In fact, at least some women appear to have rebelled or resisted in whatever way available, whenever the opportunity offered itself or could be seized. But precise patterns remain difficult to establish. High demographic casualties among both black and white populations, as well as increasing importations of fresh Africans themselves from different peoples and states, delayed the establishment of distinct social patterns. There is no reason to doubt that during this early period, which was characterized by a constant influx of Africans and the complex class and race relations of a slave society in the making, women rejected their enslavement as wholeheartedly as men. Nor is there any special reason to believe, given the patterns of African slave trading, that women necessarily made the crossing or began life in the Americas in the company of the men of their families and communities. It is more than likely that the violent removal first from their native societies and then from Africa not merely separated women from the men of their kinship but also at least temporarily disrupted accepted patterns of relations between men and women. Many women must have confronted their enslavement as uprooted individuals. And the white society into which they were introduced may not yet have developed, or been able to implement, a fixed notion of the gender relations and roles appropriate to their new servants. With a firm eye on rapid profits, many planters proved entirely willing to exploit female slaves to the limits of their physical endurance—if not beyond—with little regard to the niceties of male and female tasks. The forms of female resistance in this early period may safely be taken to have been as varied and as violent as the complexity of the class, race, and gender relations of an emerging, frontier slave society.[17]

The increasingly cohesive slave society that emerged during the eighteenth century, especially in Virginia and South Carolina, generated considerably more information on the resistance and rebellion of slaves, just as the slaveholders manoeuvred more systematically to set about mastering and to prevent revolts by their slaves. With slaves distributed, however unevenly, throughout the colonies, slave revolts occurred throughout them as well. The records of these revolts testify to women's participation in them, and frequently to their leadership as well. There was, for example, the revolt in Louisiana in the early 1770s, after which Mariana received one hundred lashes and lost her ears for her part. Although with respect to white perceptions, it is worth noting that she received a substantially lighter punishment than did the men, Temba and Pedro, despite her apparent status as leader.[18] But women could be punished as severely as men for their roles in conspiracies, or for suspicion of having committed arson. Frequently they were burned alive.[19]

The eighteenth century witnessed the emergence of forms of violent resistance, notably arson and poison, that would characterize the entire antebellum period. Women regularly played their part, or were accused of so doing, in these activities. Peter Wood has argued that in the wake of the Stono Rebellion in South Carolina the white ruling class systematically curtailed the de facto liberties that the slaves had theretofore enjoyed. The comprehensive Negro Act of 1740 deprived slaves of those personal opportunities to which they had never been entitled, but had nonetheless seized under the frontier conditions of the early years of the colony: "freedom of movement, freedom of assembly, freedom to raise food, to earn money, to learn to read English."[20] This legislation, and above all the determination of the masters that it represented, established the ownership and discipline of slaves as a matter of class, not merely individual, responsibility. It may also have sharpened the distinction between male and female forms of resistance and revolt if only by systematizing the constraints of enslavement and thus making some forms of women's activities more visible. Or, to put it differently, it may have begun to subject female slaves to the same structural constraints that relegated white women to households and male supervision.

The case of runaways suggests that slave society hedged in women even more stringently than men. At least the scholars who have analyzed the advertisements for runaways during the eighteenth century have found far fewer women than men: Wood estimated one woman to three men during the middle decades of the century; Gerald Mullin found that 11 percent of the advertisements for runaways that specified gender were for women in Virginia between 1736 and 1801.[21] It would be rash to conclude, on the basis of this evidence, that women were intrinsically more reconciled to slavery

than men. More likely, for reasons discussed below, they had more trouble in passing unobserved outside the plantation. But it is also possible that the fewer ads for female runaways also reflected masters' assumptions that a temporarily missing female had not really run away, but might only have gone to visit kin in the neighborhood. An advertisement from the *Carolina Centinel* [*Sentinel*] of New Bern, North Carolina, in 1818, requested help in securing the return of a female runaway who had already been known to be absent for a considerable period of time during which she had been "harboured" by slaves on various plantations in the neighborhood.[22] Another advertisement from the *Virginia Gazette* of Williamsburg, in 1767, sought assistance in securing the return of a female slave who clearly had been anything but docile: "Hannah, about 35 years of age, had on when she went away a green plains [*sic*] petticoat, and sundry other clothes, but what sort I do not know, as she stole many from the other Negroes." Hannah was further described as having remarkable "long hair, or wool," and being "much scarified under the throat from one ear to the other," and having "many scars on her back, occasioned by whipping." The master clearly regarded Hannah as a serious runaway. "She pretends much to the religion the Negroes of late have practised, and may probably endeavor to pass for a free woman, as I understand she intended when she went away, by the Negroes in the neighbourhood." He believed that under the pretense of being a "free woman" she was heading for Carolina.[23] The two ads reflect the combination of actual conditions and masters' perceptions: A slave woman might "visit" neighboring plantations, where she would disappear among the other slaves without causing comment or provoking a search, at least initially. If she undertook serious flight, she would probably have to attempt to pass for a "free woman" in order to have a plausible reason to be abroad. To be sure, some women did run away to join groups of maroons, but probably in far fewer numbers than men, and probably with diminishing frequency as the possibilities for establishing maroon societies were eroded. Women also, like men, ran away to the British during the Revolution.[24]

The evidence from the eighteenth century remains difficult to interpret. There has been little work on slave women during the eighteenth century, and none on their roles in resistance and revolt specifically. Given the continued influx of new Africans, we can be sure that African influences played a more direct role than they would after the closing of the trade. But we lack adequate studies of the nature of those influences on gender roles and relations. Recently Afro-American and Pan-African feminists have begun to call attention to the importance of women's roles and the degree of women's authority and autonomy in African societies. They have correctly reminded us of the prevalence of matrilineality and matrifocality among West African

peoples, and of the presence of queens and female leaders among them. The example of Nanny the Maroon in Jamaica has also been advanced as evidence of women's leadership in New World revolts.[25] As I have tried to suggest, the evidence from the middle passage, the early period, and the eighteenth century testifies to women's active participation in resistance and revolt. But other evidence suggests that from very early, and certainly by the time of Stono, some forms of revolt were considered primarily male affairs. No record survives, for example, of a female leader during the Stono Rebellion itself. Furthermore, scattered evidence indicates that at least some organized insurrections assumed a distinct military and masculine cast. The Stono Rebellion began with twenty black men who marched southwest toward St. Augustine with "colors flying and two drums beating." Vincent Harding emphasizes the importance that those rebellious slave men attached to their having become soldiers: "Sounding the forbidden drums, they were warriors again."[26] African history offers reason to believe that African women might fight as soldiers, but it also suggests that Africans normally viewed warfare as primarily an affair of men. It is, in short, probable that even during the early period African arrivals and Afro-Americans themselves assumed that armed insurrection constituted an essentially male activity.[27] The conditions imposed by white society, not to mention the whites' own visible commitment to male soldiers, can only have reinforced the Afro-American's indigenous tendencies to ascribe warfare to men.

As the eighteenth century gave way to the nineteenth, a series of interrelated events set the distinctive contours of antebellum slave society in the Southern states. In their various ways, the American Revolution, the French Revolution, the revolution in St. Domingue, the invention of the cotton gin, the closing of the African slave trade, and more set Southern society on the course that would lead through the development of a mature slave society to the conflagration of war with a rapidly developing industrial capitalist society. These developments established not merely the social relations within which slave resistance became endemic but also the terrain on which the great slave revolts of the period 1800–1831 would be launched, and they drew the lines within which slavery and its abolition would become national issues. Not incidentally, the same period also witnessed the consolidation of the bourgeois ideology of gender roles in general, and the distinctive Southern ideology of the lady—to be distinguished from the Northern ideology of true womanhood—in particular. Although there is scant reason to believe that Afro-American slaves grasped that ideology to their breasts, there is some reason to believe that its development had indirect consequences for the role of slave women in resistance. Assuredly, the implementation of the Southern ideal of the lady included a tendency to confine women to households

and to discourage their freedom from a male "protection" that imposed special burdens and limitations on slave women.

The consolidation of North American slave society, for well-examined reasons, hedged in Afro-American slaves. The role of maroons and other groups of outlyers (runaway slaves) declined. Spontaneous violent revolts of large numbers of slaves probably also declined—although Aptheker might disagree. But the political character and self-consciousness of those revolts that did materialize were heightened. Revolt seems to have become even more a specialized political and insurrectionary male responsibility. And resistance, which became the very essence of the system, fell into some recognizable patterns. As the slaveholding class attempted to impose its own paternalistic ideology upon the enslaved, and to encourage the reproduction and expansion of the slaves, it also seems to have made a minimal effort to apply general notions of gender roles in its treatment of slaves and allocation of tasks. The gender ideology of the master class bore no organic relation to the values of the slaves themselves, although they too had their own ideas of manhood and womanhood. Moreover, with respect to their slaves, the masters clearly observed the ideology of gender difference erratically and according to their own convenience. Nonetheless, the existence of notions of gender difference and gender roles among the masters and the slaves clearly shaped the distinctive patterns of female resistance.

If we are to believe our sources, black women's resistance to slavery was much more likely to be individual than collective. The cumulative effect of individual acts of resistance did contribute decisively, as both Aptheker and Genovese, who follows him on this matter, argue, to the undermining of the system from within and to the confrontationist attitudes of the slaveholders without, but I do believe that the implications of the individual acts of resistance varied and that all must be distinguished from explicitly collective resistance. Furthermore, the characteristic forms of individual female resistance differed somewhat from those of men, perhaps because of Afro-American attitudes toward womanhood, certainly because of opportunities offered and denied by white-dominated slave society. Male and female forms of resistance differed most in those instances in which the physiological differences between the genders were most significant and in those instances in which the attitudes of the slaveholders toward gender roles most directly affected the opportunities available to the enslaved. The most difficult problem consists in identifying Afro-American attitudes toward the respective gender roles of men and women, and identifying the specific African components in those attitudes.

By the time that antebellum slave society assumed its mature form, African gender attitudes are not likely to have appeared in their original form.

Like all other aspects of Afro-American culture, African attitudes toward gender had been transformed and reinterpreted in the light of American experience—the discrete experience of the slaves as well as the possible influence of white practices and values. Obviously, male and female physiology constituted the bedrock of gender differences, and physiology did distinguish between some forms of resistance that were specific to slave men and slave women. Women's reproductive capacities offered both special opportunities for resistance and some possible deterrents against particular forms of resistance. If Afro-American attitudes toward gender began with the slaves' own interpretation of physiological differences, they also must have been shaped by the gender distinctions imposed by the conditions of life in a slave society. Whether or not the slaveholding class could influence Afro-American belief, it could assuredly influence Afro-American practice. To the extent that masters distinguished between male and female slaves—and they did in innumerable ways—male and female slaves enjoyed gender-specific opportunities for specific kinds of resistance and revolt. It seems likely that those conditions also encouraged slaves to reinterpret their African values, and perhaps slowly to include some elements of white attitudes toward gender in their own distinct emerging world view.

But let me begin with those forms of resistance that were least differentiated by gender. To the extent that slaveholders pressed women into the same kinds of heavy labor in the fields and in clearing ground as they did men, women seem to have resisted in the same ways as did men. The breaking of tools and the challenging—even the murdering—of overseers were not the monopoly of male slaves. Such sources as we have clearly demonstrate—and I shall return to the point—that female slaves took enslavement and wanton oppression personally. In 1857, a slave, David, appealed his conviction for the murder of the overseer whom he had assisted another slave, Fanny, in killing. Prior to the act, Fanny had been heard to say that she was not about to allow that overseer to mess in her affairs—and the affairs in question had nothing to do with sexual exploitation.[28] Men's and women's conspiring together to kill overseers, and indeed masters, was nothing new. In December 1774, the *Georgia Gazette* of Savannah reported the "following melancholy account, viz."

> That on Tuesday morning the 29th ult. six new Negro fellows and four wenches, belonging to Capt. Morris, killed the Overseer in the field, after which they went to the house, murdered his wife, and dangerously wounded a carpenter named Wright, also a boy who died the next day; they then proceeded to the house of Angus McIntosh, whom they likewise dangerously wounded; and being there joined by a sensible fellow,

the property of said McIntosh, they went to the house of Roderick M'Leod, wounded him very much, and killed his son, who had fired upon them on their coming up and broke the arm of the fellow who had joined them. Their leader and McIntosh's negro have been taken and burnt, and two of the wenches have returned to the plantation.[29]

The incident provides much to reflect upon. To begin with, why did the white authorities not see fit to punish the "wenches" as severely as the men? There is nothing surprising in recently arrived Africans' banding together at the point of visible oppression—labor—to strike out at their oppressors. There is also nothing surprising in the persistence of such resentment and violence against overseers, as immediate oppressors, throughout the ante- bellum period. But such concerted actions, which began in the fields, seem to have been less common during the nineteenth century. Furthermore, at least on large plantations, during the nineteenth century masters seem to have frequently organized men and women into different work gangs, even if the women undertook work as heavy as that of the men.[30] At this point, it is difficult to determine the precise reasons for the masters' gender-specific organization of labor gangs. It may only have reflected a desire to cut down on distractions among the slaves during work hours. It may possibly have reflected an attempt to apply the masters' own notions of male and female spheres—however imperfectly—to their slaves. But it assuredly diminished the opportunities for collective male and female resistance at the point of production. When Fanny and David acted together, they did so, as it were, after hours. But even if male and female slaves did not often engage in col- lective violent resistance in the fields, there is ample evidence that among field hands, especially on large plantations on which life in the quarters re- mained sharply separated from life in the big house, female slaves frequently resisted their enslavement in much the same ways as did male slaves.

In a crude way, we could say that female slaves resisted as laborers harsh conditions of labor and unusual abuse of the power to supervise labor. Yet even as laborers, female slaves had recourse to forms of resistance normally denied male slaves. The extent to which the slaveholders attributed social significance to the womanhood of their female slaves—the extent to which they attempted to implement gender distinctions—limited the ways in which those slave women might resist, but also offered them special opportunities for resistance. The gender relations and norms of white society made it un- likely that female slaves would be trained for most of the specialized crafts or hired out for jobs that would provide them with an excuse for mobility. Female slaves were unlikely to become carpenters, blacksmiths, masons, or coopers, or to acquire skills in comparable specialized crafts that would lead

them to be hired around. And the pool of skilled craftsmen provided not merely the leadership for the most important slave revolts but also the largest number of fugitives. Even those female slaves who did receive specialized training, as cooks or seamstresses, for example, would be expected to remain not merely within plantation households but largely within houses. Since female slaves, like white women, were not expected to be abroad unaccompanied, they enjoyed far fewer opportunities for successful flight, unless they dressed as men.

Yet specialization of skills according to gender offered female slaves other opportunities for resistance. As cooks and house servants, they were in a privileged position for poisoning. And there can be no doubt that the ubiquitous fear of poison decisively contributed to exacerbating the disquiet of the slaveholding class. Plantation letters and diaries abound with references to poisonings, and testify to the uneasiness of the whites. Poison could not always be detected as the cause of death, but was frequently suspected. One slave woman poisoner, "an old sullen house negress," was identified when she complained to a fellow slave, who reported, of having misjudged the necessary amount of arsenic: "I thought my master and mistress would get enough, but it was not sufficient."[31] Another slave woman profited from her specialized position as a nurse to poison an infant and to attempt to do the same to her master. She was burned alive in Charleston, together with the man who supplied the poison.[32] These acts of resistance occurred after the South Carolinians had made a concerted attempt to curtail slaves' knowledge of and access to drugs by an addition to the Negro Act in 1751. The legislation prescribed punishment for any black who should instruct another "in the knowledge of any poisonous root, plant, herb, or other poison whatever, he or she, so offending shall upon conviction thereof suffer death as a felon." It also prohibited physicians, apothecaries, or druggists from admitting slaves to places in which drugs were kept, or allowing them to administer drugs to other slaves.[33] This kind of legislation, and the cautious spirit it reflected, may have decreased whites' mindlessly introducing slaves to the nature and use of medicinal drugs, but probably did not abolish the practice entirely. Slave women did serve as nurses on large plantations, and as midwives. It is also clear that slave women must have transmitted knowledge of poisonous herbs down through the generations. But white precautions, together with the gender conventions that assigned slave women to kitchens and to nursing, may have resulted in poisoning's becoming an increasingly female activity.

The position of slave women within the big house gave them uncommon access to the goods of the slaveholders. It is widely recognized that cooks and other house servants supplemented the diets of their near and dear from the

storerooms of the masters. An occasional house servant, such as Clara, could scour the big house for bullets for a son who intended to murder his master. Clara's son succeeded. And she was convicted with him.[34]

The position of slave women within the big house further permitted them special kinds of psychological resistance, the consequences of which are almost impossible to assess. Impudence and uppitiness did constitute forms of resistance that provoked responses disproportionate to the acts. House servants proverbially tried the patience and the nerves of mistresses to whom it fell to oversee their work. Since the mistress lacked the full authority that adhered to the master of the plantation, her relations with her servants could easily lapse into a kind of personal struggle. When servants compounded sauciness and subtle disrespect with a studied cheerful resistance to accomplishing the task at hand, the mistress could rapidly find herself losing control—of herself as well as her servant. "Puttin' on ole massa" must have been, if anything, more trying in its female embodiment. In 1808, a group of South Carolinians acknowledged the undermining potential of mockery in their request to the legislature that slave apparel receive the serious attention it deserved: The citizens of Charleston argued that the dress of persons of color had become so expensive "as to tempt the slaves to dishonesty; to give them ideas not consistent with their conditions; to render them insolent to the whites, and so fond of parade and show as to [make] it extremely difficult to keep them at home." They should only be allowed to wear coarse materials. Liveries were another matter, for they, no matter how elaborate, constituted a badge of servitude. But it was necessary "to prevent the slaves from wearing silks, satins, crapes, lace muslins, and such costly stuffs, as are looked upon and considered the luxury of dress." For an orderly slave society required that "every distinction should be created between the whites and the negroes, calculated to make the latter feel the superiority of the former."[35] But slave women who worked in the big house were uniquely positioned to resist that message, to undermine the distinctions, and to make the lives of privileged mistresses an unending war of nerves.

Slave women could also take advantage of their special role as reproducers to resist various forms of labor through shamming. Although male slaves too could fake illness, female slaves could and did claim pregnancy when they were not pregnant, and claim unusual discomfort or weakness when they were pregnant. The tactic did not always work, but frequently it did, and if it undoubtedly reflected a simple desire to be relieved of labor—not to work—it also reflected a marvelous challenge to the master: You want me to reproduce as a woman, treat me as a woman. John Campbell's recent study of the treatment of pregnant slaves on George J. Kollock's Georgia plantations demonstrates that, at least in this case, the records suggest that the

master did give the benefit of the doubt to pregnant slave women, especially in their third trimester, and that this latitude helps to account for the successful self-reproduction of Afro-American slaves in the antebellum South.[36] So this particular form of female resistance did more than alleviate the workload of the individual slave woman: It contributed to strengthening her people.

The relation between slave women's roles as mothers and their resistance to enslavement has generated considerable interest, albeit with contradictory conclusions. If none doubts that slave women frequently took advantage of real or claimed pregnancy to avoid labor, some have argued that they also practiced abortion and infanticide as systematic resistance to the perpetuation of the system. Court records do reveal prosecution of slave women for infanticide. And surely some cases of infanticide and numerous abortions escaped the attention of the masters and authorities. But Michael P. Johnson has recently, and convincingly, questioned whether all cases of infant death that were attributed to infanticide should have been. His discussion of the Sudden Infant Death Syndrome (SIDS) suggests that the death of slave infants by apparent smothering should be linked to their mother's labor in the fields rather than to any attempt to deprive the system of slave infants.[37] In any event, it would be difficult to argue that infanticide and abortion dealt a decisive blow to a slave society that boasted a self-reproducing and expanding slave population. And those who argue for resistance against reproduction—if it occurred with any frequency—must take into account the well-documented attachment of slave mothers to their children. It may be that some slave women practiced abortion and infanticide and that other slave women did or did not run away because of attachment to their children. But it is difficult to fit these contradictory patterns into a single explanation for female slave resistance, much less a general explanation of the significance of that resistance. We have no way of knowing whether slave women practiced abortion—and perhaps infanticide—selectively: Could they, for example, have been more likely to terminate pregnancies, if not lives, that resulted from the sexual exploitation of white men? That, indeed, would have been resistance—perhaps the primary resistance with which to counter the predatory sexuality of white men. At the present state of research, we can, at best, say only that the sexual vulnerability and reproductive capacities of slave women influenced the ways in which they resisted. We can say little about the social significance that they attached to that womanhood.[38]

The list of slave women's acts of resistance to their enslavement in particular and to the slave system in general could be extended indefinitely. Some scholars, notably Deborah Grey White and Darlene Clark Hine and Kate Wittenstein, are beginning to address that history.[39] As women, female

slaves engaged in various forms of resistance associated with their sexuality and reproductive capacities. As female slaves, they especially engaged in poisoning and theft, and were much less likely than male slaves to be fugitives or even truants. Although when they did become truants, they could melt into the slave community of another plantation, which may hint at special links among women that bound slave kin and fictive kin networks. As slaves, they engaged in murder, arson, and grand larceny. However deeply their acts of individual resistance undermined the slave system, their direct contribution to political revolt appears to have been considerably less than that of men. In short, the current state of scholarship—that is, the current reading of available evidence—suggests that female slaves, for reasons closely associated with their gender, were more likely to engage in individual than collective resistance in the period following the consolidation of North American slave society and the beginnings of an Afro-American revolutionary tradition.

But this bald assessment will not do, even for a preliminary reading. The very use of the categories of "individual" and "collective" forces us to ask other questions—with full recognition that the answers will depend upon a fresh look at the sources. For a broad gap separates the random acts of individual resistance from the political and military resistance of revolt. And if we accept Aptheker's general assessment of the systematic and cumulative resistance of Afro-American people to their enslavement, we must force ourselves to identify and understand the networks and institutions through which that people forged itself as a people and supported the efforts of its most self-conscious rebels against slavery as a social system.

As Vincent Harding has especially insisted, the various records of revolts invariably make some mention of churches or funerals or religious gatherings as a backdrop for revolt itself. As we all know, there is wide acknowledgment of secret black churches and religious meetings and networks. The significance of religion in the forging of Afro-American culture can hardly be disputed.[40] But my point here is somewhat different. In my judgment, the churches and secret religious networks undoubtedly provided the institutional links between acts of individual resistance and revolts in the name of collectivity. And women were integral members of those churches and religious associations. If our sources seem not to have revealed the roles of women in continuing, collective resistance, it may be that we have not read them with the most interesting questions in mind. It seems obvious enough that those who were caught and tried for their leadership in the great revolts would not mention the networks and institutions on which their plans depended. Why sacrifice brothers and sisters needlessly? Even more, why jeopardize the future revolts of the enslaved by betraying their collective underground organizations? Long-term resistance had to have some collective

focus, and its institutions and networks had to remain invisible to the oppressor. But recognizing the likelihood that such institutions and networks bound the daily lives of individuals to the most spectacular attacks against the system that oppressed them, we must also recognize the certainty of women's integral participation in them.

This recognition itself commands a further effort of research and imagination. Albert Raboteau explicitly and other scholars of Afro-American religion implicitly have minimized the importance of women's roles in the leadership of slave religion. Female religious leaders surfaced occasionally, especially in New Orleans and in conjunction with the persistence of voodoo. But slave women appear not to have become preachers and leaders of Afro-American Christianity—certainly not in large numbers. It is nonetheless difficult to believe that informal—and perhaps formal—associations of women, or sisterhoods, did not take shape in association with slave religious communities. Especially after the prohibition of separate black churches, such associations would likely have been as secret as the congregations to which they were linked. But Betty M. Kuyk's recent work on black fraternal orders in the United States opens new possibilities. For she finds that the black men's associations that took shape so rapidly during Reconstruction had roots in slavery, and beyond slavery in African culture.[41] If men's organizations, why not women's? Such gender groupings are reasonably common in societies in which gender constitutes one of the principal forms of social organization, as it did among many West African peoples. But for all the reasons advanced throughout this essay to explain the greater constraints on slave women than slave men, notably, the conditions of gender divisions within the dominant white society, should such women's organizations have existed in whatever form, they would surely have been even less visible than those of men. Deborah Grey White has been insisting on the importance of the female community of slaves in work and as the locus of female traditions of rites of passage, motherhood, and female identity.[42] It appears at least plausible that the community of female slaves generated some kind of religious sisterhood, however fragile and informal. At the least, it remains indisputable that slave women saw themselves as sisters in religion, as essential members of the religious community of slaves. To the extent that the religious community provided the context or underpinnings for the revolts, the women of that community constituted its backbone—not least because not being active members of the revolt they did not risk being cut down with their brothers, but would persist and keep the tradition alive.

The preoccupations of historians have, perhaps, mirrored the biases of antebellum white Southerners and of subsequent bourgeois ideology in missing the contributions of slave women to collective violent resistance and

even insurrectionary revolts. By the same token, they may also have failed to take adequate account of the full individual opposition of slave women to their enslavement. There is a danger to which we all, including women's historians, are vulnerable in insisting upon the specific experience of women as women: We can miss the recalcitrant and determined struggle of the individual soul or consciousness against reduction to the status of thing. It has become a commonplace that slave women suffered under a double burden of enslavement as workers and as women. I should be the last to dispute that harsh truth and, indeed, shall argue shortly that its implications for the growing commitment to antislavery were decisive. But first, let me point out that, however deeply slave women themselves felt their exploitation and vulnerability as women, they also seem to have insisted, in the end, on their oppression as slaves. Despite the extensive commentary that has arisen from Judge Thomas Ruffin's celebrated decision in *State vs. Mann,* there has been almost no comment on the gender of the slave who provoked the action that led to the case. Lydia "had committed some small offence, for which the Defendant undertook to chastise her—that while in the act of so doing, the slave ran off, whereupon the Defendant called upon her to stop, which being refused, he shot at and wounded her." The Supreme Court of North Carolina acquitted the white man. In Ruffin's words: "The Power of the master must be absolute to render the submission of the slave perfect."[43] Power and submission: The conflict here is one of wills. Happily, we possess direct confirmation of a slave woman's perception of that conflict as one between the will of her master and her own.

Harriet Jacobs, who published her narrative under the name of Linda Brent, structured her entire account of her escape from slavery as a remorseless and unmediated struggle against the imposition of her master's will. Although the narrative includes much on her sexuality and her children, and her master's sexual designs upon her—so much as to have earned it a description as a modern *Pamela*—in the end everything falls by the wayside except her own refusal to accept the imposition of his will. Her womanhood accounts for many of the specific forms of her oppression, but not for her rejection of oppression. And that refusal of his will was the refusal of his power, the refusal to submit perfectly, or indeed at all. Psychologically, her struggle with her master is one with the most celebrated revolts. The object is not to ease oppression, to lighten a burden, even to protect loved ones: The object is to reject slavery.[44]

The Brent narrative is all the more remarkable for being cast in the language of Northern, sentimental domestic fiction. Brent, ably seconded by the editorial efforts of Lydia Maria Child, apparently intended to ensure the recognition of her tale by Northern, middle-class women, who were steeped in their own culture's pieties of vulnerable womanhood. But her tactical

adoption of the literary conventions does not obscure the inner logic of her account, which remains not the violation of womanhood but the conflict of wills. Withal, the rhetoric of the Brent narrative has its own significance and adds a final dimension to the resistance of slave women. Northern abolitionists insisted on assessing slavery from the perspective of their own concerns. And the growing success of their opposition to the slave system depended in no small measure on their casting it as the antithesis of their own bourgeois values—presented as absolute moral standards. To their credit, they did flatly oppose enslavement. But as abolition swelled to join a more general antislavery movement, the emphasis fell increasingly upon the inherent opposition between slavery and the work ethic, slavery and initiative, slavery and democracy. In this context, the growing perception of the exploitation of slave women as a violation of the norms of true womanhood gained in importance. However deeply Northern women may have misperceived and misinterpreted the experience of slave women by imposing on them white, middle-class norms, their very misrepresentations added indispensable fuel to Northern opposition to slavery and thus, albeit ironically, added a discrete female component to that national resistance which would result in the abolition of slavery.

Notes

1. C. Vann Woodward, *Mary Chesnut's Civil War,* New Haven, 1980; Arna Bontemps (ed.), *Great Slave Narratives,* Boston, 1969; George P. Rawick (ed.), *The American Slave,* vols. 2–19, Westport, CT, 1972; and Solomon Northup, *Twelve Years a Slave,* ed. by Philip S. Foner, New York, 1970, among many.

2. Helen T. Catterall (ed.), *Judicial Cases Concerning American Slavery and the Negro,* Washington, DC, 1936, I:1, 84.

3. Herbert Aptheker, *American Negro Slave Revolts,* New York, 1943.

4. Aptheker, *Negro Slave Revolts,* e.g., 84, 89, 92, 127, 138, 148, 181, 201, 259. Aptheker does not pay special attention to women's gender-specific forms of resistance, but systematically includes them as challenges to the system.

5. Darlene Clark Hine and Kate Wittenstein, "Female Slave Resistance: The Economics of Sex," in Filomina Chioma Steady (ed.), *The Black Woman Cross-Culturally,* Cambridge, 1981, 289–300; and Gerda Lerner, "The Struggle for Survival—Day to Day Resistance," in Lerner (ed.), *Black Women in White America: A Documentary History,* New York, 1973, 27–45. Other scholars have discussed the gender-specific form of slave women's oppression, but not paid much attention to related forms of resistance; for example, Angela Y. Davis, "Reflections on the Black Woman's Role in the Community of Slaves," *Black Scholar,* 3 (December 1971), 3–15; and *Women, Race, and Class,* New York, 1981; bell hooks, *Ain't I a Woman: Black Women and Feminism,* Boston, 1981; and Jacqueline Jones, "'My Mother Was Much of a Woman': Black Women, Work, and the Family under Slavery," *Feminist Studies,* 8:2 (Summer 1982), 235–270. For women's roles in day-to-day resistance, see Raymond A. Bauer and Alice H. Bauer, "Day to Day Resistance to Slavery," *Journal of Negro History,* 27 (October 1942), 388–419.

6. Aptheker, *Negro Slave Revolts*, and Vincent Harding, *There Is a River: The Black Struggle for Freedom in America,* New York, 1981. These general studies, like specific studies of individual revolts, simply do not mention female participants, although both Aptheker and Harding are exemplary in mentioning women in those cases in which the records even hint at their presence. See also, among many, Richard C. Wade, "The Vesey Plot: A Reconsideration," *Journal of Southern History,* 30:2 (May 1964), 143–161; Robert S. Starobin, "Denmark Vesey's Slave Conspiracy of 1822: A Study in Rebellion and Repression," in John Bracey et al. (eds.), *American Slavery: The Question of Resistance,* Belmont, CA, 1971, 142–158; William Freehling, *Prelude to Civil War: The Nullification Controversy in South Carolina, 1816–1836,* New York, 1966, 53–60; *An Account of the Late Intended Insurrection among a Portion of the Blacks of This City,* Charleston, 1822, repr. 1970; Joseph Cephas Carroll, *Slave Insurrections in the United States 1800–1865,* New York, 1938, repr. 1968; John Lofton, *Insurrection in South Carolina: The Turbulent World of Denmark Vesey,* Yellow Springs, OH, 1964; John B. Duff and Peter M. Mitchell (eds.), *The Nat Turner Rebellion: The Historical Event and the Modern Controversy,* New York; 1971; Stephen B. Oates, *The Fires of Jubilee: Nat Turner's Fierce Rebellion,* New York, 1975; and Thomas Wentworth Higginson, *Black Rebellion,* ed. by James M. McPherson, New York, 1969. For contemporaneous testimony, see John Oliver Killens (ed.), *The Trial Record of Denmark Vesey,* Boston, 1970; and Henry Irving Tragle (ed.), *The Southampton Slave Revolt of 1831,* New York, 1973.

7. Aptheker, *Negro Slave Revolts,* and Harding, *There Is a River,* like Peter Wood, *Black Majority: Negroes in Colonial South Carolina from 1670 through the Stono Rebellion,* New York, 1974, do not make a point of women's absence from these military bands, but their evidence clearly indicates that women did not belong to such bands. But women, as Aptheker and Harding show, clearly did participate in other kinds of collective risings. See Daniel Horsmanden, *The New York Conspiracy,* ed. by Thomas J. Davis, Boston, 1971.

8. Among many, see, Eugene D. Genovese, *Roll, Jordan, Roll: The World the Slaves Made,* New York, 1974; Herbert G. Gutman, *The Black Family in Slavery and Freedom, 1750–1925,* New York, 1976; John Blassingame, *The Slave Community: Plantation Life in the Antebellum South,* rev. ed., New York, 1979; Leslie Howard Owens, *This Species of Property: Slave Life and Culture in the Old South,* New York, 1976; George P. Rawick, *The American Slave: A Composite Autobiography,* 1, *From Sundown to Sunup: The Making of the Black Community,* Westport, CT, 1972; and Robert W. Fogel and Stanley L. Engerman, *Time on the Cross,* 2 vols., Boston, 1974.

9. For an excellent analysis of this process, see Sydney W. Mintz, *Caribbean Transformations,* Chicago, 1974, esp., "Afro-Caribbeana: An Introduction." See also Lawrence Levine, *Black Culture and Black Consciousness: Afro-American Folk Thought from Slavery to Freedom,* New York, 1977.

10. Steady (ed.), *Black Woman,* provides a comparative perspective on the experience of African and Afro-American women, but not on the role of women in revolts in the different New World societies. Richard Price (ed.), *Maroon Societies: Rebel Slave Communities in the Americas,* Garden City, NY, 1973, provides some information on women in different maroon societies.

11. For example, Deborah Grey White, "'Ain't I a Woman?' Female Slaves in the Antebellum South," Ph.D. dissertation, University of Illinois at Chicago Circle, 1979; and Suzanne Lebsock, "Free Black Women and the Question of Matriarchy: Petersburg, Virginia, 1784–1820," *Feminist Studies,* 8:2 (Summer 1982), 271–292. Much of the

comparison between the experience of black and white women concerns the postbellum period; see, for example, Cynthia Neverdon-Morton, "The Black Woman's Struggle for Equality in the South, 1895–1925," in Sharon Harley and Rosalyn Terborg-Penn (eds.), *The Afro-American Woman: Struggles and Images,* Port Washington, NY, 1978, 43–57; and Terborg-Penn's "Discrimination against Afro-American Women in the Woman's Movement, 1830–1920," in Harley and Terborg-Penn (eds.), *The Afro-American Woman,* 17–27.

12. Carol Berkin and Clara Lovett (eds.), *Women, War, and Revolution,* New York, 1980; Stephanie Urdang, *Fighting Two Colonialisms: Women in Guinea-Bissau,* New York, 1979; Juliette Minces, "Women in Algeria," in Lois Beck and Nikki Keddie (eds.), *Women in the Muslim World,* Cambridge, 1978, 159–171; and Mangol Bayat-Philipp, "Women and Revolution in Iran, 1905–1911," in Beck and Keddie (eds.), *Women in the Muslim World,* 295–308.

13. Frantz Fanon, "Algeria Unveiled," in *A Dying Colonialism,* New York, 1965.

14. Price (ed.), *Maroon Societies;* Eugene D. Genovese, *From Rebellion to Revolution: Afro-American Slave Revolts in the Making of the Modern World,* Baton Rouge, 1979; Aptheker, *Negro Slave Revolts;* and Aptheker, "Additional Data on American Maroons," *Journal of Negro History,* 32 (October 1947), 452–460. Cf. Barbara Kopytoff, "Jamaican Maroon Political Organization: The Effects of the Treaties," *Social and Economic Studies,* 25 (June 1976), 87–105; and her "The Early Political Development of Jamaican Maroon Societies," *William and Mary Quarterly,* 35 (April 1978), 287–307; and Orlando Patterson, "Slavery and Slave Revolts: A Socio-Historical Analysis of the First Maroon War, 1655–1740," *Social and Economic Studies,* 19 (September 1970), 289–325, among many.

15. Elizabeth Fox-Genovese, "Antebellum Southern Households: A New Perspective on a Familiar Question," *Review,* 7:2 (Fall 1983), 215–253.

16. Harding, *There Is a River,* 3–23, passim; Daniel P. Mannix and Malcolm Cowley, *Black Cargoes: A History of the Atlantic Slave Trade,* New York, 1962; Basil Davidson, *The African Slave Trade,* Boston, 1961; Lorenzo Greene, "Mutiny on Slave Ships," *Phylon,* 5 (January 1944), 346–354; and Darold D. Wax, "Negro Resistance to the Early American Slave Trade," *Journal of Negro History,* 51 (January 1966), 1–15. Elizabeth Donnan, *Documents Illustrative of the Slave Trade to America,* 4 vols., New York, 1935, repr. 1965, contains many references to women's activities on the middle passage.

17. Wood, *Black Majority;* Gerald W. Mullin, *Flight and Rebellion: Slave Resistance in Eighteenth-Century Virginia,* New York, 1972; Edmund S. Morgan, *American Slavery, American Freedom: The Ordeal of Colonial Virginia,* New York, 1975, esp. 295–337; Philip Alexander Bruce, *Economic History of Virginia in the Seventeenth Century,* New York, 1895, repr. 1935, II, 57–130; James Thomas McGowan, "Creation of a Slave Society: Louisiana Plantations in the Eighteenth Century," Ph.D. dissertation, University of Rochester, 1976; Jack D. L. Holmes, "The Abortive Slave Revolt at Pointe Coupee, Louisiana, 1795," *Louisiana History,* 11 (Fall 1970), 341–362; James H. Dorman, "The Persistent Spectre: Slave Rebellion in Territorial Louisiana," *Louisiana History,* 18 (Fall 1977), 389–404; and Allan Kulikoff, *Tobacco and Slaves: The Making of Southern Cultures* [(Chapel Hill: University of North Carolina Press, 1986)].

18. Harding, *There Is a River,* 39; and Catterall (ed.), *Judicial Cases,* III, 424.

19. For example, Wood, *Black Majority,* 292; Aptheker, *Negro Slave Revolts,* 90–91, 189–190, 242, 281; and Harding, *There Is a River,* 61.

20. Wood, *Black Majority,* 324–325.

21. Ibid., 241; and Mullin, *Flight and Rebellion,* 40.

22. Ulrich B. Phillips (ed.), *Plantation and Frontier Documents, 1649–1863,* Cleveland, 1909, repr. 1965, II, 90.

23. Ibid., 93.

24. Chester W. Gregory, "Black Women in Pre-Federal America," in Mabel E. Deutrich and Virginia C. Purdy (eds.), *Clio Was a Woman,* Washington, D.C., 1980, 53–72. Benjamin Quarles, *The Negro in the American Revolution,* Chapel Hill, 1961, contains passing references to women (e.g., 27, 120–121), but pays special attention to black men's participation in the war.

25. Lucille Mathurin, *The Rebel Woman in the British West Indies during Slavery,* Kingston, 1975; Alan Tuelon, "Nanny—Maroon Chieftainess," *Caribbean Quarterly,* 19 (December 1973), 20–27; Joseph J. Williams, S.J., *The Maroons of Jamaica,* in Anthropological Series of the Boston College Graduate School, III: 4, Chestnut Hill, MA, 1938, 379–480; and Rosalyn Terborg-Penn[, "Black Women in Resistance: A Cross-Cultural Perspective," in *In Resistance: Studies in African, Caribbean, and Afro-American History,* ed. Gary Y. Okihiro (Amherst, Mass.: University of Massachusetts Press, 1986), 188–209].

26. Harding, *There Is a River,* 35.

27. Basil Davidson, *Black Mother: The Years of the African Slave Trade,* Boston, 1961, e.g., 151–152; and his *A History of West Africa to the Nineteenth Century,* with F. K. Buah and the advice of J. F. Ade Ajayi, Garden City, NY, 1966; and Paul Lovejoy, *Transformations in Slavery: A History of Slavery in Africa,* Cambridge, 1983, esp. 66–87, 108–128.

28. Catterall (ed.), *Judicial Cases,* II:1, 206–207.

29. Phillips (ed.), *Plantation and Frontier,* II, 118–119.

30. Edwin Adam Davis (ed.), *Plantation Life in the Florida Parishes of Louisiana, 1836–1846, as Reflected in the Diary of Bennet H. Barrow,* New York, 1943, throughout refers to "women" doing thus and so, frequently spinning; and Phillips (ed.), *Plantation and Frontier,* I, "Extracts from journal of the manager of Belmead Plantation, Powhaton County, Virginia, 1854," e.g., 213–214, "Women cleaning water furrows . . . ," "Women open water furrows . . . ," and "Men and Women grubbing the Land too hard frozen to plough."

31. Wood, *Black Majority,* 292.

32. Ibid.

33. Ibid., 290. See Thomas Cooper and David J. McCord (eds.), *The Statutes at Large of South Carolina,* 10 vols., Columbia, 1836–1841, VII, 422–423.

34. Catterall (ed.), *Judicial Cases,* II:1, 241–242.

35. Phillips (ed.), *Plantation and Frontier,* II, 113. The citation is from the "Memorial of the Citizens of Charleston to the Senate and House of Representatives of the State of South Carolina [Charleston 1822]."

36. John Campbell, "Work, Pregnancy, and Infant Mortality among Southern Slaves," *Journal of Interdisciplinary History,* 14:4 (Spring 1984), 793–812.

37. Hine and Wittenstein, "Female Slave Resistance"; and Michael P. Johnson, "Smothered Slave Infants: Were Slave Mothers at Fault?" *Journal of Southern History,* 47 (1981), 510–515.

38. Bauer and Bauer, "Day to Day Resistance," 50–57. Angela Davis and bell hooks (see references in note 5, above) emphasize the sexual exploitation of slave women, but do not discuss this in relation to slave women's resistance.

39. Hine and Wittenstein, "Female Slave Resistance"; and Deborah Grey White, "'Ain't I a Woman?'"; and her "Female Slaves, Sex Roles, and Status in the Antebellum Plantation South," *Journal of Family History,* 8:3 (Fall 1983), 248–261.

40. Harding, *There Is a River,* 55, but throughout; Genovese, *Roll;* and Mechal Sobel, *Trabelin' On: The Slave Journey to an Afro-Baptist Faith,* Westport, CT, 1979.

41. Albert J. Raboteau, *Slave Religion: The "Invisible Institution" in the Antebellum South,* New York, 1978, minimizes the role of women throughout, but see references on 79 and 238. Betty M. Kuyk, "The African Derivation of Black Fraternal Orders in the United States," *Comparative Studies in Society and History,* 25:4 (October 1983), 559–592. See also Bennetta Jules-Rosette, "Women in Indigenous African Cults and Churches," in Steady (ed.), *Black Woman,* 185–207, which focuses on the recent past and the contemporary period.

42. White, "Female Slaves."

43. Catterall (ed.), *Judicial Cases,* II:1, 57.

44. Linda Brent [Harriet Jacobs], *Incidents in the Life of a Slave Girl,* ed. by Lydia Maria Child, new ed. by Walter Teller, New York, 1973, orig. 1861. For the identification of Brent as Harriet Jacobs, and as her own author, see Jean Fagan Yellin, "Written by Herself: *Harriet Jacobs' Slave Narrative,*" *American Literature,* 53:3 (November 1981), 479–486. The Brent narrative should be compared with that of Ellen Craft, who was no less determined, but who ran dressed as a man and in the company of her husband. See her "Running a Thousand Miles for Freedom; or, The Escape of William and Ellen Craft from Slavery," in Bontemps (ed.), *Great Slave Narratives.*

Literary Criticism and the Politics of the New Historicism

In recent years, literary critics, surfeited with the increasingly recognized excesses of post-structuralist criticism in its various guises, have discovered history. Or rather, lest one suspect them of a regression to simplicity, they have discovered "historicism." In this enterprise they have, it should in fairness be noted, been wonderfully aided and abetted by a growing number of historians who, for their part, are reveling in this new attention to their own crisis-ridden discipline. A bastard child of a history that resembles anthropological "thick description" and of a literary theory in search of its own possible significance, this "new historicism" consists in a plethora of converging, but also conflicting, tendencies within cultural studies broadly construed.[1]

This move offers an unexpected opening to call contemporary literary theory to the bar of that history on which it had (albeit building on a long formalist precedent) previously declared war. The critics' war on history had its own logic, for the history they had received did not admit of happy endings. Heirs to the whimpering collapse of bourgeois individualism, they sought to wrest victory from apparent defeat by themselves proclaiming the primacy of sign and texts and the attendant deaths of author, subject, and all extra-textual selves. Their project captured the mood of our own, and all other post-heroic, times. Like innumerable predecessors, they sought to

claim for the epigones the mantles of the giants. In so doing they raised technique over substance, analysis over narrative, and critic over author. Indeed, pressing the limits of credibility for all but the votaries of fashion, they announced that technique had subsumed substance, analysis narrative, and, most important, critic author. There they were standing not, as Newton would have had it, on the shoulders of giants, but sitting, as the second Napoleon pretended—recall Marx's epigram about the second time—on the imperial throne. Yet, as those of us who recognize history as the most demanding of mistresses could have told them, history herself would sooner or later confront them with the naked recognition: The Emperor has no clothes.

History will not down easily: She never does. But her returns are protean, disguised, and no more salutary than we make them. Today's "new historicism" is clearly viewed by its proponents as a good thing. Not one to gainsay this heartening rush of enthusiasm, I cannot withal let it go unchallenged. For the proponents of the new historicism have yet fully to clarify either the "good" or the "thing" of their devotion. History, like criticism, must sooner or later answer to judgment, to discrimination, and, however unfashionable the term, to meaning.[2]

Tellingly, the diverse practitioners of the new historicism have yet to issue a manifesto or even a clear statement of their respective purposes. If the new historicism has an official organ, it would appear to be the journal *Representations*, which brings together historians and literary critics in a colorful carnival of cultural readings and thick descriptions.[3] Yet *Representations* does not begin to account for the diversity of new historicist work or even its multiple tendencies. Presumably, we should have to include under the general label of new historicism the growing interest in reader-response criticism, notably the work of such feminist critics as Jane Tompkins and Cathy Davidson.[4] Assuredly, we should have to include the work of such historical and theoretical critics as Fredric Jameson, Michael McKeon, Dominick LaCapra, Richard Terdiman, and Timothy Reiss.[5] And what of the growing numbers of literary historians who also have their own journal that explicitly addresses problems of theory and interpretation?[6] The attention to rethinking literary history reminds us, if need be, of the uncertain and contested boundaries between the literati's new historicism and intellectual history. One would look in vain in new historicist pages for references to the great cultural critic, Lewis P. Simpson, or to such younger intellectual historians of the South as Michael O'Brien or Drew Faust, much less to the conservative literary scholar M. E. Bradford.[7] One can only assume that from the new historicist perspective such literary and intellectual historians do not qualify as "new."

The newness of the new historicism derives in no small measure from its continuing affair with post-structuralist criticism—notably deconstruction, with which it is much less at war than one might think—and anthropological thick description.[8] It remains, in other words, enthusiastically embroiled in that web of contemporary intellectual fashion which none of us can hope to escape completely. Withal the emphasis on newness bespeaks the central paradox that informs the new historicism as a project: Notwithstanding some notable exceptions, it is not very historical. It is especially not self-critically or self-reflexively historical. For part of the project of any contemporary historicism must inescapably be a fresh consideration of history herself—that is, a hard look at the history of modern historicism and its conflicted relations with other critical strategies.

Today's historicism has developed in response to a series of debates within cultural studies and the human sciences broadly construed, not least to those that contest the validity of disciplinary boundaries themselves. In this climate, the new historicism understandably signifies different things to its various practitioners: to some, mere attention to the past; to others, context, which includes social relations; and to at least some few others, even change over time. Historicism has also been taken to provide an opening wedge for overdue attention to the claims of gender, class, and race—to the claims of the multiple subject and the uncanonized author. If so, it is, if not necessarily a good thing, at least a good intention. But we all know about good intentions and the road they pave.

In general, the devotees of the new historicism have proved less than self-aware about the relation between their concerns and the continuing debates among historians with which they intersect. From one perspective, the new historicism bears a strong family resemblance to the venerable model of history and literature, which, it might be noted, is under serious attack in its most developed form, namely American Studies.[9] Those debates have their own history, which defies neat summary here. But the central conflicts are instructive. They especially concern the relation between the canonized texts of high culture and the culture at large and the appropriate strategies for reading any texts. Or, to put it differently, previous generations have bequeathed to us the interlocking problems of which texts to read and of how to read them. These debates in turn intersect with those about the nature of history, notably the rise of social history in opposition to discredited elite history (especially intellectual and political history), and the related skepticism about the nature of historical "events" and "facts." The main tendency in new historicism has bravely swept over most of these debates without explicitly addressing the nature of the historicism—preeminently thick description—that it is seeking to restore to the reading of texts. But it seems

safe to say that the new historicists do view their project as revitalizing the increasingly formalist project of deconstruction. They thus apparently take historicism to imply something about the social life to which texts testify and by which they are informed.

Not long ago, historicism had different meanings or, better, connotations. It signified reductionism, present-mindedness, and teleology. Historicism, in short, stood in direct opposition to history, which itself was not as clearly defined as one might have hoped. The reversals—history's own deceptions—are worth savoring. The bad historicism of the recent past was normally attributed by bien-pensant bourgeois to uncouth, deterministic Marxists. Things, as things are wont, got a little confusing during the great bourgeois declension, for during a brief period the once sanctified "whig interpretation" of history—the view that history consisted in the steady progress of the human race from barbarism towards its present enlightened state—disconcertingly began to resemble historicism. No matter. We know what happens when undesirables move into a neighborhood: property values collapse. So too with intellectual values. Bourgeois individualism a-dying relegated the whig interpretation to the old neighborhood in which it was trying to confine Marxism, never pausing for that self-analysis which would have indeed revealed Marx to have been steeped in the very Scottish Historical School that engendered the whig interpretation. Today the neighborhood is being gentrified, and historicism with it. But it remains unclear whether we are witnessing a reinvigorated attention to historical understanding or a nostalgic retro window-dressing. For, as Fredric Jameson has argued, the related questions of causation and extra-textual "reality" cannot be brushed aside.[10]

History consists in something more than "just one damn thing after another," in something more than random antiquarianism, even in something more than what happened in the past. Some of those who are turning to history to redress the excesses of contemporary literary theory are calling it a "discourse"—a label that at least has the virtue of acknowledging its claims to intellectual status, and more, of acknowledging its possible internal cohesion and rules, of beginning to recognize it as a distinct mode of understanding. But their strategy runs the risk of confusing history as accounts, narratives, or interpretations of the past, with history as the sum or interplay of human actions, notably politics. School children who first learn of history as what happened in the past may lack the intellectual sophistication to grasp that what we know of the past depends upon the records— implicit interpretations of who and what matters—and upon the ways in which subsequent human beings have written about and interpreted those records. Only later do they learn to recognize history as a genre, as one

particular kind of text. We still use history to refer, however imprecisely, to what we like to think really happened in the past and to the ways in which specific authors have written about it. Contemporary critics tend to insist disproportionately on history as the ways in which authors have written about the past at the expense of what might actually have happened, insist that history consists primarily of a body of texts and a strategy of reading or interpreting them.[11] Yet history also consists, in a very old-fashioned sense, in a body of knowledge—in the sum of reliable information about the past that historians have discovered and assembled. And beyond that knowledge, history must also be recognized as what did happen in the past—of the social relations and, yes, "events," of which our records offer only imperfect clues.

History cannot simply be reduced—or elevated—to a collection, theory, and practice of reading texts. The simple objection to the subsumption of history to textual criticism lies in the varieties of evidence upon which historians draw. It is possible to classify price series or coin deposits or hog weights or railroad lines as texts—possible, but ultimately useful only as an abstraction that flattens historically and theoretically significant distinctions. If, notwithstanding occasional fantasies, the nature of history differentiates historians from "hard" social scientists, it also differentiates them from "pure" literary critics. For historians, the text exists as a function, or articulation, of context. In this sense historians work at the juncture of the symbiosis between text and context, with context understood to mean the very conditions of textual production and dissemination.

In fairness, many literary critics or theorists seem also to be working at this juncture, and their best work is opening promising new avenues. I am hardly alone among historians in being heavily indebted to the work of Antonio Gramsci and Mikhail Bakhtin in particular, although admittedly both rank more as cultural philosophers than as literary critics.[12] Thus, in important instances, the center of attention can be seen to be shifting from text to context, with a healthy emphasis on the concept of hegemony and the notion of struggle within and between discourses. But only in rare instances have new historicists embraced the full implications of this project. In most cases they have implicitly preferred to absorb history into the text or discourse without (re)considering the specific characteristics of history herself.

Such a blanket charge may appear churlish, especially since so much of the work in the new historicism has attempted to restore women, working people, and other marginal groups (although rarely, so far, black people) to the discussion of literary texts. Nor can a blanket charge pretend to do justice to the diversity of works that can be lumped under the general category of new historicism. Understandably, as with any fledgling enterprise, the new

historicists, in all their diversity, have worked piecemeal, borrowing from the materials that lie to hand. And, in the vast majority of instances, they have drawn their materials from the new social history and have followed it in substituting experience for politics, consciousness for the dynamics and consequences of power. Feminist critics, to be sure, have attended to the consequences of power—from which they singlemindedly argue women to have suffered—but have tended to homogenize its dynamics under the mindlessly simplistic category of "patriarchy." The end result, despite the uncontestable value of discrete efforts, has been to take as given precisely the most pressing questions, namely the (changing) relations of power and their (multiple) consequences.[13]

History, at least good history, in contrast to antiquarianism, is inescapably structural. Not reductionist, not present-minded, not teleological: structural. Here, I am using structural in a special—or, better, a general—sense, not in the sense developed by Saussure, Lévi-Strauss, or even Roland Barthes or Lucien Goldmann. By structural, I mean that history must disclose and reconstruct the conditions of consciousness and action, with conditions understood as systems of social relations, including relations between women and men, between rich and poor, between the powerful and the powerless; among those of different faiths, different races, and different classes. I further mean that, at any given moment, systems of relations operate in relation to a dominant tendency—for example, what Marxists call a mode of production—that endows them with a structure. Both in the past and in the interpretation of the past history follows a pattern or structure, according to which some systems of relations and some events possess greater significance than others. Structure, in this sense, governs the writing and reading of texts.[14]

This use of structure requires a word of justification. Structure has lapsed in fashion in large measure because of our recognition of the multiple ties that link all forms of human activity, including thought and textual production. In other words, the preoccupation with structure has given way to the preoccupation with system. The very notion of textuality in the large sense embodies the insistence on system, interconnection, and seamlessness, and therefore leads inescapably to what Jameson calls totalization.[15] That recognition is compelling, but it rests upon a denial of boundaries. The concept of structure, not unlike that of discourse, represents a commitment to drawing at least provisional boundaries. In this respect, structure, like discourse, attempts to take account of present and past politics. For politics consists in nothing if not the drawing of boundaries. If indeed, we live in and represent ourselves through a seamless web of textuality, ultimately the spoils of our living and representing accrue to those who draw the boundaries:

boundaries of the law, of the literary canon, of superordination in all its manifestations. In this perspective, politics as the will to define and the ability to impose boundaries constitutes the irreducible core of experience, textuality, and history. Politics draws the lines that govern the production, survival, and reading of texts and textuality—of text and Text.

Here again, we have an irony of sorts. Contemporary criticism implicitly, when not explicitly, grants the text a status *sui generis,* as if it somehow defied the laws of time, mortality, history, and politics. But beneath that surface lies an implacable hostility to history as structure and to politics as the struggle to dominate others and thus to shape the structure of social relations. Thus the evocation of history reduces to history as accident (in the Aristotelian sense) of the text rather than its essence, and thus, implicitly, reduces politics to its textual embodiment.

At the core of the contemporary critical project lies the conviction that we think, exist, know, only through texts—that extratextual considerations defy proof and, accordingly, relevance. And how wonderful it is that these critics make precisely the same claims for their theory that the more reductionist, not to say vulgar, cliometricians and psychohistorians make for theirs. In this respect, contemporary criticism as a philosophical project returns through the thickets of modern philosophy to the eighteenth-century Berkeleyan dilemma: Does the falling tree make a sound if none is there to hear it? Or, to take the modern variant, does the thought exist if none is there to write it? The radical attempt to transcend this dilemma, which does command attention, proposes the text as society, culture, history, consciousness, on the grounds that it is all of them or all that we can know. And it further proposes that in addition to being all of them that we can know, it is the only form in which we can know them.

Life would be easier if we could dismiss this challenge to our commonsensical, intuitive apprehension of the solidity of things out of hand. We cannot. In the post-Einsteinian and post-Wittgensteinian universe of intellectual relativism in all spheres, in the post-capitalist world of modern technology and of a restively interdependent globe, our culture's received wisdom about order, about cause and effect, about subject and object no longer suffices. Most of us know all too well that complexity, uncertainty, and indeterminacy govern our world and have effectively shattered our abiding longing to grasp the scheme of things entire. And those who refuse to accept the evidence—notably religious fundamentalists of varying persuasions—engage in a massive effort of denial and self-deception. Bourgeois culture had bravely assumed that the scheme of things obeyed a logic that the individual mind could grasp—had rested on a commitment to what modern critics are now dismissing as "logocentrism." Bourgeois attitudes towards history,

notably the whig interpretation, rested upon this commitment. We now know that what we called reality is but appearance, no more than the interplay of self-serving opinions. Historians told the stories that legitimated and served the perpetuation of the powerful's control of the weak. For some, the collapse of this illusion is taken to have opened the way to intellectual anarchism: to each his or her own history. For others, it may be opening the way to a new intellectual totalitarianism, or at least to an elitist thrust that divorces history from the perceptions of the general educated public.

The literary critics cannot absorb history piecemeal, as curiosity, landscape, or illustration. Nor can the historians restore history in all its innocence. The epistemological crisis of our times itself reflects the crisis of bourgeois society—a crisis of consciousness, certainty, hierarchy, and materially grounded social relations. I am not suggesting that we should return, if indeed we could, to an untransformed Marxism any more than to a sanctimonious whig interpretation. Not least, recent developments in history and literary studies have exposed the bankruptcy of the authoritative white male subject and pressed the claims of women, working people, and peoples of non-white races and non-Western cultures.[16] I am suggesting that a structurally informed history offers our best alternative to the prevailing literary models. For serious attention to the claims of history forces the recognition of the text as a manifestation of previous human societies. The problems of "knowing" history persist. We remain hostage not merely to the imperfection but to the impossibility of precisely recapturing the past and, in this sense, remain bound on one flank by the hermeneutic conundrum. But those constraints neither justify our abandoning the struggle nor our blindly adhering to the denial of history.

The acknowledgment of history's claims, however, confronts us with an especially delicious irony. With the collapse of the whig interpretation, Marxism has inherited the royal historical mantle.[17] This outcome would have delighted, if not entirely surprised, Marx, who studiously grounded his own political, philosophical, and historical project in the bourgeois society and ideology he was so resolutely opposing.[18] Today Marxism has, if anything, been tarred with the brush of cultural and philosophical conservatism, although the efforts of some neo-Marxists have succeeded in moving Marxism itself down the road of radical individualism and cultural pluralism. The moral is that, bourgeois pieties to the contrary notwithstanding, Marxism offers no more static a doctrine than any other vital political and intellectual current, and that Marxism is no more immune to the winds of political and intellectual change. At one extreme, neo-Marxists have succeeded in divorcing their work from its political moorings and legacy; at the other they have tied it too firmly to the vicissitudes of specific political regimes and parties.[19] But between

these extremes, Marxism continues to develop as an explicitly historical and political theory, even if, as John Frow has reminded us, the "political and theoretical radicalism of Marxism can no longer be taken for granted."[20]

Marxism has, in effect, benefited from the attribute that its harshest bourgeois critics have always reproached in it: a sense—however diluted—of social, which is to say political, accountability. In the old days, the same would have been true of its bourgeois opponents. Today, however, bourgeois critics have largely abandoned the political field, or rather, they have abandoned the notion of accountability. Conservatives, however much they may be recognized as members of the bourgeois camp, have not made the same mistake. But they, even more than Marxists, have been marginalized and silenced by the academic establishment. To be sure, the popular success of Allan Bloom's *The Closing of the American Mind* should make people thoughtful. But by and large the liberal academy has responded with outraged dismissal rather than serious debate.[21] Thus, by the grace of bourgeois culture in decline, Marxism has emerged as the last bastion of historical thinking.

The philosophical problems persist, not least because of our culture's reluctance to confront the conflicted relation between what Jameson calls "freedom and necessity," and what I should prefer to call "freedom and order." But most of the practitioners of the new historicism are not addressing them at all. To the extent that they implicitly accept the view of society as text and equate history with thick description, they, if anything, implicitly perpetuate the dubious politics of what many are calling our society of information. Their considerable skills are devoted to the decoding of intertwining messages with little attention to sources or consequences.

Texts do not exist in a vacuum. They remain hostage to available language, available practice, available imagination. Language, practice, and imagination all emerge from history understood as structure, as sets or systems of relations of superordination and subordination. To write in the name of the collectivity, which is what—however narrowly and self-centeredly—all fabricators of text do, is to write as in some sense as the privileged delegate of those who constitute society and culture. Here, the concern with the links that bind different texts to each other genuinely approaches attention to history. It should prompt us to read such antebellum Northerners as Nathaniel Hawthorne and Harriet Beecher Stowe, such escaped slaves as Harriet Jacobs and Frederick Douglass, and such proslavery Southerners as William Gilmore Simms, Louisa Susanna McCord, James Henley Thornwell, and John C. Calhoun, as members of an interlocking universe. For texts, as manifestations or expressions of social and gender relations, themselves constitute sets of relations: not relations innocent of history, but essentially historical relations of time, place, and domination. And without

a vital sense of the structure of those relations, the reading of texts collapses into arcane, if learned and brilliant, trivia.

With a sense of structure other possibilities open. The best recent example can be found in Michael McKeon's ambitious and compelling discussion of the origins of the English novel.[22] One need not agree with all of McKeon's formulations in order to appreciate his sensitivity to the historical location of discourses and the dynamism of their historical unfolding. For the novel did emerge in tandem with the emergence of the bourgeoisie, even if its early history also embodies a struggle between that bourgeoisie and its recalcitrant aristocratic opposition. Moreover, to take the story beyond the point at which McKeon leaves it, the ensuing history of the novel— as privileged form of bourgeois discourse—continued to enact struggles between new political positions. Bourgeois discourses, in Richard Terdiman's formulation, engendered counter-discourses.[23] And what was true for Britain and France was all the more true for the United States with its persisting division among classes, races, and world views. Antebellum Southerners, like their Northern counterparts, turned to the novel—among other genres—as a powerful weapon in defending their distinct, proslavery culture.[24]

Undeniably, an insistence on history as structure is political, although not in any narrow way. It is at once more modestly and more inclusively political than the defense of a specific political position. For texts themselves are products of and interventions in the inescapably political nature of human existence. The point is not that texts defend specific political positions, although they may, but that they derive from political relations from which they cannot be entirely abstracted.

In general, the new historicism, in failing to address these questions, has aligned itself with the post-structuralist criticism the excesses of which it is seeking to redress, and has thus positioned itself in radical opposition to history. For the new historicism is tending to restore context without exploring the boundaries between text and context. In this respect, it is modifying, but not seriously questioning, the premises that have informed post-structuralist textual analysis. And, in so doing, it is obscuring yet more thoroughly the specific character of history and historical understanding.

The defense of history as structure rests on a conviction that texts have the power to crystallize the pervasive discourses of any society and thus to shape their development. This view endows texts with considerable, although not autonomous, power. For texts enjoy a privileged position in the continuing process of fashioning and refashioning consciousness, of defining possibilities of action, of shaping identities, and of shaping visions of justice and order. But that power derives precisely from their inscription in a history reread as structured relations of superordination and subordination.

No more than the author can the text escape history, although history herself assures some texts the power to speak compellingly to more than one historical moment. No more than the author can the text claim political innocence, although a sophisticated politics invariably presents itself as comprehensive world view. The history that informs even the most abstract text is ultimately political in privileging a particular distillation of common experience. Craft and talent play their roles, as does audience response, in permitting the production and dissemination of texts and thereby in establishing their influence. But craft, talent, and audience response themselves result from history and politics. Ultimately, to insist that texts are products of and participants in history as structured social and gender relations is to reclaim them for society as a whole, reclaim them for the political scrutiny of those whom they have excluded, as much as those whom they have celebrated, for all of those in whose names they have spoken or have claimed to speak. And it is to reclaim them for our intentional political action, and ourselves for political accountability.

Notes

1. The preeminent figure associated with thick description is Clifford Geertz. See, in particular, his *Interpretation of Cultures: Selected Essays* (New York, 1973).

2. On the need to reclaim meaning, see Fredric Jameson, *The Political Unconscious: Narrative as a Socially Symbolic Act* (Ithaca, 1981).

3. *Representations* is published by the University of California Press at Berkeley and co-edited by Svetlana Alpers and Stephen Greenblatt. In fact, *Representations* does not so much stand for a philosophical movement as for a methodological one. Thus, not surprisingly, it encompasses authors of different—or undifferentiated—philosophical positions, or without philosophical concerns. Since method, however important and whatever its most devoted exponents claim, cannot stand in for philosophy, the privileging of method over philosophy understandably results in the appearance of philosophical eclecticism.

4. See especially, Jane Tompkins, *Sensational Designs: The Cultural Work of American Fiction* (New York, 1985), Cathy Davidson, *Revolution and the Word: The Rise of the Novel in America* (New York, 1987), and Janice Radway, *Reading the Romance: Women, Patriarchy, and Popular Literature* (Chapel Hill, 1984). These feminist critics are obviously building on the work of other reader-response critics, notably Wolfgang Iser. See, esp., Wolfgang Iser, *The Act of Reading: A Theory of Aesthetic Response* (Baltimore, 1978); but also for a general introduction to the work in the field, Jane Tompkins, ed., *Reader-Response Criticism: From Formalism to Post-Structuralism* (Baltimore, 1980); and Susan R. Suleiman and Inge Crosman, eds., *The Reader in the Text: Essays on Interpretation and Audience* (Princeton, 1980).

5. Jameson, *Political Unconscious*; Michael McKeon, *The Origins of the English Novel 1600–1740* (Baltimore, 1987); Dominick LaCapra, *Madame Bovary on Trial* (Ithaca, 1982); Richard Terdiman, *Discourse/Counter-Discourse: The Theory and Practice of Symbolic Resistance in Nineteenth-Century France* (Ithaca, 1985); Timothy J. Reiss, *The Discourse of Modernism* (Ithaca, 1982).

6. *New Literary History: A Journal of Theory and Interpretation* is published by the Johns Hopkins University Press and edited by Ralph Cohen. For the new developments in literary history, see Ralph Cohen, ed., *New Directions in Literary History* (Baltimore, 1974). In truth, *New Literary History* represents a catholicity and diversity that far exceed the bounds of the new historicism, however loosely drawn.

7. Among Lewis P. Simpson's extensive oeuvre, see esp., *The Dispossessed Garden* (Athens, Ga., 1975), *The Man of Letters in New England and the South* (Baton Rouge, 1973), and *The Brazen Face of History* (Baton Rouge, 1980). See also, Elizabeth Fox-Genovese and Eugene D. Genovese, "The Cultural History of the Old South: Reflections on the Work of Lewis P. Simpson," in J. Gerald Kennedy and Daniel Fogel, eds., *American Letters and the Historical Consciousness: Essays in Honor of Lewis P. Simpson* (Baton Rouge, 1987), pp. 15–41. For Michael O'Brien, see *A Character of Hugh Legaré* (Knoxville, Tenn., 1985), his edited collection, *All Clever Men Who Make Their Way* (Columbia, Mo., 1985), and his "Preface" and "Politics, Romanticism, and Hugh Legaré: The Fondness of Disappointed Love,'" in Michael O'Brien and David Moltke-Hansen, eds., *Intellectual Life in Antebellum Charleston* (Knoxville, Tenn., 1986). See also, Drew Gilpin Faust, *A Sacred Circle: The Dilemma of the Intellectual in the Old South, 1840–1860* (Baltimore, 1977). For M. E. Bradford, see, for example, *A Better Guide Than Reason: Studies in the American Revolution* (La Salle, Ill., 1979).

8 For a clear formulation of the relation between deconstruction and the new historicism, see Walter L. Reed, "Deconstruction versus the New Historicism: Recent Theories and Histories of the Novel," paper presented at the annual meeting of SAMLA, Atlanta, 1987. I am much indebted to Professor Reed for letting me read his thoughtful paper.

9. For an introduction to the debates about the nature of American Studies, see Gene Wise, guest editor, "The American Studies Movement: A Thirty Year Retrospective," *American Quarterly* XXXI, no. 3 (1979): 286–409, which includes essays by Wise and Wilcomb Washburn. For recent developments in American Studies, see, for example, Sacvan Bercovitch and Myra Jehlen, eds., *Ideology and Classic American Literature* (Cambridge and New York, 1986), and Walter Benn Michaels and Donald E. Pease, eds., *The American Renaissance Reconsidered: Selected Papers from the English Institute, 1982–83* (Baltimore, 1985).

10. Jameson, *Political Unconscious*. It should be clear from my discussion that I do not think that Jameson's work can be completely subsumed under the rubric of new historicism, if only because of his proclaimed and serious philosophical concerns.

11. See in particular, Hayden White, *Metahistory: The Historical Imagination in Nineteenth-Century Europe* (Baltimore, 1973).

12. See e.g., Antonio Gramsci, *Selections from the Prison Notebooks,* ed. and trans. Quintin Hoare and Geoffrey Nowell Smith (New York, 1971), his *Gli Intellettuali e l'organizzazione della cultura* (Torino, 1949), and his *Quaderni del Carcere,* 4 vols., ed. Valentino Gerratana (Torino, 1975); Mikhail Bakhtin, *Rabelais and His World,* trans. Helene Iswolsky (Cambridge, Mass., 1968), and Michael Holquist, ed., *The Dialogic Imagination: Four Essays by M. M. Bakhtin,* trans. Caryl Emerson and Michael Holquist (Austin, 1981).

13. See, for example, Margaret W. Ferguson, Maureen Quilligan, and Nancy J. Vickers, eds., *Rewriting the Renaissance: The Discourses of Sexual Difference in Early Modern Europe* (Chicago, 1986); Catharine Gallagher, *The Industrial Reformation of English*

Fiction (Chicago, 1985), and her "Embracing the Absolute: The Politics of the Female Subject in Seventeenth Century England," *Genders* 1 (March 1988): 24–39.

14. For a position similar to my own, see Robert Weimann, *Structure and Society: Studies in the History and Theory of Historical Criticism* (London, 1977), esp. pp. 146–87, in which he criticizes various practices of literary structuralism. In fact, the work of Roland Barthes and Lucien Goldmann, in particular, offer promising directions, even if both ultimately remain unsatisfactory on the nature of historical structures and the relations between social and literary structure. For Barthes, see, for example, Roland Barthes, *Sur Racine* (Paris, 1963); and, for Goldmann, *Le dieu caché: Etude sur la vision tragique dans les "Pensées" de Pascal et dans le théâtre de Racine* (Paris, 1955).

15. Jameson, *Political Unconscious,* p. 26.

16. For preliminary statements of my views of these matters, see my "The Great Tradition and Its Orphans: Or Why the Defense of the Traditional Curriculum Requires the Restoration of Those It Has Excluded," in Taylor Littleton, ed., *The Rights of Memory: Essays on History, Science, and American Culture* (University, Ala., 1986), and "The Claims of a Common Culture," *Salmagundi,* no. 72 (Fall 1986) [both reprinted in this volume, pp. 156–72 and pp. 145–55, respectively].

17. Jameson, *Political Unconscious,* p. 19, makes a similar point: "My position here is that only Marxism offers a philosophically coherent and ideologically compelling resolution to the dilemma of historicism evoked above."

18. For a premier example of Marx's dialogue with his bourgeois predecessors, see Karl Marx, *Theories of Surplus Value,* trans. Emile Burns, ed. S. Ryzanskaya, 2 vols. (Moscow, 1969).

19. Apolitical Marxism is best represented in the work of Edward P. Thompson and his followers. See, in particular, E. P. Thompson, *The Poverty of Theory & Other Essays* (London, 1978). Political Marxism is best represented in dominant Soviet historiography, but for Western variants, see, for example, Claude Mazauric, *Sur la revolution française: Contributions a l'histoire de la révolution bourgeoise* (Paris, 1970). For a more satisfying, yet nonetheless politically engaged Marxist history, which eschews both fashion and dogmatism, see the work of Eric Hobsbawm.

20. John Frow, *Marxism and Literary History* (Cambridge, Mass., 1986), p. 5.

21. Allan Bloom, *The Closing of the American Mind* (New York, 1987).

22. McKeon, *Origins of the English Novel.*

23. Terdiman, *Discourse/Counter-Discourse.*

24. See, for a striking example, Caroline Lee Hentz, *The Planter's Northern Bride* (Philadelphia, 1854).

Eight

Social Order and the Female Self

The Conservatism of Southern Women in
Comparative Perspective

Modern conservatism arguably begins with Edmund Burke, or, more to the point, with the great French Revolution that prompted Burke to his celebrated *Reflections*. For the French Revolution, in radically repudiating inherited notions of hierarchy and particularism, enormously accelerated the political implementation and ideological maturation of capitalism and bourgeois individualism, accelerated, that is, the revolutionary and self-revolutionizing social system that has, however unevenly, conquered the Western world and is irreversibly imposing itself on the rest.

Modern conservatism, in this perspective, emerged as the attempt to slow, soften, and sometimes even oppose outright the effects of those momentous changes.[1] But—and this is the main point—modern conservatism always has been, as it remains, deeply implicated in the social and ideological systems it mistrusts. Itself the product of bourgeois individualism, it cannot profitably be understood as a simple continuation of "traditional" thought and practice. Nothing more clearly reveals this complicity of modern conservatism with individualism and the capitalism it articulates than the difficulties that those most "traditional" of conservatives, the Southern conservatives, confront in their heroic, if ultimately unavailing, attempts to stave off the worst incursions of both without decisively breaking with them.

Antebellum Southern conservatives, most flamboyantly but by no means exclusively George Fitzhugh, had a firmer grasp of the issues—or, better,

wrote from the marrow of a social system that could lay some claims to hold-
ing capitalism and individualism at arm's length.[2] Their proslavery ideology
defied the full implications of individualism by openly proclaiming the
virtues of hierarchy and particularism. From Fitzhugh, who favored a com-
plete break with the capitalist market and flirted with the appeal of Catholi-
cism, to Henry Hughes, who promoted a secular "warranteeism" that in
many respects foreshadowed modern fascism, proslavery ideologues reso-
lutely insisted that civilization required the enslavement of some and, on
that basis, perpetuated aspects of preindividualist thought, notably a sharp,
particularist distinction among conditions. To a man—and woman—they
grounded the justification of particularistic conditions in the "natural" and
Biblically sanctioned subordination of woman to man.

Because of its grounding in slavery as a social system, antebellum South-
ern conservatism departed in significant respects from the emerging West-
ern conservative mainstream in Great Britain and France, although because
of its intimate ties to transatlantic culture and thought, it also never entirely
broke with it. Notwithstanding promising beginnings, notably by Richard
Weaver and Louis P. Simpson, the full story of Southern conservatism re-
mains to be told, but will, inevitably, be a story of the tensions that char-
acterized the slaveholding intelligentsia's attempt to adapt the bourgeois
conservatism of their British and French colleagues to their own distinct
social relations.[3] In this respect, Southern ideology faithfully captured the
complexities of a Southern slave society torn between its commitment to the
most advanced developments of its time and its determination to protect
and justify slavery as the foundation of a just social order.

The repudiation of slavery as a just condition lay at the core of bourgeois
individualism, which, in transforming Christian thought into a systematic,
propertied individualism, defined slavery as the antithesis of freedom rather
than following traditional thought in regarding it as one form of unfree
labor among many.[4] Although initially the implications of this line of
thought eluded many of its proponents, they were inescapable and, increas-
ingly, divided Southern slaveholders from their Northeastern and western
European counterparts. From 1820 to 1860, Southern intellectuals gradu-
ally found themselves alienated from the leading currents of bourgeois
thought from political economy and law to religion.[5] During the same
period, Southern literati increasingly called for regional journals to represent
the South's distinct literary culture. Especially during the 1840s and 1850s,
with the rise of Northern antislavery and abolition, not to mention the
beginnings of the women's movement, Southerners ever more insistently
proclaimed the distinctiveness and integrity of their own values. But even as
they defined those values as fundamentally different from bourgeois values,

they continued to admire and draw upon conservative bourgeois intellectuals whom they were happy to enlist in the service of their cause.

In essential respects, the conservatism of slaveholding women remains barely distinguishable from the conservatism of the men of their class and region, whose values and premises they overwhelmingly shared. As I have argued elsewhere, most slaveholding women prided themselves on participating in the literate culture of their region, including its transatlantic antecedents.[6] They assuredly participated in the elitist social attitudes of their class, and may fairly be said to have, if anything, more sharply emphasized the distinctions between themselves and those whom they viewed as their social inferiors than the men. Of their commitment to slavery, there are no reasonable grounds to doubt, occasional private mutterings about abuses notwithstanding. Their devotion to the Bible-based Christianity of their region permeated their most private writings, which it frequently structured.[7] One after another wrote in her journal of the quality and content of the preaching she had heard, noted her own Bible reading, and agonized about her progress toward worthiness as defined by scripture and interpreted by the Southern clergy.

The conservatism of slaveholding women developed apace with the conservatism of their region, gaining in definition and resolution at least partially in response to the progressive unfolding of the more radical implications of bourgeois individualism elsewhere. Slaveholding women of the late eighteenth and early nineteenth centuries, like Mary Campbell of Virginia, tended to express their conservatism almost unthinkingly as an acceptance of their own privileged position.[8] For them, the foundations of that position in slavery did not necessarily differentiate it from that of elite women in bourgeois societies, whether in the North or in Europe. They comfortably accepted early bourgeois values—notably the emerging ideology of domesticity—as fully compatible with, and indeed the proper realization of, a modernized aristocratic ethos, such as that embodied by the Whig aristocracy in Britain. Revering George Washington and celebrating the legacy of the Revolution, they never doubted that their peculiar institution perfectly embodied true revolutionary values.[9] In this respect, they indeed resembled Burke in celebrating the American Revolution while deploring the French.

The Second Great Awakening, or what has been called the "rechristianization" of the South, drew many slaveholding women to a renewed preoccupation with religion, thus tempering their sense of self as derived from social position with a sense of self as grounded in religious observance and commitment.[10] In the late 1830s, Mary Moragne, who was determining to marry the minister of her choice, reflected on her mother's response to the

news. "Her countenance grew heavy with apprehension:—she could not smile—they had been looking for *wealth & rank & fame* for me; but pride cannot now influence my resolves; the first duty I owe in this respect, is to my own heart."[11] Yet after her marriage, Mary Moragne, out of respect for her husband's wishes, forsook the writing for publication that had given her so much pleasure, thus confirming that her sense of obligation to her own heart did not extend to self-determination in the full sense of individualism. She also, as best we can tell, remained firm in the elitist social and racial attitudes of her parents and class.

By the 1850s, slaveholding women were intervening more frequently and openly in the politics of their region and, enjoying enhanced opportunities for education, were, in ever greater if still small numbers, expressing themselves on the salient issues of the day in print. The ardently proslavery Louisa McCord, who admittedly published under her initials rather than her full name, remained anomalous in directly engaging debates in politics, political economy, and theory, but hardly unique in entering the proslavery lists broadly defined. Caroline Lee Hentz, Julia Gardiner Tyler, Mrs. Henry Schoolcraft, and Augusta Jane Evans—to name but the more visible—all took up their pens to defend the values and institutions of their region, notably slavery to which they credited innumerable beneficent effects. All of these women drew upon the proslavery ideology that was being elaborated by Southern men. Writing of slavery itself, of the condition of labor in general, of woman's position, or of religion, they followed the general structure and tenor of the dominant proslavery discourse. In so doing, they were faithfully articulating the values of the many other women of their class who, in journals, letters, and private conversations, defended the same positions.[12]

Commitment to proslavery effectively guaranteed the fundamental conservatism of slaveholding women's general world view and specific positions. With respect to the politics of secession in particular, many of them proved as tough as—in some instances tougher than—their men in pushing for an intransigent prosouthern stance, although they normally did so in private rather than in public.[13] As Julia Gardiner Tyler, the wealthy Northern wife of former president and Virginia slaveholder John Tyler, argued in an angry response to an antislavery polemic by the Duchess of Sutherland, Southern women were especially well positioned to become informed about public concerns. In the South, "politics is almost universally the theme of conversation among the men, in all their coteries and social gatherings, and the women would be stupid indeed, if they did not gather much information from this abundant source."[14]

In her response, Julia Tyler especially berated the Duchess of Sutherland for having invited the women of the so-called free states to intervene directly

in the slavery question. The women of the South, she insisted, regarded any such appeal as an unmitigated affront to themselves. Julia Tyler was simultaneously chastising the Duchess for her attack on slavery and for inviting women to participate directly in politics. The American woman, she lectured, "with but few exceptions," appropriately confines her life to the "sphere for which God who created her seems to have designed her." Within that sphere, she exercises her influence "as wife, mother, mistress—and as she discharges the duty of one or all of these relations, so is she respected or otherwise."[15] The women of the Southern states have as their particular province "to preside over the domestic economy of the estates and plantations of their husbands" and they hardly take as a compliment the proposal to "introduce other superintendence than their own over the condition of their dependents and servants."[16] Southern women recognize a political insult to their persons and dignity when they receive it. They are, "for the most part, well educated; indeed they yield not in this respect to any females on earth."[17]

And to demonstrate that she had not wasted her opportunities, Julia Tyler launched into an informed and polemically astute discussion of Southern and English social relations, picking up the common proslavery theme that the English should begin by looking to their own forms of social oppression before criticizing those of others. Specifically, the English would do well to consider their own "aristocratic establishments" of primogeniture and entail and to contemplate how they would feel should well-meaning Southerners take it upon themselves to enlighten the impoverished English rural classes about their oppressed condition. Slavery, Tyler insisted, constituted a simple case of "individual property rights," in which no respectable Southerner would intrude at home or abroad.[18]

Julia Tyler's insistence on slavery as a form of property rights subtly called attention to the mutual respect that ruling classes owed to each others' institutions, and even suggested that Southerners were more democratic and faithful to the principles of individual liberty than their English counterparts. Caroline Lee Hentz, in *The Planter's Northern Bride,* used fiction to develop similar themes, although she, more than Julia Tyler, insisted upon the benefits of slavery to the slaves. For Hentz, free labor itself constituted the primary culprit. After painting a heart-rending picture of the impoverished condition of white workers in Northern states, she followed up by depicting a free black servant who begged for reenslavement on the grounds that she could not possibly provide for herself as well as slaveholders would provide for her.[19]

Mrs. Henry Schoolcraft, in *The Black Gauntlet,* yet more explicitly argued the proslavery case from the perspective of both masters and slaves.

In her view, historical example demonstrated that slavery "has been the efficient cause of civilization and refinement among nations."[20] For South Carolinians in particular the "exemption from *manual* labor" afforded by slaves "is at the foundation of a class of elevation and refinement, which could not, under any other system, have been created."[21] That same system, she held, had also provided for the slaves with a care and instruction that far exceeded anything provided to Northern workers. Let the abolitionists look to "perfecting the morals of those poor, degraded pale-faces, that surround the doors of their own State." And she invoked in support of her assertion a denunciation of white slavery drafted by operatives of the Pemberton Mills in Massachusetts according to whom the oppression they suffered was so tyrannical and their wages so low "that negro slavery is far preferable."[22]

Writing in the midst of mounting sectional crisis, Mrs. Schoolcraft, like Julia Tyler and Caroline Lee Hentz, was in part responding to the abolitionists whom she regularly charged with irresponsible meddling. But more than the others, she also directly challenged the abolitionists' world view. South Carolinians, she approvingly avowed, were "'old fogies,'" in contrast, for, unlike the abolitionists they do not believe "that *God* is a progressive being; but that throughout eternity *He* has been the same; perfect in wisdom, perfect in justice, perfect in love to all his creatures." From this perspective, she found it impossible to comprehend "the new-light doctrine, 'That slavery is a sin.'"[23] Mrs. Stowe's vision of a world in which "all are born equal" was nothing but a millennial fantasy. Even Thomas Jefferson's "All men are born free and equal" defied six thousand years of historical experience and has caused nothing but mischief.[24]

Augusta Jane Evans, arguably Louisa McCord's only intellectual equal among antebellum Southern women, fully grasped the challenge of formulating a conservatism appropriate to a modern slave society. In *Beulah,* her second novel, published in 1859, she explored a young woman's crisis of faith as a paradigm for the crisis that confronted Southern society as a whole.[25] Impressively learned and gifted with an acute theoretical mind (strange qualifications for a successful woman novelist), she modeled her protagonist's travail on Coleridge's "The Rime of the Ancient Mariner" and her own philosophy on Carlyle's *Sartor Resartus.* Perhaps no antebellum woman's novel more firmly identified a woman's struggle for identity with the main intellectual currents of the age, certainly none engaged in such a thorough investigation of contemporary metaphysics. Evans did not, in *Beulah,* specifically attend to the problem of slavery, although her proslavery conviction cannot be doubted. Her concerns focused on the state of mind of the master class, on its fitness to rule. Her having chosen a woman to embody that challenge testifies as fully as one could wish to the seriousness

with which she took women's minds and their obligation to account for themselves.

Beulah offers an intellectual woman's dense and sustained argument for woman's subordination to man, but, above all, for her subordination to God. Evans never suggests, however, that subordination should be equated with inferiority. Herself a devout Methodist, Evans never succumbed to the temptation of Catholicism, which she had, in her first novel, *Inez*, blisteringly attacked.[26] Nor did she participate in the individualist temptation to argue for subordination on the grounds of natural inferiority. She unmistakably intended to claim individual agency and accountability for women. But she emphatically rejected what she saw as the disastrous implications of Emersonian individualism, insisting, like McCord, that women could only realize her individual potential in her particular condition as woman.

Evans, like many other slaveholding women, perfectly grasped the connections among individualism, abolitionism, and the dawning defense of women's rights. Louisa McCord, for example, scornfully dismissed women's claims to independence and equality as an open invitation to turn the world into a "wrangling dog kennel."[27] For McCord, women's protests amounted to nothing more than childish railing against the human condition—an unwillingness to accept the laws of nature. In invoking nature in general and women's physical weakness in particular, McCord was, in fact, betraying her own flirtation with bourgeois thought, notably bourgeois science. Just as her interest in Josiah Nott's theories about the separate origins of the races, which many of the leading Southern clergy resolutely opposed, pointed toward postbellum racism, so did her willingness to justify women's subordination on the basis of biological difference point toward "scientific" sexism. After the war, Evans herself began to move in the same direction, but before it she continued to struggle to develop a particularist theory of the female self that would simultaneously guarantee social order and permit women the full development of their talents. Her wrestling with the problem of how best to justify women's subordination to men cuts to the heart of Southern women's conservatism in comparative perspective.

The core of slaveholding women's conservatism lay in their acceptance of slavery as the necessary foundation of their families' property and the social order of their region. Many, like Mrs. Henry Schoolcraft, also followed such proslavery ideologues as Thomas Roderick Dew in viewing slavery as the necessary foundation of any civilization worthy of the name.[28] The men who fashioned the modern proslavery argument, notwithstanding differences in tone and emphasis, readily insisted that the subordination of slaves and the subordination of women constituted inseparable aspects of a unified world view and social system. Yet the differences among them,

which superficially concerned different ways of presenting a single argument, masked divergent tendencies in Southern conservatism. If a Dew or a Fitzhugh, like many of the divines, adopted an essentially historical and particularistic argument, a Henry Hughes unquestionably pointed toward a modern corporatism. The differences, if insignificant in time and place, carried important implications for women and illuminate the complex ways in which proslavery thought intersected with emerging bourgeois conservatism. And, given the sad history of postbellum racism, they especially reveal the ways in which slavery, notwithstanding its horrors, contained the full implications of bourgeois conservatism.

The argument for women's subordination to men on grounds of physical weakness was hardly unique to the South and proved eminently compatible with bourgeois individualism. Most bourgeois intellectuals warmly embraced women's subordination, without closely investigating the way in which it contradicted the central principles of individualism. In fact, the bourgeois ideology of womanhood, which developed in the eighteenth century and matured in the nineteenth, broke with previous views of women by simultaneously universalizing the principle of all women's subordination independent of class and by promoting a newly favorable image of women as innately good, gentle, and nurturing.[29] During the early nineteenth century, the subordination of women within the family thus emerged as the main bastion of corporatism within individualist ideology. The debates over women's independent political participation and the property rights of married women challenged the denizens of individualism to follow the logic of their ideology to its inexorable conclusion by acknowledging the equality of all individuals—or, to put it differently, by acknowledging women as individuals. Most resisted that logic. But increasingly, the deep hostility to hierarchy and particularism that informed individualism encouraged political and social theories to justify women's subordination on biological rather than social grounds.

Initially, the bourgeois ideology of womanhood had represented an important element in the attack on social hierarchy, if only by implicitly asserting that women, like men, shared an identity that transcended class lines. But gradually during the first half of the nineteenth century, it began to reveal its inherently conservative character.[30] For the exclusion of women from individualism permitted the perpetuation of illusions of community and harmony in a world that was increasingly governed by the capitalist market. At the dawn of bourgeois individualism many women were themselves drawn to their newly enhanced prescribed roles. But, as the intensification of the capitalist market began to erode the economic independence of households, as demographic trends confronted more women with permanent

spinsterhood, and as education introduced some women to the lure of re-warding accomplishment, some women began to chafe under their enforced dependence on men. Economics and ideology combined, as they so often do, to introduce women to the possibilities of individualism for themselves. Bourgeois societies responded to these changes and ambitions in contra-dictory ways, frequently by improving women's access to education, some-times by recognizing the property rights of married women, and eventually by granting women the vote. But in all of these societies women's halting advance toward individualism was accompanied by a panoply of formal and informal restrictions on their equal opportunities. Bourgeois conservatism thus moved from an unquestioning acceptance of the natural subordina-tion of women to the adoption of increasingly arbitrary sexist values and practices.

Not surprisingly, antebellum Southerners found much to admire and accept in the bourgeois rhetoric of womanhood. They wrote as sentimen-tally as any of woman's sphere, of the sacred character of motherhood, of the harmony of the domestic circle. From their perspective, they were prov-ing themselves the true custodians of the fundamental values of western civ-ilization. Nor were they significantly more self-critical than their bourgeois counterparts in adopting the bourgeois rhetoric of womanhood to refer to women's nature and mission since the dawn of time. During the postbellum period, moreover, they too turned to the arbitrary and restrictive practices of bourgeois conservatism. But during the antebellum period, they grounded their version of bourgeois domesticity in the discrete character of a modern slave society. Thus even when they most enthusiastically embraced bourgeois rhetoric, they used it to describe and legitimate a different reality.

The differences are not always obvious. On the one hand Southern women from McCord to Hentz to Evans emphasized the roles as wives and mothers for which women were naturally suited, thus suggesting that women's subordination derived from natural frailty and need for protec-tion. On the other hand, they also stretched the understanding of female individualism by supporting women's education, intelligence, and ability to form valuable independent judgments. In both respects, their conservatism did not self-evidently differ from that of other elite women of their age or, for that matter, from that of conservative slaveholding and bourgeois men. Yet most slaveholding women did differ from their conservative bourgeois counterparts in their commitment to a legally defined hierarchical social sys-tem and in accepting without serious question the particularistic character of their own condition as an integral part of it. The difference, in other words, lies not so much in rhetoric or in everyday practice as in the ideology and social relations that informed rhetoric and practice.

In the absence of any systematic study of the conservatism of bourgeois women, the comparisons necessarily remain tentative, but some suggestions are possible. As Marilyn Butler has argued, Jane Austen, for example, unmistakably espoused conservative social views, and resolutely opposed the sentimental view that "subjective experience is the individual's whole truth."[31] In Butler's view, Austen, by having heroines accept marriage as the fitting conclusion for their aspirations as individuals, carried "her partisan meaning further than it could be carried in reasoned argument, even by Burke."[32] Not all Austen critics, to be sure, accept Butler's view. Feminists in particular frequently credit Austen with a much deeper commitment to female agency and independence than Butler would allow. But these debates, in essential respects, miss the main points. First, the tension in Austen's novels between women's independent agency and their willing acceptance of a social fate that muffles it precisely captures the tensions of conservative individualism. Austen's heroines must choose what is good for society and, accordingly, good for them. They enjoy considerable latitude to make the wrong choices and suffer the consequences. Second, and for our purposes more important, Austen's representation of the social system within which they make their choices indisputably privileges bourgeois over aristocratic values. Thus, in *Persuasion,* the mobility of navy people is invoked to redress the bankruptcy of the traditional aristocracy.[33]

The case of Hannah More, the best known of early nineteenth-century female apostles of conservatism, reinforces the point. An Evangelical and a member of the Clapham Sect, More promulgated a kind of religious paternalism as the proper relation between social classes and grounded her social vision in the domestic subordination of woman. Women, whom she viewed as naturally more delicate, frail, and morally weak than men, required the protection and retirement of the domestic sphere in which they found their highest destiny in assuring the happiness of men who were naturally fitted for the contests of the public world.[34] Southern women read More with great admiration, embracing her writings as a convincing articulation of their own situation and values. But More opposed slavery and devoted much of her energy to the education of the rural poor for whose edification she wrote innumerable homiletic tracts. Much like Austen, More, in other words, sought to persuade women willingly to accept their own subordination as the most effective way of stabilizing an inherently unstable capitalist world.

Whatever More's popularity among Southern women, her career and interests demonstrate that her conservatism differed from theirs in essential respects, notably in her fundamental acceptance of individualism. She was, to her very core, a reformer who sought to make the world a better place by promoting worthy causes. That she also sought to guard it against too rapid

upheaval—sought, that is, to keep various groups willingly in their appropriate places—in no way belies that acceptance. For Southern women, as McCord acerbically noted, reform betokened Yankee meddling. It would be hard to imagine Southern women writing tracts of any variety to educate the white rural poor, much less the black. Many did seek to introduce their slaves to the benefits of Christianity, some even taught favorite slaves to read, but the kind of reform that envisioned other members of society as individuals who must be brought willingly to accept their condition did not figure among their desiderata. Not least, most intuitively understood what McCord explicitly stated: Any serious movement to reform would, sooner or later, point toward the abolition of slavery. At most, accordingly, Southern women supported their clergy's advocacy of reforming slavery in the interests of strengthening it—of making the South a genuinely Christian slave society.

Never immune to the rhetoric of bourgeois individualism, never unilaterally opposed to individualism itself, Southern women frequently assimilated aspects of bourgeois thought to their own commitments. It is, for example, possible to read Evans's *Beulah* as an extended allegory for the reform of Southern society. But the reforms that Evans proposed, including a turning away from the corruptions of fashion and a turning towards the virtues of temperance, were all mobilized in the interests of consolidating slave society and delineating a world in which individualism could be contained within particular conditions rather than overriding them. If proslavery Southern men anchored the legitimacy of slavery in the subordination of woman to man, slaveholding women were more likely, in their heart of hearts, to anchor the subordination of woman to man in the exigencies of slavery—more likely, that is, to accept their own subordination as necessitated by that slavery which they firmly believed essential to any acceptable social order.

Notes

1. Russell Kirk, *The Conservative Mind from Burke to Eliot* (Chicago: Regnery Books, 1986).

2. Elizabeth Fox-Genovese and Eugene D. Genovese, "The Argument for Slavery in the Abstract," unpublished paper delivered at annual meeting of the Southern Historical Association, New Orleans, 1987.

3. Richard Weaver, *The Southern Tradition at Bay* (New Rochelle, NY: Arlington House, 1968); Louis P. Simpson, *The Dispossessed Garden* (Athens: University of Georgia Press, 1975) and *The Man of Letters in New England and the South* (Baton Rouge: Louisiana State University Press, 1973).

4. David Brion Davis, *The Problem of Slavery in the Age of Revolution* (Ithaca: Cornell University Press, 1966); Eugene D. Genovese, *From Rebellion to Revolution* (Baton Rouge: Louisiana State University Press, 1979); Elizabeth Fox-Genovese, *The Female Self*

in the Age of Bourgeois Individualism, Joanne Goodman Lectures, delivered at the University of Western Ontario, September 1987.

5. Eugene D. Genovese and Elizabeth Fox-Genovese, "Slavery, Economic Development, and the Law," *Washington and Lee Law Review* 41 (Winter 1984): 1–29; Elizabeth Fox-Genovese and Eugene D. Genovese, "The Divine Sanction of Social Order: The Religious Foundations of the Southern Slaveholders' World View," *Journal of the American Academy of Religion* 55, 2 (Summer 1987): 211–33. On the law, see Mark Tushnet, *The American Law of Slavery: Considerations of Humanity and Interest* (Princeton: Princeton University Press, 1981).

6. Elizabeth Fox-Genovese, *Within the Plantation Household: Black and White Women of the Old South* (Chapel Hill: University of North Carolina Press, 1988).

7. Elizabeth Fox-Genovese, "The Religion of Slaveholding Women," in *That Gentle Strength: Aspects of Female Spirituality,* ed. Lydia L. Coon (Charlottesville[: University Press of Virginia], 1989).

8. Campbell Family Papers, Perkins Library, Duke University.

9. The references to Washington are ubiquitous. See, e.g., Mary Moragne, *The Neglected Thread,* ed. Del Mullen Craven, 66 (22 February 1838).

10. John Boles, *The Great Revival, 1787–1805: The Origins of the Southern Evangelical Mind* (Lexington: University of Kentucky Press, 1972); Jan Lewis, *The Pursuit of Happiness: Family and Values in Jefferson's Virginia* (New York: Cambridge University Press, 1983).

11. Moragne, *Neglected Thread,* 233 (26 February 1842).

12. Fox-Genovese, *Within the Plantation Household,* ch. 5.

13. Eugene D. Genovese, "Toward a Kinder and Gentler America: The Southern Lady in the Greening of the Politics of the Old South," in *Marriage and the Family in the Victorian South,* ed. Carol Bleser (New York: Oxford University Press, 1990).

14. Julia Gardiner Tyler, "To the Duchess of Sutherland and the Ladies of England," *Southern Literary Messenger* 19, no. 20 (Feb. 1853): 121.

15. Ibid., 120, 121.

16. Ibid.

17. Ibid.

18. Ibid., 125.

19. Caroline Lee Hentz, *The Planter's Northern Bride* (Chapel Hill: University of North Carolina Press, 1970).

20. Mrs. Henry Schoolcraft, *The Black Gauntlet* (Philadelphia: Lippincott, 1860), 93.

21. Ibid., 227.

22. Ibid., 306–7.

23. Ibid., iv.

24. Ibid., v.

25. Augusta Jane Evans, *Beulah* (Atlanta: Hoyt and Martin, 1898; orig. ed., 1859).

26. Augusta Jane Evans, *Inez: A Tale of the Alamo* (New York: Grosset and Dunlap, 1887; orig. ed., 1855).

27. Louisa S. McCord [L.S.M.], "Woman and Her Needs," *DeBow's Review* 13 (September 1852): 168, and her "Enfranchisement of Women," *Southern Quarterly Review* 21 (April 1852): 322–41.

28. Thomas Roderick Dew, *Digest of the Laws* (New York: Appleton and Co., 1852).

29. Elizabeth Fox-Genovese and Eugene D. Genovese, *Fruits of Merchant Capital* (New York: Oxford University Press, 1983), ch. 11.

30. Elizabeth Fox-Genovese, "Women, Affirmative Action, and the Myth of Individualism," *George Washington Law Review* 54, 2 & 3 (January and March 1986): 338–74.

31. Marilyn Butler, *Jane Austen and the War of Ideas* (Oxford: Oxford University Press, 1975), 293.

32. Butler, *Jane Austen*, 299.

33. Elizabeth Fox-Genovese, "The Female Self in the Age of Bourgeois Individualism," Joanne Goodman Lectures, University of Western Ontario, 1987.

34. Hannah More, *Coelebs in Search of a Wife and Strictures on the Modern System of Female Education*, in *The Works of Hannah More*, 2 vols. (New York: Harper and Brothers, 1841); Catherine Hall, "The Early Formation of Victorian Domestic Ideology," in *Fit Work for Women,* ed. Sandra Burman (New York: St. Martin's Press, 1979); M. G. Jones, *Hannah More* (New York: Greenwood Press, 1968; orig. ed., 1952).

Nine

Contested Meanings

*Women and the Problem of Freedom in the
Mid-Nineteenth-Century United States*

I.

Having lived amid the men with the guns in Alfred, Georgia, Paul D., the male protagonist of Toni Morrison's novel *Beloved,* knew that under slavery you protected yourself by loving small. Under those conditions, you "picked the tiniest stars out of the sky to own. . . . Grass blades, salamanders, spiders, woodpeckers, beetles, a kingdom of ants. Anything bigger wouldn't do. A woman, a child, a brother—a big love like that would split you wide open in Alfred, Georgia." Paul D. knew exactly what Sethe meant when she told him that she had to get her children to freedom before she could truly love them: "to get to a place where you could love anything you chose—not to need permission for desire—well now, *that* was freedom."[1] As those who have read *Beloved* know, Sethe defended her freedom to love her own children—to call them hers and to call herself a mother—by murdering her second daughter, the "crawling already?" baby, whom she posthumously named Beloved after a word that moved her in the funeral service.

For Paul D. and Sethe, freedom above all meant what Orlando Patterson calls "personal freedom," the freedom which, "at its most elementary, gives a person the sense that one, on the one hand, is not being coerced or restrained by another person in doing something desired and, on the other hand, the conviction that one can do as one pleases within the limits of that other

person's desire to do the same." Personal freedom thus means the "power to do as one pleases, *insofar as one can*," in contrast to sovereignal freedom, which Patterson defines as "the power to act as one pleases, regardless of the wishes of others."[2] The notions of personal and sovereignal freedom have both been central elements in the Western tradition of freedom, which, in Patterson's view, also includes a notion of civic freedom—in his words, "the capacity of adult members of a community to participate in its life and governance." Further, the practice of civic freedom implies the existence of some kind of political community with "clearly defined rights and obligations for every citizen," although not necessarily a full political democracy.[3]

Notwithstanding Patterson's analytic care in defining what he calls the constitutive elements in the "uniquely" Western chord of freedom, the specific meaning of freedom remains elusive, primarily because of a widespread assumption that each of us knows what it means and a scarcely less widespread tendency to think of it in relation to our own experience. Yet those who have written most passionately about freedom have been those who simultaneously believed themselves entitled to it and deprived of it. Thus, perhaps as often as not, freedom has been claimed—and implicitly defined— in the heat of struggles against oppression or tyranny. In the modern West, freedom has preeminently been understood, as the implicit tension between Patterson's volumes respectively entitled *Slavery and Social Death* and *Freedom* suggests, as the antithesis of slavery, which, in the first instance, means an absolute or existential rather than contingent condition.[4]

The absolute antithesis between freedom and slavery is a distinctly modern phenomenon, born of the era of the American, French, and Haitian revolutions when political struggles toppled the traditional embodiments of sovereignal authority, replacing them with new models of civic freedom justified by and grounded in the sovereignal freedom of individuals.[5] Prior to the eighteenth century, Western societies were more likely to understand freedom as contingent and personal, and many were likely to separate the internal or future freedom of the Christian from the more limited freedoms that accrued to those of different stations in the world. Patterson argues that the genius of St. Paul lay in conjoining a vision of internal freedom that even slaves might enjoy to a vision of God's sovereignal freedom in which those who were saved might ultimately participate. In contrast, the genius, if we may call it that, of the great bourgeois revolutions was to transfer sovereignal freedom from God or the absolute monarch to the individuals who composed the polity.

The logic of this translation commands attention, especially since it is cutting such a wide swath in our own time. Following the lead of Thomas Hobbes and John Locke, eighteenth-century political theorists and

revolutionaries reworked the notion of sovereignty, repudiating the sovereignal authority of monarchs whose trampling of the prior freedom of individuals they condemned as illegitimate. Sovereignty, they insisted, derived from the individual, who sacrificed some portion of his freedom upon entering into society. The principle of the individual's sovereignal freedom necessarily remained intact, if only because it was theoretically essential to the legitimation of governments. But its practical exercise was never assumed to be absolute. The sovereignal freedom of individuals in theory was thus checked by respect for the personal freedom of others in practice. The notion of civic freedom embodied this compromise between the competing sovereignal freedoms of the individuals who comprised the polity.

In practice the implementation of individual sovereignty, even in the early democratic republics, proved considerably less than universal, contrary to modern assumptions. In the United States, slaves, women, and even some men of insufficient property were excluded from active political participation, although all enjoyed some of the benefits of membership in a society that recognized the claims of civic freedom. But the most stalwart defenders of freedom, especially those from the South and including the Virginia political luminaries, automatically assumed that the citizenship of individual men was grounded in households whose members they represented in the polity and for whose well-being they assumed responsibility. Thus indirectly all free women and men participated in the life of the republic and enjoyed the protection of its laws even if they did not participate directly in its governance. Slaves enjoyed many fewer benefits from their residence within the United States, of which, according to the Dred Scott decision, they could not be considered citizens; but even slaves enjoyed the protection of some laws. For the great majority of the signers of the Declaration of Independence and the Constitution, these unequal political relations were grounded in Christian doctrine, which acknowledged the concept of stewardship and mediated participation in civic freedom.

Yet as Adam Seligman, following John Dunn, has recently argued, the early Lockean conception of individualism, and hence individual freedom, did not break radically with the previous and still pervasive religious vision of governance and political obligation.[6] In effect, Locke transferred the source of obligation and responsibility from the public arena to the interstices of the self (these are my words, not those of Seligman or Dunn). This move rested upon a separation between public and private that the early modern patriarchalism of a Robert Filmer or James I would not have acknowledged.[7] That separation, and the attempt (which concerns Seligman) to mediate it through the concept of civil society, decisively shaped the development of the idea of individualism.

In complex and shifting ways, the idea of individualism depended upon some combination of the related ideas of freedom, equality, reason, universalism, and autonomy—each of which, with the possible exception of autonomy, already had a history of its own. The novelty of individualism, in other words, lay less in the intellectual traditions upon which it drew than in its attempt to combine and rework them. In time and place, individualism's most radical innovation doubtless lay in its claims about the nature of political sovereignty, which it ascribed to independent (male) individuals rather than to a single sovereign who embodied in his (or occasionally her) person the ultimate, although in practice rarely unconditional, political will of the polity as a whole.[8]

The lingering death of old habits and attitudes long ensured that the political claims of individual freedom would be restricted to selected members of the polity, notably, those men who owned sufficient property to be deemed to have a direct stake in its governance. Yet even as political individualism restricted its benefits in practice it cultivated a more generous rhetoric of freedom and equality that invited the identification of those who lacked the attributes to claim political individualism for themselves. In that generosity lay the mainspring of its powerful hegemony, even among those who did not yet benefit directly from it. Thus political regimes grounded in the commitment to individual freedom presided over most of the history of modern slavery.[9]

I am well aware that I have shifted from the evocation of individual freedom to that of political individualism. I have done so with malice aforethought, for the shift captures the frequently unacknowledged tension at the heart of modern notions of freedom. Today, most of us find it virtually inconceivable to speak of personal freedom without simultaneously speaking of civic or political freedom: that is, the freedom to participate in the shaping of the laws and institutions that structure our public lives. Our difficulty in this regard elides the public and private and exposes our tendency to see civic freedom as a combination of personal and sovereignal freedom. Our difficulty is new. Until very recently, the modern conception of civic freedom, and the political individualism upon which it rested, coexisted with a persisting corporatism that recognized the personal freedom of people who did not participate directly in civic freedom.

II.

The experience of women in general and of slave women in particular challenges any simple understanding of the meaning of freedom in the history of the American republic. When the Founders said that all men were created equal, they meant all human beings—male and female, black and white.

They held that view as honestly as they believed that women were unsuited for political participation and as honestly as they accepted slavery. And they were in no contradiction at all. They did not agree that all people were equal, except in the equal worth of their respective versions of humanity—that is, in the equality of their souls before God—and in their innate sense of right and wrong, which therefore made each person responsible for his or her acts. In our own time, the meaning of freedom has been stretched to cover many more conditions, relations, and individuals than the original architects of American freedom ever intended and has especially, if irrationally, conflated freedom and equality. As a result, one may discern a growing tendency to reinterpret civic freedom from the perspective of personal freedom and, at the extreme, to push the meaning of personal freedom toward sovereignal freedom. In the process, we risk the loss of the Founders' assumption that practical freedom inescapably implied a recognition of coexistence—of limits and of responsibilities.

The Christian (specifically Calvinist) aspect of Locke's influence upon their thought commands attention. In working from a Calvinist conception of the equality of human souls before God, Locke was decisively separating equality from freedom in its permissive or anarchistic implications. The equality of souls lay in their equal subordination to God's dominion, which is to say in their individual responsibility to a higher authority. Hence the freedom of individuals lay in their ability to choose sin over virtue—to defy God's authority and pay the predictable price. The equality and freedom of political life exercised a much more restricted sway and primarily concerned the equal stake in sovereignty and governance shared by propertied male individuals, who were enjoined to represent the interests of their households of dependents.

During the antebellum period, American women did not directly participate in civic freedom, although we may safely assume that they all identified in greater or lesser measure with the message of personal freedom that pervaded the young nation's political ideals. Most undoubtedly still understood personal freedom primarily in terms of Christian teachings, to which they turned for guidance about their relations with and responsibilities toward others.[10] Many also, without seeing any contradiction, embraced significant elements of the emerging language of civic freedom. Thus during the 1830s, female mill operatives in Lowell turned to the revolutionary tradition to justify their opposition to their employers. Identifying themselves as "daughters of freemen," they insisted,

> *Let oppression shrug her shoulders*
> *And a haughty tyrant frown,*

> *And little upstart Ignorance,*
> *In mockery look down.*
> *Yet I value not the feeble threats*
> *Of Tories in disguise,*
> *While the flag of Independence*
> *O'er our noble nation flies.*[11]

There is no mistaking the young women's determination to claim the promises of American independence as peculiarly their own. In a second protest poem, another of their number drove the point home, and in so doing signaled yet more radical implications of the message of freedom:

> *Oh! isn't it a pity, such a pretty girl as I—*
> *Should be sent to the factory to pine away and die?*
> *Oh! I cannot be a slave,*
> *I will not be a slave,*
> *For I'm so fond of liberty,*
> *That I cannot be a slave.*[12]

The women operatives of Lowell belonged to a literate culture. For them, political language, like the language of the Bible in which they were immersed, linked formal literate culture to their personal situation. They had grown up hearing and reading the words that helped them to define their own identities. For them, the simple assertion that you, the boss, cannot do this to me, the woman worker, could best be rendered in the political language that defined the status of male citizens. But in borrowing that language, they were claiming it for their own identities. By the same token, they modified the culture from which they were borrowing. In particular, as they moved from the positive assertion, I too am free, to the negative assertion, I cannot be a slave, they gave new meaning to the common metaphor of slavery as the antithesis of freedom. During the 1840s and the 1850s, any number of women who sought to improve their own condition would insistently exploit the metaphor.

The metaphor of slavery as the antithesis of freedom resonated powerfully among the early proponents of women's rights, many of whom had already been active supporters of abolition.[13] The best-known vignette is that of the young Elizabeth Cady Stanton, who attended the World Anti-Slavery Convention in London with her husband only to find that the women would not be recognized as delegates—and were not allowed to address the assembly nor even be seated with the men. The outraged Stanton found it "pitiful to hear narrow-minded bigots, pretending to be teachers and leaders of men,

so cruelly remanding their own mothers, with the rest of womankind, to absolute subjection to the ordinary masculine type of humanity."[14] Sitting through the proceedings, she and Lucretia Mott turned their thoughts to the plight of women. Mott had little faith in "the sincerity of abolitionists who, while eloquently defending the natural rights of slaves, denied freedom of speech to one-half the people of their own race." These self-styled philanthropists would have been appalled at the thought that women might be physically harmed, but "the crucifixion" of women's "pride and self-respect, the humiliation of the spirit, seemed to them a most trifling matter."[15] Walking home from the last session, Stanton and Mott resolved that immediately upon their return to the United States they would "form a society to advocate the rights of women."[16]

At that meeting, which was eventually convened in Seneca Falls, New York, in 1848, Stanton presented an impassioned defense of women's equal right to the freedom that men enjoyed. She did not reject women's special maternal and domestic responsibilities, but insisted that so long as women were degraded and oppressed, women could not meet those responsibilities and the nation would languish in its current state of "moral stagnation." Men commonly objected that "if the principles of freedom and equality" she advocated were put into practice, the harmony of domestic life would be destroyed. To the contrary, she countered, "there can be no true dignity or independence where there is subordination to the absolute will of another, no happiness without freedom." And as for women's role as mothers in shaping the character of young men, "So long as your women are slaves you may throw your colleges and churches to the winds."[17]

Stanton, who modeled the convention's Declaration of Sentiments on the Declaration of Independence, nonetheless insisted that the meeting was not intended to discuss only the details of social life. She and her colleagues were not proposing to petition the legislature "to make our husbands just, generous, and courteous, to seat every man at the head of a cradle and to clothe every woman in male attire."[18] She and her colleagues had assembled to discuss their civil and political rights and wrongs, "to protest against a form of government, existing without the consent of the governed—to declare our right to be free as man is free, to be represented in the government which we are taxed to support."[19] She thus focused directly upon civic freedom: the right of women to participate in the governance of the polity in which they lived and to which they paid taxes. And her Declaration of Sentiments began with the precise language of the Declaration of Independence, including "We hold these truths to be self-evident," but it modified the content by substituting for the "all men" of the original, "all men and women are created equal."[20]

Stanton did not restrict herself exclusively to civic freedom, for, in her view, man's presumption toward woman vastly exceeded her simple exclusion from political participation. "He has made her, morally, an irresponsible being," by allowing her to commit crimes with impunity, provided they be committed in the presence of her husband. He has deprived her of education and, in the church as well as the state, restricted her to a subordinate position. He has distorted public sentiment by assigning to her a different code of morals than that which obtains for man. In sum, "He has usurped the prerogative of Jehovah himself, claiming it as his right to assign for her a sphere of action, when that belongs to her and to God." Thus has man not merely disfranchised but degraded women by attempting in every means at his disposal "to destroy her confidence in her own powers, to lessen her self-respect, and to make her willing to lead a dependent and abject life."[21]

In that time and place, most Americans perceived Stanton's demand that women participate equally in civic freedom through the exercise of the franchise as unacceptably radical. But, as we may appreciate, the true radicalism of her Declaration lay in her insistence that men, in their relations to women, had arrogated sovereignal freedom to themselves, thereby demeaning and degrading women as autonomous individuals. Here is where the metaphor of freedom as the antithesis of slavery came powerfully into play. For Stanton, in evoking the cost to women of the deprivation of freedom under which they lived, borrowed heavily from eighteenth-century evocations of slavery as debilitating dependence. In so doing, she suggested that the deprivation of freedom had endowed women with the psychology of slaves, coloring their entire relation to the world. Thus, although in her speech to the convention she insisted that she did not intend to transform men's and women's roles, her passionate denunciations of the ways in which deprivation of freedom had distorted their respective characters betrayed an underlying perfectionist desire to refashion radically many aspects of the world.

Stanton neither mentioned nor protested against biblical teachings about women's subordination. She betrayed no inclination to attack religion, which she believed supported her cause. Her complaints lay with the men who had assumed the position of God and closed church leadership to women. Her strategy effectively divorced revealed religion from its institutional manifestations in the world, leaving it to women to claim the essence of religion for themselves. In this spirit, she exhorted her listeners to live as they should and feel their individual accountability to their Maker. She wished woman to know that her spirit was "fitted for as high a sphere as man's." She wished woman to "live *first* for God, and she will not make imperfect man an object of reverence and awe." Only thus would woman learn that her dependence must be upon God, her true happiness must derive from accomplishment of

her duty. "Thus will she learn the lesson of individual responsibility for time and eternity."[22]

Stanton's thinking about the direct relation of the individual soul to God very much resembled that of the abolitionists with whom she and many other advocates of women's rights had worked. Like them, she was essentially arguing that the dictates of individual conscience took precedence over the teaching of ministers or even the Bible. The radicalism of this position lay in the claim that the freedom of the Christian included the right—for some, the obligation—of the individual Christian to define the meaning of freedom. Toward the end of her life in such writings as "Solitude of the Self" and *The Woman's Bible,* she openly advocated an emancipation and self-determination for women that challenged all institutional and ideological barriers. Women's freedom required a liberation from the artificialities of law and custom that, in freeing them, would transform society.[23]

III.

If Stanton began with the intention of claiming civic freedom for women, her reflections upon the implications of women's experience of "enslavement" led her to the conviction that women's emancipation required something akin to sovereignal freedom. To be sure, she did not write as if she were claiming for women the uncontested freedom to tell others what to do. Identifying the condition of women with that of slaves, she more modestly claimed that men had no right to tell women what to do. In practice, she would assuredly have acknowledged the legitimacy of a personal freedom that permitted women to do as they chose insofar as they could without encroaching upon the similar freedom of others. In theory, however, she focused exclusively upon what she believed women needed in order to rid their own minds of the crippling habits of dependency and compliance. We may be permitted to doubt that her goals could have been realized without serious cost to the freedom to which men had become accustomed, or, more important, without cost to the prevailing conception of freedom in society as a whole.

No less than Stanton and her colleagues, Southern slaveholding women understood the power of the association between abolition and freedom for women, but they rejected its implications. In practice, the vast majority supported slavery, which they recognized as an essential foundation for their own position as ladies. Life amid slaves caused them no end of frustrations, but it afforded them a freedom from household labor that they valued highly. More often than not, they viewed their own difficulties in supervising slaves as, in large measure, the consequence of their own weakness of character. They would commonly rail that this or that slave was lazy, uppity,

or unruly; they would complain that all slaves were impossible; they might even express doubts about whether the ownership of slaves was good for women's or men's character. But when they turned to their diaries and journals they usually prayed for the strength and maturity to live up to their responsibilities by governing their slaves properly.[24]

Theoretically, most slaveholding women regarded slavery as a legitimate, indeed divinely sanctioned, social system. And those who thought about the theoretical justifications for slavery knew that the biblical justification for the subordination of slaves to masters was grounded in the prior justification for the subordination of women to men.[25] Louisa S. McCord, a formidable intellectual and polemicist who was more interested in economic theory than theology, readily intervened in public debates on the slave trade, the diversity of races, and the difference between white and black slavery.[26] A passionate defender of free trade, McCord paid more attention to the laws of economics than the laws of God. A passionate defender of Southern independence, including Southerners' right to hold slaves, she fully understood the claims of freedom. But she impatiently rejected the notion that they should be applied to women individually.

McCord never doubted the personal and intellectual capacities of gifted women (among whom she surely counted herself); she never denied that some women might chafe at being restricted to their allotted sphere. Of course women may suffer from "*compression,*" as may men. Who, at one time or another, does not? "Human cravings soar high. Perhaps there is no human being, not born in a state of imbecility . . . who does not suffer, or fancy that he suffers, from compression."[27] But she remained convinced that women's physical weakness necessitated male protection, which, in her view, justified women's social dependence upon men. Suppose, she suggested, that one were to pit an individual woman against an individual man, "in a direct state of antagonism, by throwing them into the arena together, stripped for the strife." Suppose one were to say to the man that this woman differs in no essential respect from himself, that she is "your equal and similar, possessing all rights which you possess, and (of course she must allow) possessing none others." What, in such a contest, would become of the woman's physical weakness? For McCord, the answer was clear: The woman would lose and the world become a "wrangling dog kennel."[28]

McCord unhesitatingly lumped the defense of women's individual rights with abolitionism, socialism, and all the other pernicious -isms that threatened to unravel the legitimate social fabric. The triumph of -isms would turn the world into a topsy-turvy nightmare—"a species of toothache, which, by some socialistic, communistic, feministic, Mormonistic, or any such application of chloroform to the suffering patient, may be made to pass away in a

sweet dream of perfection."[29] The freedom that McCord, like many other slaveholding women, cherished was the freedom of their country, in which they believed themselves to participate. Freedom, in other words, adhered to the collectivity and, accordingly, to those who belonged to it. Their knowledge that not all members of the collectivity enjoyed an equal measure of personal freedom did not shake their confidence in the conception. And even McCord attacked the proclivity of Stanton and her colleagues to present religion as purely a matter of individual conscience. Such a perfect "democratic system," she scathingly noted, can only result in the deposition of God Himself, "by reducing *His* influence to a *single vote*," which in turn will result in the reversal of ranks until a militant proponent of women's rights (she had Harriet Martineau in mind) might ultimately "prefer (as some . . . recent works seem to suggest) to have it decided that she is *Le Bon Dieu* himself."[30]

When McCord and other pro-Southern women wrote of tyranny, they were invariably attacking the tendency of Northerners, especially those whom they called Black Republicans, to reduce the South to a state of subjugation.[31] In this respect, they interpreted the mounting calls for the freedom of slaves and of women as a direct attack upon the freedom of their society and hence upon their own freedom. In their minds they were defending a viable concept of civic freedom against a host of arrogant and presumptuous folks who were demanding the extension of sovereignal freedom to all. They worried that such challenges threatened the very concept of civic freedom, and they especially worried that these claims of sovereignal freedom directly defied God's law.[32]

At the close of the antebellum period, Augusta Jane Evans, who harbored serious doubts about the effect of slavery upon women's character, published a novel, *Beulah,* in which she searchingly explored the problem of women's freedom. Her protagonist, Beulah Benton, loathes the very idea of dependence in any form. Reproaching a friend who tries to convince her that a woman's heart has special needs, Beulah retorts, "What was my will given to me for, if to remain passive and suffer others to minister to its needs? Don't talk to me about woman's clinging, dependent nature. You are opening your lips to repeat that senseless simile of oaks and vines; I don't want to hear it; there are no creeping tendencies about me."[33] Like Louisa McCord, but yet more thoroughly, Evans enters the lists against the Northern drift toward a religion grounded only in the individual conscience. Evans represents Beulah's seduction by the forces of skepticism, singling out the Emersonian temptation to confuse the individual with God. Eventually, Beulah regains her faith and with it her ability to love. At the novel's close, she has married the guardian whose offers of adoption and financial support she had previously brushed proudly aside. Evans did not intend Beulah's

marriage to signal her repudiation of a woman's legitimate claims to personal freedom; she did intend it to signal her willing repudiation of illegitimate claims to sovereignal freedom. Beulah's greatest strength lies in her unmediated relation to God; but that very relation includes acceptance of God's law, which assigns different social and civic positions to women and men.

IV.

By the close of the antebellum period, literate white women in the United States had mounted a serious contest over the meaning of freedom, especially as it applied to themselves. Northern antislavery and women's rights women frequently evoked the plight of black slave women as emblematic of the disorder and abuse wrought by the deprivation of freedom, but most of them also harbored a strong dose of racism that made them less than empathetic with black women's position.[34] Proslavery Southern women for their part might easily express deep devotion to a specific slave or deplore the tendency of white men to consort with slave women sexually. But, in general, neither group fully understood the situation and feelings of slave women, if only because they had great difficulty in viewing that situation as essentially similar to their own. The vast majority of white Southern women saw the possible emancipation of the slaves as a direct threat to themselves and the stability of their society. White, antislavery Northern women favored emancipation on principle, but since they normally did not know or live among any significant number of African-Americans, their convictions in this regard largely remained abstract.

Throughout the antebellum period, black slave women harbored and developed their own distinct conception of freedom, which began, and sometimes ended, with their own release from bondage. Knowing slavery from the perspective of the slave, they had no doubt that it constituted the antithesis of freedom. They lived with the everyday indignities and frequently the pain of being subject to the will of another and being (sometimes harshly, sometimes brutally) disciplined if they refused to comply. In everyday life, their lack of freedom meant that their persons and their time were largely at the disposal of their owners. Whether working in the fields or in the house, they followed the orders of masters, mistresses, overseers, and even capricious, undisciplined children. They were expected to do as they had been told, and if they did not they could expect to be punished.[35]

The more serious consequences of their enslavement, as many of them understood, nonetheless lay elsewhere. Slavery deprived women and men of the freedom to enter into legally sanctioned, binding marriages. It deprived them of the freedom to determine their children's futures, and frequently of

the possibility of keeping their children with them. The absence of freedom disastrously curtailed, although never completely foreclosed, their ability to build their own churches and community institutions, their ability to provide their children with a literate education, even their ability to enforce their preferred visions of male and female roles. Slavery demonstrably limited their individual and collective mobility, but it no less portentously limited their individual and collective stability. At the extreme, it pitted each of them individually against the sovereignal freedom of the master—the power of his will over their lives.[36]

The worst case of the isolated slave who struggled in solitary combat against the will of an overbearing master did occur, but it was not the norm. The real horror of that absolute opposition between freedom and slavery as embodied in the master and the slave respectively lay precisely in its defining the outer limits—the logical possibilities—of slavery as a social system. In practice those possibilities were not realized, or only realized episodically. The majority of African-American slaves in the United States did not suffer the "social death" that Orlando Patterson sees as the essence of all forms of slavery.[37] Patterson's view implies an existential interpretation of slavery as the absence of freedom and hence of social connection, much as black is described as the absence of color. Considering slavery from an analytic perspective, Patterson views it as an absolute, which, in effect, means as the antithesis of sovereignal freedom.

The point is not that African-American slaves lacked civic freedom and endured severe restrictions upon their personal freedom. On both counts, they did. But they did not live in the kind of chaotic limbo that the total deprivation of all elements of freedom would imply. Some significant portion of the lives of most slaves was ordered as if they did enjoy at least some freedom. The notion that slavery in the United States should be viewed as a total institution, analogous to Nazi concentration camps, has been discredited primarily because historians of the slave community have not found that the majority of slaves were reduced to Sambos or Uncle Toms.[38] To the contrary, historians have found compelling evidence of a vigorous culture and strong familial or community bonds among slaves who had the wit to hide much of their independent life as a people from the eyes of their owners.[39]

Slave women developed their own patterns of everyday resistance to ease their oppression, finding countless ways to take possession of their tasks, to take pride in their skills, to provide small advantages for themselves and their children, to run off for brief periods to carve spaces of quiet and privacy out of their lives. They developed sophisticated techniques that pushed many a mistress to the brink of distraction because a task would be left undone, done too slowly, or not done in the prescribed way. Former slave children fondly

recollected the time their mothers found—frequently at night—to make special food or clothes for their families, to instruct their children, or to worship in secret with other slaves. Here and there, narratives by former slaves or accounts by whites provide glimpses of passionately independent women whom no man could handle. Frequently these women were depicted as being of recent African origin, which they may or may not have been. But the convention of associating fierce, unbreakable independence with recent African origins suggests much about the attitudes of the majority of slaves. For these women whom none could handle were not merely represented as being cut off from whites, but from other members of the slave community as well. If only by contrast, the figure of the indomitable, independent African woman, who recognized no law other than her own will, reminds us that the majority of slaves did see themselves as members of a community that was bound together by shared conventions and practices, if not by formal laws.

The conventions and practices that ordered the lives of the majority of slave women derived from both African and American traditions and took from both sources a recognition of interdependence. As Patterson has argued, the Western conception of freedom was unique, so we should not expect the slaves to have derived it from their African past.[40] In this perspective, their unambiguous opposition to slavery might best be understood as precisely a rejection of slavery rather than a defense of freedom per se. The African societies from which the slaves were torn recognized neither individualism nor private property in the modern Western sense. African traditions and practices derived from a worldview that emphasized the importance of family, lineage, and collective effort. African societies also practiced slavery, but not usually the chattel slavery that was practiced in the United States. African slavery could be brutal, but conceptually it tended to be expressed in ideologies that emphasized the inequality and interdependence among people and the interdependence of the material and spiritual worlds.[41]

Southern proslavery ideology shared many of these features, especially the emphasis upon hierarchy and interdependence. Thus as Southern paternalism took shape it rested upon a commitment to the reciprocal, if unequal, rights and responsibilities of slaveholders and slaves, who belonged to a single household. Slaves were the first to understand and defend what they took to be their rights within this context, notably their rights to regular periods or days of rest and their claim upon some of the goods of the household. Among the black and white women, the slaves' sense of their rights frequently took the form of a cook's understanding that she was entitled to a certain amount of white flour or some other delicacy for her own family or a maid's understanding that she was entitled to some share of her mistress's

cast-off clothing. More often than not, a female slave who ran off to the woods for a day or two—not the same as running away—or dawdled while completing an errand believed that she was acting within the rules of reciprocity, which is to say within her rights.

To invoke paternalism in this sense is emphatically not to invoke benevolence, for paternalism rested on violence and could wear a brutal face. It is, however, to underscore the ways in which slaveholders and slaves, however unequally, collaborated in creating and sustaining a sense of their mutual rights and responsibilities. And, more often than not, a slave's exercise of his or her "rights" required that a master or mistress meet his or her "responsibilities." Accordingly, both parties to this relation felt that they had claims upon one another that could not easily be encompassed by the individualist language of freedom. Both sides, to be sure, were aware of the language; both applied it to some aspects of their respective situations. But neither relied upon it entirely in their relations among themselves.

For the slaveholders—to risk simplification—the language of freedom applied to the public or civic realm of politics and governance in which male heads of households participated, and women, children, and slaves did not. For the slaves, following the Haitian Revolution, it also applied to a public realm the laws of which enforced their enslavement.[42] We know that countless slaves enthusiastically embraced the signs of civic freedom, and the Fourth of July became such a favorite day for them that even slaveholders, who in other situations remained remarkably blind to the evidence of their slaves' independent wills, tempered their rhetoric in public speeches. National independence was one thing, but the possible meanings that slaves might give to invocations of individual liberty and equality were entirely another.

The more literate and sophisticated slaves understood the issues perfectly. In 1852, Frederick Douglass openly reproached a white audience in New York City for their wanton appropriation of words that should belong to all. "What," he queried, "to the American slave, is your Fourth of July?" A day, he answered his own question, "that reveals to him, more than all the other days in the year, the gross injustice and cruelty to which he is the constant victim." Withal, he insisted, he was "not wanting in respect for the fathers of this republic," whom he acknowledged as "brave" and "great men." Thus, however disadvantageous the position from which he, as a former slave, was bound to regard them, he would unite with whites "to honor their memory."[43]

But the slaves' growing understanding that freedom was a status to which they, as a people and as individuals, might aspire and even fight for, did not overnight revolutionize their political perceptions. Knowing themselves to be slaves, their first understanding of freedom normally focused

directly upon their determination to reverse their condition. Or to put it differently, they readily thought of freedom as, indeed, the antithesis of the enslavement they knew. It was in this spirit that countless slaves sought to claim for themselves the benefits of the civic freedom to which they knew they were entitled. But their understanding of the specific content of that civic freedom—what they expected it to mean in everyday life—was considerably more complex. They continued to adhere to concepts of social and political relations that derived from their African traditions and that were, in some measure, reinforced by their own determination to shape their experience as members of slaveholding households.

V.

Emancipation represented the political triumph of the Northern conception of freedom, which most Northerners presumably understood in the sense of civic freedom. Only a few leaders, most notably Thaddeus Stevens, insisted that the freedmen would require a sustained period of economic experimentation and political dictatorship to prepare them to overcome the legacy of slavery and participate in a republican polity. In the prevalent view, emancipation had simply freed former slaves to take their place as independent members of the polity. To decree the slaves' freedom was not, however, the same as its implementation. And, as the early claims on behalf of women's rights might have suggested, the inclusion of those who had previously been denied civic freedom might well raise questions about personal and sovereignal freedom as well. Radicals like Thaddeus Stevens understood that freedom without the means to sustain it might prove a mixed blessing at best, but they lost the fight for those forty acres and a mule that the majority of slaves believed would establish their position as independent farmers. The ultimate failure of Reconstruction to effect economic democracy and provide substantively for the former slaves left slaves and slaveholders to negotiate the new meaning of freedom as best they could, beginning with the meaning of free labor. The Freedman's Bureau played an important role, especially in the case of agricultural labor, frequently defending the freedpeople's interests, sometimes mediating between freedpeople and planters or landlords. But even at its best, it exercised only a limited sway over the full scope of former slaves' lives and even over their relations with their former masters and mistresses.[44]

For Northerners, it seemed natural that emancipation pre-eminently meant the implementation of the freedom of labor that lay at the center of Republican ideology and policies.[45] Freedpeople must work in order to live; employers must pay workers for their labor. But nothing, least of all labor, was that simple. In the event, sharecropping and tenancy proved much more

common than agricultural wage labor throughout the South during the latter decades of the nineteenth century, but the regions such as the sugar parishes of Louisiana in which wage labor did prevail reveal much about both sides' attitudes toward the meaning of freedom. In the sugar parishes, both planters and freedpeople viewed postbellum labor through the prism of their relations under slavery. Thus while both sides were willing to capitalize on the advantages of free labor, neither side was willing to forego the advantages that paternalism had afforded them.[46] Freedpeople, for example, saw no inconsistency in drawing wages for their labor and continuing to demand that the planter provision their animals or grant them access to his animals and tools. Planters, for their part, had no patience with the notion that they should absorb the cost of labor and continue to respect traditional rights and prerogatives. If freedom had arrived, so be it. But they had always viewed the freedom of the labor market as the very antithesis of their own paternalistic relations with labor, and if the market had triumphed, then paternalism had no further claims upon them. Their clear-sightedness on this aspect of their new labor relations did not, however, prevent them from expecting their laborers to put in extra hours during the harvest season. And so it went, with neither side being prepared to adjust to the full implications of market relations.

Some planters, who sought to regulate the lives of their laborers as fully as possible, instituted prohibitions against leaving the plantation without a pass, drinking, gambling, and even the use of "bad language." Freedpeople understandably viewed such attempts as a direct assault upon the essence of their freedom, which lay in their ability to do as they saw fit. At the same time, freedpeople frequently recognized the importance of discipline to efficient collective labor, and they assuredly recognized that the wages they received for that labor gave them greater autonomy than they had ever known.[47] That very autonomy became another source of friction as workers in the sugar parishes of Louisiana, for example, were known to collect their monthly wages and take off for the city until they had been spent. Planters retaliated by attempting to withhold the wages until the end of the growing season, but freedpeople protested that this practice compromised their freedom, the essence of which lay in their ability to leave the plantation as they chose.[48]

If planters had difficulties in negotiating the meaning of free labor with freedmen, their difficulties with freedwomen were greater yet. Throughout the South freedwomen, with the full support of their men, sought to withdraw from field labor entirely and, if possible, from domestic labor in the houses of others as well. Freedwomen's aversion to field labor had appeared during the war and grew steadily thereafter. Even when freedwomen did

agree to work in the fields, notably during harvests or other demanding seasons, planters complained that they never put in the full time required. In regions in which tenancy took hold, planters usually attempted to make contracts depend upon the willingness of freedwomen to participate in the labor.[49]

The reasons for freedwomen's resistance to paid labor for whites were many, but high among them ranked the commitment of both freedmen and freedwomen to the creation of their own families and households. It is widely known that countless former slaves responded to emancipation by formalizing marriages that under slavery had had no legal standing.[50] Shortly after the end of the war, one articulate freedman had exhorted a group of his fellows, enjoining them to recall that "The Marriage Covenant is the foundation of all our rights."[51] For both freedmen and freedwomen, the solemnization of marriages represented the premier sign of their ability to shape their own and their children's lives, to claim the essential promise of civic freedom, namely, the formal link between their public and private lives. For many former slaves, this was no empty formality, but the official recognition of their participation as a people in civil society. Each former slave might feel the lure of individual freedom, but most recognized that, even as individuals, freedpeople above all required the structure of families, churches, and schools to build a possible future for their people.[52]

For freedpeople, the corporate or institutional units of marriage, family, churches, and schools lay at the core of the meaning of freedom, but did not always come easily. They had to be defended not only against the claims of former slaveholders and a new class of landowners who were accustomed to the power to dispose of the labor of slaves as individuals, but against the hostility of a larger white community that could not easily stomach the prospect that former slaves would be their equals in Southern society. Although the most visible struggles normally occurred between individuals, many of those apparently personal struggles turned less on the individual case than on the consolidation of institutions, beginning with nuclear families, that grounded the place of freedpeople as free members of society. Thus a planter who sought to secure the labor of a married woman in his fields or his house was not merely laying claim to her as an individual, he was directly challenging her role as wife and mother and her husband's prior claim to her loyalty and labor.

Clearly most freedwomen concurred with their men that their first responsibility should be to their own families and that the freedom of the community would benefit from their willing assumption of the domestic roles against which Northern proponents of women's rights were beginning to protest. We would be naive to assume, however, that all freedwomen

slipped naturally into their new roles. Slavery had mightily conspired to treat slave women as individuals, at the cost of their responsibilities as wives and mothers. Slavery had assuredly not been entirely successful in this regard, but it took a heavy toll. In consequence, it is not surprising that freedwomen were inclined to fight for a measure of personal (including sexual) freedom, on the understanding that the meaning of freedom would have to include their own right to do as they pleased.[53] Thus for freedwomen, every bit as much as for freedmen, embedded in the meaning of freedom lurked a wrenching contradiction between stability and mobility.

Stability dictated that freedwomen recognize some limitations on their personal freedom in the interests of the cohesion of the African-American community. And many seem to have agreed to those limitations on the understanding that they helped to define and safeguard women's roles as wives and mothers. Both African and American traditions valued those roles highly, especially that of mother, and one of the most widely recognized failures of slaveholding paternalism, as many slaveholders themselves worried, lay in its tendency to violate them.[54] During Reconstruction and thereafter, if we may believe African-American writers, women willingly associated their own propriety as wives and devotion as mothers with the respectability and "uplift" of the African-American community as a whole.[55]

No matter how fully freedwomen understood the importance of stability, many continued to flirt with the lure of mobility. Their experience of slavery, no less than that of freedmen, had predisposed them to understand freedom as a direct and ultimately personal repudiation of the power of slaveholders to dispose of their time, their labor, and their persons. The freedom to love a husband or children included the recognition of obligation to others. It may well have represented the essence of personal freedom in the sense of doing as one wished within the limits of another's desire to do the same, but in the context of intimate personal relations the limits of the other person's desire to do the same normally included foregoing freedoms that, without those relations, one might have properly enjoyed. Thus a mother who, under slavery, might well have felt entitled to run off, leaving one or more children to be cared for by others, would, precisely by virtue of having gained the freedom to define herself as a mother, lose the freedom to come and go at will. And in fact, even as slaves few women were willing to abandon their children.

VI.

For better or worse, slavery had bequeathed to freedwomen a sense of themselves as individuals that profoundly colored their understanding of the meaning of freedom and influenced the ways in which they redefined their

relations with their world. Not long after Appomattox, Mary Jones overheard a discussion about the meaning of freedom between the cook and house-maid who had recently been her slaves. Kate and Flora dwelled especially upon their desire to own gold watches, bracelets, and chains, presumably seeing such items as fitting external signs of their new status.[56] Nor were they alone in their ambitions. Countless freedwomen challenged their former mistresses directly by assuming the airs and attire of ladies, notably parasols and veils. The challenge struck home. One officer of the Freedman's Bureau reported that the freedwomen's wearing of veils had so offended young white women that for a time they refrained from wearing veils themselves.[57]

One may readily savor the satisfaction the freedwomen got from the response of the white ladies, but the deeper significance, like that of the young white ladies' response, lay in its exposure of the symbiotic ties that bound many black and white Southerners together in a struggle of wills as fierce as any that their respective men experienced. Many former slavehold-ing women experienced emancipation as a devastating blow, even when they also claimed relief at being rid of the responsibility of supervising and car-ing for slaves. Mary Boykin Chesnut, in concluding her celebrated diary, captured the feelings of many when she grimly wrote, "I do not write often now—not for want of something to say, but from a loathing of all I see and hear. Why dwell upon it?"[58]

Initially, slaveholding women resisted the obvious truth that their for-mer slaves wanted to be free. Mary Chesnut, for example, confessed herself "daunted" when, in 1865, her friends the Martins left Columbia "and their mammy, the negro woman who had nursed them, refused to go with them."[59] But even those who acknowledged the freedpeople's desire for free-dom had great difficulty in understanding what freedom meant to them. One after another complained in her diary about problems with the former slaves who had chosen to remain, but who now expected to be treated like the free laborers they were. Ella Gertrude Clanton Thomas had an especially difficult time in coming to terms with those of her former slaves who stayed; Cather-ine Edmonston expressed relief at being free of the responsibility for hers.[60] But whatever a white woman's response, she might easily confuse the freed-people's departure, or even their decision to remain on new terms, with her own increased domestic burdens. From her perspective, their freedom meant her enslavement: what she bemoaned as unprecedented burdens, former slave women embraced as new, if uncertain, opportunities.

When former slaveholding women evoked their own enslavement, as many did, they frequently conflated the emancipation of their slaves with the Northern victory, thus reading their personal enslavement as a specific case of the enslavement of their society. As a seventeen-year-old, Emma LeConte

reflected in her diary upon the terror of Sherman's approach and his destruction and pillaging of Columbia, South Carolina. She wrote proudly of still feeling unconquered, but of hating the Yankees more than ever, viewing the very name Yankee as "a synonym for *all* that is *mean,* despicable and abhorrent."[61] In a similar spirit, Amelia Gayle Gorgas wrote that although she loved her home state of Alabama, she dreaded "to reside there while the present state of the negroes remains unsettled—indeed I do not feel as if it were my state or country while we are ground under the heel of Yankee despotism."[62] Shortly thereafter, Elizabeth Kilcrease in Georgia wrote to a friend to bemoan the loss of her slaves and to share the remark of another of her friends who claimed, "I have lost my religion since the Yankees set my negroes free." Doubtless, Kilcrease commented, "this has been the experience of many Southern women."[63]

Such women were wont to understand freedom primarily as civic freedom —the freedom and order of their own society. They understood full well that religious and secular proslavery ideology were as one in linking the justification of slavery to the subordination of women, and they were accustomed to acceding to limitations upon their own freedom as necessary to a social order they valued highly. But as Elizabeth Kilcrease suspected, her friend was not alone in losing her faith in the wake of the Yankee victory. Emancipation forced Gertrude Thomas to recognize "how intimately my faith in revelations and my faith in the institution of slavery had been woven together." And her faith was shaken. For a time she doubted God, the truth of revelations, everything. "When I opened the Bible the numerous allusions to slavery mocked me."[64] Sarah Hine expressed the despondency of many when she wrote to a friend that white Southerners "share nothing on earth to look forward to, we have no future, no country, we are slaves to the will of others."[65]

For such women the world had indeed ended, or at least been turned upside down. And if they did not initially devote much thought to the implications of the defeat for their personal freedom, many gave considerable thought to its implications for the freedom of their former slaves. Lenora Clayton, for example, claimed sincere concern for the fate of the freedpeople, but doubted they were ready for freedom. Finding free labor more efficient than slave labor, she had no further interest in defending slavery, but she nonetheless believed that "the priceless boon of freedom is what few, if any [former slaves] comprehend."[66] And Laura Comer noted in her diary, "Freedom has fallen so suddenly upon the negro as to completely upset his equilibrium & turn his head."[67]

Women like Laura Comer might have been shaken to discover that freedwomen's ideas of freedom had much in common with what white women

wanted for themselves. Eliza Andrews, however, began to understand the issues fairly rapidly. When Andrews's maid Charity first informed her that she had selected the name of Tatom and should henceforth be referred to as Mrs. Tatom, Andrews was amused. She nonetheless reflected that the freedpeople seldom, if ever, took the names of their owners when selecting what they called "their entitles." Presumably, she noted, since the name of the owner had been given to them in slavery, they wished "to throw off that badge of servitude. Then, too, they have notions of family pride."[68] Thus did Andrews implicitly acknowledge that the expression of family pride through the choice of one's own name represented an important sign of freedom. Although, however paradoxical it may seem, some freedpeople did take their former owners' names for precisely the same reason.

The most intense struggles between white and black women over the appropriate meaning of freedom occurred within households as both tried to come to terms with the meaning of free labor in the domestic context.[69] Former slaveholding women were loathe to be reminded that their former slaves now had families of their own to which they returned at night. Former slave women predictably insisted that these families represented their most important obligations. And how could a good wife and mother deny another good wife and mother's most sacred obligations? White mistresses found even apparently small signs of their free servants' independence almost unbearable, for they served as constant reminders of the independence of those whom they had been accustomed to view (however preposterously) primarily as extensions of their own will.

As paid workers, freedwomen found innumerable ways to remind their mistresses of their independence, if only by pretending not to understand instructions, working slowly, or leaving tasks undone. To make matters worse, free maids and housekeepers, like free male agricultural workers, rarely agreed that their wages evened accounts between them and their employers. Determined to preserve the aspects of paternalism that had benefited them, they insisted upon the mistress's obligation to provide them with cast-off clothing, a "servant's pan" of food for their family, or even personal assistance at times of emergency.[70] These practices challenged elite white women's own notions of freedom and frequently resulted in an accommodation between mistress and servant that preserved important elements of the more personal relations of paternalism. The white women took less kindly to freedwomen's determination to establish themselves on an independent footing and, above all, to ensure the social and economic advancement of their children. Gertrude Thomas did not miss the point. She raged at the idea that, while her own sons worked in the fields, the sons of freedwomen attended school.[71]

Throughout the former slave states, whites moved steadily toward depriving freedpeople of as much of the economic mobility and independence normally associated with freedom as possible. Whether by attempting to bind laborers to plantations through tenancy, sharecropping, and the payment of annual (rather than weekly or monthly) wages, or by attempting to deny them such attributes of economic freedom as the free participation in markets, whites sought to ensure the economic marginalization and continuing subordination of blacks.[72] These restrictions affected freedwomen in distinct ways. Should, for example, the everyday struggles between mistress and maid get out of hand, the maid would find herself vulnerable to accusations of theft, burglary, and poisoning, which she might not deserve. Freedwomen who delighted in the public display of clothing, or were simply out of an evening, might also find themselves jailed for "public disorder" or "drunkenness." Whites further sought to regulate the hours in which freedpeople could conduct commerce in order to curtail the independent markets that had sprung up in the wake of emancipation. Such restrictions were especially resented by freedwomen who frequented the markets in quest of calico, foodstuffs, and jewelry.[73]

Freedwomen struck back against the restrictions upon their freedom with all of the weapons at their disposal and more than a few ended in jail for their pains. Normally, their conflicts were with whites, but some fought bitterly against other freedpeople as well. Like freedmen, they had taken from slavery a fierce determination to be able to go where they pleased and do as they chose. Having endured enslavement, they were quick to believe that freedom must indeed mean its opposite. On more than one occasion, they behaved as if they sought to establish a sovereignal freedom that, in their view, mirrored and reversed the freedom enjoyed by their former owners. But their most radically individualistic interpretations of freedom normally coexisted with a fierce commitment to establish a viable claim to civic freedom for their people, even if that meant putting their own ambitions on hold. Among the many tragedies of Reconstruction and thereafter was the determination of Southern whites to forestall that participation in civic freedom and, indeed, economic freedom as well.

The costs on both sides ran high. For the freedpeople, they included a denial of civic freedom that frequently sent many individuals on a counterproductive quest for a freedom that recognized no legitimate limits; for the whites they included the crippling conviction that their own freedom depended upon the brutal oppression of others. Both parties to the struggle remained convinced that the interdependence of genuine personal and civic freedom could only be understood as a war.

VII.

By the end of the 1860s, the Thirteenth, Fourteenth, and Fifteenth Amendments had transformed the meaning of freedom in the United States by extending personal and civic freedom to the former slaves, although not until fifty years later did women acquire the basic civic freedom of suffrage. And not until the 1960s were the gains that the amendments had so broadly sketched fully assured to the descendants of slaves. By the time the civil rights movement reopened the struggle for full personal and civic freedom for African-Americans the possible meanings of freedom had radically expanded, and the emergence of a new wave of the women's movement would expand them even further. As these struggles broadened to include more groups who believed their freedom to be curtailed, they increasingly tended to cast their claims in terms of individual rights, not merely to participation in civic freedom, but to a more generalized freedom from a broad range of oppressions—with the definition of oppression, as Elizabeth Cady Stanton's writing presaged, subject to steady expansion.

Ironically, as the substance of slavery receded ever further into the past, the legacy of slavery as the antithesis of freedom cast a lengthening shadow. Many of those who felt themselves in some way excluded from the full promise of American freedom were increasingly tempted to cast their claims in absolute terms. Freedom, in this view, indeed meant the antithesis of slavery, but the antithesis of an absolute, existential slavery that very much resembled Patterson's conception of social death. And as the insistence of the claims mounted, the deep lessons of American slavery were dissipated in the shadowy reaches of fragile memory.

American slavery had been a violent, brutal system of social relations in which the lives of slaves were largely at the mercy of the slaveholders, who all too frequently abused their power. But American slavery never reduced African-American slaves to things, and rarely, if ever, to fully isolated and disconnected individuals. To believe otherwise is to deny the record of the heroic effort of African-American slaves to wrest from adversity the elements of personal dignity, mutual loyalty, and family and community solidarity. More, it is implicitly to identify freedom with a sovereignal freedom that inherently denies the freedom of others. That that tendency to favor sovereignal freedom existed, we know. It is all too human for those who have suffered oppression to seek to turn the tables on their oppressors by whatever means lie to hand. But the costs of acting on that tendency are high, and the effort itself usually proves self-defeating. Thus, in *Beloved*, Sethe attempts to explain to Paul D. how she killed her daughter by explaining to him what freedom meant to her. Maybe, she muses, she could not love her

children "proper in Kentucky because they wasn't mine to love." School-teacher, in attempting to return Sethe and her children to slavery, threatened that freedom, and Sethe "couldn't let her nor any of em live under school-teacher." Cornered, she defended their freedom: "I took and put my babies where they'd be safe."[74] Yet, as Toni Morrison unmistakably cautions us, to kill a child in the defense of freedom is, whatever else it may be, the murder of a "crawling already?" baby.

Freedom has always been contested: such is its nature. Throughout most of Western history, most people have understood freedom to be preeminently internal, a matter of the individual soul's relation to God—which is to say, not of this world. In the measure that they have understood freedom to be of this world, they have preeminently understood it as a quality that pertained to corporate groups or collectivities, which were frequently represented by one or more individuals who acted in the name of the freedom of the group. Our modern world has increasingly transformed freedom into an individual right to be claimed and realized precisely in the world. But the very broadening of freedom's possible meanings has inevitably made those meanings the object of a steadily escalating contest of individual wills, with decreasing attention to the public good. With supreme historical irony, the escalation of demands for individual freedom now threatens the very survival of freedom itself.

Notes

1. Toni Morrison, *Beloved* (New York, 1987), 162.

2. Orlando Patterson, *Freedom, vol. 1: Freedom in the Making of Western Culture* (New York, 1991), 3–4.

3. Ibid., 4.

4. Orlando Patterson, *Slavery and Social Death: A Comparative Study* (Cambridge, Mass., 1982).

5. Patterson, *Freedom*, 322, following David Brion Davis, *The Problem of Slavery in Western Culture* (Ithaca, N.Y., 1966), notes that not until the eighteenth century did the Church recognize an incompatibility between internal freedom and external slavery. See also, David Brion Davis, *The Problem of Slavery in the Age of Revolution, 1770–1823* (Ithaca, N.Y., 1975); Eugene D. Genovese, *From Rebellion to Revolution: Afro-American Slave Revolts in the Making of the Modern World* (Baton Rouge, La., 1979); Elizabeth Fox-Genovese, *Feminism Without Illusions: A Critique of Individualism* (Chapel Hill, N.C., 1991).

6. Adam B. Seligman, *The Idea of Civil Society* (New York, 1992), 23. John Dunn, *The Political Theory of John Locke* (Cambridge, Mass., 1969).

7. Robert Filmer, *Patriarchia and Other Political Works,* ed. Peter Laslett (Oxford, 1949); Elizabeth Fox-Genovese, "Property and Patriarchy in Classical Bourgeois Political Theory," *Radical History Review* 4, nos. 2 and 3 (Spring/Summer 1977): 36–59 [reprinted in this volume, pp. 1–20]; Gordon J. Schochet, *Patriarchalism in Political*

Thought: The Authoritarian Family and Political Speculation and Attitudes Especially in Seventeenth-Century England (New York, 1975).

8. For a fuller discussion of these issues, see Fox-Genovese, *Feminism Without Illusions.*

9. Elizabeth Fox-Genovese and Eugene D. Genovese, *Fruits of Merchant Capital: Slavery and Bourgeois Property in the Rise and Expansion of Capitalism* (New York, 1983).

10. See, for example, Elizabeth Fox-Genovese, "Religion in the Lives of Slaveholding Women of the Antebellum South," in *That Gentle Strength: Historical Perspectives on Women in Christianity,* ed. Lynda L. Coon, Katherine J. Haldane, and Elisabeth W. Sommer (Charlottesville, Va., 1990), 207–29.

11. *The Man,* Feb. 22, 1834, quoted in Thomas Dublin, *Women at Work: The Transformation of Work and Community in Lowell, Massachusetts, 1826–1860* (New York, 1979), 93.

12. Harriet Hanson Robinson, *Loom and Spindle; or, Life Among the Early Mill Girls* (New York, 1898), 84, quoted in Dublin, *Women at Work,* 98–99.

13. Ellen Carol DuBois, *Feminism and Suffrage: The Emergence of an Independent Women's Movement in America, 1848–1869* (Ithaca, N.Y., 1978), 32, insists that women's dissatisfaction with their position was as much cause as effect of their participation in the antislavery movement. See also Blanche Glassman Hersh, *The Slavery of Sex: Feminist Abolitionists in America* (Urbana, Ill., 1978).

14. Elizabeth Cady Stanton, *Eighty Years and More: Reminiscences, 1815–1897* (New York, 1971; orig. ed., 1898), 81.

15. Ibid., 82.

16. Ibid., 83.

17. Elizabeth Cady Stanton and Susan B. Anthony, *Correspondence, Writings, Speeches,* ed. Ellen Carol DuBois (New York, 1981), 34–35.

18. Ibid., 31.

19. Ibid.

20. Elizabeth Cady Stanton, "Declaration of Sentiments," in *The Concise History of Woman Suffrage: Selections from the Classic Works of Stanton, Anthony, Gage, and Harper,* ed. Mari Jo and Paul Buhle (Urbana, Ill., 1978), 94–95.

21. Ibid., 95.

22. Stanton and Anthony, *Correspondence, Writings, Speeches,* 33.

23. *Concise History of Woman Suffrage,* 311. Elizabeth Cady Stanton and the Revising Committee, *The Woman's Bible,* Pts. I & II (Seattle, 1974; orig. ed. 1898).

24. Elizabeth Fox-Genovese, *Within the Plantation Household: Black and White Women of the Old South* (Chapel Hill, N.C., 1988); Fox-Genovese, "Religion in the Lives of Slaveholding Women."

25. Elizabeth Fox-Genovese and Eugene D. Genovese, "The Divine Sanction of Social Order: The Religious Foundations of the Southern Slaveholders' World View," *Journal of the American Academy of Religion* 55, no. 2 (June 1987): 201–23, and our "The Religious Ideals of Southern Society," *Georgia Historical Quarterly* [70] (1986)[: 1–17], repr. in *The Evolution of Southern Culture,* ed. Numan V. Bartley (Athens, Ga., 1988).

26. L. S. M. [Louisa S. McCord], "Carey on the Slave Trade," *Southern Quarterly Review* 25 (January 1854): 115–84; L. S. M., "Diversity of the Races: Its Bearing upon Negro Slavery," *Southern Quarterly Review* 19 (April 1851): 392–419; L. S. M., "Negro and White Slavery—Wherein Do They Differ?" *Southern Quarterly Review* 20 (July 1851):

118–32. For a general discussion of McCord, see Fox-Genovese, *Within the Plantation Household*, 242–89.

27. L. S. M. [Louisa S. McCord], "Enfranchisement of Women," *Southern Quarterly Review* 21 (April 1852): 324–25.

28. L. S. M. [Louisa S. McCord], "Woman and Her Needs," *DeBow's Review* 13 (September 1852): 275, 268.

29. Ibid., 268.

30. L. S. M., "Enfranchisement of Women," 330.

31. Augusta Jane Evans to Mary Howard Jones, November 26, December 4, 1860, Benning/Jones Collection, Chattahoochee Valley Local & Oral History Archives, Columbus College Library, Columbus, Georgia. See also, Elizabeth Fox-Genovese, "To Be Worthy of God's Favor: Southern Women's Defense and Critique of Slavery," *32nd Annual Fortenbaugh Memorial Lecture* (Gettysburg College, 1993).

32. Jamie Stanesa, "Dialogues of Difference: Personal Identity, Social Ideology, and Regional Difference in American Women Writers, 1850–1860," Ph.D. diss., Emory University, 1993; and Elizabeth Moss, *Domestic Novelists in the Old South: Defenders of Southern Culture* (Baton Rouge, La., 1992).

33. Augusta Jane Evans, *Beulah,* ed. Elizabeth Fox-Genovese (Baton Rouge, La., 1992; orig. ed., 1859), 116. See my introduction for a fuller discussion of these issues in the novel.

34. For free African-American women's perceptions of Northern white women's racism, see Harriet E. Wilson, *Our Nig; or, Sketches from the Life of a Free Black, In a Two-Story White House, North. Showing That Slavery's Shadows Fall Even There, by "Our Nig."* ed. Henry Louis Gates, Jr. (New York, 1983; orig. ed., 1859) and Harriet Jacobs' correspondence in Harriet Jacobs, *Incidents in the Life of a Slave Girl: Written by Herself,* ed. Jean Fagan Yellin (Cambridge, Mass., 1987). Cf. Jean Fagan Yellin, *Women and Sisters: The Antislavery Feminists in American Culture* (New Haven, Conn., 1989).

35. Fox-Genovese, *Within the Plantation Household;* Eugene D. Genovese, *Roll, Jordan, Roll: The World the Slaves Made* (New York, 1974); Deborah Gray White, *Ar'n't I a Woman? Female Slaves in the Plantation South* (New York, 1985).

36. Fox-Genovese, *Within the Plantation Household,* esp. 372–96. See also Peter Kolchin, *Unfree Labor: American Slavery and Russian Serfdom* (Cambridge, Mass., 1987).

37. Patterson, *Slavery and Social Death.*

38. Stanley Elkins, *Slavery: A Problem in American Life* (Chicago, 1959); Ann J. Lane, ed., *The Debate Over Slavery: Stanley Elkins and His Critics* (Urbana, Ill., 1971).

39. Genovese, *Roll, Jordan, Roll;* Lawrence Levine, *Black Culture and Black Consciousness: Afro-American Folk Thought from Slavery to Freedom* (New York, 1977); Herbert G. Gutman, *The Black Family in Slavery and Freedom, 1750–1925* (New York, 1976); Fox-Genovese, *Within the Plantation Household.*

40. Patterson, *Freedom.*

41. See G. A. Hopkins, *An Economic History of West Africa* (New York, 1973); Ester Boserup, *Women's Role in Economic Development* (London, 1970); Claire C. Robertson and Martin A. Klein, eds., *Women and Slavery in Africa* (Madison, Wis., 1984); and, for the general problem of the relation between African and Western culture, Kwame Anthony Appiah, *In My Father's House: Africa in the Philosophy of Culture* (New York, 1992).

42. Genovese, *From Rebellion to Revolution.*

43. Quoted in Ibid., 132–33.

44. On the general response to the destruction of slavery and the emergence of free labor during the war, as captured in the papers of the Freedman's Bureau, see the volumes in the series *Freedom: A Documentary History of Emancipation, 1861–1867,* Ira Berlin, Barbara J. Fields, Thavolia Glymph, Joseph P. Reidy, and Leslie Rowland, eds., ser. 1, vol. 1, *The Destruction of Slavery* (New York, 1985); Ira Berlin, Thavolia Glymph, Steven F. Miller, Joseph P. Reidy, Leslie Rowland, and Julie Saville, eds., ser. 1, vol. 3, *The Wartime Genesis of Free Labor: The Lower South* (New York, 1990); and Ira Berlin, Steven F. Miller, Joseph P. Reidy, and Leslie Rowland, eds., ser. 1, vol. 4, *The Wartime Genesis of Free Labor: The Upper South* (New York, 1993).

45. Robert W. Fogel, *Without Consent or Contract: The Rise and Fall of American Slavery* (New York, 1988); Eric Foner, *Free Soil, Free Labor, Free Men: The Ideology of the Republican Party Before the Civil War* (New York, 1970).

46. John Rodrigue, "Raising Cain: From Slavery to Free Labor in Louisiana's Sugar Parishes, 1862–1880," Ph.D. diss., Emory University, 1993, 340. On the general problems, Gerald David Jaynes, *Branches Without Roots: Genesis of the Black Working Class in the American South, 1862–1882* (New York, 1986); Joseph P. Reidy, *From Slavery to Agrarian Capitalism in the Cotton Plantation South: Central Georgia, 1800–1880* (Chapel Hill, N.C., 1992); William Cohen, *At Freedom's Edge: Black Mobility and the Southern White Quest for Racial Control, 1861–1915* (Baton Rouge, La., 1991).

47. Rodrigue, "Raising Cain," 199–200; Jaynes, *Branches Without Roots.*

48. Rodrigue, "Raising Cain," 244.

49. Ibid., 329–30; Noralee Frankel, "Workers, Wives, and Mothers: Black Women in Mississippi, 1860–1879," Ph.D. diss, George Washington University, 1982.

50. See, for example, Gutman, *The Black Family in Slavery and Freedom.*

51. Ira Berlin, Joseph P. Reidy, and Leslie S. Rowland, eds., *The Black Military Experience,* ser. 2 of *Freedom: A Documentary History of Emancipation, 1861–1867* (New York, 1982), 672–73.

52. See, for example, James D. Anderson, *The Education of Blacks in the South, 1860–1935* (Chapel Hill, N.C., 1988).

53. Nicholas Lemann, *The Promised Land: The Great Black Migration and How It Changed America* (New York, 1991), esp. 21–24.

54. Fox-Genovese, *Within the Plantation Household*; Jacqueline Jones, *Labor of Love, Labor of Sorrow: Black Women, Work, and the Black Family from Slavery to the Present* (New York, 1985). On slaveholders' concern that slavery did not respect slave marriages, see Fox-Genovese, "To Be Worthy of God's Favor"; Bell Irvin Wiley, "The Movement to Humanize the Institution of Slavery During the Confederacy," *Emory University Quarterly* 5 (Dec. 1949): 207–20; Bell Irvin Wiley, *Southern Negroes, 1861–1865* (New Haven, Conn., 1938), 168–72; Clement Eaton, *A History of the Southern Confederacy* (New York, 1961), 237–38; Calvin H. Wiley, *Scriptural Views of National Trials* (Greensboro, N.C., 1863); John Berrien Lindsley, "Table Talk," Dec. 10, 1861, May 8, 1862, John Berrien Lindsley Papers, Tennessee State Library and Archives.

55. Frances Ellen Watkins Harper, *Iola Leroy; or, Shadows Uplifted* (New York, 1988; orig. ed., 1892); Pauline E. Hopkins, *Contending Forces: A Romance Illustrative of Negro Life North and South* (New York, 1988; orig. ed., 1900); Claudia Tate, *Domestic Allegories of Political Desire: The Black Heroine's Text at the Turn of the Century* (New York, 1992), for instance, 149; Elizabeth Fox-Genovese, "To Write the Wrongs of Slavery," *Gettysburg Review* [2] (Winter 1989): 63–76.

56. Mary Jones to Mary Jones Mallard, November 17, 1865, in Robert Manson Myers, ed., *The Children of Pride: A True Story of Georgia and the Civil War* (New Haven, Conn., 1972), 1308–9.

57. Sidney Andrews, *The South Since the War* (New York, 1969; orig. ed., 1866), 187. See also Leon Litwack, *Been in the Storm So Long: The Aftermath of Slavery* (New York, 1979), 6, 116, 245, 315.

58. C. Vann Woodward, ed., *Mary Chesnut's Civil War* (New Haven, Conn., 1981), July 26, 1865, 834.

59. Ibid., February 16, 1865, 715.

60. Ella Gertrude Clanton Thomas Diary, Perkins Library, Duke University. An edited and somewhat cut version of the diary has been published as *The Secret Eye: The Journal of Ella Gertrude Clanton Thomas, 1848–1889,* ed. Virginia Ingraham Burr (Chapel Hill, N.C., 1990); Beth G. Crabtree and James W. Patton, eds., *The Journal of a Secesh Lady: The Diary of Catherine Ann Devereux Edmondston, 1860–1866* (Raleigh, N.C., 1979). See also, W. Maury Darst, ed., "The Vicksburg Diary of Mrs. Alfred Ingraham (May 2–June 13, 1863)," *Journal of Mississippi History* 44 (May 1982): 148–79.

61. Earl Schenck Miers, ed., *When the World Ended; the Diary of Emma LeConte* (New York, 1957), 66. See, in general, Elizabeth Fox-Genovese, "Diaries, Letters, and Memoirs," *Encyclopedia of the Confederacy,* Richard Current et al., eds. (New York, 1993) [, 470–78].

62. Amelia Gayle Gorgas to Joseph Gorgas, July 29, 1865, Gorgas Family Papers, University of Alabama, Tuscaloosa. See also, Mary Tabb Johnston with Elizabeth Johnston Lipscomb, *Amelia Gayle Gorgas: A Biography* (University, Ala., 1978).

63. Elizabeth Kilcrease to Clara Barrow, November 30, 1865, Barrow Family Papers, University of Georgia, cited by Mary Margaret Johnston-Miller, "Heirs to Paternalism: Elite White Women and Emancipation in Alabama and Georgia," Ph.D. diss., Emory University, 1994.

64. Ella Gertrude Clanton Thomas Diary, October 8, 1865. See also, Fox-Genovese, "Religion in the Lives of Slaveholding Women of the Antebellum South."

65. Sarah Hine to Charlotte Branch, February 10, 1866, Margaret Branch Sexton Papers, University of Georgia, cited by Johnston-Miller, "Heirs to Paternalism."

66. Lenora Clayton to Mary Ann Cobb, November 7, 1865, Howell Cobb Papers, University of Georgia.

67. Laura Beecher Comer Diary, July 1, 1865, in Anne Kendrick Walker, *Braxton Bragg Comer: His Family Tree from Virginia's Colonial Days* (Richmond, Va., 1947), 115.

68. Eliza Frances Andrews, *The War-Time Journal of a Georgia Girl,* ed. Spencer Bidwell King, Jr. (Macon, Ga., 1960), 346–47.

69. On the postbellum relations between elite women and their slaves, see Johnston-Miller, "Heirs to Paternalism."

70. For a full discussion, see Ibid. On the early-twentieth-century remains of these practices, see Voloria Mack-Williams, "Hard Workin' Women: Class Divisions and African-American Women's Work in Orangeburg, South Carolina, 1880–1940," Ph.D. diss., State University of New York, Binghamton, 1991.

71. Ella Gertrude Clanton Thomas Diary.

72. Mary Ellen Curtin, "The Human World of Black Women in Alabama Prisons, 1870–1900," in *Southern Women: Hidden Histories,* Virginia Bernhard, Betty Brandon, Elizabeth Fox-Genovese, Theda Purdue, eds. (Columbia, Mo., 1994) [, 11–30]. See also

Louis P. Ferleger, "Share-cropping Contracts and Mechanization in the Late-Nineteenth-Century South," *Agricultural History* 67, no. 3 (Summer 1993): 31–46, and his "Farm Mechanization in the Southern Sugar Sector After the Civil War," *Louisiana History* 23, no. 1 (Winter 1982): 21–34.

 73. Curtin, "Human World."

 74. Morrison, *Beloved,* 163–64.

"To Weave It into the Literature of the Country"

Epic and the Fictions of African American Women

Toward the end of Frances Ellen Watkins Harper's novel, *Iola Leroy,* Dr. Frank Latimer asks Iola Leroy (to whom he will shortly propose marriage), who is seeking to do "something of lasting service" for her people, why she does not write a "good, strong book that would be helpful to them?" More than willing, she reminds him that the writing of a successful book requires leisure and money and, even more, "needs patience, perseverance, courage, and the hand of an artist to weave it into the literature of the country."[1]

By the time that Harper published *Iola Leroy; or, Shadows Uplifted* in 1892, she had been a successful and admired writer for almost forty years, as well as an indefatigable worker for the advancement of her people, but she had never previously published a novel. With empathetic hindsight, it should be possible to understand why she had not. Leisure and money had their say for her and, even more, for other African American women writers, but may not alone have accounted for the apparent difficulty of telling the story of African American women or even for the difficulty of African American women's telling the story of their people.

Consider the special qualities that Harper thought such a telling required: "patience, perseverance, courage, and the hand of an artist." She believed

that those qualities were necessitated by what must be the object of such a telling: "to weave it into the literature of the country." Today, it has become a commonplace among many critics, especially those interested in the writing of women and African Americans, that the literature of the country was not noticeably receptive to dissident points of view. Many, indeed, would hold that those to whom the dominant culture has been less than receptive have no call to respect its sensibilities and, yes, prejudices. How, such critics ask, can you be expected to write yourself into a culture that trivializes or stereotypes, when it does not blatantly ignore, your experience?

The prospect appears all the more daunting when we acknowledge that African American women knew that their experience turned the expectations and assumptions of the dominant culture topsy-turvy. Harriet Wilson, the first African American woman (so far as we know) to try her hand at novel writing, saw her only effort, *Our Nig*, sink into oblivion.[2] On reflection, the fate of *Our Nig* should not occasion undue surprise. It was, if ever there was one, a countertext and an almost unbearably angry one at that. Harriet Wilson had no truck with the sentimental domestic pieties of mid-nineteenth-century American culture, and from its opening pages *Our Nig* reverses all of them.

Within two brief chapters, Wilson sketches the spiraling "degradation" of Mag Smith, white mother of her mulatto protagonist, Frado. Abandoned after having succumbed to the seduction of a man who considerably outranks her in social station, Mag bears an "unwelcomed" child, who almost immediately dies. Mag welcomes the death, which Wilson suggests her readers should acknowledge as a "blessed release." What, she ponders, could have been the fate of such a child? "How many pure, innocent children not only inherit a wicked heart of their own, claiming life-long scrutiny and restraint, but are heirs also of parental disgrace and calumny, from which only long years of patient endurance in paths of rectitude can disencumber them" (6–7). Wilson has thus identified her text with the seduction and abandonment of what, at this point in the novel, appears to be her main female character, the birth and death of her illegitimate child, and the passing assertion that many of those who are formulaically called "pure, innocent" children inherit wicked hearts of their own.

In defying the conventions of womanhood and the prescribed feelings of motherhood, Mag has embraced a fate from which she can no longer escape. When a move to another town fails to free her from her past or to improve her material circumstances, she returns to the scene of her disgrace, eking out a meager living from the few odd jobs that immigrant laborers disdain. The black man, Jim, who supplies her with wood, offers the only human fellowship she experiences, and when he asks her to marry him, she listlessly

acquiesces. Viewing his white wife as a "treasure," Jim does his best to pro-
vide well for her. Together, they have two children, including the girl Frado.
But after Jim dies of consumption, Mag spirals even lower, living, unmarried,
with his black business partner, Seth Shipley.

Wilson explains that Mag, having lived for years as an outcast, had stifled
the feelings of penitence and the agonies of conscience. "She had no long-
ings for a purer heart, a better life. . . . She entered the darkness of perpet-
ual infamy. She asked not the rite of civilization or Christianity. Her will
made her the wife of Seth" (16). And, when circumstances again worsen,
Seth persuades her to give the children away. The main story begins with
Mag's leaving Frado at the house of the affluent, white Bellmont family.
Throughout the first day, "Frado waited for the close of day, which was to
bring back her mother. Alas! it never came. It was the last time she ever saw
or heard of her mother" (23). Yet in comparison with Mrs. Bellmont, an
acknowledged "she-devil," whose viciousness dominates Frado's experience
throughout the remainder of the novel, Mag ranks as the good mother.

These opening chapters stand alone among the writings of nineteenth-
century American women, perhaps alone among all nineteenth-century
American literature. And they introduce what probably qualifies as the angri-
est and least compliant novel by a nineteenth-century woman writer. The
willful noncompliance with cultural conventions and fierce determination to
tell a story that few were eager to hear do much to account for the oblivion
to which *Our Nig* was relegated. On the face of it, nothing could seem fur-
ther from Harper's determination to write her story into the literature of the
country. The simple lesson to be drawn from *Our Nig* is that the attempt
to write the story of African American women into the literature of the
country runs into what may well be insuperable obstacles. Wilson seems to
suggest that if you tell the truth, no one will read you, which is tantamount
to saying that you cannot both tell the truth and meet prevailing literary
expectations. Conversely, if you do meet prevailing literary expectations,
you will not be telling the truth, which may make it very difficult for you to
write with power and conviction.

It would be easy, but not entirely accurate, to attribute the long disap-
pearance of *Our Nig* to racial and sexual prejudice.[3] In publishing the novel,
Wilson clearly understood the risk she ran of alienating even those most
likely to be sympathetic. In the preface, she attempts to anticipate and dis-
arm hostility. First, she mobilizes the conventions of her own lack of talent
and the distressing circumstances that have nonetheless driven her to write.
Even the most pressing misfortunes would not, however, lead her to "pal-
liate slavery at the South, by disclosures of its appurtenances North" (3). Her
mistress's principles were wholly "*Southern*." And had she recounted every

misery of her life, as she has not because of her reluctance to provoke shame in her antislavery friends, "the unprejudiced would declare [her treatment] unfavorable in comparison with treatment of legal bondmen" (3). Like other authors before and since, Wilson dares to hope that her candid confession will disarm the severest criticism. And finally, she appeals to all of her "colored brethren" for "patronage, hoping they will not condemn this attempt of their sister to be erudite" (3).

In essential respects, as Wilson may have known or at least suspected, *Our Nig* has more in common with antebellum Southern women's writing than with Northern women's. I know of no Southern woman writer who had the audacity to claim that the brutal neglect of white working women in the North drove them into the arms of free black men, but many claimed that it drove them to death. Wilson's portrait of Mrs. Bellmont's cruelty, bad faith, and lack of manners should have warmed the heart of Caroline Lee Hentz, Mary Eastman, or Louisa McCord.[4] *Our Nig* offers little or nothing to flatter the sensibilities of antislavery Northerners. To the contrary, it forcefully suggests that the curse of racism has so infected the United States as to make the choice between sections, and even the choice between slavery and freedom, virtually meaningless. To drive the point home, Wilson introduces into her own antislavery text a final ironic gloss by having her protagonist, Frado, marry a black man who was working for abolition and who falsely claimed to be a former slave. Thus Wilson, admittedly against the odds, was trying to make her readers understand that even the righteous work of antislavery may not be what it seems. This was not a story that many readers would have found useful to pass on.

If Wilson could lay any claim to having written her story into the literature of the country, it could only be by a series of reversals that bordered on insults none was willing to accept. Yet if one gets beyond what we might call the overt political "message" of her story, the ways in which she was trying to weave it into the literature of the country command attention. Unlike Harriet Jacobs, Wilson did not drop so much as a passing curtsy to prevailing views about the purity of women or the devotion of mothers. Whereas Jacobs goes to great lengths to establish the respectability of her mother and her own devotion to her, Wilson represents her mother as abandoning her as the logical and unemotional consequence of a degraded life. Where Jacobs represents her fair-skinned, literate black mother as having enjoyed a loving and respectable marriage to a man who had all the feelings of a free man, Wilson represents her white mother as having had a bastard before marrying a black man simply to put bread on the table.

Henry Louis Gates sees *Our Nig* as essentially autobiographical with Frado as Wilson's persona, and he calls attention to the ways in which Wilson

slipped into the use of personal pronouns to refer to relations that properly adhere to Frado. Similarly, Jacobs used the persona of Linda Brent to disguise her own identity and, presumably, to conceal aspects of her experience. Jacobs' greatest disguise, however, lies in the language in which she wrote and represented Linda Brent as speaking and in the middle-class sensibilities that she represented Linda Brent as embodying. Notwithstanding Linda Brent's profuse apologies for having had her children by a man to whom she was not married, there is nothing about *Incidents in the Life of a Slave Girl* that would not have passed muster in any respectable Northern, middle-class home.

Our Nig is another matter entirely. Wilson made virtually no concessions to middle-class sensibilities. Not only did she represent white folks in a harsh light but she unambiguously represented the debilitating cost of their behavior for black folks. Being abandoned and abused does not transform Frado into a long-suffering saint. Wilson represents Frado as openly hating her mistress and as taking her revenge any way she can. Tellingly, Wilson forthrightly acknowledges that children may inherit a wicked heart that is all their own and that requires restraint. Throughout *Our Nig,* in other words, Wilson frontally attacks the comfortable pieties that might have made her novel palatable to white readers. Suffering, abuse, and discrimination, she insists throughout, do not necessarily—and perhaps do not ever—transform fallible human beings into saints.

Wilson's uncompromising insistence on disrobing the most cherished white, middle-class icons indirectly confirms that she knew that which she was attacking. Her request that her colored brethren not condemn their sister's attempt to be erudite was probably no casual figure of speech. A comparison of her and Jacobs' texts strongly suggests that she was, if anything, the more learned of the two. Like so many African American writers, Wilson manifests considerable knowledge of American and British elite culture. She borrowed many of the epigraphs at the head of each chapter from highly appreciated white poets, primarily of the first half of the nineteenth century: Shelley, Byron, Thomas Moore, Martin Tupper, Eliza Cook, and, for the final chapter, the book of Ecclesiastes.

Notwithstanding dramatic differences in tone and diction between the epigraphs and the chapters, the ways in which they complement and gloss each other are clear. Thus, the verse from Thomas Moore that introduces the first chapter about Mag Smith speaks of the grief beyond all others that

> First leaves the young heart lone and desolate
> In the wide world, without that only tie
> For which it loved to live or feared to die;

> Lorn as the hung-up lute, that ne'er hath spoken
> Since the sad day its master-chord was broken!

And, immediately following the verse, the chapter begins, "Lonely Mag Smith! See her as she walks with downcast eyes and heavy heart. It was not always thus. She *had* a loving, trusting heart" (5). But Mag, like her daughter after her, had lost her parents early and been left to develop into womanhood, "unprotected, uncherished, uncared for" (5). Wilson does not specify whether the loss that cripples Mag's ability to feel is her loss of her parents, especially her mother, or her loss of the well-born lover to whom she transferred that most basic love "for which she loved to live and feared to die."

The fourth chapter, "A Friend for Nig," in which James Bellmont first appears, is preceded by a verse from Byron on the blessings of friendship. The verse emphasizes the unique place of friendship in youth, "When every artless bosom throbs with truth, / Untaught by worldly wisdom how to feign." Youth, it concludes, is the time

> When all we feel our honest souls disclose—
> In love to friends, in open hate to foes;
> No varnished tales the lips of youth repeat,
> No dear-bought knowledge purchased by deceit.

The chapter that follows contains two references to Frado's loss of her mother. In the first, she tells the friendly Aunt Abby, "'I've got to stay out here and die. I ha'n't got no mother, no home. I wish I was dead'" (46). In the second, she responds to James's assurance that she will not be whipped because she ran away and his injunction that she must try to be a good girl. "'If I do, I get whipped. . . . They won't believe what I say. Oh, I wish I had my mother back; then I should not be kicked and whipped so. Who made me so?'" (51).

When James responds to her query that God made her so, just as He made James, and Aunt Abby, and her mother, she asks if the same God made her as made her mother. And when James assures her that He did, she responds that then she does not like that God, "'Because he made her white, and me black. Why didn't he make us *both* white?'" (51). James, at a loss to answer her "knotty questions," encourages her to go to sleep, promising that she will feel better in the morning. It took, Wilson informs us, "a number of days before James felt in a mood to visit and entertain old associates and friends" (51).

In these instances, as in innumerable others throughout the novel, Wilson demonstrates a remarkable literary skill that is all the more difficult to appreciate because it is so very much her own. Her striking mixture of voices

combines the spare, almost modernist, narrative of the early chapters about Mag Smith; the direct and unvarnished conversations, including Frado's dialect; and occasional interventions of an omniscient narrator in a rather studied neoclassical voice. The various voices tend to be divided between the specific situations and general reflections. Thus the chapter that follows the passage from Byron and introduces James begins, "With what differing emotions have the denizens of earth awaited the approach of to-day" (40).

In some ways, the alternation between the specific and the general resembles the alternation between the use of the personal pronouns that identify Mag Smith as "my mother" and the use of Frado to identify the protagonist who, by the logic of Mag Smith as "my mother," should be I. The novel never pretends to resolve these apparent contradictions. It does not even explicitly acknowledge them. Throughout, the voice of Harriet Wilson remains somewhat confused and divided among Frado and the various narrative voices. Unlike Harriet Jacobs, she does not try to fit the voice of her protagonist into the rhetoric of domestic fiction. And unlike Harriet Jacobs, she does not restrict her judgments about human nature and the order of the universe to the formulas of domestic fiction. *Our Nig* never attains the unity of tone that characterizes *Incidents in the Life of a Slave Girl*. To put it differently, *Incidents* attempts to placate its readers; *Our Nig* does not.

Jacobs, it appears, believed that to write the story of African American women into the literature of the country, the story would, at least in some measure, have to be tailored to the expectations of its prospective readers. Wilson was no less interested in having readers appreciate and, especially, buy her book, which she claimed to have written out of a desperate need for money, but she proved less able or willing than Jacobs to force either her story or her language into the prevailing mode of domestic fiction.

Even the cautious Jacobs hinted that the conventions of domestic fiction did not perfectly capture her own experience, but she steadfastly persevered in shaping that experience to fit the conventions as closely as possible. She especially exploited the dictum of the leading domestic sentimentalists, notably Harriet Beecher Stowe, that slavery represented the absolute contradiction of domestic norms. Adherence to this dictum permitted her to present her own lapses from domestic virtue as the consequence of slavery, not of her character or breeding. To represent her mother as the model of domesticity, she emphasized the ways in which her mother's experience had resembled that of a free woman.

Freedom, in Jacobs' pages, emerges as the condition of and proxy for female virtue. This assumption perfectly mirrored the most cherished claims to moral superiority advanced by white Northeastern women writers. It further linked virtuous female behavior to the ideology of male individualism

that was, increasingly, condemning slavery as the antithesis of freedom.[5] For the majority of the Northeastern domestic sentimentalists, the natural corollary to their belief in the complementarity of female domestic virtue and male individualism was human perfectibility. In their view, children, who were born innocent, confirmed the innate goodness of human nature which, with proper nurturing, could continue to perfect itself throughout life.

The assumptions and goals of the domestic sentimentalists left little place for tragedy. As a rule, occurrences that presumably contradicted their commitment to perfectionism—losses, reversals of fortune, deaths, evil deeds, the breaking up of families—resulted from specific character failings or corrupt social institutions or bad mothering. By attributing these failings to specific causes, rather than to the inherent tragedy of the human condition or the innate possibilities for evil in human nature, the domestic sentimentalists successfully presented evil as correctable and tragedy as avoidable. Thus they rarely distinguished between the evils inherent in slavery and those which must attend any social system. And they thereby dramatically narrowed the variety of human experience. Clinging firmly to the belief that their values embodied the highest aspirations of humanity, they blithely assumed that those values should be acknowledged as moral norms. In any event, nineteenth-century American politics increasingly confirmed their view of their values as normative. The triumph of bourgeois individualism in politics proceeded in tandem with and ensured its triumph in literature.

It is safe to assume that Harriet Wilson sensed what was coming and that *Our Nig* embodies her rejection of it. Northeastern, middle-class complacency did not, in her view, exhaust either the complexities of human nature or the possibilities of literature. After the Civil War, at an accelerating rate, others would come to criticize what they perceived as the self-satisfied narrowness of middle-class American culture. In general, their criticisms did not overturn the paradigmatic narratives of individualism. Many recent critics have called attention to the ways in which women writers began to wrestle with the inherently masculine assumptions of the master plots of American culture, but their primary mission has been to reclaim individualism for women.[6] The same, with appropriate qualifications, can be said for African American male writers, who from slavery days have focused on their own exclusion from individualism's promises of male authority and autonomy.

Thus following the Civil War, as before it, the political and literary premises of individualism dominated what Harper called "the literature of the country." These premises, which explicitly emphasized individual autonomy and responsibility as universal attributes, implicitly harbored sexual and racial assumptions that restricted access to an authoritative literary voice. Perhaps more important, they intertwined with a vision of the history of the

country that continued to feature slavery as the antithesis of freedom. The persistence of slavery as the sign of national sin proved wonderfully compatible with the commitment to perfectionism. Northerners enthusiastically embraced anti-slavery as the sign of their own transcendence of sin. Southerners never accepted the equation of slavery with sin, but they also faced serious obstacles in writing their distinct views into the literature of the country. Before the war, their defense of slavery as the foundation of a more humane social order met with irate resistance from the antislavery North. After the war, defeat stripped Southerners of the will to defend slavery as an alternate vision of social order, and they settled upon a racism that had disfigured but by no means overwhelmed their antebellum worldview.

Harriet Wilson shared the Northern opposition to slavery but not white Northerners' righteous conviction that they had put slavery behind them. As she suggested in the preface to *Our Nig*, she believed that the most insidious forms of slavery did persist in the North. Her fictional illustration of this persistence resulted in a comprehensive and angry indictment of the many insidious forms that slavery can take. Obviously, Mrs. Bellmont's abuse of and disregard for the humanity of Frado top the list and constitute the primary focus of the novel. But the early chapters on Mag Smith add an important dimension that links Wilson's work to a distinct tradition of African American women's writing.

Wilson depicts the free white Mag Smith as eerily similar to unfortunate black slave mothers. Mag is drawn, by overwhelming circumstances, into bearing and abandoning mulatto children. As she tumbles toward the nadir of her misfortunes, she enters into a marriage sanctified only by her own will. On the face of it, the use of Mag to introduce Frado's story seems puzzling. Many domestic novelists chose to make their heroines orphans, but normally paid little attention to their mothers, who were invariably presented as having died. To the extent that white domestic novelists, notably Harriet Beecher Stowe, considered the circumstances of slave mothers, they wrote them directly into the conventions of maternal devotion and attributed their possible failures to fulfill those conventions to the brutality of slavery. In *Incidents*, Harriet Jacobs hewed closely to this model, with respect both to her own mother and to her attitudes toward her own children.

In *Our Nig*, Wilson implicitly asserts that prevailing domestic conventions cannot be stretched to fit the story she wants to tell. But, in so doing, she confronts the intractable problem of how it is possible to tell the story, especially the woman's story, of slavery. As a free white woman whose life resembles that of a black slave woman, Mag Smith represents a double inversion: the inversion of the conventional story of free white women by behaving like a slave; the inversion of the story of black slave women by being

white. Her life confuses the neat boundaries favored by the narrative of individualism. It is no wonder that *Our Nig* did not attract a large readership. And because it fell into such a long neglect, it is difficult to argue that Wilson's concerns directly influenced subsequent African American women writers. Yet I am prepared to argue that the themes of *Our Nig* continued to engage the imaginations of African American women who struggled, with mixed success, to write their own story into the literature of the country. Above all, however, *Our Nig* suggests the magnitude of the obstacles African American women writers confronted.

Many African American writers tried to solve some of the problems by selecting mulatto heroines. Such heroines, of whom Clotel, Iola Leroy, Sappho Clark, and Hagar Ellis are but the better known, offered the perfect compromise between the virtues of freedom and the degradation of slavery. The compromise worked especially well with fair-skinned female protagonists who could plausibly be described as innately virtuous and innocent victims. (Victimization posed problems for the representation of men, as the figure of Uncle Tom confirms.) Such heroines could plausibly be represented as beautiful by white standards, as speaking in perfect English, and, frequently, as having been raised in the belief that they were white, which means having been raised to observe the conventions of bourgeois domesticity.

Such a sketch of the mulatto heroine should clarify the problems that confronted any African American woman writer who attempted to write of a woman's experience of slavery from the subjective perspective. The main requirement for the high yaller heroine was that she have internalized none of the abuses of slavery. She must be a victim, but only in her external circumstances. Her scars must never be those of character. The formula of the mulatto heroine contains a significant measure of racism, especially in its assumption that white standards of female beauty are normative. More important, however, the formula betrays the hold of the individualist narrative on the literary imagination. For the individualist narrative, in emphasizing women's difference from men, effectively cast all women as victims and claimed that they willingly embraced their victimization. White women had a point, albeit a more limited one than they admitted, in comparing the condition of women to the condition of slaves. But then, free white women and black slave women shared an unwillingness to speak openly of the most scarring pains of their situation.

Normally the critics who write about mulatto heroines do not include Frado. Yet Frado was a mulatto. She differed from her literary sisters in having a white mother and a black father, in her appearance, and, above all, in the anger with which she responded to the indignities of her situation. In

essential respects, Frado represents the inversion of the "tragic" mulatto of convention. Where the tragic mulatto is patient and long-suffering, Frado is angry and rebellious. Unlike the conventional mulatto heroine, Frado exposes the internal scars that her experience has traced in her mind. In many ways, she more closely resembles a heroine in an ancient Greek tragedy than the heroine of a domestic novel. No comforting domestic pieties can encompass the experience of the child who has been born into an interracial union based on economic dependence and who has been abandoned, again for economic reasons, by the mother she loves but whom she also resents for not having made her white. Wilson's evocation of Frado carries an especially bitter and biting irony because enslavement did follow the condition of the mother.

Frado's conflicted feelings about her mother begin to hint at what may have been the conflicted feelings of slave girls toward their mothers. Such conflicts are, indeed, the stuff of tragedy. But the domestic tradition did not allow for tragedy in the sense of inherent and irreconcilable conflicts. The orphan heroines of domestic fiction do not admit to having hated the mothers who abandoned them, if only through a death that was no fault of their own, and whom they also loved. Harriet Jacobs firmly assures us that Linda Brent's daughter felt no resentment toward her mother. And as African American women began to write their story into the literature of the country, they were understandably tempted to sustain the silence.

It is safe to assume that the oral culture of slaves, most of whom were not literate, found a way of preserving some of the conflicts and tensions. The sources abound with examples of slave mothers who beat their own children out of the panicky determination to teach them that the world was a dangerous place. The same mothers frequently risked their own safety to provide their children with tokens of love. And, yes, occasionally a slave mother, who could take no more, ran off, abandoning her children. Now and then a slave mother even killed one of her children to put it out of the reach of conditions she finally judged intolerable. But these were not stories that could easily be woven into the literature of the country. In *Beloved*, Toni Morrison breaks the silence, but until recently this was truly, in her words, "not a story to pass on."[7]

Following emancipation, African American women were primarily concerned with establishing families and communities and beginning to enjoy the prerogatives of freedom. Even when their hopes were most sorely deceived, many remained committed to the ideal of comfortable respectability. And then, for those who could write of their experience, there was the problem of shame. The literature of the country did not invite women's public confessions of sexual abuse, much less confessions of extramarital

sexual pleasure or conflicted feelings toward children. In the end, the real cost and horror of slavery did not lend themselves to the narratives of bourgeois individualism, if only because whoever told the story would have to admit that this was done to me. And admitting that this was done to me amounted to writing oneself out of the story entirely.

In trying to write themselves into the literature of the country, African American women were, if for understandable reasons, also tempted to write themselves out of the oral culture of their people and into the "proper-speaking" English that signaled middle-class respectability. More dangerous yet, they were tempted to deny or bury the truth about the real suffering of their mothers and grandmothers. The conventions of domestic fiction offered them no way to write of that experience, primarily because the conventions remained so closely tied to individualist premises. And, pretenses to universality notwithstanding, the individualism of American culture trailed innumerable assumptions about the specific ways in which women, slaves, and blacks related to the free white male embodiment of individualism. Individualism thus confronted African American women writers with a wall of denial. If they wrote as women, they had to write themselves white—and passive. If they wrote as blacks, they had to write themselves male. In retrospect, it appears that this overdetermined denial of African American women's experience may account for the extraordinary vitality of their writing in our own time.

To break the stranglehold of silence, African American women writers have had to find ways to tell stories that fundamentally challenged the most unyielding assumptions of the literature of the country. More than has commonly been recognized, Harriet Wilson pointed the way. However significant *Our Nig* remains for having been the first novel written by an African American woman, it deserves special attention for throwing down the gauntlet to received conventions, even as it proclaimed its author's conversance with high literary tradition.

Recall, if you will, that Wilson prefaced each of her chapters with a passage of verse. She apparently wrote some herself; others she borrowed from the most appreciated literature of her day. In general, her choices were excellent, especially because, on first reading, they serve to assimilate her story to the prevailing sensibilities of her epoch. The verses apparently confirm that Mag and Frado's emotional travails echo those that preoccupied established poets. The borrowed verses thus suggest that Mag and Frado's pain merges with a universal experience. But look again. When Wilson quotes Byron on the ways in which youth honestly discloses the soul and disdains deceit, does she really mean that school boys are honest with each other in a way that adults are not? Or is she subtly mocking the claim of honesty and casting

her readers, by implication the American public, as the foes who deserve open hate? To choose one reading or another would miss the complexity of her intent. She wanted both.

Wilson, by her use of those verses, was proudly writing herself into the literature of the country. By the double entendre with which her text endowed them, she was also serving notice that to accommodate her story the literature would have to change. Her strategy unmistakably implied that the literature of the country would have to allow for conflicted readings and multiple perspectives. In this respect, Wilson bequeathed an important legacy to her most talented successors, who, even if they had never read her, drew something of her sensibility from the experience that they shared with her.

African American women's experience of slavery indelibly colored their relation to the literature of the country, because the pieties of that literature could not encompass their experience. Gradually and unevenly, African American women writers have created an alternative literature that features collective rather than individual subjects. The point is not, as some like to claim, that they repudiated the dominant (white male) literary tradition. They did not. From Wilson's evocation of Byron and Shelley to Hurston's love of Shakespeare and Milton to Morrison's admiration for the ancient Greek dramatists, their continuing engagement with the high Western literary tradition resonates throughout their work. But as they have increasingly felt freer to try to tell the hard, unvarnished truth of their mothers' and grandmothers' lives, they have been led to conjoin the oral tradition of their people with the literary tradition of their aspirations.

The most compelling work of African American women writers draws its peculiar vitality from its attempt to fuse disparate oral and literate traditions and from its determination to make the literary tradition apply. Like Harriet Wilson, they are implicitly posing the question, If this is beautiful and moving, then what is it about? And they are answering that if it is indeed about you, must it not also be about me? Their insistence is helping to move the literature of the country away from the narrow assumptions of individualism toward a properly epic vision. The story of African American slavery is, ultimately, an epic that implicates all of us. The abolitionists' attempt to cast it as a Manichaean struggle between the forces of good and evil rested on an individualist vision of the good that denied the slaves' experience. Today, the descendants of slaves are forcefully reminding us that their experience has been and may yet be ours. In this spirit, Harriet Wilson chose, for the last chapter of *Our Nig,* an epigraph that ironically invoked a biblical favorite of the slaveholders—as if, once again, to demonstrate the strange and conflicted

close connection between the two variants of Southern culture. She chose the words of the biblical preacher, "Nothing new under the sun."

Notes

1. Frances Ellen Watkins Harper, *Iola Leroy; or, Shadows Uplifted* (New York, 1988), 262.

2. Harriet E. Wilson, *Our Nig; or, Sketches from the Life of a Free Black, in a Two-Story White House, North, Showing that Slavery's Shadows Fall Even There, by "Our Nig,"* ed. Henry Louis Gates, Jr. (1859; New York, 1983), hereinafter cited parenthetically by page number in the text. For the history of the novel and a discussion of its relation to the culture of the period, see Gates's Introduction.

3. See ibid., xxxi–xxxiv, on the paucity of references to it.

4. Caroline Lee Hentz, *The Planter's Northern Bride* (Chapel Hill, 1970); Mary Eastman, *Aunt Phillis's Cabin* (Philadelphia, 1852); Louisa S. McCord, Review of *Uncle Tom's Cabin, Southern Quarterly Review,* XXIII (n.s. VII) (January, 1853), 81–120.

5. See Elizabeth Fox-Genovese, *Feminism Without Illusions: A Critique of Individualism* (Chapel Hill, 1991), for a discussion of the ideology of bourgeois individualism and its implications for women.

6. See, among many, Jane Tompkins, *Sensational Designs: The Cultural Work of American Fiction, 1790–1860* (New York, 1985). Many feminist critics argue that women's literature embodied different values from those of men, but in my judgment even when the purported female values appear most harshly to criticize (male) competitive self-assertion, they remained tied to the fundamental premises and worldview of individualism, which was responsible for a specific vision of female nature and values. For a fuller development of the argument, see Fox-Genovese, *Feminism Without Illusions.*

7. Toni Morrison, *Beloved* (New York, 1987). For references to such events in the lives of slave women, see also Elizabeth Fox-Genovese, *Within the Plantation Household: Black and White Women of the Old South* (Chapel Hill, 1988).

Eleven

Abortion and Morality Revisited

It has, with good reason, become virtually *pro forma* to thank Naomi Wolf for introducing or, better, reintroducing the moral question into the "pro-choice" side of the debate over abortion. And thanks are, indeed, in order, if only because the attention garnered by her article, "Our Bodies, Our Souls," reinforced by the public attention to partial birth abortion, has reminded many Americans that there may be a dark side to their easy acceptance of "a woman's right to choose."[1] Gratitude for this opening of the discussion should not, however, blind us to Ms. Wolf's more portentous message, which concerns nothing less than the nature of morality itself.

Ms. Wolf, a committed feminist, has publicly acknowledged that if abortion is a "necessary evil," it is also "always a matter of deep, moral gravity, a transgression." In her view, most Americans agree with her that "abortion should be a legal right" but, also like her, "need to be free to recognize it or claim it as a moral iniquity."[2] The cavalier assumption that we may simultaneously defend abortion as a woman's legal right while we indulge our own need to recognize its moral gravity takes the breath away, not least because it so nakedly exposes the disintegration of our moral vision.

Ms. Wolf sees no contradiction between her two goals, which she apparently believes can be conjoined in practice through the dedicated building of common ground on which pro-choice and pro-life advocates can meet and work together. Her ambition in this regard is nothing if not sweeping. "I want to transform the way we deal with this problem in the United States."[3] Admittedly, her specific proposals for transformation seem rather

less sweeping than the ambition itself. She imagines a world in which "passionate feminists might well hold candlelight vigils at abortion clinics, standing shoulder to shoulder with the doctors who work there, commemorating and saying goodbye to the dead" (59). (One can imagine such occasions being announced or commemorated by some appropriate Hallmark cards.)

But she also believes that the possibility of such vigils—and the common mourning they imply—depends upon the prior advent of a world in which women and men are truly equal and sexuality is truly free. So the contradiction between her desire to acknowledge abortion as the taking of life and to protect women's unconditional right to it does leave its mark in the utopianism of her picture of the conditions that would foster her proposed solution.

In fairness, neither critics nor supporters have paid much attention to Ms. Wolf's proposed solution, and we may reasonably assume that even she did not give it much thought. Rather, her claim to serious attention lies in her having attempted to underscore the moral gravity of abortion without sacrificing her pro-choice convictions.

Some years ago, in *Feminism Without Illusions,* I also attempted, albeit with much less success than Ms. Wolf is now enjoying, to do the same.[4] There, I argued that no position on abortion that substituted rights— whether of the fetus or the woman—for an acknowledgment of the sanctity of life could do justice to the seriousness of abortion. At the time, I believed that my insistence that the nature of the argument (rights as against the sanctity of life) did not necessarily point toward a complete repudiation of *Roe* v. *Wade,* although many of my readers readily understood that I would favor a restriction of abortion to the first three or four months.

Subsequently, in an article on feminism and the rhetoric of individual rights, I returned to the issue, arguing, as had Mary Ann Glendon before me, that the story of a woman's right to abortion as "told by our laws is one of desperate loneliness and anomie that is very difficult to reconcile with the prevailing feminist stories about women's special sense of interconnectedness and responsibility."[5]

Although Ms. Wolf notes that others, notably Camille Paglia, Roger Rosenblatt, and Lawrence Tribe, have called attention to aspects of the "logical and ethical absurdity" in the pro-choice position, she does not refer to Glendon's or my work, with which she is presumably familiar. This silence would merit no attention, if it were merely a question of the reference *per se.* But it seems more than likely that she avoided our arguments, many of which she agrees with and even echoes, because both of us raise the question of limitations upon women's access to abortion. Both of us, that is, raise

the possibility of restricting abortion to the first trimester, of requiring pre-abortion counseling and a brief waiting period, and of requiring minors to obtain the consent of an adult.

The pro-choice feminists regard all of these measures and others like them as anathema. And the Lawrence Tribe whom Ms. Wolf approvingly cites ranks as a leading theorist of a woman's right to abortion which, in his view, even requires the murder of an infant who survives an abortion on the grounds that the woman's right actually includes the right to a successful abortion.

Ms. Wolf's apparent unwillingness to entertain the possibility of even marginal limitations upon a woman's access to abortion reveals more than she intended. And her reluctance, forcefully expressed in her *Firing Line* exchange with William Buckley, to label the act of abortion an unqualified evil confirms the implications of her unwillingness to see a woman's access to abortion curtailed. In the end, what she seeks is not a change in the laws governing abortion but a change in "the language in which we phrase the goals of feminism" (58). But we may only expect such change when women become freer and more powerful, which, she acknowledges, they are becoming.

Meanwhile, "as a result of the bad old days before the Second Wave of feminism," women, she insists in "Our Bodies, Our Souls," still "tend to understand abortion as a desperately needed exit from near-total male control of our reproductive lives" (58). Women, in short, still respond as victims and, like so many victims, tend to take their frustration out upon those even weaker than they.

Ms. Wolf does not fully condone that response, although she above all wishes to convince women that they are no longer as complete victims as women of previous generations had been. But even as she enjoins feminists to acknowledge the essential truth that abortion does stop the beating of a heart, and does kill a baby, she refrains from any criticism of their specific political goals, which she strongly endorses. And even though she hopes that changes in women's social situation will decrease the frequency with which they resort to abortion, she does not seek to change laws or actions, but to change the rhetoric in which feminists defend them. What she cannot face is the possibility that changing the rhetoric may make things worse rather than better.

Others have cogently and eloquently criticized Ms. Wolf's argument in whole or in part, but the main point remains the charge, leveled separately by William McGurn and Rebecca Ryskind Teti, that, in McGurn's words, "if there can be abortion without guilt—better yet without sin—there can be

anything."[6] Teti pushes the point home, reminding us that "'the right to do wrong' is simply another expression for 'might makes right.'" If, she adds, "Ms. Wolf is a hard-headed nihilist, perhaps that is what she wants. But she should see that 'might makes right' is a game women can never win" (82). And nobody better understands women's disadvantage in the world of "might makes right" than feminists, who have done so much to discredit or strip men of the advantages of might. Abortion thus occupies a unique and uniquely-disturbing place in the feminist agenda, of which it is arguably the linchpin.

Most feminists offer two main justifications for abortion: 1) that abortion alone can anchor women's equality with men, and 2) that abortion is the *sine qua non* of women's sexual freedom. The two overlap in the recognition that women's ability to bear a child constitutes the primary substantive or natural difference between women and men. Ms. Wolf never challenges that basic understanding, with which she demonstrably concurs. In this perspective, her plea that we recognize the moral gravity of abortion rings hollow indeed. In effect, all she is saying is that a woman has the right to commit even so morally grave an act as murder without being accountable to anyone but "her" God.

For in Ms. Wolf's logic, the gravity of taking the life of an unborn child must count for less than the freedom of the woman to pursue an unencumbered life. The woman's "right to choose" trumps the child's "right to life." And we have come full circle to the longstanding battle over abortion that Ms. Wolf was trying to reorient.

By the time I read Ms. Wolf's article in *The New Republic,* I was receiving instruction to join the Catholic Church, which I did in December of that year. Many longstanding and recent influences had brought me to the Church, but my years of thinking and writing about abortion played a special role. I had long appreciated the gravity of abortion, but like many others had been reluctant to accede to the response which that gravity required.

Personally, the notion of binding moral obligation did not daunt me, but I knew full well that fewer and fewer Americans shared my tolerance in this regard, and I especially worried about political practicality.

Our culture has become so resistant to the notion that a mistake may have consequences that, rather than face those consequences, many of us prefer to rebuff or trivialize the compelling claims of life. Who are we to say that a young woman who unintentionally becomes pregnant should carry the child to term, even at the cost of her own plans for her life? More important, which of us is willing to impose such an obligation on another?

Precious few, if the polls are to be trusted.[7] In this respect, Ms. Wolf has got it precisely right: Most Americans do recognize the moral gravity of abortion, and most are extremely reluctant to translate the recognition of gravity into a moral law.

Isn't it enough—as Ms. Wolf would have it—that God require us to acknowledge abortion as a wrong? How dare He require that we refrain from performing, undergoing, or condoning it? If strong pro-life advocates have acquired a reputation for intransigence, it may be primarily because so many people regard their position as unacceptably authoritarian, while failing to understand that the pro-choice forces are no less so. For one of the main issues between the two groups does concern the very notion of moral authority, and it is on this terrain that the pro-life forces are being most effectively out-maneuvered.

Ms. Wolf never allows her evocation of the life of the fetus, or moral gravity and transgression, to compromise the presumptive claims of a woman's right to choose—with whatever anguish and regret—to sacrifice the life of her baby to her own convenience. In this perspective, her distinction among the serious, self-indulgent, and openly fatuous reasons for choosing abortion amounts to no distinction at all. It is reassuringly easy to deplore the girls (and I use the term advisedly) who view abortion as the equivalent of the outmoded fraternity pin—a test of a boyfriend's devotion and commitment.

But we can ill afford to fall into the trap—however comforting and seductive—of taking our own condemnation of such frivolity as proof of our moral standards. For if, as Ms. Wolf concedes, the essence of abortion lies in the termination of a human life, then the distinctions among the reasons for which a woman decides to abort become virtually meaningless.

As with murder, the sheer *finality* of the act of abortion drains most of the reasons for committing it of any compelling significance, or, rather, it demotes them to the status of the accidental. To be sure, some motives are considered to mitigate or qualify murder's status as a crime, preeminently self-defense, but also such variants of it as the "battered woman syndrome." Those who are judged to have committed murder "by reason of insanity" also partially evade the full sanctions that fall upon those who do so with cold premeditation. Normally, however, a clever attorney's first line of defense is to deny that the defendant committed the crime in the first place. In the case of abortion, the claim of innocence is foreclosed, and Ms. Wolf shows no interest in advancing a version of the insanity plea. So, she is left with a variant of self-defense, which she, like other feminists, seems to favor.

Unlike many other feminists, however, Wolf stops short of advancing the case for abortion as pure, justified self-defense.

Today, Christians (including the most devout) recognize that when a pregnancy threatens a woman's life, the woman rather than the baby she is carrying should be saved. Presumably, this position embodies something of the Christian and natural law recognition of a fundamental right to self-preservation. But the feminist insistence upon a woman's right to abortion on demand has nothing to do with self-preservation in the sense in which it is commonly understood.

Significantly, President Clinton, out of loyalty to or under pressure from his feminist supporters, refused to sign the ban on partial birth abortion that included an exception to save the life of the mother. And his insistence that the exception must include the "health of the mother" was widely recognized as a way of ensuring the continuing availability of partial birth abortions to virtually all those who seek them. Feminists have never—or never primarily—been interested in outright threats to the life of the mother. What interests them is the quality of a woman's life, which they too often judge to be improved by the absence of children.

Throughout "Our Bodies, Our Souls," Ms. Wolf flirts with the idea that quality of life constitutes a poor justification for murder—indeed, she has been congratulated for having the courage even to suggest this much. But she seems loath to take the *next* moral and philosophical step, namely to admit that once we acknowledge the fetus as a human life, the grounds for preferring one standard of "quality of life" over another collapse. For feminists, the quality of life at issue is not the one that the baby may expect but the one that its mother currently enjoys. For pro-life advocates, however, the life embodied in the baby takes precedence. For the baby, the stakes are literally self-preservation, whereas, for the mother, they are convenience and comfort.

All things being equal, convenience and comfort have their specific claims, but not claims that override our moral obligations to vulnerable life. No less important, Christianity, like the other major religions, has traditionally taught that an individual who presumes to decide whether another individual should live or die pridefully usurps a power that belongs only to God.

Ms. Wolf *does* know that the claims of life embody a moral imperative which her pro-choice politics cannot encompass. Thus she attempts to work her way out of the impasse by postulating equality between the woman's right to choose the life she wants to live, and the moral claims of the life she is carrying.

The linchpin of her strategy lies in the personalization of morality. Thus, in the *Firing Line* debate with William Buckley and Helen Alvaré, she refused to concede that abortion is "evil" (although why she thinks calling it a "necessary evil" mitigates its intrinsic evil remains puzzling). Rather, she insists that she is calling for something that Americans find it difficult to do—"to keep in mind simultaneously the legal entitlement to do something . . . while always feeling ourselves to be morally accountable, scrutinizing our motivations."[8]

No Catholic needs to be reminded about the importance of scrutinizing one's motivations—and one's words, thoughts, acts, or failures to act. Such self-investigation is the substance of confession. But, in Ms. Wolf's rendition, what Catholics call the examination of conscience lacks the external authority of God's judgment and mercy.

In "Our Bodies, Our Souls," Ms. Wolf bemoans that so many on the left have become "religiously illiterate" and, accordingly, deeply misunderstand the meaning of the word "sin." She reminds her political comrades that "in all of the great religious traditions, our recognition of sin, and then our atonement for it, brings on God's compassion and our redemption" (57). But her very attempt to reclaim a moral and religious sensibility for the Left betrays the limits of her own understanding. To the best of my knowledge, even our heartfelt recognition of sin and atonement for it do not necessarily "bring on" God's compassion, much less our own redemption. The very essence of God's omnipotence lies in His independence from our actions and our powerlessness to control Him. The point is not that God is not likely to show mercy to those who sincerely repent of their sins. He is. But we can never know, and, above all, we cannot force His hand. We owe Him, He does not owe us: in the words of Psalm 100, "Know ye that the Lord he is God: it is he that hath made us, and not we ourselves."

Whatever Ms. Wolf would like to believe, God's commandments are not a private matter, and believers do not privately negotiate their observance with Him. Faithfulness to God includes the expectation that we will indeed be punished for our sins, although those who sincerely cultivate "a proper fear of judgment" may reasonably place even greater faith in His mercy. For a Catholic, it is sinful presumptuously to judge the depth or sincerity of another's faith and, like other Christians, we are required to pray for forgiveness for all, including, and perhaps especially, those who seemingly defy the basic tenets of faith.

Nor would I even wish to judge Ms. Wolf's relations with her God, which are indeed between her and Him. But nothing obligates me to agree that religious faith is an entirely private matter.

Pro-life intellectuals frequently evoke the analogy between slavery and abortion, arguing that evils of such magnitude command our forceful resistance. At the core of their appeal lies the implicit recognition that fateful moral questions may never be regarded as just another life style. The moment we shroud respect for the sanctity of life—and the right of the most vulnerable members of our society to protection—with the cloak of privacy, we commit ourselves to sanctioning the domination and exploitation of the weak by the strong.

There was a time when I believed that the practicalities of politics in a pluralistic democracy argued for the acceptance of legal abortion during the first trimester of a pregnancy. And a single trimester of legal abortion may still be the best political compromise we can expect. As Marjorie Reiley Maguire argues in her contribution to the symposium on "Our Bodies, Our Souls," the feminist tendency "to meld the legal justification for abortion with a moral justification for abortion" may be understood as a "reaction to the other swing of the pendulum which demands an absolute conformity between civil law and moral law."[9]

Arguably the greatest challenge of our time lies in understanding and defending the appropriate relations between civil and moral law—between religion and the polity—in our modern democracy. Abortion, assisted suicide, and the other issues that touch upon the sanctity we accord to human life have brought those tenuous relations to a crisis, and the overwhelming temptation has been to reduce the claims of religion and morality to the privacy of individual conscience.

God, however—as He frequently reminds us—is not mocked. It behooves us to remember that the "privatization" of morality constitutes the ultimate mockery, not merely of His specific laws, but of His authority to establish law in the first place. Notwithstanding a variety of ecumenical initiatives and considerable evidence of good will, the relations among different faiths remain delicate, and the fundamental differences among them are unlikely to be resolved anytime soon. Under these conditions, few Americans are likely to countenance the reestablishment of a specific religion.

Furthermore, some churches and denominations have made substantially greater concessions to the prevailing secularism of our times than others, with the result that, even within the predominant Jewish and Christian traditions, there is little prospect of immediate agreement on many questions. On the main issues, notably those that concern the sanctity of human life, it nonetheless appears that the most important divide does not separate members of different faiths so much as it separates those who tend toward religious conservatism from those who tend toward religious liberalism—it

cuts across the boundaries of specific faiths. Not surprisingly, this divide corresponds closely to the divide between those who are pro-life and those who are pro-choice.

Ms. Wolf has tried to bridge the chasm between the two groups through rhetoric—by claiming, as it were, the rhetoric of life for what Pope John Paul II has called "the culture of death." Her attempt founders on her determination to view morality as a private matter, but her very failure offers a valuable lesson to those who are pro-life.

Above all, she reminds us that the place to begin is with the inescapable public claims of morality. It is not enough simply to oppose abortion, assisted suicide, cloning, and all the rest. The necessity for such opposition should be self-evident. More important, however, we must begin the long, arduous struggle to reestablish the claims of morality upon our public life. And that struggle requires cooperation with, and respect for, people of faith who differ from us on many specific matters.

The goal cannot be to impose every requirement of our specific religion upon others, but to work with others to establish a climate of respect—dare I say reverence?—for fundamental moral claims. And if we do our work well, we may even begin to convince a majority of Americans that a private morality is as much of an oxymoron as a private law.

In an imperfect—a fallen—world, it is unrealistic to expect a perfect correspondence between civil and moral law. There are things that are Caesar's, and they should be rendered to him. The outrage comes in rendering unto Caesar the things upon which he has no claim. And among those, the sanctity of human life must always enjoy pride of place.

Notes

1. Naomi Wolf, "Our Bodies, Our Souls," *The New Republic* (16 October 1995), reprinted in the *Human Life Review* XXII, no. 1 (Winter 1996), 45–59. All citations to that article will be to the *Human Life Review* and the page numbers will be given in parentheses in the text.

2. "The Rhetoric of Abortion." Transcript of *Firing Line* debate among Naomi Wolf, Helen Alvaré, and William Buckley (26 January 1996), *Human Life Review* XXII, no. 2 (Spring 1996), 87–88.

3. Ibid, 90.

4. Elizabeth Fox-Genovese, *Feminism Without Illusions: A Critique of Individualism* (Chapel Hill: University of North Carolina Press, 1991).

5. "Feminism and the Rhetoric of Individual Rights, I & II." *Common Knowledge* 1, nos. 1&2 (1992). Mary Ann Glendon, *Abortion and Divorce in Western Law* (Cambridge: Harvard University Press, 1987).

6. William McGurn, "With Friends Like Her," *Human Life Review,* XXII, no. 1 (Winter 1996): 74; Rebecca Ryskind Teti, "You Can't Get There from Here," *loc cit.* 81–4. See also the other contributions to the debate over "Our Bodies, Our Souls" in the same issue.

7. For a fuller discussion, see Elizabeth Fox-Genovese, *"Feminism Is Not the Story of My Life": How Today's Feminist Elite Has Lost Touch with the Real Concerns of Women* (New York: Doubleday/Nan A. Talese, 1996) and James Davison Hunter, *Before the Shooting Begins: Searching For Democracy in America's Culture Wars* (New York: Free Press, 1994).

8. "The Rhetoric of Abortion," 89.

9. Marjorie Reiley Maguire, "Rhetoric and Reality," *loc cit.,* 66.

Twelve

Caught in the Web of Grace

On December 9, 1995, the day after the feast of the Immaculate Conception, and in the presence of family and a few close friends, I joined the Catholic Church, receiving four sacraments in little more than an hour. A day of grace abounding if ever I have known one and a day bathed in the undiluted quiet happiness of coming home. For me, that day wove together the essential threads of the preceding fifty-three years of my life, as those who shared it with me had come to understand. Yet, to many outsiders, it seemed at best baffling, at worst, incomprehensible.

Why or how could a non-believing, woman intellectual—and a reputedly Marxist-feminist one at that—be joining that bastion of tradition and hierarchical authoritarianism, the Catholic Church? Those who, for years, had doubted my radical credentials and targeted me as a pernicious ideological opponent did not take long to decide that that is precisely what they would have expected if only the thought had crossed their minds. (It is an inadvertent testimony to the radical secularism of the academic world that the thought had not.) But even people who were friendlier toward me probably harbored similar thoughts, if for dissimilar reasons.

For such people, the friendly and the unfriendly alike, the notion of conversion, and indeed the very idea of religious faith, has become so foreign that the only plausible explanation for it must necessarily be political: In their view, my conversion merely marked the culmination of my progress toward political and cultural conservatism. These are people who, according to St. John, quoting Isaiah, "could not believe. For Isaiah again said, 'He has blinded their eyes and hardened their hearts lest they should see with

their eyes and perceive with their hearts, and turn for me to heal them.'" Not long since, I should have counted myself among their number, for, like them, I had lived immersed in a moral and intellectual climate that inhales materialism with the air we breathe. In such a climate, the intrusion of religious faith seems faintly shocking: The people we know just do not do things like that. As it happened, I counted among my friends and acquaintances a significant number of believers, some of them devout. I had always respected their faith, but I did not entirely understand it. Thus, even my appreciation of the faith of others and my understanding that gifted intellectuals may indeed be believers was filtered through the lens of the intellect.

A Surprising Comment

Philosophical materialism constituted a master theme of my education, and variants of it still reign supreme in the academic milieu in which I have always worked. For years, I had complacently assumed that modern science and philosophy had permanently destroyed the intellectual validity of religious faith, displacing it from its position as the cornerstone of knowledge and ontology to the realm of idiosyncratic personal consolation. And I recall being somewhat startled when, during a conversation with a highly accomplished scholar, a friend and a Catholic, I confidently said something about the incompatibility of religion and science, and she, with an easy and tolerant amusement, responded along the lines of, "Good gracious, I thought we had moved well beyond those debates." Her words stayed with me, unexpectedly surfacing at odd moments, and I found myself reading with unprecedented interest about the puzzles of black holes and the renewed possibility of a creative intelligence at the origin of the universe.

By the time of that conversation, I was already giving serious thought to joining a church, although I was uncertain about which one. Given my family background and personal connections, I had initially assumed that I would settle on the Presbyterians or the Episcopalians. Presbyterians figure prominently among the Christian friends and colleagues I most respect, and their unflinching Calvinism brought me back to the moral ethos in which I had been reared. The Episcopalians, for their part, featured the rituals and the language of the Book of Common Prayer that I had been taught to cherish. My preliminary investigations into the current state of both denominations, however, rapidly revealed that to join the Episcopalians I would not have to profess a belief in Jesus Christ as my personal savior. Talk about cushions under the knees of sinners! The very loophole the Episcopalians offered became, upon reflection, the decisive reason not to join their church.

Thinking about the Episcopalians reminded me of the stories my father used to tell me of his own childhood. His mother descended from the first

minister of the Bay Colony and, during my childhood, my grandmother worshipped at Jonathan Edwards's church in Northampton. For me, and countless others, she embodied the essence of religious devotion and probity, and I have no doubt that my father's atheism at least partially represented an attempt to mitigate her compelling influence on his early life. His father, whose family had settled in Boston and Cohasset, Massachusetts, during the eighteenth century, represented the more worldly and social tradition of the Episcopalians. And my father loved to tell of how, as a boy on visits to his father's family, he was offered the choice between the Presbyterians and the Episcopalians and regularly chose the Episcopalians because they gave much better picnics.

Since better picnics were not what I was after, I turned again to the Presbyterians and, with my husband, occasionally attended their services. High standards distinguish the preaching at Peachtree Presbyterian in Atlanta, and the preachers do not spare their flock stern reminders of God's commandments and expectations. I began to feel that I could join the Presbyterians, not least because they preserved the teachings, the music, and the moral rectitude that had characterized my beloved grandmother and, indeed, my atheist father. But an ineffable influence stayed me, and I kept postponing the decision. Even in retrospect, the precise reasons remain elusive, but I did know I was not an Evangelical, and I did harbor an as yet poorly defined sense of faith as, in some way, grounded in an acceptance of mystery and a reverence for the sacred. My failure to find those things in Presbyterianism may have more to do with the shortcomings of my understanding than with Presbyterian beliefs or observance, but I could not shake the sense that becoming a Presbyterian did not ask enough of me.

Campus Turmoil

Meanwhile, I was wrestling with seemingly overwhelming professional problems, including my politically-pressured resignation as director of Emory University's Institute for Women's Studies and a suit against the university that specifically named me for, among other things, having sexually harassed a former graduate student and member of the Institute's staff. Significantly, my intolerable "sins" as director of Women's Studies included having spoken for the Rochester, N.Y. chapter of Feminists for Life and having admitted (with the concurrence of my colleagues, who, at the time, had no idea what they were doing) into the Women's Studies graduate program a devout Catholic who soon became president of Emory Students for Life. In retrospect, it seems improbable that the suit would ever have gained even minimal credibility or persisted as long as it did had not so many of my former friends and colleagues in Women's Studies decided that my views on important

issues, in the measure that they understood them, could not be tolerated within the Women's Studies "community." Not surprisingly, the burdens of those years—four and a half of them by the time the case was settled—prompted me to considerable soul searching about personal responsibility, the meaning of suffering, and my own deepest beliefs. In time, this travail and those reflections strengthened my burgeoning faith and contributed to my conversion.

Like politics and intellectual inquiry, the sufferings of those years predisposed me to reflect seriously upon religion, but none of them "caused" my conversion: More accurately, they helped to prepare the soil in which the seed of conversion would be sown. All of them also converged in reinforcing what one might call my natural inclinations as shaped by important features of my education. For if formal religious observance had played only a marginal role in my upbringing, other aspects of religion had run like shining threads through it. Both of my non-believing parents embodied what, in retrospect, I recognize as exceptional character and breath-taking personal courage. As a child, I so took those qualities for granted as not even to recognize them as such: They were simply the framework and standard of my world. My father had absorbed the essence of his mother's Calvinism, and his own atheism never abandoned or mitigated its basic teachings and power.

Jewish Background

My mother had grown up as a member of New York's German Jewish bourgeoisie in a family that celebrated Christmas and Easter but attended neither synagogue nor church. Her allegiance to her Jewish heritage nonetheless ran deep and proud, and, growing up under the shadow of Hitler and the Holocaust, I was reared to share her pride in that ethnic and cultural legacy. But the Jewish identity to which I have always remained faithful was one of intellect and music and habits of being, not of religious faith. For years, I did not even fully understand that Judaism was a faith: I did not know the names of the religious holidays or when they occurred; I had never participated in a Seder; I had never celebrated Hanukkah or Passover; I had never set foot in a synagogue.

My childhood, which unfolded under the aegis of my father's atheism and my mother's more cautious agnosticism, nonetheless included a surprising depth of Christian education. My mother focused upon providing my brother and me with a basic knowledge of the Bible, which, on Sundays, she read to us and later enjoined us to read ourselves. We learned the titles of the books and selected passages, especially certain psalms, by heart. During the summers, we were regularly taken to Sunday evening hymn singings,

and on no Sunday were we allowed to play cards. Until I was about ten, my parents dutifully took us to Sunday school every week, selecting the church less according to doctrine than according to the quality of instruction, especially in biblical history. These criteria, combined with my mother's personal taste for sobriety of expression and minimal emphasis upon Jesus Christ, ensured that Unitarians and, especially, Quakers emerged as first choices, but over the years we had also been entrusted to Presbyterians and Episcopalians.

This religious education had indeed served its educational purposes well, notably by affording me a solid introduction to the Bible, especially the Old Testament. And our Christmas celebrations, which always included a crèche as well as presents, carols, and a tree, had firmly implanted St. Luke's account of the nativity in my mind. What it had not done was to inculcate in me an understanding of faith itself. My grandmother, with whom I spent a month of each of my first ten years, did that, taking me with her to church, saying grace at meals, and teaching me to say my prayers before going to sleep at night. But her valuable lessons and example were never enough to counteract the intrinsic secularism of my world, especially after I left home for school and college.

The abiding spiritual lessons that my parents provided, they seem to have provided inadvertently, usually in the course of discussions of moral obligation and intellectual honesty. Both were unswerving in their own integrity and left no doubt that they expected the same of us. And as the years passed, my father and I increasingly discussed moral and religious topics. A great teacher, he retained a heartfelt admiration for the Old Testament prophets that he imperceptibly transmitted to me. Even today, his basic precepts remain etched in my mind. The greatest courage, he taught me young, is not physical but moral, and the challenges to moral courage are the same as the near occasions of sin: They weave through the fabric of everyday life, challenging us to rise above jealousy, greed, deception, and self-interest. In the same spirit, he repeatedly reminded me that no honor or knowledge or worthy behavior can flourish in the absence of intellectual honesty, which necessarily begins with the most exacting honesty about oneself to oneself.

Meeting the Medievals

In retrospect, it seems clear that his precepts left a deeper impression than even he knew, and I can only chuckle in recalling an occasion upon which my interpretation of them must have stunned him. He had come to visit my brother and me during a summer we were spending at schools in Switzerland and, at the end of the day, took me out for what seemed a very grown-up dinner. (I was fourteen at the time and beginning to test my wings.) Our conversation was weaving through a range of our customary serious topics,

when, savoring a new stage in our companionship and moved to demonstrate both my trust in him and my mastery of his teachings about right and wrong, I interjected, "I can imagine committing adultery, but I know I would go to hell for it." To this day, I do not know how he maintained a sober countenance in the face of his virginal daughter's unsolicited moral pronouncement, but I suspect he was at least pleased that I had come to understand that sin evokes judgment and consequences.

As I moved through my teens and into my twenties, these discussions persisted and expanded to include the work I was doing in college. What, in retrospect, seems somewhat surprising is how firmly he steered me in the direction of medieval history and philosophy and twentieth-century Catholic thought. Although he never intervened directly in my work, he frequently suggested courses I might take and even paper topics. As a result, I took medieval civilization with David Herlihy, a serious Catholic, and for Herlihy's and other courses wrote papers on Peter Abelard's ethics, Gothic art and scholasticism, and the relation between T. S. Eliot and the neo-Scholastics, notably Jacques Maritain. In addition, as a double major in History and French, I read widely in Paul Claudel, Charles Péguy, and François Mauriac. For Herlihy, I read St. Thomas, St. Anselm, St. Bernard, and the other great Scholastics and medieval mystics. Teresa of Avila and Ignatius Loyola became my models of saintly mission and rigor, virtual equals, in my father's pantheon, to John Calvin.

During my junior year in college, which I spent studying in Paris, he arranged for me to sit in on a course in adult Catholic education, offered by the Dominicans, that focused upon the assumption of the Virgin Mary. Meanwhile, he and I shared long discussions of Arnold Toynbee's *Reconsiderations,* on which he was writing an article, and he frequently focused our attention upon Christ as the unique model of total self-consciousness and loving self-sacrifice. Then, as throughout my life, he urged me to understand the redemptive power of suffering and its necessary place in the life of any worthy human being.

By the time I reached graduate school, the fruits of these teachings had become the bedrock of my understanding of the world. Above all, I built upon the knowledge that truth exists only in the mind of God, which alone can encompass the entirety of time present, time past, and time future in the twinkling of an eye. In this spirit, I never doubted that a human life must have a purpose, that each of us must serve something larger than himself. Deep-seated doubts about the intrinsic value of the radical individualism that began to sweep through American culture in the 1960s did not enhance my standing among the left-wing circles in which I frequently moved. My husband, Eugene Genovese, had a long history on the left, and most of his

former comrades and acquaintances hated me on sight. Nor did the leaders of the emerging women's movement embrace me as a sister. In my mind, dedication to social justice and to the improvement of women's position should not lead to a war to the death with tradition, authority, or the binding obligations of marriage and family. Events proved me naïve, and the very commitments that had briefly marked me as a woman of the left were now marking me, in the eyes of my critics, as a woman of the right. Yet then as now, I was no more the one than the other. Throughout the years, my commitment to social justice and compassion for the dispossessed have remained remarkably steadfast, although events have modified my views about how best to express that commitment.

Beyond Individuality

The growing struggle in my heart and soul was not, however, a matter of left and right, but rather one of right and wrong and our ability to recognize them. Throughout the 1980s, I was increasingly writing and speaking about women's issues, especially abortion, and it was the attempt to understand their full implications that gradually pulled me toward church membership and faith. I had never liked abortion, but had assumed, for many years, that, in a democracy, the political goal should be to limit it to the first trimester, to impose a waiting period and counseling, and to require minors to obtain an adult's consent. Thus, my instinctive position closely resembled that of Mary Ann Glendon, whose work I had come to admire. The more I thought and wrote about the issues, however, the more troubled I became by the idea that any one of us could—much less had a right to—decide what constituted a valuable life. How could we know that bearing a child rather than finishing law school would "ruin" a young woman's life? How could we know that bearing and rearing a handicapped child would not transform grief and inconvenience into a blessing we could never have envisioned?

The growing attention to euthanasia, assisted suicide, and partial-birth abortion steadily strengthened my conviction that individual human beings could not be entrusted with decisions about life and death and that a willingness to hold any life cheap or expendable corrupts those who claim the right to make those decisions. And the more I pondered, the more conscious I became of the hubris that pervades the secular academy and intelligentsia. Contemplating the pride of others made me only the more mindful of my own and of the danger lurking in our cavalier assumptions that our minds can encompass the consequences of our acts. Increasingly it seemed to me that the very material triumphs of modernity, including the dense interconnections of the far-flung parts of the globe—and increasingly, the universe—diminished our ability even to imagine the unforeseen consequences

of our acts. Yet the escalating uncertainty and indeterminacy make the imperative of a moral and ontological center the more compelling. All around me, people seemed to be finding that center in the needs, wants, and feelings of the isolate self, but for me such individualism or identity politics exacerbated the problem rather than eased it.

Nothing in this personal history compelled my conversion to Catholicism, or even explains it. It would be aesthetically satisfying to be able to evoke a single moment of blinding light—a road to Damascus—but there is none. One ordinary day, when I was again musing over the question of joining a church, I knew I would join the Catholic Church. I had not previously been thinking of doing so, indeed the thought had never consciously crossed my mind. I am devoted to my husband's devoutly Catholic family, but since he had left the Church in adolescence, their faith remained something to appreciate rather than to share. In a general way, my husband's family and my Catholic friends have always known that we respect and, in some measure, understand their Church, but, notwithstanding private prayers, they never openly pressed for our conversion. If any single person influenced me in this regard, it was the Catholic graduate student whom, to the horror of my colleagues, I had admitted to Women's Studies. Sheila O'Connor, during her years at Emory, had gradually become a close friend and virtual member of the family, and through her I had become friendly with a circle of other Catholic students, but even she, who prayed fervently for our souls, had never, I think, allowed herself to consider that I might join the Church. Nor had my husband, who knows me better than anyone, foreseen my decision.

There are kinds of knowing that transcend the play of words and ideas. Of such quiet certainty, but more deeply so, is the knowledge of faith, which steals into the soul. Daily exposure to Sheila's living faith contributed to my own sense of faith as the fabric of a life, and I strongly suspect that our Lord, if he finds me an acceptable servant, counts me as a jewel in her crown in heaven. But even that palpable example could not substitute for the internal certainty. We live surrounded by examples of virtue and faith that we admire without ever attempting to make them our own. The miracle and mystery for me lay in the recognition that they might also be mine.

Accepting Sacrifice

Since my first year of college, Gerard Manley Hopkins had figured among my favorite poets, and I had almost without knowing it memorized some of the passages that most deeply touched me. At the time, I had no understanding of the place of Catholicism in his imagination, and did not even much attend to his having been a Catholic. Who knows how I managed to ignore

the significance of the subtitle of my favorite of his poems, "The Windhover: To Christ Our Lord," but I did. Consequently, I but rarely considered why I was so moved by my favorite of the poem's lines:

> No wonder of it: Shéer plód makes plough down sillion
> Shine, and blue-bleak embers, ah my dear,
> Fall, gall themselves, and gash gold-vermillion.

What I did nonetheless fully understand was Hopkins' insistence that the most compelling beauty and mastery must evoke our reverence; that, for those who seek, their signs abound in the world around us; and that, especially, flaming, soul-stirring beauty emerges from work, from the acceptance of boundaries, and from sacrifice.

While in France during my early twenties, I met and eventually became friends with one of the most extraordinary men I have ever known, André Amar, a one-time president of the Jewish World Congress, the director of a private bank, and a professor of philosophy. His lectures on the history of Western thought dazzled with a brilliance I have rarely encountered, but their true brilliance lay in the reverential seriousness with which he engaged the thinkers and topics he was discussing. On one occasion he especially engaged religion, sternly instructing the throng of largely materialist students that none of their secular theories provided an adequate explanation of religion. The sacred, he insisted, is irreducible: It is its own form of knowledge, has its own epistemology and its own rules. Always remember, he concluded, that the sacred is a realm unto itself and we only impoverish ourselves by attempting to contain it within secular categories. Although at the time I could not fully apprehend his meaning, I always have remembered both his words and the tone in which they were uttered.

Like Hopkins, Amar challenged me, albeit in different ways, to relinquish the pride of intellect that had been my mainstay since childhood. I was not accustomed to viewing my deep thirst for intellectual mastery as a matter of pride, although I fully appreciated its value as a defense against the inevitable disappointments of the world, not to mention against sloth and self-indulgence. Even as I became increasingly conscious and suspicious of the pride of intellectuals, including myself, who pretend to know what is best for themselves and others—who seek to order the world closer to their heart's desire—I failed to grasp pride's protean role as a deeply internalized defense against faith.

One of the aspects of Catholicism that most attracted me was its compelling intellectual tradition in which I had so long been immersed. But the vision of the sacred offered by Hopkins and Amar, while never repudiating the intrinsic value of intellectual work, clearly required something more than

mere intellectual acquiescence: It required, as I gradually came to understand, that one "fold the wings of intellect" (to borrow from Sheila's mother and my friend, Mary Alice O'Connor). In the words of Jesus, as reported by St. Matthew, it required that one become as a child: "Truly, I say to you, unless you turn and become like children, you will never enter the kingdom of heaven."

The Demon of Anguish

Conversion, in my experience, has been less an event than an unfolding. My years of reading Catholic theologians and writers had taught me that the struggle for faith is, precisely, a struggle. St. Teresa, St. Thérèse, Flannery O'Connor, and Georges Bernanos, among many, bring that truth vividly alive. Even as we believe, we yearn to deepen that belief; even as we practice the habits of faith, we strive to practice them more faithfully. Long before I consciously dreamt of conversion, Bernanos occupied a special place in my imagination, and his *Dairy of a Country Priest* ranked high on my list of favorite books. I had, as I thought at the time, discovered the book for myself, which is to say that no one had suggested it to me, and to my surprise, since it is in many ways theologically and intellectually demanding, had read it with the breathless excitement I normally reserved for lighter fiction. And for years thereafter, I cherished the reflection of that country priest, "*Je crois au fond que l'angoisse c'est un démon impur.*"

Today, in my unfolding conversion and thanks to the direction of Father Richard Lopez, who gave me instruction and has remained my confessor, I am coming to understand that the anxieties that I once, like so many non-believers, took seriously, signify not ideals, but temptations. For in seeking to assuage our anxiety, we are driven to the goods and accolades of a world that will always leave us wanting. Faith, in contrast, helps us to glimpse a reality that transcends the flawed and deceptive materiality of the world. Conversion, like the faith of which it is a part, thus resembles the early Jewish and Christian understanding of metaphorical ontology as described by Jeffrey Burton Russell in *A History of Heaven: The Singing Silence*. Russell explains that for traditional religious writers, metaphors are ontology, and the metaphors that open the mind to truth continually grow. Thus, metaphor provides the best route to an understanding of heaven, which "is itself the metaphor of metaphors, for a metaphor opens to more and more meaning, and heaven is an unbordered meadow of meaning."

Perhaps the reality and the essence of my conversion—and any conversion—may best be captured by analogy to the real presence in the Eucharist. For in the Eucharist we come to understand that the greatest of all mysteries is the ultimate reality, and that groping toward faith consists in the

continuing struggle to grasp the most ineffable and elusive as the most real. This quest unites my conversion to those of countless others and, by minimizing its uniquely personal cast, acknowledges it as less the work of the creature than the grace of the Creator. "I am the good shepherd; I know my own and my own know me, as the Father knows me and I know the Father; and I lay down my life for the sheep. And I have other sheep that are not of this fold; I must bring them also, and they will heed my voice. So there shall be one flock, one shepherd."

Catholic and Feminist

Can One Be Both?

Can one be both Catholic and feminist? Many of us these days are asking the question, sometimes with considerable anguish. The real question, however, is why is this a question at all. Why do so many of us see the relations between Catholicism and feminism as problematic? Until we can answer this, we will find it difficult to think constructively about the prior question of whether it is possible simultaneously to be both Catholic and feminist. Many of us, I suspect, think the answer to this question should be "yes," if only because we believe ourselves to be both. But knowing that others perceive irreconcilable conflicts between Catholicism and feminism, even the most optimistic of us is likely to pause. For we do know that even if we hope to reconcile the claims of Catholicism and feminism within our own beliefs and lives, most Catholics and most feminists would insist that such reconciliation is difficult if not impossible.

The perceived difficulties originate in the allegedly incompatible demands that both Catholicism and feminism impose upon their adherents. Catholic teaching includes a series of prescriptions about human sexuality, fertility, and marriage. As Pope John Paul II and the Magisterium insist, Catholicism does not countenance sex outside of marriage or divorce and does require that sexual relations be open to reproduction, which, in practice, means refraining from the use of artificial contraception. In addition, Catholics are held to revere life in all its forms and hence to refrain from

abortion, suicide, and assisted suicide, all of which are viewed as forms of murder. The Holy Father has further enjoined Catholics to oppose capital punishment in virtually all cases. These requirements apply equally to women and men, but there can be no doubt that their consequences, notably with respect to the prohibition against abortion, may appear to fall more heavily upon women.

In addition to forcefully underscoring the practices from which Catholics must refrain, the Holy Father has repeatedly emphasized the dignity of women as persons, acknowledged the abuse and injustice that has too frequently been inflicted upon women, and welcomed modern advances in women's worldly and professional equality with men. Praising "the culture of equality," he has written that "respect for the full equality of man and woman in every walk of life is one of civilization's greatest achievements." And he sadly acknowledges that "unfortunately even today there are situations in which women live, *de facto* if not legally, in a condition of inferiority." Such injustice makes it all the more "urgently necessary to cultivate everywhere a culture of equality, which will be lasting and constructive to the extent that it reflects God's plan."[1]

The Pope's frequent remarks upon the dignity and vocation of women testify to his genuine concern to further steady improvement in women's traditional position, which has been historically, and throughout much of the world remains, one of subordination to men. To the disgust of feminists, however, he has also insisted upon women's specific genius, which includes responsibilities as well as rights. Women's right to equal treatment and respect, like their right to equal partnership in the mystery of redemption, derives from their equal value as persons in the eyes of God. And many of their responsibilities, like men's, derive from the same source. But women also have specific responsibilities that derive from their nature as women, notably their ability to bear new life and the special intimacy of their relation to it. Thus the Pope does, to be blunt, insist that in some essential ways women and men differ and that, in the measure that they do differ, must be acknowledged to have subtly different vocations.

On the face of it, many recent Catholic statements about the nature, dignity, and rights of women appear to have much in common with feminism. But, in this case, as in many others, everything depends upon the meaning we ascribe to the words *Catholicism* and *feminism,* and today the meaning of both is hotly contested. The core of feminism lies in the simple demand that women receive the same respect as men as independent, capable human beings. Yet the very simplicity of that demand raises as many questions as it answers. What does equal respect for women and men mean, and what does it require? If you listen to the more radical feminists, you would have to

believe that feminism requires unlimited sexual freedom, complete individual autonomy, and absolute equality between women and men in all areas of life. For the radicals, feminism necessarily includes not merely personal dignity, freedom from sexual harassment and rape, and equal pay for equal work, but abortion on demand; sexual freedom for women, including the freedom to engage in extramarital affairs with men or women; lesbianism and bisexuality as coequal to heterosexuality, which is increasingly referred to as "heterosexism"; single-sex marriage; freedom from any special responsibility to children; single motherhood; no-fault divorce; equal participation in the military; and more. At a minimum, this agenda suggests that contemporary feminism, in its most radical and politically influential manifestations, has established itself as a resolutely, if not aggressively, secular program. In particular, in declaring uncompromising war against men's alleged domination over women and women's alleged enslavement to children, it has discredited the ideals of service and sacrifice.

Feminists reason that women, as the victims of systematic and universal oppression, are entitled—perhaps obligated—to struggle against all of its protean manifestations, notably the ubiquitous instances of men's violence against women. Today, few Americans disagree, and most willingly support feminist campaigns against rape, the abuse of women and children, and *quid pro quo* sexual harassment. But feminists also find evidence of male violence in more ambiguous areas. Their favorite targets include, but are not limited to: the domestic division of labor, the distribution of political and occupational positions, styles of classroom teaching, standardized tests, male models of moral reasoning, scientific theory and practice, single-sex education for men, and professional sports. According to many feminists, all of these forms of violence and more may be traced to the patriarchal family and patriarchal religion, which together share primary responsibility for imprisoning women within constrictive social relations and demeaning interpretations of female nature.

Feminists seek to free women from the stereotype of womanhood that both the family and revealed religion have perpetrated upon them. And like many who seek liberation from what they experience as a condition of enslavement, they have tended to argue that freedom must mean the total repudiation or reversal of that condition. They have especially resented the tendency of churches and families to base their vision of women's roles upon assumptions about female nature, most notably female sexuality. Thus, feminists frequently link their campaign for women's sexual freedom to their campaign against family and religion, arguing, at the extreme, that to survive in the Christian churches, women must reclaim their sexuality from the male domination that Christianity has foisted upon them. In an attempt to

impose their views, they have frequently—and with considerable success—turned to the government to implement them. To date, their campaigns against religion have primarily been waged within the churches, but some are now proposing that all churches be denied tax-exempt status unless they comply with an antipatriarchal agenda in their allocation of institutional positions and use of language. For Catholicism, the implementation of this program would mean women priests and the deletion of all references to God the Father. For people of all faiths, it would signal the end of the constitutional separation of church and state.

The radicalism of some feminist attacks on religion was captured by the fourth and most recent "Re-Imagining" conference, which began by inviting the participants to bite into one of the apples piled in bowls on the tables at which they were sitting. The point of the exercise was to reclaim Eve and, with her, a woman's right to the knowledge of good and evil. In a similar spirit, a school of Catholic feminist theologians has enthusiastically turned the tools of postmodern cultural analysis against the Virgin Mary, for whom it has little patience—at least in the form in which the Church has presented her. And, at the extreme, many ostensibly Christian feminists call for goddess or Sophia worship on the grounds that the male God and Savior of Christianity do not reflect women's experience. These feminist critiques of patriarchal religion have begun to make a serious impact upon the churches, most of which suspect that they have not always treated their female members with the respect they deserve. But this laudable eagerness to acknowledge women's dignity may be blinding many to the nature of the challenge they are trying to accommodate in a proper Christian spirit. For feminist demands upon the churches have inevitably and invariably hewn more closely to the imperatives of politically radical secularism than to those of Christianity.

Feminist rereadings of religion through the lens of secular concerns has a longer history than many may suspect. In 1848, at Seneca Falls, Elizabeth Cady Stanton and a group of colleagues assembled to defend women's right to the same civic freedom as men enjoyed on the grounds that "all men and women are created equal."[2] But even at Seneca Falls, Stanton turned her attention to the ways in which man held woman spiritually and morally hostage. "He has made her, morally, an irresponsible being," by assigning to her a different code of morals than that which obtains for man. In sum, "He has usurped the prerogative of Jehovah himself, claiming it as his right to assign for her a sphere of action, when that belongs to her and to God."[3]

Some years later, in *The Woman's Bible,* Stanton launched an open challenge to religious authority in the name of women's emancipation and self-determination. In a spirit that contemporary feminists would find entirely congenial, she insisted that women's freedom required liberation

from artificial laws and customs that, by freeing women, would transform society.[4] In *The Woman's Bible,* Stanton offered a series of harsh commentaries on the Old Testament, reproaching Moses for not having been "more merciful in his judgments of all witches, necromancers and soothsayers," who "possessed the same power and manifested 'many of the same wonders'" as he and who "should not have been so severely punished for their delusions."[5]

She nonetheless reserved her real fire for the New Testament, which she judged even less friendly to women. Rejecting the Christian claim that the New Testament brought "promises of new dignity and of larger liberties for women," she announced that women's inferior position is actually "more clearly and emphatically set forth by the Apostles than by the Prophets and the Patriarchs."[6] She especially deplored the position of Mary, whom she described as having belonged to the Jewish aristocracy. With this distinguished ancestry, Mary should have been granted a husband of her own rank rather than a humble craftsman. But then Stanton could not understand why Mary had to be human at all. "If a Heavenly Father was necessary, why not a Heavenly Mother? If an earthly Mother was admirable, why not an earthly Father?" Above all, she objected to the idea that Mary's motherhood of Jesus honored women as a sex. In her view, "a wise and virtuous son is more indebted to his mother than she is to him, and is honored only by reflecting her superior characteristics." These and similar complaints amply prepare Stanton's reader for her concluding observation that "Biblical mysteries and inconsistencies are a great strain on the credulity of the ordinary mind."[7]

Armed with a postmodern theory that insists upon the social construction of all religion, contemporary Catholic feminists are carrying Stanton's impatience with the Virgin Mother to new levels. They contend that Catholic moral theology, formulated by a misogynist male hierarchy, has used Mary to guarantee "the perpetuation of compulsory heterosexuality, the valorization of virginity, and the denigration of female sexuality."[8] Incensed by Pope John II's devotion to her, they insist that reverence for Mary as the virgin Mother of God imprisons women within the traditional feminine stereotypes of virginity or heterosexual marriage. The scope and intricacy of the attack exceeds my purposes here, although it should give Christians pause to see Jesus described as an "illegitimate child."[9] Indeed, the prevailing feminist attitude toward Christian doctrine is well captured in Uta Ranke-Heinemann's title, *Putting Away Childish Things: The Virgin Birth, the Empty Tomb, and Other Fairy-Tales You Don't Need to Believe to Have a Living Faith.*[10]

In underscoring the fundamental secularism of most feminist goals, I am passing no judgment on the inherent worthiness of the goals themselves.

Many of those goals, notably equal pay for equal work, are not merely admirable, but necessary as a matter of simple justice. Others may be open to civilized debate, but nonetheless reflect a serious attempt to permit women to move as freely in the world as men and equally with men to enjoy the fruits of their talents and labor. But the worthiness of the goals should not blind us to their single-minded focus upon the goods of this world and, beyond them, to the liberation of the individual woman from binding ties or obligations to others. This inherent feminist secularism obviously poses serious problems for Catholic women, all the more since most feminists have tended to be critical of Christianity and downright hostile to Catholicism. It is in this context that Rosemary Radford Ruether and Elisabeth Schüssler Fiorenza, both Catholic feminist theologians, have joined the attack on the purported oppression, patriarchalism, and male dominance that have deeply compromised Christianity.[11]

The many interlocking political and theological debates that pit feminists against Catholics and all orthodox Christians touch upon virtually every aspect of our society, culture, and faith. At their core, however, lies feminists' visceral hostility to Catholicism's male priesthood and opposition to abortion. Feminists see Catholic teaching on these and other matters as the negation of Catholicism's profession to honor the equal worth and dignity of women and men. Yet belief in the equal dignity of women and men lies at the heart of Catholicism. Catholicism has always insisted upon the freedom of each individual to follow or rebel against the Holy Spirit. Catholicism has always acknowledged the special dignity of women, the ideal of which is embodied by the Virgin Mary. Historically, these teachings coexisted with Catholicism's tacit or open acceptance of significant inequality between women and men. Recently, however, Catholic theologians, beginning with the Holy Father, have increasingly insisted upon the fundamental equality of women and men. Consider, for example, the words of Pope John Paul II in *On the Dignity and Vocation of Women:* "*both man and woman are human beings to an equal degree,* both are created in *God's image*" (22). Neither, however, can exist alone, but only "as a 'unity of the two,' and therefore *in relation to another human person.*" For both women and men, "being a person in the image and likeness of God also involves existing in a relationship, in relation to the other 'I'" (25).

The great twentieth-century theologian, Hans Urs von Balthasar, also insisted upon the exemplary quality of the feminine for all human beings. Insisting that the word for "answer" or "response" is feminine, he drew the lesson that "woman is essentially an answer [*Ant-wort*] in the most fundamental sense. . . ."[12] For "if man is the word that calls out, woman is the answer that comes to him at last" (254). Thus Balthasar wrestled with the

same problem that angers feminists today, namely, how can the idea of equality between women and men be reconciled with the idea of man's primacy? Unlike feminists, however, Balthasar refused to agree that the difference between men and women diminished women's dignity and importance. To the contrary, he insisted that "the word that calls out only attains fulfillment when it is understood, accepted and given back *as* a word." In his view, man's dependence upon woman thus confirms that "man can be primary and woman secondary" because "the primary remains unfulfilled without the secondary. The primary needs a partner of *equal rank and dignity* for its own fulfillment" (254).

Throughout the most compelling modern Catholic teachings on the nature and dignity of woman runs this emphasis upon a complementarity of women and men that in no way diminishes women's importance or standing. Indeed, if we follow Balthasar, man himself is "responsive" or feminine in relation to God. In this respect, it is tempting to argue that, as the answer that fulfills the word, women embody the exemplary human posture—that of receptivity or confirmation. None of this has satisfied feminists who persist in coveting the role of the word that is answered for themselves, presumably on the erroneous assumption that Catholics see a direct analogy between man and God and thus deify man in relation to woman. They do not, and we might do well to recall that the teachings of the Church consistently question—indeed, they defy—the deification of any human being. If pride constitutes the first of the capital (mortal) sins and humility the first of the capital virtues, how do we insist upon the equality of women and men in the world as the premier standard for Christianity?

Feminists would counter that their real object is to ensure the equality of women and men within the faith—their equal "personhood." Yet their equality of personhood has been there from the start. It is the equality of roles—of worldly authority, standing, and freedom—that is at issue. Neither Christianity in general, nor Catholicism in particular, has taught that standing in the world testifies to a person's worthiness. If anything, they have taught the contrary. The Catholic Church's recent teaching on abortion unmistakably focuses upon the intrinsic, spiritual value of the most impoverished and most vulnerable human life, which has been created in God's image, not upon women's condemnation to the status of second-class citizens.[13] The point of the prohibition against abortion is to protect human life, not to demean women. Women's bodies do bear children, which places women at special risk to live the direct consequences of the Church's teaching on life. Some might even hold God responsible for having given women such bodies, but the teaching on life bears no necessary relation to the Church's teaching on the value of women's personhood. Eve's

punishment for her part in the fall was not to bear children, but to bring them forth in pain.

At most, then, the Church implicitly acknowledges a difference between women, who can, and men, who cannot bear children. If anything, the Church celebrates women's ability to bear children as a reflection of Mary's having borne Jesus and thereby having redeemed Eve's trespass. And, given the unique position of Mary, Queen of Heaven, in Catholicism, it seems difficult to argue that a reverence for women's ability to bear children demeans and oppresses women in religion or theology. That women's unique ability in this regard may, in some way, make their worldly lives more difficult or complicated is an entirely different question. Yet Christian feminists turn naturally to that worldly standard to imagine what women's dignity as Christians requires.

Feminists, including many Catholic feminists, regularly attack the Vatican's general conservatism, specifically its teaching on women "in which women's role is circumscribed, which underscores women's difference from men, and which romanticizes and exalts women's 'special' purpose and duty." And although they sometimes concede that the Vatican claims to agree with feminists that the position of women must be improved, they deplore its wish to link that improvement to "women's 'unique nature' as mothers."[14] Above all, these feminists cannot abide the thought that anyone, especially the Pope, might claim that women differ in any way from men, that women have a "unique nature," and that women have any special responsibility or vocation to ensure the well-being of families.

The more outraged they become at official Catholic pronouncements on these questions, the clearer it becomes that they detest the very idea that the capacity for or experience of motherhood might in any way distinguish women from men. And they angrily condemn the Pope's claims in *Evangelium Vitae* that it depends upon women "to promote a new feminism which rejects the temptation of imitating models of 'male domination,'" and that "the experience of motherhood makes you acutely aware of the other person, and at the same time, confers on you a particular task."[15] In writing thus, the Pope was arguing that women occupy a unique place, in thought and action, in the work of transforming culture so that it supports life. Now if these words are cause for objection, we are entitled to ask why. Do pro-choice Catholic feminists deny that women have a special affinity for the support of life? Do they want women to embrace the male model of domination? And why should we regard a reluctance to support life and oppose domination as especially Christian—indeed, as Christian at all?

Increasingly, feminists seem to be insisting that women's equality with men requires that women be liberated from the consequences of their bodies,

notably the ability to bear children. It has become anathema in many feminist circles to suggest that women may have different tastes, proclivities, virtues, and vocations than men. Justice and equality require that women be able to do everything that men do, which means that their power and success in the world must not be compromised by the special, much less "unique," ties to children and the family. As more and more women have begun to compete directly with men in the world of work and politics, feminists have become increasingly reluctant to acknowledge any difference between women and men out of fear that the acknowledgment of difference might in some way compromise women's chances for success. Thus, they have declared war on the notion of sexual difference itself. For they know that should they agree that men and women differ they might have to agree that each sex has distinct responsibilities, and they cannot agree that anyone has the right to hold them to any responsibilities they do not freely assume.

Many Catholics, including Catholic women, have understandably reacted to the feminist attack on their faith by repudiating feminism entirely, but I do not believe that that is what the Holy Father is asking us to do. Rather, in reminding us of the abiding importance of women's special responsibility to families, especially children, he is inviting us to formulate a Catholic understanding of feminism's most generous goals. It is difficult to imagine a Catholic feminism that does not take account of children or that liberates women from any responsibility to them. Each day, our media offer new examples of the desperate condition of children who lack the love and security that a strong, two-parent family provides. And we all know that such families still depend heavily upon women, even if many fathers are doing more than in the past. Women do have a unique relation to the children they bear, and that relation should be understood as both a vocation and a sacred trust for which women should be honored, in the exercise of which they should be supported, and in which they themselves should take pride.

We also know that even the most devoted mothers cannot completely insulate their children against the outside world. We further know that today motherhood and family responsibilities do not normally take up all of the years of a woman's life. Above all, we should know that the world desperately needs the active participation of Catholic women. Motherhood may manifest an essential aspect of women's nature and, hence, shape many women's sense of their vocation. But as a specific social role—or set of tasks and responsibilities—motherhood rarely accounts for the entirety of any woman's, even a Catholic woman's, vocation. And well-educated Catholic women face very special responsibilities in this regard. First, the world, beginning with their own families, sorely needs their talents. Second, their

daughters and other women especially need them to develop and represent the dignity and vocation of women's combined action at home and in the world. Finally, the example they set and the values they advocate might powerfully influence our society's sense of an honorable and responsible feminism.

More than a generation ago, Edith Stein, Jewish convert to Catholicism, Discalced Carmelite, student of Husserl, philosopher, and teacher, reflected upon the role and vocation of women in the modern world. Above all, she reminded her readers that the contemporary roles of women—like those of men—reflect the fallen condition of all humans. Firmly defending women's opportunity to enter any profession they choose, Stein nonetheless insisted upon a difference between women and men, including men's leadership of and responsibility for women within families. Men, she noted, may be more likely than women to achieve that lordship over the world which was denied them by original sin, while women, for their part, may be more likely to nurture not merely their young but the earth. But, she cautions, a man's

> one-sided endeavor to achieve perfection easily becomes a decadent aspiration in itself; our desire for knowledge does not respect limits placed on it but rather seeks by force to go beyond these limits; human understanding may even fail to grasp that which is not essentially hidden from it because it refuses to submit itself to the law of things; rather, it seeks to master them in arbitrary fashion or permits the clarity of its spiritual vision to be clouded by desires and lusts.[16]

Stein did not, however, restrict women's roles to their family responsibilities. To the contrary, she insisted upon women's independent right to vocations in the world and, especially, to the intrinsic value of those vocations. But her enthusiasm about women's vocations did not change her belief that woman's nature differs from that of man in important ways. Many contemporary feminists choke on the notion that women are especially called to a life of service, presumably because they assume that service primarily means service to men. Some traditionalists, including some Catholics, have done their part to encourage this view by emphasizing women's responsibilities as dutiful and long-suffering wives and mothers at the expense of their pursuit of vocations beyond the family. Yet there are no grounds to believe that it is more appropriate for women than for men to bury their talents, just as there are no grounds to believe that families do not need the devotion of men as much as they need the devotion of women. The opportunities, pressures, and complexities of the modern world, as Stein insisted, challenge us to rethink the ways in which women and men meet their respective responsibilities—a rethinking that does not require that we view men and women as identical.

If feminism at its angriest depicts the world as dangerous to women's self-respect and ambition, it simultaneously suggests that a properly reconfigured world will promote women's happiness and fulfillment. Both visions have troublesome aspects. It remains unproven that the world is as uniformly hostile and detrimental to women as feminists contend. Indeed, key indicators like women's college attendance and their earnings suggest that we have seen dramatic improvement in a remarkably short span of time.[17] Furthermore, it remains unclear that these gains have dramatically increased women's satisfaction with their lives. My point emphatically is not to minimize the importance of these and other improvements in women's position, but rather to suggest that happiness and fulfillment do not necessarily follow from them. Happiness and fulfillment flow from our relations with other people and with God, and they may as often derive from self-denial as from self-promotion. A Catholic feminism must be flexible and capacious enough to encompass human and divine love and all of the constraints and rewards that both afford.

Notes

1. *Pope John Paul II on the Genius of Women* (Washington, D.C.: United States Catholic Conference, 1997), 22, passage from the Angelus Reflections, June 25, 1995.

2. Elizabeth Cady Stanton, "Declaration of Sentiments," in *The Concise History of Woman Suffrage: Selections from the Classic Works of Stanton, Anthony, Gage, and Harper,* ed. Mari Jo and Paul Buhle (Urbana: University of Illinois Press, 1978), 94–95.

3. Ibid., 95.

4. Ibid., 311. Elizabeth Cady Stanton and the Revising Committee, *The Woman's Bible,* Pts. I & II (Seattle: Coalition Task Force on Women and Religion, 1974; orig. ed. 1898).

5. Stanton, *The Woman's Bible,* I, 134.

6. Ibid., II, 113.

7. Ibid.

8. Maurice Hamington, *Hail Mary?: The Struggle for Ultimate Womanhood in Catholicism* (New York & London: Routledge, 1995), 74.

9. Jane Schaberg, *The Illegitimacy of Jesus: A Feminist Theological Interpretation of the Infancy Narratives* (New York: Crossroad, 1990).

10. Uta Ranke-Heinemann, *Putting Away Childish Things: The Virgin Birth, the Empty Tomb, and Other Fairy-Tales You Don't Need to Believe to Have a Living Faith* (San Francisco: Harper-San Francisco, 1994).

11. Rosemary Radford Ruether, *Disputed Questions: On Being a Christian* (Nashville: Abingdon, 1982); Elisabeth Schüssler Fiorenza, *Discipleship of Equals: A Critical Feminist Ekklesia-Logy of Liberation* (New York: Crossroad, 1993).

12. Hans Urs von Balthasar, *Theo-Drama: Theological Dramatic Theory* 3, 284–85, cited by Edward T. Oakes, *Patterns of Redemption: The Theology of Hans Urs von Balthasar* (New York: Continuum, 1994), 254.

13. Pope John Paul II, *The Gospel of Life* (Evangelium Vitae): *The Encyclical Letter on Abortion, Euthanasia, and the Death Penalty in Today's World* (New York: Random House, 1995).

14. "The Campaign for a Conservative Platform," *Conscience* XVI, no. 3 (Autumn 1995): 11. *Conscience* is the pro-choice Catholic journal edited by Rosemary Radford Ruether.

15. Ibid., 14, quoting *Evangelium Vitae.*

16. Edith Stein, *Woman,* trans. Freda Mary Oben (Washington, D.C.: ICS Publications, 1987), 70.

17. Elizabeth Fox-Genovese, *"Feminism Is Not the Story of My Life": How Today's Feminist Elite Has Lost Touch with the Real Concerns of Women* (New York: Doubleday/ Nan A. Talese, 1996), includes a full discussion of these issues.

Fourteen

Diversity and the Scholarly Task

Today, diversity enjoys quasi-sacred status in the academy, although the meaning of the term frequently appears maddeningly imprecise. Minimally, it evokes the varied national, ethnic, class, and racial backgrounds of the American population at the close of the twentieth century. But those who most fervently evoke it normally intend a good deal more. Above all, they intend a radical relativism that asks us to view the world through the prism of our own situation and experience, and to consider each person's view— or standpoint—as good as any other. Respect for diversity in this sense pre- supposes a moral egalitarianism that refuses to value one set of beliefs more highly than another and, by the same token, refuses to condemn any belief as morally suspect.

In theory, respect for diversity should enhance the study of religion both now and in the past. Today, in practice, it is frequently doing the opposite. Historically, scholars of religion, including believers of different faiths, have pioneered in scholarship that respected diversity. Religious studies helped to open the way to the study of different cultures, if only because religious texts offer accessible and visible manifestations of cultural difference. However paradoxical it may seem, such scholarship seems to have been at its richest and most successful during periods in which scholars were most securely and unapologetically grounded in their own faith, if only because a firm commit- ment to faith discourages fear of the faith of others.

Today's champions of diversity manifest no such tolerance, for their re- lativist and egalitarian principles deny the validity of a faith that accepts the truth of its teachings. The very notion of truth is inherently anti-egalitarian. Which of us has a right to try to tell others, who may view the world differ- ently, that some things are right and others wrong? As James Davison Hunter

"Diversity and the Scholarly Task," unpublished manuscript, from the papers of Elizabeth Fox-Genovese, currently in the possession of Eugene D. Genovese.

and his colleagues found in interviewing people for *Before the Shooting Begins,* even many Americans who oppose abortion resist condemning a woman who has an abortion on the grounds that they cannot judge her situation.[1] Sexual behavior of all kinds increasingly enjoys a similar tolerance, especially among academics, who are likely to insist that any form of desire must be respected as a matter of respect for the diversity of self-expression. This elision of realms represents a breathtaking chutzpah: Suddenly, forms of behavior, which may presumably be modified, are equated with natural attributes, which may never be completely shed. The flagrant blackmail culminates, as Lee Siegel has argued in *The New Republic,* in queer theory, which repudiates the very natural differences that respect for diversity was initially intended to shelter. Queer theorists, Siegel explains, "wish to dissolve the categories of sexual identity and, with them, the way in which society has invested sexual identity with moral value, endorsing some sexual identities and stigmatizing others. Queers are engaged in a vast theoretical project of breaking up fixed sexual identities into the fluidity of sexual acts or practices. Instead of whom you have sex with, queer theory is interested in how you obtain sexual pleasure."[2]

The relation of queer theory to the study of religion is tighter than many of us would like it to be. The theoretical project to break up fixed identities into the fluidity of acts or practices is cutting a broad swathe through religious studies programs and the study of religion throughout the humanities and social sciences. In an effort to divorce religion as a phenomenon from the truth it imparts, many postmodern or progressive scholars of religion are avoiding the content of religion and fixing their attention upon religion as performance. This strategy identifies religion as one social or cultural phenomenon among many, thereby effectively reducing its content to the status of mere epiphenomenon. I do not wish to slight the intrinsic interest and significance of phenomenological studies of religion. American religion, in particular, has typically witnessed a proliferation of denominations and sects, each with its distinct practices and forms of worship. Especially since the disestablishment of the late eighteenth and early nineteenth centuries, the character of a denomination may, as scholars have argued, vary considerably in response to the nature of its membership, which may include a preponderance of women or men, and which may be urban or rural, affluent or poor, or largely foreign born.

Patterns of seating in churches varied according to denomination, location, and date. Before the Civil War, some churches separated women and men, and most separated blacks and whites. If churches encouraged members to "buy" pews, seating would normally vary by social class. Some churches sponsored camp meetings and encouraged active response from

the congregation; others did not. Sociologists like Nancy Ammerman have studied specific churches to ascertain patterns of membership. Patterns of charitable activities, the role of women in decorating the church, the responsibilities of the minister's wife, the function of and participation in Sunday School have all received scholarly attention, which has deepened our understanding of the social and cultural function of specific churches and of religion in general. Historical, sociological, and anthropological studies enrich our appreciation of the place of religion in American life. Bold interpretations of patterns of religions belief, for example Ann Douglas' *The Feminization of American Culture,* prompt us to reflect upon secular changes in American religion as a whole.[3] This scholarship has attracted the talents of believers and non-believers alike, and it has enriched our understanding of American religion.

Even the most "objective" or "scientific" of these phenomenological studies, however, differs significantly from the recent studies inspired and informed by the imperatives of diversity. The older work, which might reasonably be called modernist in spirit and method, retained a basic respect for the distinct quality of religious belief. Modernist scholars, who frequently espoused an aggressive secularism, often treated religious faith as a dangerous enemy and even denounced it as mere superstition. But they never doubted that, however deluded, those who joined churches and propounded religious values did believe something. The new scholarly generation, which includes an appreciable cohort of postmodernists and proponents of cultural studies (frequently one and the same), is showing little patience with religious faith *per se*. Postmodernists and those I shall call culturalists tend to view most of the "world historical" religions with suspicion and subordinate the differences among them to the authoritarianism that unites them.

In this instance, pretenses to the contrary notwithstanding, rather than honoring diversity they deplore it. Alternatively, they mindlessly praise all non-western religions on the simple grounds of their non-westernism. In the measure that they do acknowledge diversity, they do so primarily as a way to vilify Christianity for its defense of truth and moral commandments. Their insistence upon the claims of Jews, Muslims, Hindus, and Buddhists becomes a way to displace Christianity as a central force in American culture. Respect for religious diversity thus becomes the weapon of choice against the lingering ghost of Christian faith. The diversity they refuse to countenance is that which would grant Christian faith equal standing with postmodern religious nihilism.

In this climate, it should come as no surprise that, in the name of diversity, postmodernist and culturalist scholars have embarked upon a radical retelling of American religious history, as announced in the tile of the recent

book, *Retelling U.S. Religious History*. In the book's introduction, Thomas Tweed, its editor, emphasizes the kinship between this effort and the work of social historians and feminist scholars who have dedicated themselves to giving voice to the voiceless. Tweed approvingly quotes the words of Lawrence Levine, a social historian: "To teach a history that excludes large areas of American culture and ignores the experiences of significant segments of the American people is to teach a history that fails to touch us, that fails to explain America to us or to anyone else."[4] Tweed himself insists that "the stories that fill history textbooks are important because they negotiate power and construct identity. They situate us in society and tell us who we are. Historical narratives often reflect, and shape, the social and economic order: individuals and groups excluded from narratives are excluded from more than stories. . . . There is always a great deal at stake for narrators and readers, always much to gain and lose in power and meaning."[5]

Tweed and his collaborators explicitly repudiate the idea of a meta-narrative of American religious life and substitute for it a collection of stories about specific groups and movements, which they group into two parts: 1) "Meaning and Power at Social Sites" and 2) "Contact and Exchange at Geographical Sites." The titles of the discrete chapters capture the spirit of the book as a whole and merit a moment's attention: "Sexuality in American Religious History"; "Ritual Sites in the Narrative of American Religion"; "Women's History *Is* American Religious History"; "The Illusion of Shifting Demand: Supply-Side Interpretations of American Religious History"; "Eastward Ho! American Religion from the Perspective of the Pacific Rim"; "Indians, Contact, and Colonialism in the Deep South: Themes for a Postcolonial History of American Religion"; "Voices from the Attic: The Canadian Border and the Writing of American Religious History"; and "Exchanging Selves, Exchanging Souls: Contact, Combination, and American Religious History." Concern for diversity demonstrably shapes the book's agenda, and the majority of the topics covered derive directly from the concerns of academic postmodernism and cultural studies, with a nod to postcolonial theory. A case could be made for the discrete interest of any of the topics, and one might argue that any comprehensive history of religion in the United States should take some account of them. But the idea that, even taken together, they can pass muster as a comprehensive history is preposterous.

Better even than the titles, the volume's index confirms the magnitude of the assault upon religion as a living faith. Jonathan Edwards receives one mention, Charles Finney receives two, Anne Hutchinson and Mary Baker Eddy (woman that they be) receive one apiece as does Cotton Mather, while Increase Mather is nowhere to be found. Few, I fear, will even notice the

absence of Charles Hodge and James Henley Thornwell, yet they indisputably ranked as the leading Presbyterian theologians of their day, which, given the absence of competition from other denominations, means the leading Protestant theologians in the country. Predictably, none of the longest entries directly concerns theology or ecclesiology, although sexuality, gender roles, women, Native Americans, and ritualization receive generous attention. Both African Americans and European Americans receive less attention than Native Americans, and the sub-headings under both entries have little to do with church membership or religious belief. European Americans especially merit attention for having been adopted into Indian tribes, for their disdain for Native Americans, for their diversity, ideological polarizations, racial ideology, and sexuality. The female religious majority of African Americans receives attention as do the association of African Americans with lynching and jazz, their relations with Native Americans, and the racial ranking of them.

Again, permit me to insist that the problem does not lie with the topics themselves, although honesty requires me to confess that my enthusiasm for most is at best lukewarm. The problem lies in anointing them as the main themes in the history of American religion. For better or worse, American religion was disproportionately shaped by white men of European origin, many, although by no means all, of whom came from comfortable if not affluent backgrounds. Theologians, ministers, educators, and evangelists— and a single man often combined two or more of these roles—disproportionately shaped the theology, ecclesiology, ritual, and moral prescriptions of American Protestantism. And American Protestantism decisively shaped the life, beliefs, and *mentalité* of the country as a whole. This recognition does not require that American religious history focus exclusively upon the clergy, but it does suggest that it would be rash, if not downright silly, to try to tell the story of American religion without them.

Recent theoretical and empirical work has opened new paths for the study of religion. For example, it is now foolhardy to attempt a comprehensive account of American religion, today or in the past, without serious attention to the role of women, not merely as members of churches, in which they have frequently outnumbered men, but as active participants in shaping the religious culture and, probably, even the theology of American churches. Although, in my judgment, sexuality does not rank as the determining force in American religion, there can be no doubt that the regulation of sexuality figured among the major dimensions of religious morality. Ironically, a broad comparative and historical perspective would demonstrate that moral concerns about sexuality did not distinguish American religion from other systems of belief.

The sexual morality of American religion, notably Christianity and, within Christianity, Protestantism, may have differed in its specifics from the sexual mores of other peoples, but it very much resembled them in viewing female sexuality as a matter of grave concern. This simple fact—and, *pace* the postmodernists, it is a fact—sheds important light on the charges of feminist scholars that Christianity has uniquely denigrated and constrained women's sexuality. If all, or virtually all, known societies have hedged in women's sexuality, especially that of marriageable virgins, then it is difficult to fault American Christians for having done the same. To the contrary, the universality of the tendency, at least until the very recent present, suggests that very diverse peoples have concurred that women's sexuality deserves or requires significant protection or containment. One interesting question concerns women's own feelings about prevailing Christian sexual morality. Committed feminists have produced most of the scholarship on women and religion, and they bring strong contemporary convictions to their work. Consequently, we may fairly ask whether the majority of eighteenth-, nineteenth-, and early twentieth-century women shared those convictions.

What we do know is that a significant number of American women, almost certainly a majority, considered themselves Christians, and many considered themselves devout Christians. Countless women turned to religion for consolation amid the travails of frequently difficult lives and for a standard for their own worthiness. Many women viewed their lives as a journey in the manner of *Pilgrim's Progress,* and many Southern slaveholding women structured their private journals around the Sabbath. Their private writings abound with references to the quality of preaching, the texts of sermons, and their own spiritual reading. It is tempting to believe that many women's visceral rejection of the doctrine of infant baptism directly or indirectly contributed to the liberalization of Protestant theology on that question. Many discriminated sharply between true piety and what they called "fashionable" religion, which they judged purely a matter of external show. Regularly confronting the risk of death in childbirth, women had reason to take divine judgment and salvation seriously, and most viewed the omnipresent risk of death as grounds to hold themselves to the highest standards of religious fidelity.

Contemporary feminist scholars scan the records of women's religious experience for evidence of bitterness and rebellion, but the evidence is scarce, although here and there an Elizabeth Cady Stanton deplored male religion's propensity to cast women as lesser moral beings than men and vehemently protested the role allotted to the Virgin Mary. And Stanton launched her attack on religion late in her career after the disappointment of the Reconstruction Amendment, and after secularism had begun to capture

the bastions of intellectual life. Stanton's career, like that of many other woman's rights activists, began in the abolition movement. By the middle third of the nineteenth century, a small group of women were beginning to protest the curtailment of women's rights as fully independent beings, but few even of this group extended their protest to religion. Indeed, after the Civil War, as women's consciousness of their distinct interests grew, many of their largest and most successful movements, notably the Woman's Christian Temperance Union, remained closely bound to their religious commitments.

Women did not remain immune to the currents of secularism that were percolating throughout American society, but surprisingly few of them were prepared to repudiate religion entirely. Throughout the nineteenth century, women's preponderance among church members continued to grow with the result that religion appeared increasingly a female preserve. Consequently, scholars who claim to respect women's historical contributions would do well to attempt to understand their faith before deconstructing it or dismissing it. The evidence strongly suggests that women deserve considerable credit for the vitality of American religion and for struggling to hold men to its precepts during a period in which growing numbers of European men were falling away. The interesting question thus becomes what did women seek and find in religion that kept them faithful to it? The possible answers are numerous and complex and many of them assuredly intertwine with a variety of social factors. But social factors do not exhaust the reasons for women's persisting faith, nor can that faith be reduced to a mere articulation of social concerns.

Today, no study of religion can afford to ignore women, who have often constituted a majority of believers, and attention to women's religious experience has figured prominently among the demands of those who enjoin us to take account of diversity. Similarly, no study of religion can afford to ignore African Americans, who, until very recently, have also displayed a deep attachment to it. Even more than women, African Americans have developed a unique understanding of Christianity, which, under slavery, they combined with strands of their African traditions. In these instances and others, attention to diversity does encourage us to revise and deepen our understanding of American religion and to attend more carefully to its syncretic elements. Attention to diversity also invites us to broaden our theoretical perspective in an effort to explain the relations of various groups to the dominant Protestant tradition. But no matter how much importance we ascribe to diversity and how much the recognition of diversity leads us to modify that dominant story, we cannot afford to jettison it in favor of a congeries of discrete sub-plots.

Many today worry that the claims of diversity have made it impossible to understand and present religion in the United States as a single story. According to this reasoning, the religious experience of different groups has diverged so widely from the central tradition as to call the explanatory value of that tradition into question. But the real challenge thrown by the proponents of diversity lies elsewhere. For the ultimate goal of the postmodernists and culturalists is not simply to recapture the varieties of religious experience, but thoroughly to discredit the dominant religious tradition. Deeming that tradition oppressive to its core, they project their struggles against it in the present onto the past. The deadly core of their attack lies in the determination to dissolve religion into the general category of ideology. By arguing that religion can only be understood as an articulation of individual experience, they deny its claim to embody a truth that transcends the varieties of individual experience. This move strips religion of its power to draw people together across the lines of class, race, ethnicity, and sex. But to complete the destruction of religion in the present, the postmodernists and culturalists must establish that its claims to universality have always been fallacious.

It is no accident that the claims of diversity have called into question the possibility of telling the story of American religion as a whole. The possibility of telling that story depends upon some respect for the nature of religion as a distinct sphere—as a system of belief or a body of truth that cannot readily be reduced to the social, material, or ideological realm. It further depends upon the acknowledgment that the United States has had a dominant religious tradition and that, even amidst the decomposition and discrediting of that tradition, its traces persist. Here, I propose to make a few brief suggestions about the ways in which we might still tell a coherent, if complex, story of religion in the United States, and, in so doing, I shall follow the model established by Mark Noll in *The Scandal of the Evangelical Mind*. But any attempt to sketch such a story must begin with the recognition that in the United States, Protestant Christianity has figured as the dominant religious tradition and has so decisively contributed to the shaping of American institutions that it continues to enjoy a hegemonic, if bitterly contested, status.

Noll argues that until the Civil War, Evangelical Protestantism dominated the spiritual and intellectual life of the country, notably through its predominance in educational institutions at all levels. Notwithstanding considerable change and internal development from the early days of settlement and the establishment of the Puritan ascendancy until the ferment of the years before the Civil War, Evangelical Protestantism manifested a vigorous spiritual and intellectual vitality that exercised impressive influence on the development of American institutions and political life as well as upon

American intellectual life. After the Civil War, however, Protestants began to lose their hold on schools and colleges, and the new graduate schools, which increasingly set the pace for intellectual work, developed entirely under secular leadership. By the end of the nineteenth century, Evangelicals were on the defensive, and the growing religious diversity that resulted from the massive immigration of 1890–1910 further weakened their hegemony. Under these conditions, Evangelicals increasingly fell back on fundamentalism, bunkering in to resist the onslaught of modernity.*

Throughout the twentieth century, religious pluralism has continued to challenge Protestant hegemony, but one may reasonably argue that it has never been the main threat. Notwithstanding differences of doctrine and ecclesiology, people of different faiths were more likely than not to agree about social and moral norms, notably with respect to the roles of women and men and the sanctity of the family. Attitudes toward sexuality did not so much separate believers of whatever faith as unite them. The more important threat came from the rising tide of secularism, and it was all the more deadly for having established its most important beachhead within the liberal Protestant churches themselves.

Secularism's intrusion into American religion began early, some might argue as early as the half-way covenant. And we know that throngs of eighteenth-century Americans lived out their lives unchurched—without benefit of God or creed as Jim Turner would have it.† But their experience probably had more to do with the unsettled conditions of their society than with a clear choice of unbelief. In any event, they provided fertile ground for the two Great Awakenings and the lesser waves of evangelization. The more important source of unbelief arose within the Northern churches, and its carrier was the growing premium placed on the dictates of individual conscience, notably in the debates over slavery and abolition. Willy-nilly, dedication to the abolition of slavery led some Christians to bring religion before the bar of worldly standards and to demand that divine interventions comply with their individual sense of right and wrong.

Notwithstanding the righteousness of the abolitionists' cause, their stance inaugurated a growing tendency to view religion in individualist and ultimately instrumentalist terms. The Evangelicals' retreat into fundamentalism exacerbated rather than eased the problem. For in retreating from

*Mark Noll, *The Scandal of the Evangelical Mind* (Grand Rapids. Mich.: Eerdmans, 1994).

†James Turner, *Without God, Without Creed: The Origins of Unbelief in America* (Baltimore: Johns Hopkins University Press, 1999).

engagement with the intellectual currents of their day, the Evangelicals virtually condemned orthodox Christianity to reaction and intellectual sterility. Doubtless, the defensive anti-intellectualism of orthodox Christians facilitated the secularists' campaign to marginalize them, but the Evangelicals do not bear sole responsibility for the widening gulf between faith and reason. Wherever the responsibility lies, the loss was great.

The modern identity politics that fuels so much of the current preoccupation with diversity descends directly from the abolitionist insistence upon an extreme interpretation of the right of private judgment. Thus, however paradoxical it may seem, American preoccupation with diversity also descends directly from a certain tendency within American Protestantism. In this perspective the insistence upon the claims of diversity embodies a specifically Western and arguably Protestant sensibility rather than a universal norm or value. The parochialism of diversity as an intellectual and moral value does not invalidate it, but does invite us to look closely at its premises and goals. In its more generous forms, diversity roughly resembles the Christian imperative to love one's neighbor as oneself and echoes the universalism that distinguished Christianity from the start.

To look at the claims of diversity in this fashion may help to suggest a strategy for teaching and studying American religion. And here, the work of Mikhail Bakhtin proves especially suggestive. Bakhtin's emphasis upon the dialogic character of culture helps us to understand American religion as a continuing and expanding interchange or conversation. From the start, Protestant Christianity has enjoyed a dominant or hegemonic position, but it has persisted, grown, and changed in interaction with other religious traditions and its intersections with them have mediated the interactions among them. This focus permits us to understand American religion as one story, albeit a story with many characters and subplots. If we relinquish the ideal of a single story, we are left with the Tower of Babel, which may well be the postmodernists' goal. But if it is, it reflects a larger goal—namely to reduce religion to one among many manifestations of ideology. And this view of religion, if realized, would represent the ultimate triumph of secularization: the destruction of religion as a distinct and irreducible force, the destruction of the ideal of truth and the rejection of the truth of faith as itself a form of knowledge—men and women's ultimate deification of themselves. The danger of diversity lies in the solipsistic isolation of Babel; its promise lies in the mutual comprehension of Pentecost—under the guidance of the Holy Spirit.

Notes

1. James Davison Hunter, *Before the Shooting Begins: Searching for Democracy in America's Culture Wars* (New York: Basic Books, 1991).

2. Lee Siegel, "The Gay Science: Queer Theory, Literature, and the Sexualization of Everything," *New Republic,* November 9, 1998, 32.

3. Ann Douglas, *The Feminization of American Culture* (New York: Knopf, 1977).

4. Lawrence W. Levine, "Clio, Canons, and Culture," *Journal of American History* 80 (December 1993): 867, quoted in *Retelling U.S. Religious History,* ed. Thomas A. Tweed (Berkeley: University of California Press, 1997), 3.

5. Thomas A. Tweed, introduction to *Retelling U.S. Religious History,* 2.

Fifteen

Historical Perspectives on the Human Person

> What is man that thou art mindful of him?
> And the son of man that thou visitest him?
> For thou has made him a little lower than the angels,
> and thou has crowned him with glory and honour.
>
> *Psalm 8:4–5*

Contemporary Western society—the most materially advanced in the history of the world—stands alone and without precedent in the high value it attributes to the individual person. Simultaneously, it stands exposed for the cheapness in which it holds human life. Individual rights, human rights, self-esteem, and related concepts dominate our culture's sense of the good that must at all costs be defended. Yet unborn babies, terminally ill patients, or those who simply "dis" others in the street are deemed expendable. Some lives embody the essence of all that is admirable and worthy; others are to be brushed aside as mere encumbrances. What remains to be explained is who gets to decide which lives deserve respect and protection and which do not. Which of us has a right to decide which lives are worth living?

The well-known passage from the eighth Psalm with which I began reminds us of the unique place the human person enjoys in creation, delicately poised between God, whom we are made to serve, and other living creatures—animals, fish, and birds—over whom God has granted

us dominion. Contemporary culture, certainly in the United States and Europe, readily embraces the idea of man's dominion, but it shows markedly less enthusiasm for the idea that we rank lower in the hierarchy of merit than the angels and God. Our age has lost the Psalmist's marvel at the unique blessings that God has showered upon us, preferring to assume that they are ours by right or by our own merit. Our complacency and self-satisfaction constitute the very essence of the culture of death against which the Holy Father warns us, for our boundless self-absorption blinds us to the value of others.

Caught in a dangerous paradox, our age simultaneously celebrates the unique value of human life and, however inadvertently, dismisses it as of no consequence. The life we are told to value is our own, and the more highly we value it the more easily we are tempted to discount the value of the lives of others. Preoccupation with self at the expense of the other is nothing new: Cain established the model at the dawn of time. But our culture is breaking new ground in its attempt to establish selfishness as a higher principle, swathed in words like *choice* and *fulfillment* and *autonomy.*

In historical perspective, fixation upon the rights and unique value of the individual is something new. Until very recently, societies, including the most sophisticated societies of the Western world, have primarily regarded individual persons as members—and often as representatives—of groups, notably as members of families, but also of clans, tribes, social castes or estates, religious orders, or various trades or professions. The preferred forms of classification have varied, but the prevailing principle has held firm. A human person has been understood as someone's daughter, father, wife, or cousin—one link in a kinship that defines all of its members.

Christianity's insistence that God loves each individual broke radically with these patterns. Christianity affirmed the value of each particular person independent of ethnicity or sex or social standing, pronouncing, in the words of St. Paul, that "There is neither Jew nor Greek, there is neither bond nor free, there is neither male nor female: for ye are all one in Christ Jesus." (*Galatians* 3:28.) More, in affirming the value of each, Christianity also affirmed the value of all. In other words, Christianity viewed the human person as both particular and embodied and as universal. The parable of the Good Samaritan was intended to teach Jesus' followers that the command to treat others with charity extended beyond the members of one's own ethnic group.

In Christian perspective, it was not possible truly to value any single person without valuing all persons or to value all persons (humanity) without valuing each single person. In both respects, Christianity broke with the tribalism of Ancient Israel and of much of the rest of the world, establishing

new standards for the freedom each person should enjoy and for equality among persons. Christians did not, however, immediately attempt to impose their standards of spiritual dignity and spiritual equality upon relations among persons in the world. Over time, Christianity powerfully influenced the character of Western culture and even political life, but it owed much of its success to its remarkable ability to adapt to prevailing institutions and relations.

Only with the birth of modernism, notably in the dangerous—if widely celebrated—*cogito ergo sum* of René Descartes, did the disembedding of the individual person from the collectivity that grounded his identity begin to be viewed as a positive good. And only with the Enlightenment and the great eighteenth-century revolutions, notably the French Revolution of 1789, did the ideal of individual freedom attain preeminence over all forms of dependence and connection. In the waning years of the eighteenth century a political and intellectual vanguard proclaimed freedom the absolute antithesis of slavery and promulgated an understanding of freedom that favored the severing of all binding ties among human beings. Freedom in this lexicon means autonomy, self-determination, and independence from binding obligations, and this is the idea of freedom that has triumphed in our own time. Significantly, it originated as a radically secular idea, one frequently launched as a direct challenge to God. At the extreme, its consequences have been disastrous, but its most chilling implications may yet lie ahead. For it is the pursuit of this ideal of freedom that has brought us sexual liberation, abortion, assisted suicide, and an entire battery of assaults upon human life.

Before focusing upon the ways in which the radical pursuit of freedom has cheapened the value of the human person, however, it is necessary to acknowledge its many benefits. For the pursuit of human freedom has heightened the dignity and improved the lives of countless persons throughout the globe. The same history that has brought us the progressive discrediting of ties among persons has promoted a remarkable improvement in our understanding of the intrinsic value and dignity of each person. During recent centuries in many parts of the world, we have witnessed the abolition of slavery, an improvement in the position of women, greater attention to the discrete needs of children, respect for the needs and dignity of those who suffer from various handicaps, and more. As Pope John Paul II has emphasized, these gains are not trivial, and on no account must we countenance their reversal. The puzzle remains that they have been accompanied by—and many would argue have depended upon—a hardening of attitudes towards the intrinsic value of all human persons and, especially, towards the binding ties among persons.

These two tendencies confront us with a paradox. On the one hand, we have a decreasing respect for the bonds among persons, and on the other an increasing commitment to the value and rights of previously oppressed groups of persons. On the one hand we have an inflated concern for the rights and sensibilities of the individual, on the other a callous disregard for any life that, in any way, inconveniences us. This paradox challenges us to rethink our understanding of the human person, and especially the nature of the freedom and rights to which each of us is entitled. A misguided understanding of freedom will inescapably shape our understanding of the claims of life. Presumably, if one values human life, one opposes its willful termination, especially in its most vulnerable forms. Yet many of those who claim to value human life view abortion, assisted suicide, and even infanticide as necessary to its defense. For only the right to secure liberation from unwanted obligations protects the individual's freedom, which many view as the essence of any life worth living.

There is nothing surprising in the inclination to celebrate freedom as freedom from rather than freedom for, with the "from" understood as oppression and the "for" understood as service. Throughout history, the majority of labor has been unfree and the majority of women have been subordinated to men—initially their fathers or uncles and, later in life, their husbands or brothers. The Old Testament and Classical literature both abound with examples. Agamemnon sacrificed his daughter, Iphigenia, to further his prospects for victory in the war against Troy. Until recent times, Hindus in India practiced suttee whereby a widow was burned upon her husband's funeral pyre. Even in England, the sale of wives, although increasingly rare, persisted into the nineteenth century. Similarly, serfdom and slavery persisted throughout the world well into the nineteenth century and may still be found in some places today.

Under conditions in which even upper-class women rarely owned property in their own names and poor women might be beaten or bullied at will, it is not surprising that the early proponents of woman's rights embraced the analogy of slavery to describe their own condition and spoke of breaking the chains of their bondage. In practice, the women who were most likely to protest women's condition were from the urban middle class and sought to enjoy the same advantages of education and professional careers as their brothers. Such women normally benefited from codes of middle-class gentility and did not suffer from the horrors of abuse, sexual slavery, oppression, denigration, and desertion that plagued less privileged women—although some did. But they readily depicted their lot as indistinguishable from that of their less fortunate sisters. By the early twentieth century, the more radical were beginning to argue that marriage and childbearing were the true

seedbeds of women's oppression, and to lobby for expanded legalization of divorce and artificial contraception.

Throughout these and related efforts, feminists continued to describe their goal as freedom from bondage and to claim their right to be regarded and treated as full human persons. Most people initially responded to the women's movement with hostility or incredulity, but few, even among opponents, claimed that women did not count as full human persons. They simply insisted that they were very different persons than men and, consequently, in need of a different social situation. The conviction that women and men, although both fully human persons, differed by nature persisted well into the twentieth century. Doctors argued that women's bodies made them unfit for college, psychologists argued that women had a distinct criminal disposition, lawyers argued that women should not be admitted to the bar, countless people argued that women should not vote, and virtually everyone assumed they should not engage in armed combat. Yet within the comparatively brief span of a century or so, feminists began to convince growing numbers of people of the justice of their cause, and, in so doing, to convince many that the natural differences between women and men had been vastly exaggerated.

We would be rash to minimize the magnitude of their extraordinary rhetorical victory, which significantly expanded the meaning of individual freedom and ultimately resulted in a reconfiguration of the moral landscape. By rhetorically extending the absolute opposition between freedom and slavery to the condition of women, feminists had declared any limitation upon a woman's freedom—including those imposed by her own body—as illegitimate. The campaigns against slavery and the subordination of women both embodied a worthy—indeed necessary—commitment to increasing the dignity accorded to all human persons and the equality among them. Both, in other words, represented what we may reasonably view as moral progress. Yet both tacitly embraced the flawed premise that to be authentic, freedom must be unlimited, or better, unconditional, which, by a sleight of hand, reduced the ties among persons to another form of bondage.

Throughout the modern period, material change has undergirded and, arguably, accelerated changing attitudes towards the human person. Modern urban societies provide many more possibilities than traditional rural societies for people to live alone. In rural society the interdependence of persons constitutes the very fabric of life, and none can survive without mutual cooperation. Typically, rural societies also favor a clear articulation of authority whereby one member of the family or group assumes primary responsibility for and direction of the rest. Typically, that person has been the male head of a household, family, or tribe. What modern critics are loath

to understand is that rarely—if ever—could such a head exercise his authority without the tacit or active collaboration of those over whom he presides.

We should, nonetheless, err in romanticizing traditional societies, although many find it tempting to do so. These were worlds in which life for many could often be "nasty, brutish, and short." They were worlds in which cruelty among persons abounded and in which death stalked young and old alike. Not for nothing did the Palestine of Jesus' time abound with cripples and lepers, hemorrhaging women and desperately ill children. Population has increased in the modern world because modern medicine has done so much to control disease and defer death, more than because of an increase in the number of births. The prevalence of disease and the likelihood of early death have led many traditional rural societies to value highly women's fertility and the birth of children. Here too, however, romanticization misleads, for even groups that welcome births might turn around and kill infants they could not support. Traditional societies, even when Christian, did not necessarily manifest "respect for life" in the sense we use the phrase today. They did, however, know that their agricultural and military survival depended upon sustaining their population or increasing it.

These traditional rural worlds did not ordinarily celebrate the unique attributes of each person as we are wont to do today, but they did value each person as an essential member of the family, household, or community. No family could function for long without a mother or appropriate female substitute, typically a maiden aunt, and widowers with small children were normally quick to remarry. Similarly, it could not function for long without a strong senior male who, with or without assistance, could bring in crops, care for livestock, and defend against predators. Personal autonomy did not figure as the *summum bonum* among rural folk for whom interdependence provided the best guarantee of family or community survival. Modern critics of those bonds frequently focus upon the injustice of specific forms of subordination: slave to master, wife to husband, children to parents. But in repudiating the injustice of women's subordination to men, for example, they end by attacking all binding ties as obstacles to women's liberation, not just specific abuses, which cry out for uncompromising repudiation. The reasoning seems to be that binding ties have always disadvantaged women and that abuse is the rule rather than the exception.

The acceleration of economic progress transformed the rural world, mainly by moving the economic center of gravity to cities, which offered new possibilities for people to live in smaller groups or even on their own. Drawing ever larger numbers of people into wage labor, capitalism insinuated itself into the interstices of families and households, reinforcing the culture's growing tendency to encourage members to see themselves as individuals.

Capitalism's dependence upon an accelerating consumption of material goods furthered the cultural emphasis upon the psychological goods of autonomy, satisfaction of desire, and instant gratification. Secular psychology contributed mightily to the transformation of "I want" from evidence of selfishness or greed to a sign of mental health. In the same spirit, it declared war on the idea of sin, which it denounced as nothing more than a sadistic campaign to thwart people's enjoyment of life. Multinational corporations have powerfully supported, and indeed, advanced these tendencies, for their interests do not benefit from stable families, but rather from a large pool of unencumbered employees, who are prepared to live with their cell phones always turned on and a suitcase always packed.

Some modern scholars have delighted in exposing the ways in which traditional societies held persons in thrall to repressive norms, primarily fostered by punitive, misogynist, patriarchal, and hierarchical forms of Christianity—especially Catholicism. Others have tended to romanticize folk and working-class cultures, presenting them as more spontaneous and less repressed than the middle-class culture of the modern urban world. Both views contain a measure of truth and a measure of falsehood. But both, however inadvertently, suggest a greater emphasis upon the bonds among persons than commonly prevails today. Whether one views the traditional world as good or bad—or, more plausibly, a mixture of both—it was a world in which people developed a sense of themselves as persons as a function of their relations with others, often beginning with their relation to God. Nor were these attitudes unique to Christians. In different versions, they prevailed among Jews, Muslims, Hindus, and Confucians, as well as among adherents to various forms of polytheism, animism, and other systems of belief.

Here, I do not wish to engage in debates about the deeper character of the various faiths but simply to underscore that all have shared a sense that the individual could only prosper in union with the group. These were faiths that viewed the human person as an integral part of a larger group whose needs would take precedence over the specific person's whims and desires—faiths that promoted unambiguous messages about good and bad, that attributed little importance to individual subjectivity, and that had little interest in progress. Like all others, traditional oral cultures do change, but as they lack written records, they do not register change but rather absorb it into "the way things have always been." Modern secular cultures, in sharp contrast, focus upon the dynamism of change and the superiority of the "new."

Traditional societies' conservatism with respect to the rights and independence of the individual, like their strong commitment to holding persons to prescribed social and familial roles, represented above all a commitment

to the survival and internal coherence of the family or community. In this spirit, they rejected individual judgment as an appropriate guide for behavior, not least because they fully recognized the disruptive power of individual passions, notably anger and desire. Saint Paul said it clearly in *Galatians* (5:13–15): "For you have been called to liberty, brethren; only do not use liberty as an occasion for sensuality, but by charity serve one another. For the whole law is fulfilled in one word: Thou shalt love they neighbor as thyself. But if you bite and devour one another, take heed or you will be consumed by one another." Mindful of the dangers of strife within families and among neighbors, traditional societies might enforce their convictions through methods that seem repressive or even brutal today. Even the more rigid, however, did not often rely upon the extreme measures that some contemporary groups have been known to use, such as killing girls who try to attend school. Today's extremes, as Bernard Lewis, the great authority on Islam, has argued, primarily embody a panicky reaction against what are perceived as the excesses of the disintegration and decadence of contemporary Western society.

Those who fear the destructive potential of Western cultures do not err. It is child's play to muster examples of rampant consumerism and what Karl Marx called the fetishism of commodities, which today seems to be degenerating into the commodification of personal relations. Even the most casual acquaintance with American media—especially television—reveals a world that has all but dehumanized persons by severing the binding connections among them. For all the talk of the warmth and support of substitute, alternate, or proxy families, American culture depicts a world in which family represents no more than a person's current choice, which may easily be replaced by another choice. We have never lacked for critics of the symptoms of this culture of easy-come, easy-go, and recent years may even have seen an increase in the defense of marriage, attacks upon the harm that divorce wreaks upon children, and defense of the value of modesty and premarital chastity. We have dedicated groups and individuals who oppose abortion and so-called assisted suicide, and we are apparently seeing an appreciable increase in the number of Americans who have doubts about the desirability of legal abortion, especially after the first trimester. What we lack—and the lack is devastating—is an insistent, concerted counter-offensive. We lack it because more often than not even those who oppose many specific forms of social decomposition accept the main premise that underlies them all, namely the primacy of the convenience and comfort of the individual.

Recently, I had the opportunity to speak with a group of faithful Catholic women, many of whom attend daily Mass, all of whom rightly consider themselves devout. Blessed with considerable material comfort, they

have all given generously to the parish for decades, and would all consider themselves loyal supporters of the Church. During my talk, I mentioned my growing horror at abortion as one of the important elements in my own conversion to Catholicism. When we broke into informal conversation over lunch, one of the women drew me aside because she wanted me to know that notwithstanding her respect for the teachings of the Magisterium, if she had a thirteen-year-old daughter who was impregnated during a rape, she would whisk her off to an abortionist before you could say "boo." Startled, I responded, "And what if she were twenty-three and finishing law school?" She looked startled and suddenly abashed.

An intelligent woman, my acquaintance readily understood my point that, with each passing day, we Catholics seem to be finding it easier to acquiesce in the logic of the secular world. The results are disastrous for our understanding of the human person and our ability to sustain binding relations with others. We have too readily acquiesced in the secular view of the human person as, above all, an individual who is fundamentally disconnected from other individuals. The disconnected individual may enter into relations with others, but the relations remain contractual, subject to termination at the choice of either party. Such instrumental relations are bad enough for adults, but they are disastrous for children, not to mention the handicapped, the unborn, and the terminally ill. More, they are in direct contradiction to the teachings and spirit of our faith. For how are we to understand Jesus' repeated commands that we love one another as ourselves, if not as a command to recognize that our own personhood depends upon our recognition of the other? In this sense, the modern era has not merely transformed the idea of the person, it has effectively abandoned it in favor of the subjective individual.

The irony of our situation is painful. In historical perspective, we appear to place a higher value on the individual—as an individual—than any previous society, yet we increasingly view the individual as essentially a subjective being whose will and desires should determine what he or she is due. Only in this spirit would it be so easy to present an unborn baby—and, for some people, one that has been born as well—as nothing more than an obstacle to its mother's freedom to pursue the goals she has chosen. Rather than emphasizing the mother's obligation to the human life she is carrying, our culture increasingly insists upon her right to be free of it. The mother's right to choose thus negates the unborn child's right to live, and by claiming this right to deny the personhood of another, the mother negates her own. No longer a person whose being, sense of self, and place in the world depend upon her relations with others, beginning with her primary relation with

God, the woman becomes an isolated individual, disconnected from others whom she can see only as objects to be manipulated or obstacles to be cleared away.

Christianity led the way in promoting a view of each person as valuable, unique, beloved, and endowed with freedom. Yet Christianity also presupposed that each person derived meaning from relations with others—that the very essence of personhood lay in the recognition of the equal personhood of the other. Thus, the Christian ideals of the value and freedom of each individual coexisted comfortably with a culture that placed a much higher value on the group than the individual, who was primarily understood as a member of the group. The Reformation placed a new emphasis on the individual, but Luther, Calvin, and their heirs remained tied to a communal ethos. Their doctrine of *Sola Scriptura,* however, opened the way for a disastrous slide into a rising secular bourgeois individualism that, in our time, has largely overwhelmed the protestant Churches and—let us admit frankly—is now threatening our own. For as individualism gradually triumphed over the collective values of traditional culture, it did so in radically secular terms and usually in direct rebellion against the Church.

This history has left us a dangerous and insidious legacy, for the individualism that spearheaded a broad cultural revolt against the teachings of the Church also insinuated itself into the thinking of Christians, including Catholics. The goods that individualism purported to offer are almost irresistibly seductive: tolerance of the behavior of others; delight in bodies and sexuality; acceptance of oneself, complete with flaws; the legitimacy of desire; and on and on. Consequently, any attempt to oppose or criticize them seems ungenerous, judgmental, and intolerant. Who am I to tell another how to live his or her life? What gives me the right to impose punitive values upon another?

In *Writings on an Ethical Life,* Peter Singer reaffirms his argument that "the life of a fetus . . . is of no greater value than the life of a non-human animal at a similar level of rationality, self-consciousness, awareness, capacity to feel, etc., and that since no fetus is a person, no fetus has the same claim to life as a person." This reasoning, Singer continues, necessarily applies "to the newborn baby as much as to the fetus." Thus, if we but free ourselves from the "emotionally moving but strictly irrelevant aspects of the killing of a baby, we can see that the grounds for not killing persons do not apply to newborn infants."[1]

Singer's chilling perspective exposes the ultimate logic of the emphasis upon the individual's right to choose, for in Singer's world, the individual may first decide what counts as life before deciding between life and death.

By this sinister logic, the choices of rational individuals may never be judged evil, for they are always choosing life as they define it. Thus does our purported and seductive solicitude for the freedom of each individual mask the ominous tendency in our Western societies to objectify the very individuals we pretend to celebrate. Substituting rights for mutual bonds, we are substituting the individual for the human person, thereby freeing ourselves to deny the humanity of others. Thus does the slaughter of the innocents become "a woman's right to choose."

Note

1. Quoted in *Presbyterians Pro-Life News* (Fall 2000): 3; PresProLife@compuserve.com.

Sixteen

Deadly Choice

Abortion as a War against Women

During the weeks leading up to the thirtieth anniversary of *Roe v. Wade,* there seemed to have been more news and commentary about abortion than there had been for years. The anniversary always elicits a flurry of opinion, but 2003 was different, and not only because of the significance of the anniversary. For one thing, in George Bush we have a president who is not merely pro-life for reasons of political discipline or expediency but, as far as one can tell, for reasons of personal conviction—and faith. For another, Republican majorities, however slim, prevail in both the House and the Senate, and we will likely see one or more vacancies on the Supreme Court, not to mention other federal courts throughout the nation.

This new political configuration has emerged at a moment when one major piece of pro-life legislation (the Born-Alive Infants Protection Act) has been enacted, and other important bills are pending before Congress: the Partial-Birth Abortion Ban Act (twice vetoed by President Clinton, and more recently stalled by Senator Daschle), the Unborn Victims of Violence Act, the Child Custody Protection Act, the RU-486 Patient Health and Safety Protection Act, and the Abortion Non-Discrimination Act. Notwithstanding the cries of panic and outrage from the pro-abortion forces—even the typically supercilious *New York Times* published a hysterical editorial on the demise of legal abortion—none of these bills will threaten the core of *Roe v. Wade,* although several undermine its logic. Presumably, the hyperbole of the pro-abortion forces derives in part from their fear of the slippery

"Deadly Choice: Abortion as a War against Women." *Touchstone: A Journal of Mere Christianity* 16 (September 2003): 36–41. Copyright 2003 by the Fellowship of St. James. All rights reserved. Used by permission of the Fellowship of St. James.

slope: If you diminish any aspect of unrestricted access to abortion, you open the door to its re-criminalization. But only in part.

The majority of Americans could live comfortably with the modest restrictions on abortion proposed in the bills now before Congress. Until recently, most apparently had only a vague impression of *Roe*'s provisions and assumed that it permitted first-trimester abortions but little more, except in the case of exceptional circumstances: rape, incest, or threat to the life of the mother. The pro-abortion lobby encouraged its supporters in their illusions, beginning with the claim that it was only defending a woman's right "to choose."

Several developments of the last few years have nonetheless jeopardized that cultivated ignorance. The debates over partial-birth abortion have highlighted abortion's brutality and the possibility of performing it on viable, healthy babies. On the other side, the growing sophistication and use of sonography and fetoscopy have introduced innumerable couples to the human form of babies in the earliest stages of development. A mother who has seen a photograph of her "child" is less likely to turn to abortion than one who believes she is only carrying a bit of unformed tissue. In addition, a recent study shows that only five out of one hundred obstetrician/gynecologists are now willing to perform an abortion.[1] These developments and many others have begun to shred the image of abortion as a "victimless crime" that is no crime at all but only failsafe protection for a decent woman who wants to make the most of herself and her life.

Gender Supplants Sex

The militancy of today's pro-abortion campaign is beginning to expose its real goals. At the heart of those goals lies a passionate commitment to the transformation of women's roles, relations with others, and nature. The pro-abortionists propose a radical revision of what it means to be a woman—if not the abolition of the very substance and concept of woman. By now, they have persuaded the media, who in turn have apparently persuaded most Americans, to substitute *gender* for *sex*. Presumably the campaign has succeeded because it has convinced the public that *gender* is more respectful of women's varied talents and capabilities than *sex*. And most Americans agree that women deserve respect as persons "in their own right," which is to say, as responsible and autonomous individuals. But most Americans—apart from college students who have been exposed to women's, gender, or cultural studies—probably do not understand the full significance of the displacement of sex by gender.

The theoretical rationales for the preference for gender may become dizzyingly convoluted, but they rest on the common premise that biology

has betrayed and oppressed women, who must be liberated from it. At first, proponents of gender argued that purported differences between the sexes were nothing but "socially constructed" gender roles, designed to keep women subordinate to men. That argument allowed for the possibility of a substratum of biological sex, but insisted that it had been distorted by society's imposition of gender roles. More recently, cutting-edge academic theorists have dismissed sex entirely, arguing that the notion of a "real" biological sex is itself a sleight of hand—another trick of language employed to keep women in their place and to imprison the fluidity of everyone's polymorphous sexual desires.

We may safely assume that most Americans do not fully grasp the connections that bind the preference for gender to the sanctity of a woman's unconditional right to abortion, but they include a commitment to a woman's right to liberation from her biological sex and especially from any children with whom her (woman's) body may betray her.

From the start, the pro-abortionists have championed abortion as the cornerstone of women's freedom and have fought for its recognition as a fundamental right—the necessary precondition for women's equality with men. They have a point—albeit a deeply misguided one—and those who disagree cannot afford to underestimate its appeal. The pro-abortion forces ground their case in a comprehensive worldview. Doubtless many of their followers either do not recognize the worldview or pay it little mind. But in some ways, their uncritical acceptance makes them all the more dangerous, for they do not understand the magnitude of what they are agreeing to. And their uncritical acceptance vastly strengthens the hand of the hardcore pro-abortion faithful, who understand precisely the magnitude of their blueprint for women.

A Culture Conducive to Abortion

How have the advocates of abortion convinced vast numbers of people, many of them decent people of good will, that women's prospects for happiness and self-realization depend upon unrestricted access to abortion? The simple answer lies in their success in convincing people that full personhood for women depends upon their becoming equal to men in every way—which effectively means securing freedom from their bodies and, especially from children. The more complicated answer arises from the assumptions of our culture as a whole, especially its escalating sexual permissiveness, its loss of spiritual direction, its pathological fear of human mortality and the related cult of youth, its dedication to instant gratification and disdain for sacrifice, and, perhaps most portentously, its abandonment of children.

These assumptions contain key elements of the pro-abortion worldview. The defense of abortion grows logically out of a culture that is denigrating and eroding the ties that bind people. It invites Pope John Paul II's label of the "culture of death," for it subordinates reverence for and joy in life to obsession with material goods and sexual desires. Ironies abound. The carriers of the culture of death fear and deny death, which they would forestall by any means imaginable: stem-cell research, cloning, the harvesting of organs from living human beings at the beginning or near the end of their lives, and more. Their self-image as passionate defenders of life—their own and those of people like them—blinds them to the myriad ways in which they save one life at the price of another—often many others.

In addressing the thirtieth anniversary March for Life, President Bush spoke of embryonic stem-cell research in words echoed in his State of the Union speech: "We must not create life to destroy life. Human beings are not research material to be used in a cruel and reckless experiment." By the same token, we must never destroy one life to "save" another life— whether physically by providing organs from living persons, or metaphorically by "liberating" a woman to complete an education or pursue a career or simply to enjoy her "freedom."

Abortion advocates try to square the circle by assigning the right of judgment to themselves: They will decide which lives are meaningful and which are not, even which lives are human lives at all and which are not. A baby in the womb, conveniently dehumanized by the designation of "fetus," falls into the latter category, except when it is "chosen." As should be obvious, the standards that govern who is chosen can only be subjective and, consequently, reinforce the "me, me, me" tendencies of our times. Here we have another irony. The culture's emphasis upon the autonomous or disconnected self serves many purposes, not least those of employers who seek to divest themselves of responsibility for providing as many benefits as possible and have little or no patience with maternity leave.

High Costs of Abortion

The pro-abortionists' embrace of women's right to the anxious freedom of disconnected individualism has effectively deprived women of the protections and support that pregnancy and maternity require. Affluent women who can afford unlimited paid help may not unduly suffer from the practical inconveniences, but less affluent women assuredly do. And most women suffer from the emotional disconnection.

We now have a substantial number of depressing studies that demonstrate the high cost of abortion for women. We need not linger over the evidence

of the many women dead from hasty, botched, or unsanitary legal abortions, although it is enough to make one cry.[2] Predictably, the women who suffer this fate are likely to be poor and often African-American or Hispanic. As yet we lack reliable evidence about the number of these cases—but it may well exceed the highly dramatized number of pre-*Roe* back-alley abortions, which, according to Dr. Bernard Nathanson, was wildly inflated.[3]

We do, however, have reliable studies that point to a link between abortion and breast cancer. The precise nature of the link—which the *New York Times* irately rejects *in toto*—still provokes heated debate, but it is becoming increasingly difficult to dismiss its existence out of hand. Even the mainstream American media are now forced to acknowledge that a first pregnancy brought to term provides an important protection against breast cancer. By the same token, the deliberate termination of a first pregnancy by abortion may have potentially dangerous consequences, even though a spontaneous miscarriage will not.

The devastating emotional consequences of abortion are beginning to be even more widely documented. Women who have had abortions are at high risk to suffer serious and lasting depression, and they are more likely than women who have not had abortions to suffer drug or alcohol addiction. If women who have had an abortion subsequently have children, their children are more likely to experience a variety of emotional and behavioral problems than the children of women who have not had abortions—although appropriate psychological treatment that alleviates the woman's pain may ease her relations with the children who have "survived."

The majority of women who have abortions experience deep loss, grief, and regret. Rather than liberating them, the experience imprisons them in pain. Doubtless we would benefit from more complete studies, but we now have enough evidence to say with confidence that for the vast majority of women, abortion represents a worst-case scenario. Too often, it also confirms their abandonment by the father of their child and the larger community. More often than not, girls and women have abortions because they lack the support to have their child.[4]

Abortion's Targets

The most dramatic refinement of existing studies of abortion's impact is likely to highlight the social background of the women in question. One may easily imagine the arguments of middle-class academicians and activists: Since the women who turn to abortion are disproportionately poor, we can expect them to manifest a variety of social pathologies independent of the abortion. Consequently, how can we claim that the abortion

"caused" their addiction or depression? Well-designed studies can control for those factors, but another inordinately more important issue exposes the class and racial biases of the pro-abortion activists: What does it say about our society and our prospects for building a culture of life if the poorest among us are encouraged to believe that they cannot bear the children they conceive?

According to Damon Owens, national spokesman for the Life Education and Resources Network (LEARN), "More black babies are killed in a three-day period by abortion than were ever lynched in the history of America." Although estimates vary slightly, it is clear that abortions are now performed much more frequently on African-American than on white women. Thus, while African-Americans account for 12 percent of the population, African-American women undergo 36 percent of the abortions. As such statistics become more widely known, it is no wonder that sections of the African-American community are beginning to respond with hurt and outrage— or even to cry genocide. "Abortion is the number-one killer of blacks," said the Reverend Johnny Hunter, LEARN's national director. "We're losing our people at the rate of 1,452 a day. That's just pure genocide. [Margaret] Sanger's influence and the whole mindset Planned Parenthood has brought into the black community . . . say it's okay to destroy your people. We bought into the lie."[5]

Before you dismiss that claim as hyperbole or hysteria, reflect upon the campaigns of Planned Parenthood, which still solicits support by telling potential donors—however covertly and discreetly—that they do not want to support "those" people's children; which supports offering birth control to even the youngest girls; and which passionately advocates the provision of abortion to the women of the third world. Cries of alarm at over-population, themselves misleading and unsupported by evidence, covertly target non-white and non-Western peoples. And it should give us pause to note that among the nations with the most liberal abortion laws are England and Canada, both of which feature high levels of immigration and national health services.

Meanwhile the flight from responsibility for children is resulting in a dramatic and potentially disastrous population decline in the developed world. In addition to promoting a decrease in specific sections of the national and world populations, Planned Parenthood has been encouraging under-age girls who, in what is emerging as a common pattern, engage in sexual relations with older men, to lie about their age to secure an abortion without parental consent, or to lie about their partner's age to evade reporting requirements. Its policy defies parental consent laws, frequently evades laws

against the transportation of a minor across state lines, and amounts to nothing less than the aiding and abetting of statutory rape.[6]

Abortion & Women's Freedom

All of these strategies and more represent a concerted campaign to free women—and society at large—from responsibility for children. According to the pro-abortion forces, women have for too long been saddled with a responsibility for children that has barred them from the most interesting and lucrative occupations—and often from any occupation at all. These charges contain enough truth to prevent our dismissing them out of hand. We gain nothing by denying difficult truths, and we risk trivializing our own case by doing so. Most women do want—and need—some regular interaction with the larger world and have much to contribute to it. Many women must earn some income if their families are to maintain a good standard of living. The care that children need and deserve requires as much time as most jobs and professions and is not compatible with them.

If the past three decades have taught us anything, they have taught us that you cannot have it all—or, more accurately, cannot have it all at one time. Happily, for most people, life is long enough to permit them, women and men alike, to change careers one or more times over the course of their lives. In addition, thanks to technological developments, the number of occupations that can be pursued on a part-time basis is growing, as is the number of opportunities for working from home. The pro-abortion forces have attempted to resolve the contradiction between children and work by eliminating children from the equation—with disastrous consequences.

The temptations are great to blame specific people—often parents—for the antisocial behavior or violent acts of children and adolescents. Similarly, it is easy to fault parents who leave children in daycare from seven in the morning until ten at night, or in the care of a "nanny" who may not like children or her job or who may lack sufficient education to stimulate the development of a child's mind. The whole country shudders at a Susan Smith, who drowns her children, or at parents who leave children locked in a house while they go off on vacation. But in ascribing blame to specific individuals for such crimes, we may miss a larger point. The glorification of individual choice in our society, crystallized in the idea of a woman's "right" to abortion, has hardened our sensibilities even as it has cut children adrift to fend for themselves—often with results as chilling as those presciently described in 1954 by William Golding in *Lord of the Flies*. At first glance, these problems may seem to bear little relation to the harm abortion inflicts upon women. Does not the care of children cripple women's freedom? Why

should fathers not assume a full half of the responsibility, as proponents of "joint parenting" propose? Pro-abortion activists represent themselves as the last best defenders of women's freedoms. Without abortion, they argue, all of women's gains since the 1960s would be wiped away. On the basis of this logic, which the media promote, they claim the high ground of the true defense of women's interests.

They have scored a remarkable rhetorical success, largely because of their political genius for appearing merely to express the received wisdom of "mainstream" culture. Where once Americans were enjoined to view women through the lens of "mom and apple pie," they are now enjoined to see them through the lens of autonomy, briefcase, and soccer. Countless Americans have been seduced into supporting abortion as the innocuous right to "choose" self-realization and fulfillment—no more than any self-respecting individual would ask. In this script, those who oppose abortion on demand—or any form of abortion at all—represent the forces of repression that seek to thwart women's development as persons and independent actors in the world.

If we are to challenge the logic of the pro-abortionists and the script to which it leads, we must first acknowledge the importance and justice of women's participation at all levels in the worlds of work, politics, and the arts. We do not aspire to return women to subservient domesticity—much less to deprive the world of their considerable talents. Any such attempt will fail, probably provoking destructive reactions along the way. The attempt will also impoverish any effort to defend the sanctity of life. Our challenge is to offer women new visions that do not pit their lives against the lives of their children in a Darwinian struggle for survival. In that struggle, no one wins.

Pro-abortionists consistently imply that the bearing and rearing of children is work fit for servants. If many American adults have ignored their message, a distressingly large number of American children appear to have heard it loud and clear. They intuitively know, even if adults prefer not to, that the repudiation of children is the ultimate confession of moral and social bankruptcy. But few Americans of any age are willing to acknowledge that the repudiation of children is also a repudiation of women.

Not surprisingly, the most enthusiastic fans of abortion have been men—at least until they have children of their own. The availability of abortion liberates a man from the obligation to marry the woman he impregnates, although the chivalrous man usually offers to pay half the cost of the abortion. The pregnant woman does not always find the offer comforting. At the same time, middle-class women frequently bemoan the dearth of eligible men, never drawing the simple conclusion that the dearth may bear some

relation to their defense of their right to "choose," and especially to their insistence that, because the baby is a mere extension of their sexuality, the "choice" is theirs alone to make.[7]

Not all women can bear children, and not all women wish to do so, but the potential to do so lies at the core of being a woman—it is what women can do that men cannot and what makes exact equality between the sexes an illusory goal. By trivializing women's ability to bear children, legalized abortion has stripped women of their distinct dignity as women; it has shredded the primary tie between women of different classes, races, ethnicities, and national origins; it has seriously diminished women's prospects for marriage and even further diminished their prospects for a lasting marriage; and it has exposed them to unprecedented levels of sexual exploitation. Welcome to the brave new world of freedom, ladies—and gentlemen.

A War against Humanity

Among the many horrors of the Holocaust, the most dangerous lay in the attribution to one person of the power to decide whether another should live or die. Even the slave system of the antebellum United States, which so many evoke as an analogy for abortion, never granted masters that power over slaves. That power severs the connection with and recognition of the other that, as Pope John Paul II has passionately argued, define us as persons. Under the conditions of the Holocaust, the other became an object. By allocating lethal power to a mother, who is thereby authorized to kill her own child, abortion opens up the possibility for the more wealthy and powerful among us to measure all the others, including the elderly, the handicapped, and the seriously ill, in terms of their convenience and to dispatch those who fail to measure up—or whose care simply costs too much financially or emotionally.

At the extreme then, and dramatically in a world of managed—which increasingly means rationed—health care, abortion becomes the cutting edge of a war against our humanity. Throughout history, some women have obtained abortions and committed infanticide, sometimes because the men who impregnated them deserted them, sometimes because of their own bad character or crass exploitation of another, sometimes because economic change deprived them of the means to marry and support a family. But until our own time, these patterns have been cyclical, like the recurring wars that have deprived specific generations of women of the opportunity to marry.

Our legalization of abortion and, yet more portentously, our proclamation of it as a positive good, represents something new, and we should be rash indeed to expect it to follow the course of previous cycles. In severing the binding tie between women and the children they conceive, legalized

abortion dismisses women from the company of responsible persons who are capable of sacrificing a piece of their freedom for the good of others—especially the children who embody our future.

Thus, legalized abortion begins as a war against women, whom it tells that, to be worthy, they must become men. But it ends as a war against humanity, against both our lives and our humanness. The life issues, which begin with abortion, are the most important issues of our time, and women are in the front lines. It remains to be seen whether we will rise to the challenge.

Notes

1. Alan Guttmacher Institute study, "Abortion Incidence and Services in the United States in 2000," written by Lawrence B. Finer and Stanley K. Henshaw (http://www .agi-usa.org/pubs/journals/3500603.pdf).

2. "State Reports—New York: Provider Had History of Botching Abortions," *The Kaiser Daily Reproductive Health Report* (August 8, 1995). There have also been a number of stories on the Mafia's investment in abortion clinics. See Bob Jones, "Making a Killing," *World*, vol. 16, no. 13 (April 7, 2001), archived at www.worldmag.com; and Phil Brennan, "Is the Mob Now Whacking the Unborn?" NewsMax.com (March 30, 2001) at www.newsmax.com/archives/articles/2001/3/30/142843.shtml.

3. In his years as a pro-abortion activist, Dr. Nathanson maintained that 5,000–10,000 women died from illegal abortions each year; later he wrote, "I confess that I knew the figures were totally false . . . [b]ut in the 'morality' of our revolution, it was a useful figure. . . ." Bernard Nathanson, *Aborting America* (New York: Doubleday, 1979), 193.

4. David C. Reardon, *Aborted Women Silent No More* (Springfield: Acorn Books, 1987, 2002); and David C. Reardon and Theresa Burke, *Forbidden Grief: The Unspoken Pain of Abortion* (Springfield: Acorn Books, 2002). See also Elizabeth Ring-Cassidy and Ian Gentles, *Women's Health After Abortion: The Medical and Psychological Evidence* (Toronto: The deVeber Institute for Bioethics and Social Research, 2002); and Philip Ney, "A View from Clinical Psychiatry," in *Back to the Drawing Board: The Future of the Pro-Life Movement,* ed. Teresa R. Wagner (South Bend: St. Augustine Press, 2003), 82–96.

5. According to the Centers for Disease Control and Prevention's December 2000 report, black women account for 36 percent of all abortions performed, even though blacks represent 12 percent of the population. In 1996, the Alan Guttmacher Institute (Planned Parenthood's research arm) reported: "Blacks, who make up 14 percent of all childbearing women, have 31 percent of all abortions, and whites, who account for 81 percent of women of childbearing age, have 61 percent."

6. Charles A. Donovan, "Planned Parenthood: A Business That's Never Been Richer," *Focus on the Family Citizen Magazine* (February 4, 2003). Reportedly for financial as well as ideological reasons, Planned Parenthood also provides referrals for abortions (from which it profits), but not for adoptions (from which it does not). See, "Planned Parenthood: Abortion, Not Adoption," at the American Life League website (media@ all.org); and "A New Religion: An Analysis of Planned Parenthood Federation of America's Annual Report (2000–2001)," at http://fightpp.org/show.cfm?page=special _reports. On Planned Parenthood's campaigns to encourage very young women (girls) to have abortions, see Joseph Farah, "Planned Parenthood on the Run," WorldNetDaily

(May 30, 2002) at http://www.worldnetdaily.com/news/article.asp?ARTICLE_ID =27780, and ARTICLE_ID=27804.

7. For a general discussion of these issues as well as specific evidence on the attitude of different groups toward abortion, see Elizabeth Fox-Genovese, *"Feminism Is Not the Story of My Life": How Today's Feminist Elite Has Lost Touch with the Real Concerns of Women* (New York: Doubleday / Nan A. Talese, 1996).

Part Two

Remembrances of
Elizabeth Fox-Genovese

Seventeen

The Story of a Well-Lived Life

Robert P. George

Elizabeth Fox-Genovese was a scholar as notable for her bravery as for her brilliance. After what she described as her "long apprenticeship" in the world of secular liberal intellectuals, it was careful reflection on the central moral questions of our time that led her first to doubt and then to abandon both liberalism and secularism. Needless to say, this did not endear her to her former allies.

At the heart of her doubts about secular liberalism (and what she described as "radical, upscale feminism") was its embrace of abortion and its (continuing) dalliance with euthanasia. At first, she went along with abortion, albeit reluctantly, believing that women's rights to develop their talents and control their destinies required its legal availability. But Betsey (as she was known by her friends) was not one who could avert her eyes from inconvenient facts. The central fact about abortion is that it is the deliberate killing of a developing child in the womb. For Betsey, euphemisms such as "products of conception," "termination of pregnancy," "privacy," and "choice" ultimately could not hide that fact. She came to see that to countenance abortion is not to respect women's "privacy" or liberty; it is to suppose that some people have the right to decide whether others will live or die. In a statement that she knew would enflame many on the Left and even cost her valued friendships, she declared that "no amount of past oppression can justify women's oppression of the most vulnerable among us."

Betsey knew that public pro-life advocacy would be regarded by many in the intellectual establishment as intolerable apostasy—especially from one of the founding mothers of "women's studies." She could have been forgiven for keeping mum on the issue and carrying on with her professional work on the history of the American South. But keeping mum about fundamental matters of right and wrong was not in her character. And though she valued her standing in the intellectual world, she cared for truth and justice more. And so she spoke out ever more passionately in defense of the unborn.

And the more she thought and wrote about abortion and other life issues, the more persuaded she became that the entire secular liberal project was misguided. Secular liberals were not deviating from their principles in endorsing killing whether by abortion or euthanasia in the name of individual "choice"; they were following them to their logical conclusions. But this revealed a profound contradiction at the heart of secular liberal ideology, for the right of some individuals to kill others undermines any ground of principle on which an idea of individual rights or dignity could be founded.

Even in her early life as a secular liberal, she was never among those who disdained religious believers or held them in contempt. As an historian and social critic, she admired the cultural and moral achievements of Judaism and Christianity. As her doubts about secularism grew, she began to consider seriously whether religious claims might actually be true. Reason led her to the door of faith, and prayer enabled her to walk through it. As she herself described her conversion from secularism to Catholicism, it had a large intellectual component; yet it was, in the end, less her choice than God's grace.

Betsey continued her scholarly labors, especially in collaboration with her husband Eugene Genovese, our nation's most distinguished historian of American slavery. Not long ago, Cambridge University Press published their masterwork, *The Mind of the Master Class.* Soon after Betsey's own religious conversion, Gene (who had long been an avowed Marxist, but who had gradually moved in the direction of cultural and political conservatism) returned to the Catholic faith of his boyhood under the influence of his beloved wife.

As if she had not already antagonized the intellectual establishment enough, Betsey soon began speaking out in defense of marriage and sexual morality. Her root-and-branch rejection of the ideology of the sexual revolution—an ideology that now enjoys the status of infallible dogma among many secular liberal intellectuals—was based on a profound appreciation of the centrality of marriage to the fulfillment of men and women as sexually complementary spouses; to the well-being of children for whom the love of mother and father for each other and for them is literally indispensable; and

to society as a whole which depends on the marriage-based family for the rearing of responsible and upright citizens. If her pro-life advocacy angered many liberal intellectuals, her outspoken defense of marriage and traditional norms of sexual morality made them apoplectic.

Betsey's marriage to Gene was one of the great love stories of our time. They were two very different personalities, perfectly united. He was the head of the family; she was in charge of everything. Their affection for each other created a kind of force field into which friends were drawn in love for both of them. Although unable to have children of their own, they lavished parental care and concern on their students and younger colleagues, who in turn worshipped them.

Betsey leaves us many fine works of historical scholarship and social criticism—works admired by honest scholars across the political spectrum. Even more importantly, her life provides an unsurpassed example of intellectual integrity and moral courage. Her fervent witness to the sanctity of human life and the dignity of marriage and the family will continue to inspire. May the living God who drew her to Himself comfort her bereaved husband and grant her a full share in His divine life.

Eighteen

Lioness

Wilfred McClay

Touchstone has lost a valued member of its family, and America has lost one of its leading intellectual lights, with the death of historian (and *Touchstone* contributing editor) Elizabeth Fox-Genovese on January 2, 2007 at the age of 65. Author of many books on a dazzling array of subjects, including most recently a massive and definitive study of proslavery ideology coauthored with her husband Eugene Genovese, Betsey also was an adult convert to the Roman Catholic Church, being received in 1995. (Gene soon followed his wife, returning to the church of his youth.) This conversion seemed especially remarkable, at least on the surface, given her former visibility and influence as a lioness of academic Marxism and feminism. But in fact, there was a striking consistency in her life's pattern, albeit one that runs so completely against the typical academic's grain as to be unintelligible to those who think in conventional ways.

She has told the story of her conversion in an article in the April 2000 issue of *First Things* (where she also was a contributing editor), and a reading of that account is a necessary starting place for assessing the background to her change. But anyone who followed the track of her published work knows that the change was not nearly as great as it might have

seemed. Looking backward at her pilgrimage, one can say that for Betsey, Marxism and feminism, although clearly heresies, were the kind of heresies that point one toward the truth. For like all heresies, they contained an important piece of the truth, a piece that can be built upon once it is freed from association with falsehood.

Marxism spoke much truth about the degradation of a world where all human relations are reduced to the exchange of inert commodities. Even after their conversions, both of the Genoveses retained their strong aversion to the deification of the market and the exaltation of "choice"; and one reason for their lifelong interest in proslavery ideology was precisely because of its precapitalist eschewal of the cash nexus as an adequate basis for human relations. They retained a lot of Marx, but they had turned Marx on his head; for when Marx said famously that "Religion is the sigh of the oppressed creature, the heart of a heartless world, and the soul of soulless conditions," it turned out that he was righter than he knew. The injustices that Marxism identified were not illusions; the illusion was the solution that Marxism proposed, which turned out to be an intensification without limit of the very soullessness it sought to combat.

As for feminism, it is not a coincidence that one of Betsey's most important books was called *Feminism Without Illusions*. It was in fact a critique of individualism, grounded in the insistence that no workable notion of equality between men and women could be based on an assumption of the interchangeability of men and women, and the reduction of marriage and childbearing and family life to contractual relationships. It also pointed out the presumptuousness of the feminist movement, in assuming that the concerns of a small number of elite academic women spoke for all women. This theme took on added prominence in her 1996 book "*Feminism is Not the Story of My Life*," which simply listened to the concerns of a wide range of American women, and found that the standard feminist narrative simply didn't touch these women's lives. With the publication of that book, she had ensured that her status as a lioness of American feminism had come to an end.

But a lioness she remained. I had the pleasure of working together with Betsey as a member of the National Council on the Humanities, where she was a formidable and valued presence, until her illness made her unable to attend meetings. She always had a nose for quality, and was vigilant about even the most minute matters. She never did anything by rote, never went through the motions, and her amazing energy and the power of her critical intellect filled the room. No one who knew her will ever forget her.

Elizabeth Fox-Genovese, 1941–2007

Robert L. Paquette

Two years ago, Betsey Fox-Genovese, a prize-winning historian and recipient of a National Humanities Medal (from the administration of George W. Bush) played to a packed house at Hamilton College. One of my colleagues, one of Betsey's former students, had invited her to campus, preceding a visit by the president of Planned Parenthood, to speak about abortion. Friends knew that Betsey had been battling multiple sclerosis for some years. The disease had taken an obvious toll on her mobility. She edged toward the podium under escort in some difficulty. One leg was braced; she grasped a metal cane in each hand. Reaching her destination, poised and cheerful, at the lower end of the auditorium she turned to her audience to speak about "Life and Death: Who Decides?" Gripping the lectern, she remained erect throughout the performance. She spoke spiritedly. Despite advance publicity, few of Hamilton's feminist radicals had deigned to attend. The majority of undergraduates in the audience, I suspect, did not like what she had to say. (The student who covered the story for the campus newspaper persisted in referring to her in print as "the activist.") Betsey, a convert to Catholicism in 1995, expressed concern about the moral relativism that was sweeping society. Morality, after all, is inherently authoritarian. The radical individualist claim, "Woman's body, woman's right," she regarded as preposterous. Women's sexual freedom had led to a libertinism that was intensifying male predation. She suggested that well-run orphanages might be a better option

for raising children than a drug-infested apartment of a single African-American mother addicted to welfare. Utilitarian calculation of who lives and who dies, she declared, "opens the road to the Holocaust."

Betsey Fox-Genovese died on January 2, from complications related to surgery. Her courageous service to the cause of truth will be greatly missed.

Thinking about the contentious issue of abortion had led Betsey to a remarkable turn in both her academic career and personal life. Three decades before her appearance at Hamilton, she was attracting attention at the University of Rochester as a brilliant young Marxist-feminist scholar who had published an impressive first book on the development of modern economic theory in eighteenth-century France. She moved to SUNY Binghamton in 1980 and became a nationally recognized force in women's studies. Emory University wanted a Ph.D. program in the field and hired Betsey to build it. Under her aegis, it became, in the words of the *Chronicle of Higher Education,* "one of higher education's leading women's-studies programs." But in 1992, six years after the founding, Betsey resigned the directorship under pressure from "disgruntled" students and professors. You see, Betsey believed that a women's studies program should be a program about, well, women, that is to say, one open to all students, men and women, conservative and liberal, who were serious about investigating questions of sex and gender. In short, she tried to prevent her program from becoming little more than a hothouse for the incubation of the wildest species of feminist critical theory. A few denizens of the deep also complained that she demanded too much of them. Dozens of graduate students who completed their dissertations under her auspices and then landed jobs in a buyer's market would come to bless her for her standards. I know because she sat on my dissertation committee, and I would not have become a professional historian without her mentoring.

In the mid-1970s, I entered the graduate program in history at the University of Rochester to work with Betsey's beloved husband, Eugene Genovese, one of the most influential American historians of his generation. Their relationship had a striking complementarity. Gene is stocky, brusque, hard-shell, Bensonhurst, Brooklyn College, working-class, and Sicilian; Betsey was tall, elegant, contemplative, Waspish, Harvard, and to the academic manner born. Robert George, director of Princeton's James Madison Program, in a moving tribute to Betsey on *National Review Online,* was spot on about their marriage, calling it "one of the great love stories of our time." "They were," he continued, "two very different personalities, perfectly united. He was the head of the family; she was in charge of everything." Gene produced *Roll, Jordan, Roll* (1974), the best book ever written about slavery in the

Old South; Betsey produced *Within the Plantation Household* (1988), the best book ever written about black and white women in the Old South. Together they produced *Mind of the Master Class* (2005), a weighty volume of staggering erudition on the political thought of the Southern slaveholders. Want to know what Southern slaveholders thought about Islam and Muhammed? Hegel and Schleiermacher? Balzac and Boethius? The Gracchi and the Golden Rule? Start there.

In intellectual interest, Betsey ranged more widely than Gene. Those interested in consuming her scholarship be forewarned: You will need to adjust your metabolism. During her career, she published scores of books and articles on everything from mystery novels to mythology, from the life of Pierre Samuel Du Pont de Nemours to the fiction of Zora Neale Hurston. She treasured the classics of the Western canon, and shared her enthusiasm for them with her students. "A Hawaiian quilt or a Scottish ballad may embody the same human value as the Mona Lisa," she once wrote in criticizing feminist trivialists. "But aesthetic value has its own claims, which concern for human equality and personal experience do not exhaust." In her downtime, she could also serve an exquisite soufflé, differentiate between an H. Upmann and a Macanudo, and delineate the record of every member of the Yankee's pitching staff. With her, you quickly recognized that you were in the presence of a special talent.

Betsey and Gene had a weakness for stray cats, and both stepped up during a threshold moment in my life and offered me a place to stay. They were living in Ithaca, New York, at the time, near Cornell University where her father, Edward Fox, had taught for decades as a professor of European history. For a wayward, working-class graduate student with tendencies toward indiscipline scrambling to finish his dissertation, working in that environment, watching Gene and Betsey in action seems in retrospect like being surrounded by panels resplendently decorated with a series of rich tapestries, each with a story to tell. Adjusting to their regimen, I learned not only how to be a professional historian, but also something about how to live. In fact, Betsey quite literally dressed me for the road ahead. Hamilton College had invited me on campus as a finalist to interview—my first—for a position in American history. She looked at my wardrobe, swallowed hard, and called Brooks Brothers. They fitted me on short notice for a blue plaid three-piece suit. I've taught at Hamilton for twenty-five years.

In explaining her conversion to Catholicism in the religious journal *First Things,* Betsey referenced St. Augustine rather than St. Paul. Her epiphany came without a flash of light, a sonic boom, or a rush to the bloodstream. She had reached a conclusion about God intellectually and waited for her heart to catch up. Gene, who had repented of Marxism himself, followed her

into the Church a few years later. Thinking about continuity in her work brings to mind two of her favorite quotations. One was from the German political philosopher Eric Voegelin: "The order of history emerges from the history of order"; the other, from Dostoevsky, "Without God, is not everything permissible?"

In her two most important books on feminism, *Feminism Without Illusions* (1991) and *Feminism Is Not the Story of My Life* (1996), Betsey played Cassandra, warning that the postmodernist march to feminist utopia was more likely to lead us to a scene straight out of *Clockwork Orange*. The feminist shibboleth "the personal is political" had chilling implications, for in eviscerating the line between public and private, feminists were undermining the basis of legitimate authority itself, fostering a "flagrant nihilism" that would ultimately translate into a "transparent totalitarianism." How could feminists, she asked, claim a special value for women's experience if the differences between men and women exist merely as "an artifact of language and domination"? If hegemony is about the mystification of power, how is it that feminist theorists are immune in their calculations from the self-serving outrages they detect in others? Needless to say, the response of the feminist establishment to these books was vitriolic.

In part one of the *Mind of the Master Class*, Betsey and Gene devote a section to the Southern slaveholders' shifting views of the French Revolution. They zero in on John Randolph of Roanoke, the brilliant but irascible Virginia statesman, who in his late teens was a hotspur for the Jacobins. Randolph read Edmund Burke's *Reflections on the Revolution in France* as a young man and was utterly dismissive of it. In his early forties, however, during the War of 1812, Randolph returned to Burke and this time reread *Reflections* carefully. "It has been an intellectual banquet of the richest viands," Randolph gushed. "What a man!" This sad occasion calls for the emendation of only one word.

Twenty

Remembering Betsey

Christina Bieber Lake

Brilliant. Brave. And a perfect picture of magnanimity.

These are the words I have always used to describe my friend and mentor, Elizabeth Fox-Genovese. Now I write them in memory, with the mixture of grief and joy that comes with this privilege.

I first met Betsey in 1995, when I was doing graduate work in English at Emory University. I took her "Southern Women Writers," the first of many seminars I would have with her. She was a historian by training, but in her teaching and scholarship, a humanities guru. Educated primarily at Harvard, her scholarly interests began with her investigations of the origins of physiocracy, and from there naturally expanded to the antebellum South, which was also her husband's scholarly terrain. Her award-winning book *Within the Plantation Household: Black and White Women of the Old South* is a testament to the things that mattered most to her: impeccable, morally committed scholarship that endures. It also illustrates her lifelong commitment to the cause of feminism, which for Betsey was always about real justice for real women. *Within the Plantation Household* is a work of history, with all the usual trappings, but it is also a window into the lives of ordinary Southern women, who are given the opportunity to speak for themselves. The book is a perfect picture of Betsey's convictions, for she always spoke for herself with courage, and encouraged countless other women to do so. Including me.

I remember timidly approaching her in the quad during a break, when she was smoking one of those dark cigarettes she loved (and later gave up).

I asked her if she would direct my dissertation research; what I got was a broad smile and the beginning of a friendship. What I did not know until later was that it was a serendipitous time for both of us to meet. Make no mistake about it: while I hope I was an encouragement to her at an exciting but tumultuous time in her life, I know I got the much better end of the deal. She was an ideal mentor, the kind most graduate students can only dream about. She read my work carefully, and even line-edited it (she was a lucid and meticulous writer). She took me out to lunch more times than I can remember, which I would have appreciated even had I not been the bean-eating graduate student that I was. I have wonderful memories of dinners with her and her husband, Gene—along with other academic sorts—at their home in Atlanta. If you escaped being knocked over by their large dogs at the door, you were treated to a delicious meal. Betsey was an academic who could also cook, which says a lot about her. We often talked about NFL football. She even tried, at my request, to set me up with young men she respected. What I appreciated most was that under her care, I was neither a pet mind to indoctrinate nor a tool with which to fight other academics. She respected me and wanted me to succeed, to write about things that mattered to me, and to do so shrewdly—but also without fear.

I didn't know at the time we met that she was nearing the final stage of her full reception into the Catholic Church—and about to bear the brunt of hostility occasioned by her conversion. I had entered Emory as a bit of a pariah myself: an evangelical studying American literature. But because of Betsey's faithfulness I was able to work with a woman who not only respected my faith commitments—which she would have done even before her conversion—but also now fundamentally shared them. It was a privilege to sit in a graduate seminar on Flannery O'Connor with an accomplished scholar who was seeing these texts with new eyes herself.

Like O'Connor, Betsey thought of her faith as the natural outworking of intellectual honesty and a commitment to the truth. It is thus not surprising that in reflecting upon the arc of her life, a favorite passage of hers from another Southern writer, Eudora Welty, came to my mind:

> The events in our lives happen in a sequence of time, but in their significance to ourselves they find their own order, a timetable not necessarily —perhaps not possibly—chronological. The time as we know it subjectively is often the chronology that stories and novels follow: it is the continuous thread of revelation.

I know that Betsey's turn to the Catholic Church was this kind of moment for her. In her essay "A Conversion Story," appearing in *First Things,* she noted that many of her fellow academics were mystified by her faith journey.

But for her there was continuity. Marxist theory—which she and her husband had earlier embraced—is, at its core, an ethical critique. She wrote that "over the years, my concerns about morality deepened, and my reflections invariably pointed to the apparently irrefutable conclusion that morality was, by its very nature, authoritarian. Morality, in other words, drew the dividing line between good and bad." The academy had come to view morality in increasingly relativistic terms, and Betsey knew better. So she began to take very unpopular stands, such as believing that a woman can be, without contradiction, both pro-life *and* a feminist. Not only can be, but *should* be.

Betsey also found in the Catholic Church a spiritual articulation of the very best parts of her scholarly vocation, to love and to serve others. She had already done that part well, but, fully committed to God, she began to do it with greater joy, even as she began to struggle more with her health. And against a world that measures value by accomplishment, she recognized that the most important legacy we can have as scholars and teachers is to see others as God sees them:

> For if He loves us all, He also loves each of us. And recognition of that love imposes on us the obligation to love one another, asking no other reason than God's injunction to do so [. . .] knowing how little we merit His love, our best opening to the faith that He does lies not in the hope of being better than others, but in the security that His love encompasses even the least deserving among us.

I have tried to emulate Betsey's style as a scholar and a teacher. But it is this core humility that I can only pray will characterize my life in the way that it has characterized hers.

Betsey, thank you. You will be missed.

In Honor of Elizabeth Fox-Genovese

Mary Odem

It is an honor and privilege to speak to you today about my colleague Betsey Fox-Genovese. I remember very distinctly the first time I met Betsey—when I came to Emory seventeen years ago for a job interview for a joint position in history and women's studies. Betsey met me at the Emory Inn for breakfast, and I was struck in that first meeting by her elegance, her graciousness—she sought to make me feel welcome and at ease—and her intellectual insight and passion. I learned something else about Betsey as we left the restaurant. When I got into her car, I was greeted by her long-haired, long-legged companion named Joseph who occupied almost the entire back seat of the car. When we got to campus, I hurried to keep up with Betsey and Joseph striding across the quad, and thought to myself, "This is going to be a very interesting interview!" And indeed it was.

Over the next several years, I came to know Betsey as a devoted and gifted scholar, teacher, and mentor. When I came to Emory, her pathbreaking and eloquent book, _Within the Plantation Household: Black and White Women of the Old South,_ had recently been published to widespread critical acclaim. In one of many glowing reviews, Mechal Sobel wrote that Fox-Genovese succeeds brilliantly at the "enormous tasks she undertakes of telling the life stories of the last generation of black and white women of the Old South, and of analyzing the meanings of these interconnected stories as a way of illuminating both Southern and women's history." With this book

"In Honor of Elizabeth Fox-Genovese." Address presented at memorial service for Elizabeth Fox-Genovese, Emory University, Atlanta, Georgia, April 14, 2007. Used by permission of the author.

and the many articles she wrote before and after its publication, Betsey elevated American women's history to a new level of theoretical and conceptual sophistication. An internationally renowned and prolific scholar, Betsey made significant contributions not only to the field of women's history, but also to European history, U.S. southern history, literature, women's studies, and religious studies. The breadth and depth of her body of scholarship is truly amazing.

Betsey wrote a number of scholarly works in collaboration with her husband, Gene, including their latest book, *The Mind of the Master Class*, published in 2005, a commanding study of the intellectual and moral worldview of southern slaveholders. Betsey and Gene formed an incredible intellectual partnership. As one eminent historian has written, "What would southern antebellum history be like without the work of the Genoveses?" Like the best kind of scholarship, their work has sparked lively, intense debates, and while scholars and readers have disagreed with their arguments, few would ever doubt the intellectual depth, rigor, and importance of their work.

Betsey's contributions and talent as a teacher are equally impressive. She has been a devoted mentor to so many graduate and undergraduate students that it is hard to keep count. Her students work in colleges and universities throughout the country in the fields of history, literature, women's studies, and religion. In recognition of her contribution to the education of women, the Women's Studies Department has designated a chair in her honor in the Matheson Reading Room of the Candler Library. The department's acknowledgment: Betsey advocated strongly for the rigorous intellectual development of women and was "committed to promoting women's education in the broadest sense: education as learning and the development of independent thought; education as self-confidence and the ability to deal with the world on equal terms."

Betsey's commitment to education extended beyond the undergraduate and graduate students at Emory. Linda Calloway, an admired and beloved member of the WS staff, relates how Betsey encouraged her to take advantage of the program that allows staff to pursue an undergraduate degree at Emory while continuing to work full-time. Of course such a program requires not only tremendous effort on the part of the staff person, but also the support and flexibility of one's supervisor. Linda said that it was because of Betsey's encouragement and mentoring that she was able over a number of years to obtain her undergraduate degree at Emory.

We came to understand the strength of Betsey's commitment to teaching over the last several years as she made heroic efforts to come to campus, teach her classes, and meet with students. My colleagues and I stood in awe and admiration of the courage and determination she showed in the face of

a debilitating illness. MS weakened her body, but certainly not her faith, her spirit, and her dedication to her calling as teacher and mentor.

I want to close by recounting my last encounter with Betsey, which made a powerful and, I think, lasting impression on me. I visited Betsey in the hospital in mid-December, a time when she was very weak. When I walked into the room, she was once again very gracious as she welcomed me and sought to make me feel comfortable. She talked with appreciation and respect about the hospital personnel who were caring for her and seemed to know them all by name. At the time a young nurse, recently graduated, was caring for Betsey and struggling with a certain procedure and taking a long time to complete it. Though Betsey was clearly in discomfort and pain, she spoke only encouraging words to the young nurse: "Don't worry, you can do it; you're doing a wonderful job."

To the end she was a dedicated teacher. Her example of dignity, compassion, and commitment in the face of suffering and pain will stay with me and continue to be a source of inspiration.

Twenty-two

Elizabeth Fox-Genovese

Mark M. Smith

A graduate of Bryn Mawr College, Institut d'Études Politiques, and Harvard University (where she studied under Franklin Ford and David Landes), Betsey began her distinguished career as a scholar of French history before turning her redoubtable intellect to the history and literature of the American South and women's history. From 1973 until 1980 she was a member of the University of Rochester's history department. In 1980 she left Rochester for State University of New York at Binghamton, and in 1986 she was invited by Emory University to establish and direct its new Institute for Women's Studies program, which she did with terrific energy, focus, and determination until 1991.

Betsey was a prolific and versatile scholar. She delivered almost 250 invited lectures and authored scores of articles on a truly impressive variety of topics. As comfortable talking meaningfully about literature and religion as she was about history and political economy, Betsey's store of knowledge was frighteningly deep, a product of a genuine, insistent curiosity about the world. She served on many editorial boards, consulted for a wide range of organizations, and was deeply involved in the religious and social life of her community, serving her church, The Immaculate Heart of Mary in Atlanta, especially.

Obituary for Elizabeth Fox-Genovese. *Journal of Southern History* 73 (2007): 516–17. Copyright 2007 by the *Journal of Southern History*. All rights reserved. Used by permission of the *Journal of Southern History*.

Although of fiercely independent mind, Betsey was extraordinarily collaborative. In addition to her famous partnership with her husband, Eugene Genovese, which produced two landmark studies—*The Mind of the Master Class: History and Faith in the Southern Slaveholders' Worldview* (Cambridge, Eng., 2005) and *Fruits of Merchant Capital: Slavery and Bourgeois Property in the Rise and Expansion of Capitalism* (New York, 1983)—she coauthored or coedited several books, most notably with Elisabeth Lasch-Quinn, Virginia Bernhard, Betty Brandon, Theda Perdue, Elizabeth H. Turner, David Burner, and Forrest McDonald, among others.

Elizabeth Fox-Genovese was best known in Southern history circles for her magnificent study *Within the Plantation Household: Black and White Women of the Old South* (Chapel Hill, 1988), which received the C. Hugh Holman Prize of the Society for the Study of Southern Literature and the Julia Cherry Spruill Prize of the Southern Association for Women Historians, and was named an outstanding book of the year by the Augustus Meyer Foundation for the Study of Human Rights. But Betsey had multiple audiences. Her first book, *The Origins of Physiocracy: Economic Revolution and Social Order in Eighteenth-Century France* (Ithaca, 1976), remains highly regarded among historians of eighteenth-century France. She was also a preeminent thinker among women's studies scholars and a public intellectual of the first order. Her *"Feminism Is Not the Story of My Life": How the Feminist Elite Has Lost Touch With the Real Concerns of Women* (New York, 1996) especially generated enormous interest outside of the academy. Betsey's achievements were honored at the highest levels. Most conspicuously, President George W. Bush awarded her a National Humanities Medal in 2003.

Betsey demanded nothing less than excellence from her graduate students. Committed to all of her students, she took a particular interest in guiding the careers of African American scholars. Although it was more than forty, no one knows precisely how many graduate students she directed. Betsey did not keep a list. She nurtured and tended her students' development throughout their careers, and that sort of mentorship was never reducible, in her mind, to an enumeration.

Refined, gracious, and compassionate, Elizabeth Fox-Genovese was, more than anything, an impeccable lady whose cumulative acts of kindness will resonate for many years in many hearts. She is survived by her beloved husband of thirty-seven years, Eugene Genovese, her sister, Rebecca MacMillan Fox, her brother, Edward Whiting Fox Jr., and five nieces and nephews.

Twenty-three

Memories of Betsey Fox-Genovese, a Lady of Grace

Lorraine V. Murray

I met Elizabeth Fox-Genovese—or "Betsey" as she was called—for lunch at Panera Bread a few years before her death. We had much in common, according to our mutual friend, Father Richard Lopez. We both had been devoted to the feminist movement, we were both academics and writers, and we were both working at Emory University.

We chatted about so much that day: our perspectives on the failures of feminism, our feelings about Catholicism, and our great fondness for Father Lopez. But frankly, I felt a bit overwhelmed by this wonderful lady whose accomplishments so far outshone my own. Little did I know that I would, in a few years, be writing her obituary for a Catholic magazine, and then having the honor of reviewing her last book for *The Georgia Bulletin*.

It was only when I began researching her life for the obituary that I realized what a truly remarkable, even saintly, woman I had met that day. An acclaimed feminist scholar and historian, Betsey had started out strongly supporting women's "right" to abortion, but over the years, her perspective had changed. Eventually, she became an outspoken defender of life, breaking ties with the feminists who insisted on connecting pro-woman ideals with abortion. This was one conversion, while the other was from what she herself had called a "non-believing Christian" to a devoted Catholic.

Her resume is impressive indeed: She was the Eléonore Raoul Professor of the Humanities and professor of history at Emory University, as well as the founding director of the Institute for Women's Studies. An acclaimed author and scholar, she was very happily married to another renowned historian and writer, Dr. Eugene D. Genovese, with whom she co-authored *The Mind of the Master Class.*

After writing the highly touted *Feminism Without Illusions: A Critique of Individualism,* Betsey became increasingly troubled by the moral relativism that typified the feminist stance on abortion.

"It seemed difficult to imagine a world in which each followed his or her personal moral compass," she later wrote, "if only because the morality of some was bound, sooner or later, to clash with the morality of others."

As she struggled with the moral issue of life, she also grappled with the personal question of faith. She had grown up in a nominally Christian home but had not practiced any religion for many years. Finding herself drawn to Catholicism, she decided one day to attend Mass at the Cathedral of Christ the King, where she was stunned by the figure of the crucified Christ. Writing about her conversion for *First Things* a few years later, she said, "There, directly in front of me, was . . . a Lord whom as yet I barely knew and who nonetheless seemed to hold me fast."

After receiving instruction in the faith from Father Lopez, she was received into the Catholic Church in December 1995. She described experiencing a deep joy that "consecrated a decision that now seemed to derive as much from the heart as the mind." When her husband, Gene, also had a change of heart and returned to the Catholic faith of his childhood, the two became active in parish life at Immaculate Heart of Mary Church, where he is still a parishioner.

In 1996, she wrote the groundbreaking book *"Feminism Is Not the Story of My Life": How Today's Feminist Elite Has Lost Touch With the Real Concerns of Women.* The book recorded the voices of ordinary women as they struggled with the conflict between raising children and holding down jobs. It revealed that many women felt excluded by feminism due to its dismissal of marriage and motherhood.

Betsey asserted a truth that cannot be repeated too often: "The rearing of a child might well be the most important and rewarding thing that most women—or men—do in their lives."

She eventually resigned as director of the women's studies institute at Emory, but she remained a history professor and an outspoken defender of the sanctity of life. She became active in Feminists for Life, a group that is pro-woman and pro-child and recognizes abortion as a terrible crime against women as well as children.

I will never forget Betsey and our lunch together. In her last few years, she suffered terribly from a lingering illness, but she bore the hardship with graciousness and little complaint. Her faith truly sustained her as she embraced the Cross of Christ, which she carried with the help of her beloved husband and other family members. She died on January 2, 2007, and I believe the Lord is still "holding her fast."

The Best Colleague

Mark Bauerlein

Elizabeth Fox-Genovese died in January 2007, a victim of health problems that had plagued her for years and had caused her racking pain. Her students and colleagues weren't aware of how severe it became because Betsey managed a smile and a greeting whenever she entered a classroom or passed them on the quadrangle. She taught classes, directed dissertations, read books and manuscripts, crafted arguments, and wrote articles at a pace characteristic of a fresh PhD out to make a name for herself before turning 35. Her husband, the historian Eugene Genovese, watched her in agony at home and tried to keep her back, but Betsey, always conscientious, cared too much about scholarship and young minds to slow down. Besides, the last decade and a half of her life threw her onto a course of inquiry and rumination and writing that would not be halted. She directed dozens of dissertations, sending new women's studies, English, and history PhDs across the country with broad and deep training in American and African American history and literature. She operated in a field fraught with psychopolitical sensitivities, and yet while she was a leading scholar of women's studies and of African American studies, and while she believed in the necessary correctives they made to traditional scholarship, she conducted her labors without melodrama or resentment. In her own eyes, her books, such as *Within the Plantation Household*, were, at a metascholarly level, sober corrections of previous failures in American historiography.

These were exhausting efforts. Added to them, her break with academic feminism, her formal conversion to Catholicism in 1995, and her toil on the chapters eventually published in 2005 as *The Mind of the Master Class* (with

Gene)—not to mention dozens of essays, reviews, speeches, commentaries, and academic tasks—were weighty and life-consuming affairs. The demands were heavy and the rewards many, and she could not decline a trip to the White House to receive the National Humanities Medal any more than she could turn down a chance to address an international conference of Catholic bishops on feminism and abortion or avoid an undergraduate who needed help with a paper on Southern plantation life. She had entered a zone of activity and experience that few ever do, where intellectual, emotional, spiritual, and professional cares and duties intermingled and conjoined, yielding a whole and complete vision that bore wisdom and patience, as well as expertise, and supplied energy far exceeding what her fragile body could generate on its own.

The physical costs added up, and so did the professional ones. It was unfortunate that the advances she made in her own beliefs set her at odds with the world in which she labored. Here is how she once described one of those changes and the response it evoked:

> Thus when, in December 1995, I was received into the Catholic Church, my non-believing colleagues tactfully refrained from comment, primarily, I suspect, because they literally did not know what to say. More likely than not, many of them assumed that, having lived through some difficult years, I was turning to faith for some form of irrational consolation. Consequently, from their perspective, to acknowledge my conversion would, implicitly, have been to acknowledge my vulnerability. Others, who were less sympathetic, doubtless assumed that my turn to Rome reflected what they viewed as my reactionary politics, notably with respect to abortion. From their perspective, I had exiled myself from acceptable conversation of any kind.

Those suppositions are a lot more gentle than they actually appear, since to label the second group as "Others who were less sympathetic" was an act of generosity. For they were adversaries. I don't mean colleagues who disagreed with her scholarship on eighteenth-century French thinkers or antebellum Southern intellectuals, or who rejected her critique of feminism, or who disputed her vision of humanities curricula, though enough of those people spoke out in meetings and contested her in print. I mean people who regarded her and treated her with belligerence, sometimes openly but more often on the sly. For them the opposition was personal more than intellectual.

In my first years on the Emory University campus, a harried and ill-prepared assistant professor, thinking about tenure and trying to adjust to professorial mores, I didn't know Betsey, but I sat in on or overheard

conversations now and then that touched, in blunt and disconcerting ways, upon that bad woman running Women's Studies. Betsey's opinions certainly provoked them, but the comments frequently went beyond dissent and sank into animus. After Betsey's position against abortion crystallized, a not-so-young graduate student in English informed me, as if she were lecturing an undergraduate, "Anybody who's pro-life has no business in a women's studies program at all"—a specimen of prejudice common on college campuses, though at least a contention one could argue back and forth. But when a junior professor spent a quarter hour in the faculty lounge one morning detailing in acid caricature how Betsey would knit in department meetings, and did so loud enough for three professors drinking their coffee and reading the paper to hear, something besides disagreement was in play.

It must have been unpleasant for Betsey to enter a committee room knowing that others didn't want her there. It probably frustrated her practical labors, too, although the quality and quantity of her research and writing don't seem to have suffered, even in her last years. The rancor touched me only once, after a group of professors at Emory put forward a proposal to the administration for a "great books" program for undergraduates. We wanted to incorporate important texts in religion, philosophy, literature, economics, and art into a liberal arts major, and we made sure to include traditions from all across the cultural and ideological spectrums. The dean of the college asked us to drop the "great books" heading, which we did, and the proposal advanced to the faculty curriculum committee for approval. Not long after we got word that the committee had rejected the submission, stating among other things that it didn't see the purpose of or need for adding another humanistic major to the undergraduate curriculum. We were disappointed, of course, not least because the committee members did not credit our dismay that so many Emory students, including those in the humanities, graduated with little or no familiarity with Homer, Plato, Virgil, Seneca, Augustine, Dante, Descartes, Bacon, Milton, or Rousseau. The proliferation of majors and programs in the humanities has continued for decades, breaking liberal arts knowledge up into racial, ethnic, gender, ideological, and historical pieces, leaving students' minds correspondingly severed from enriching traditions and backgrounds. We understood the new major as a necessary alternative, a centripetal force of learning on campus to counter the breakup. But if the committee members did so as well, they found our proposed solution a problematic, not beneficent, alternative.

Another indication reached me a few days later. I was at the gym, in the middle of a workout, when a friend approached and started talking about campus happenings. It was the usual stuff—complaints about salary, students

bugging him for attention, vacation plans—until he mentioned news that he'd gotten from a colleague on the faculty curriculum committee about its recent decision. He didn't know I was involved in the "great books" plan and proceeded to fill me in:

> "Well, I guess Betsey Fox-Genovese is trying to get some reactionary program going here," he said with a smirk.
>
> "What are you talking about?" I replied.
>
> "Professor X in Art History told me about it." [I can't recall the exact name of his colleague.]
>
> "About what?"
>
> "She's on a college committee," he explained, "and they just rejected a plan by Fox-Genovese to get some old-fashioned, white-male major back on the books."

He muttered this with the blithe air of a crowd of informed and like-minded fellows on a moral high ground, and the only surprising thing about it was how mindlessly he uttered the mockery of our proposal. For him the narrative was neat and clean. A challenge had been issued, right-thinking minds had stood up, and a vicious design was defeated. That was the interpretation so casually accepted and imparted by my friend, who, I should add, often carped about the ignorance and vulgarity of Emory students and of his own colleagues. The standard poles held sway in his outline—conservative vs. progressive, traditionalist vs. multiculturalist, dead white male vs. everybody else—even though the proposal we drafted gave thorough representation to women and minority authors and untraditional issues. If the committee at large felt as did the one member whose views were repeated to me, then the meaning of our proposal was embodied for them in the presence of Betsey's signature, among the signatures of many other colleagues, on the document. Betsey's involvement was the first fact in my friend's rendition, the signal establishing its moral parameters.

"Really?" I responded.

I then recounted the actual situation and tried to convince him of how he and others had distorted it. For Betsey was a minor figure in planning the "great books" program, as was just about everybody else on the list, including me. One associate professor from political science had put it together by himself, working all year to draft the proposal, search for outside funding, make preliminary inquiries with the administration, and gather supportive faculty from several departments. I attended a couple of planning sessions and offered some suggestions on the proposal document, that's all. Betsey did no more, and we regarded our role in the enterprise as supportive, by no means crucial. And yet, when it came time for a group of faculty members

empowered to judge curricular plans and policies, at least one of them, and one assumes several more, zeroed in on Betsey's involvement and acted accordingly.

It is a typical academic story, and not an unusual one. Still I can only imagine how often Betsey must have encountered such episodes in her work and her travels. As I said, she had adversaries. But the strange thing is that I never saw Betsey *make* an enemy. In the last ten years of her life, we sat in on meetings together, I watched her in formal debate a few times, and I joined her and many other colleagues for faculty dinners and other occasions. The colloquies sometimes edged into controversial subjects, with Betsey usually in the minority or alone, but never once did I see her descend into disrespect or cynicism. Everybody remembers her elegance and grace, and she certainly carried herself with a memorable wit and composure. What many haven't credited is that the style spilled over to forensic mores as well as social ones. A faculty discussion over policy, the back-and-forth parleys in a seminar, a Q-and-A session after a lecture—these occasions had their etiquette, and for her it derived less from academic social patterns than from basic human decorum. She intimidated people, yes, but through the force of her ideas and speech, not the threat of any other power. She argued firmly, but she never bullied. She defended her students with a maternal instinct at the same time that she demanded better work from them. I never saw her use majority numbers to beat down a dissenter.

Her forbearance extended to private exchanges. I had come to join Betsey and Gene for dinner every month or two and to converse with her on campus now and then. I worked in Washington, DC, at the National Endowment for the Arts for a few years, and whenever Betsey came up for meetings with the National Endowment for the Humanities, where she was a council member, we were able to catch up over lunch. On each of those occasions, I groused a lot and Betsey sympathized. My topics were not unfamiliar to her—how themes of race, gender, and sexuality had become fixations in the humanities, and class a concern of people who'd spent all their lives on elite campuses; how young PhDs lacked many of the rudiments of learning; the gelatinous prose of literary theorists; the distance between academic thinking and public affairs; etc. Betsey took in each complaint and returned with seasoned comments—not mere receptive ones but useful ones, a point of information or an allusion to a text or an illustrative tale. Professional grumbling usually hits a quick dead end, and for most people its utterance pretty much fulfills the purpose. But Betsey wanted more, and so she steered it into productive channels, making it a labor of understanding.

Whenever the conversation turned to individuals, she did the same, treating them in terms of their ideas and opinions, not their person, judging

the quality of their intellect, not the makeup of their character. If I veered into irate comments, she veered away from them. However much she suffered personal assaults, I never heard her react in kind, not even in confidential settings. To slur a colleague at Emory or elsewhere was simply not her way. And watching her analyze her adversaries, breaking down their premises, citing their books, quoting their heroes, linking an idea of theirs to a social attitude, an action or proposal to a previous but unremembered action or proposal, people around her not only learned a lot about the ideologies and machinations of academia; we also took a lesson in professional ethics. The lesson was, "We have better things to do than decry one another," and those better things included respecting (while disputing) the intellectual contours of one's antagonists.

That stance of hers made our every exchange a profitable one, and an enlivening one. Beneath the analyses and arguments, negative and despairing though they sometimes sounded, one sensed an abiding faith in the enterprise, Betsey's firm belief in and personal enactment of higher education's noble mission. Apart from the personalities, bureaucracy, grading, and meetings—apart from students growing more mercenary about their undergraduate careers, professors more absorbed in their professional standing, and administrators more managerial in their decision making—the primary motive must endure, so she insisted. Knowledge and eloquence matter, and the college campus owes a debt to the past to ensure their continuation in the future. We have a calling, a precious one, and nowhere else in contemporary society are the materials of greatness and wisdom safeguarded and transmitted as they are behind the campus walls. To despair over local circumstances, cheapened standards, and irresponsible colleagues was understandable, she admitted, but it also made one forget the venerable charge.

Her veritable bearing, then, was a reproof to anything less. Maybe that explains the animosity toward her, the enmity out of all proportion. She placed ideas and outlooks not only in a framework of true and false, but also small-minded and large-minded, selfish and dutiful. Some might have felt it as a rebuke, and instead of reflecting upon themselves, they turned on her. She advocated an explicitly moral dimension of teaching, too, not the moral approach of political correctness or the moral therapeutic that makes immediate personal experience the measure of all things. Instead, she offered moral duties that derived, in the end, from her religious beliefs, duties to observe canons of taste and custom, to recognize the limits of human knowledge and action, and, as she put it in *Common Knowledge* two years ago, to "grant respect to tradition on its own terms." If those duties crossed the sacred principles of her colleagues, she spoke up nonetheless. She embraced

feminism in the 1970s with as much commitment as her colleagues did, but in 2004 she came to write: "It has not been easy to acknowledge that feminism has promoted the unraveling of the most binding and important social bonds." She was raised in a secular household, and her conversion came not in a swift transformational moment but through a slow and exacting meditation over many years. Such blunt and reasoned retractions violated the beliefs that pass as academic manners, and she paid for it. But I think that the pain of changing her own mind during those years affected her more than her maltreatment by colleagues. She was honest and courageous enough to test her own certainties and to let some of them go. She was her own toughest critic, and her example is one every intellectual should follow.

Twenty-five

First and Lasting Impressions

Evelyn Brooks Higginbotham

At times of loss, I am reminded of the passage from Ecclesiastes: "To every-thing there is a season. . . . a time to be born and a time to die." But death is almost always untimely. There is so much still to say and to do—even for those who believe and live in the hope of salvation, even for those who can acknowledge their readiness to depart this mortal life because of age or ill-ness. Death seems to come not in the fullness of time, but in time cut short. Thus, it is hard for me to grasp that Elizabeth Fox-Genovese has written her last thought and uttered her last controversial statement. It is harder yet to grasp that she leaves behind her beloved husband Eugene Genovese, dear friends, and a once-upon-a-time friend like me who, despite our differing politics, must acknowledge her inspirational and formative role in my life. Forever etched in my mind are fond memories of moments spent with Betsey, Gene, their dog Josef, and various cats along the way—Tapestry, Cleopatra, Georgia, and Carolina—first in their home in Rochester and later in Atlanta.

I met Betsey when I began graduate school at the University of Rochester in 1975. I had come to Rochester to study with her husband. I had read virtually everything by Gene and sought his mentorship. After reading *Roll, Jordan, Roll: The World the Slaves Made* (1974), I believed him to be the most brilliant historian in the academy. I marveled at his skills of conceptualization, his complex thinking, his Marxian analysis of a different sort, and his interdisciplinarity, which drew extensively from historical sources and also from the insights of Antonio Gramsci, Hegel, and the latest

anthropological and sociological scholarship. Among the 1970s scholars of slavery, Gene most deftly interwove the hegemony of planter ideology and the everyday resistance of the slaves. Gene was the first historian to take seriously the religion of Southern slaves—to probe their beliefs and present them in a comparative perspective, along with beliefs of Southern whites and of slaves in the Caribbean and Brazil. Because of my primary interest in African American and women's history, I did not initially anticipate Betsey's potential influence on my research agenda. Her writing and teaching in the mid-seventies focused on Europe. I took the women's history course taught by Christopher Lasch.

In the dedication page of *Roll, Jordan, Roll*, Gene had written: "For MISS BETSEY, My own personal Bright and Morning Star." It did not take long for me to discover that Betsey's brilliance complemented Gene's, shining equally as bright and indeed in more directions. She had a densely theoretical and multidisciplinary mind, and she also had an elegant appearance and style, along with amazing gourmet cooking skills. The "royal couple of academia," as they would later be called, offered their students frequent opportunities for intellectual exchange inside and outside the classroom. They had a warm and special way of bringing students into their home and into their lives; so too did my teacher Stanley Engerman and his wife Judy. I had never before experienced such a fascinating combination of spirited intellectual exchange and convivial hospitality, with the Genoveses proclaiming the prebourgeois character of slavery and Engerman proclaiming slavery's capitalist character.

If first impressions are truly lasting ones, I must confess that Betsey's graduate seminar in European history introduced me to abiding themes in her scholarship and in her personality. To apply the word "abiding" may seem odd, perhaps erroneous with respect to someone whose work and loyalties changed significantly in the last fifteen years of her life. And yet for me, the Elizabeth Fox-Genovese whom I encountered as a professor in my first year of graduate school left lastingly valid impressions. The first impression was her scholarly and personal commitment to insert often neglected voices and experiences into traditional narratives for the purpose of upsetting timeworn assumptions. Thus Betsey's inclusion of the Haitian Revolution in our discussion of the democratic revolutions took me by pleasant surprise. Today, such an inclusion may seem unremarkable to students in history departments that readily adopt the Atlantic world paradigm, but despite the publication of C. L. R. James's *The Black Jacobins* (1963) and my having attended both a historically black university and a white university, I found no history professors attentive in any rigorous way to Haiti in relation to France or the larger revolutionary context.

It is certainly not the case that the early classroom setting of my relation-ship with Betsey prepared me for the changes to come. Not that the process of twists and turns in one's life is necessarily unusual. Most people change, more often than not becoming more conservative in one way or another with age. There are a number of once-leftist historians currently self-identified or identified by others as "neocons." For more than a decade now, I have watched at a distance—at times sympathetic, while at other times baffled by the changes in both Gene and Betsey. To me, Betsey's transformations appeared the more numerous; more than Gene's. Over the past three decades, Elizabeth Fox-Genovese defied anything close to a consistent de-scription, moving from Marxist to non-Marxist, French historian to histo-rian of antebellum Southern women, feminist to nonfeminist, religious agnostic (of sorts) to devout Catholic. In 1989, Christine Stansell could review Betsey's book *Within the Plantation Household* as "the best radical scholarship in 'mainstream' Southern history," while in 2005 Enrico Dal Lago reviewed *The Mind of the Master Class,* coauthored by Betsey and Gene, as the "best proof of Fox-Genovese's and Genovese's completion of a path toward utter rejection of historical materialism."

Nor does change come always unwelcome. I and many others cheered her transformation into a historian of Southern women. In many ways, her shifting interest in the Old South was logical, if not predictable. In her Euro-pean seminar, I had read her first book, *The Origins of Physiocracy: Economic Revolution and Social Order in Eighteenth Century France* (1976), which resonated in interesting ways with studies of Southern planter ideology. Bet-sey's prowess in economic history and political theory, as well as her mar-velous close reading of texts, situated physiocracy within Enlightenment thought and concluded that the movement's major thinkers, Quesnay and Mirabeau, having consciously endeavored to avoid Hobbes's model of social conflict in the process of creating a modern society, rejected the doctrine of representative government in favor of a concept of legal despotism—a doc-trine that combined English capitalist ideas of economic markets with tradi-tional French authoritarian political ideas. The physiocrats championed Liberty, Property, and Security, reflecting their "understanding that the modernization of France turned not upon the confrontation between clearly defined classes, but upon the confrontation between two world views—that implicit in the theory of the Tableau and that of the ancien régime—each of which embodied a discrete social system." Contemplating the physiocrats in one course and, in another course, Gene Genovese's forceful arguments for the hierarchical and corporatist nature of the Old South and its "pre-bour-geois" economic system, I found myself making a number of connections

between their scholarship and personalities. After the publication of their co-authored *Fruits of Merchant Capital* (1983), which further buttressed the idea that slaveholders were *in* but not *of* the capitalist economic system, Betsey's shift to Southern history appeared to me seamless.

The explosion of the field of women's history in the 1970s most likely influenced her decision to focus on Southern women. Notwithstanding the pioneering work of Anne Scott, Catherine Clinton, Jacqueline Jones, and Deborah Gray White, little published work existed on either slave mistresses or slave women. Betsey's intellectual and theoretical sophistication in *Within the Plantation Household* carried slavery studies and women's studies to new heights. Indeed, no one had previously established with such depth and analytical rigor the fundamental differences between women of the Old South and those in the North. This prizewinning book challenged in exciting ways the historiography that posited such themes as woman's consciousness, woman's sphere, and woman's culture. Her analysis completely reoriented interpretations that revolved around a common patriarchal oppression of slave mistresses and slave women and rejected interpretations that took at face value the words of Mary Boykin Chesnut, diarist and slave mistress: "poor women! poor slaves!" For Betsey, models of womanhood that blurred Northern and Southern women's domestic experiences, or that portrayed Southern women's consciousness as simply a variant of Northern women's, overlooked the very different material realities that underlay gender relations and gender conventions. Reliant upon anthropological and sociological work for the most part, Betsey centered her analysis on the importance of the household, as the book's title reveals. The Southern household was not to be equated with "home" or even "family." Betsey defined the household as the fundamental site of the relations of production and reproduction in the South—the "basic social unit in which people, whether voluntarily or under compulsion, pool their income and resources." Her utilization of the household as her conceptual rubric facilitated her command of the complexity of Southern social relations, particularly gender relations, in much the way that the paternalist compromise had riveted the massive information in *Roll, Jordan, Roll*.

According to Betsey, the Southern "household" operated within the context of precapitalist production relations and thus, unlike the North, the "separation of home and work—the reduction of household to home" did not prevail in the South. Nor could the ideology of bourgeois domesticity that confined Northern middle-class women to their separate sphere be generalizable to the South. The discourse of rights within liberal individualism spread in association with the Northeastern capitalist economy in the

post-Revolutionary era, bequeathing to Northern women a universal and powerful literacy for demanding social and political equality with men. Not so for Southern women, Betsey insisted. At the time of the publication of *Within the Plantation Household,* neither women's historians nor scholars of slavery had ever analyzed the Southern household in this way. The book would inform later important books, notably Stephanie McCurry's *Masters of Small Worlds: Yeoman Households, Gender Relations, and the Political Culture of the Antebellum South Carolina Low Country* (1997) and Kathleen Brown's *Good Wives, Nasty Wenches, and Anxious Patriarchs: Gender, Race, and Power in Colonial Virginia* (1996).

Throughout the 1980s, Betsey stood among the giants of women's history, with such pioneering figures as Nancy Cott, Carroll Smith-Rosenberg, Linda Kerber, Mary Beth Norton, and Ann Scott. Betsey played an undeniably formative role in women's studies not only because of her writings but also because of her participation at women's history conferences and at the meetings of the traditional historical organizations, her leadership in an important pedagogical project to integrate women into the larger American survey, and her appointment as the founding chair of the women's studies department at Emory University. I benefited enormously from her focus on women and gender during this period. Betsey offered invaluable guidance as I wrote my dissertation and afterward, when I entered the historical profession.

Betsey's scholarship began to shift gears in the early 1990s. The publication of *Feminism without Illusions* (1991) set her at odds with a number of feminists, although her critique of feminism appeared at a time when women academics readily admitted to contestations in feminist theory as well as to deep fissures in the movement. In 1988, Marianne Hirsch and Evelyn Fox Keller had pulled together a cadre of women scholars for the purpose of addressing opposing viewpoints among feminists—for the purpose, as they put it, of assessing the consequences of "a decade in which the feminist illusion of 'sisterhood' and the 'dream of a common language' gave way to the realities of fractured discourses." Their edited book *Conflicts in Feminism* (1990) comprises articles by prominent names in women's studies, including Ann Snitow, Nancy Cott, bell hooks, Joan Scott, and Martha Minow, to list only a few contributors. Their diverse perspectives leave no doubt of an awareness of divisions exacerbated by the reality of the political and economic climate of the 1980s, the so-called sex wars, and the "Baby M" and "Sears" court cases. For example, Snitow discussed differences between middle-class feminist theorists and working-class "motherists" who did not adhere to a feminist identity as individuals but nonetheless acted collectively as women in protection of their communities and their children. Cott's

examination of the debates over the Equal Rights Amendment in the 1920s underscored the historical legacy of feminist conflict in regard to women's equality with men versus women's difference from men, while Scott deconstructed the equality-difference debate with reference to the adversarial feminist testimonies in the Sears case. The black theorist bell hooks laid bare the racial limits of feminism. Many black women academics had forsaken the "feminist" label altogether, preferring "womanist" as a way to criticize the white middle-class presumptions inherent in "sisterhood" and to protest the black community's dual racial and gender oppression.

Thus, Elizabeth Fox-Genovese did nothing new in calling attention to the discordant voices in feminism. The awareness of "feminist illusions" hardly began with her, but two issues separated her analysis from other feminists'—her willingness to broach the subject of abortion from a critical perspective and the related but also distinct challenge to the individualist ideology intrinsic to feminism. Most disquieting for feminists was her analysis of abortion. She questioned its logic along intellectual lines; in other words, its coherence, given the conflicting feminist arguments about absolute individual rights (equality) and women's "maternal" character (difference). It is interesting that in *Feminism without Illusions,* Betsey presents a far more nuanced discussion than in her later writings. She states: "Abortion challenges feminists to come to terms with the contradictions in their own thought, notably the contradiction between the commitment to community and nurture and the commitment to individual rights. Without doubt, the easiest way would be to reach some determination about our collective definition of life. Most Americans would probably accept abortion on demand up to the twentieth week of pregnancy." For Betsey, the crucial issue at this point is a definition of life that is collectively not individually determined, since the matter of abortion defies a solution that "will escape intellectual inconsistencies and some unresolved moral tension." When Betsey converted to Catholicism, however, her position toward abortion came into line with the unambiguous teachings of the church. Her conversion confirmed and gave heft to her pro-life views, but I do not believe that religious faith alone constituted the defining issue that distanced her from other feminist scholars.

From Betsey's perspective, it was perhaps initially inconceivable that her position on abortion would bring her academic sisters to castigate her out of their ranks, especially given feminism's protean quality at the time and the many acknowledged differences among feminists. The book's conclusion states as much—her concern about being considered disloyal and her hope that feminists might embrace divergent views. In so many ways, *Feminism without Illusions* is a brilliant work; and I say this as a supporter of women's

right to choose. The cool reviews hardened her, I am sure. I can imagine her and Gene in painful discussions as to why there was no place for feminists like herself and Jean Bethke Elshtain at the sisterhood table. In 1996, Betsey would later condemn the feminist movement for its inability to embrace women like herself, women "who do not support every plank in its increasingly radical platform." However, if in the 1990s the majority of American women continued to cherish their pro-choice right, for feminists the stakes were even greater. In the introduction to *Conflicts within Feminism,* Hirsch and Keller attested to this point: "As the eighties turn into the nineties, it may well be that the threat to prohibit abortion offers the only uncontested issue around which most if not all feminists can rally."

Bad timing tended to hurt some of Betsey's arguments. Had she published *Feminism without Illusions* not in 1991 but a decade later, she might have found arguably greater sympathy in the academy. I do not know. What is obvious to me is that her predilection toward women's difference, and specifically her acknowledgment of the implications of the biological difference between the sexes, proved disconcerting to burgeoning women's studies departments that eschewed essentialism in any form and gave priority to the social construction of gender over sexual anatomical difference. Moreover, her critique of theory, especially poststructuralism's and postmodernism's "atomizing" tendencies, seemed out of step in the early nineties. The book assailed theory, just as an avalanche of writings across the disciplines descended upon the academy in the name of Derrida and deconstruction, the "linguistic turn," Lacan, and Foucault. Historians such as Joan Scott and Carroll Smith-Rosenberg, and I must include myself, found much to learn from some of the new theory, particularly its insights about reading and about understanding the past. Many of us had cause to criticize problematic features of such innovative writing, but none of us was ready to throw the baby out with the bathwater. I myself considered the new attention to theory reminiscent of the tradition of the Genoveses. After all, in the late 1960s and early 1970s it had been the highly revisionist interpretation of Marxist theory by Gene and Betsey that won my devotion to their scholarship.

Rereading *Feminism without Illusions,* I am reminded of my encounters with Betsey in graduate school. My first impressions of her are lasting impressions. I cannot overstate her consistent attention to the critique of individualism, which long preceded her feminist writings. Betsey's seminar at the University of Rochester gave me the first glimpse of this mainstay of her thinking. The theme of individualism would run steadily through her life's work, threading together the permutations of her personal and scholarly identities in the years to come. In her course on European history, she

assigned the writings of C. B. Macpherson, and ever since I have believed that Betsey's analytical perspective was shaped tremendously by his theoretical critique of the seventeenth-century roots of liberalism and its central component—the rights and worth of the individual. In *The Political Theory of Possessive Individualism, Hobbes to Locke* (1967), Macpherson was determined not merely to analyze such foundational theorists as Hobbes, Locke, and Bentham, but to explore the limits and excesses of individualism in the seventeenth and eighteenth centuries—and then, as if that were insufficient, to explore them in the context of the maturing market relations of the nineteenth and twentieth centuries, when the labor movement (as well as the struggles for liberation from colonial rule) demanded the inclusion of groups that had been denied equality of rights. In his "diagnosis of the weakness" of individualism—of assumptions about human freedom as based solely on the individual as proprietor of his own person and of society as a series of market relations—Macpherson disclosed the deeply rooted possessive character of market society and of liberal thought. His detailed, if repetitive, book scrutinizes the implications of individual rights (self-interest) in relation to the interests of the larger community of individuals (political obligation) and concludes that,

> to get a valid theory of political obligation without relying on any supposed purpose of Nature or will of God (which we may call an autonomous theory of political obligation), one must be able to postulate that the individuals of whom the society is composed see themselves, or are capable of seeing themselves, as equal in some respect more fundamental than all the respects in which they are unequal.

Pondering the diversity of Betsey's writings, I cannot help but acknowledge that she remained steadfast to an understanding of the implications and meaning of individualism similar to Macpherson's, as well as to arguments like his about the belief that individual rights derive from society instead of from innate nature. She made points along these lines in a range of contexts—physiocracy, the slaveholding South, and feminism. For example, in the *Origins of Physiocracy,* she stated that "the importance of the physiocratic legacy . . . lies not in this or that specific chain of ideas, but rather in the deeper problems of adapting free market economics and possessive individualism to the specifically French experience." In her discussion of the grain trade debate, she noted that the philosophe Diderot, who had agreed with the physiocrats that "the right of property is sacred from individual to individual," abandoned the idea of a sacred individual right if society were imperiled. Diderot was convinced that "the social interest must override individual interests when provisioning the country was at stake."

Within the Plantation Household also takes up the theme of the individual's relation to society and there, as I noted earlier, individualism is viewed in the context of the American regional divide, Betsey's purpose being to ground ideology in the material context of two very different economic and social formations. The North's theory and practice of individualism, she argues, eventually translated into women's struggles for property rights, suffrage, and the abolition of slavery. Combined with the doctrine of separate spheres, the logic of bourgeois individualism also gave voice to their belief in women's difference from men—an empowering belief and rhetoric for social housekeeping. On the other hand, "the Southern notion of individual rights," Betsey emphasized, "coexisted with corporatist values that legitimated white men's personal power over dependents."

Most glaringly, her critique of individualism lay at the root of the impending disharmony between Betsey and her feminist colleagues. In *Feminism without Illusions,* she described feminism as dually the "daughter of individualism" and the "daughter of women's exclusion." As her statement regarding abortion that I quoted earlier reveals, Betsey came increasingly to perceive abortion as a consequence of the logic of unbridled individualism. Moreover, her recognition that feminism rests on the foundation of individualism prompted her tireless commitment to exposing the contradictory and fraught relationship between the individual and her community. This relationship is at the core of the book's overall analysis, although she devotes a chapter specifically to her own feminist critique of individualism. In that chapter, she both praises and criticizes individualism in her call to reform late-twentieth-century America, where the idea of absolute individual rights too often trumps the claims of the larger society. Betsey remained steadfast in her attention to the meaning and implications of individualism and to the understanding that individual rights derive from society and not innately from nature. In 1991, she envisioned feminism as having the potential to bring "individualism back to its social moorings. . . ." Her faith in feminism would soon diminish.

Finally, my one and only formal class with Betsey presented occasions for me to observe qualities about her personality. She wore a mood ring, a near-forgotten icon of the 1970s. The mood ring consisted of a large oval stone that changed color with changes in the wearer's body temperature— thus exposing one's inner emotions. I cannot say that I ever understood the ring's scientific basis, and I have long since forgotten which colors were said to register happiness, insecurity, or discomfort. What I have not forgotten is my feeling each time I saw the ring's various colors. I have occasionally, over the years, thought about this little oddity, always interpreting it as indicative of her willingness to risk exposure of her deepest feelings rather than permit

them to exist conveniently hidden and undetected. I never inquired of my classmates as to their perceptions, but to me the ring signified the courage to present oneself, vulnerable, to onlookers. Despite the profound shifts in her intellectual identity and despite her rightward politics, which have caused me and others great consternation, I must acknowledge that she never abandoned the tendency to present herself vulnerable, despite the pain and frustration it assuredly caused her. Reading afresh her autobiographical meditations in the "Afterword: Personal Thoughts on the Consequences of Difference" of *Feminism without Illusions,* I am struck by the candor and poignancy of her words and their unacknowledged familiarity to many women of the present, myself and other women of her generation included. I am reminded of her mood ring. I will always remember Betsey as a "Bright and Morning Star."

Modeling the Dedicated Life

Elizabeth Fox-Genovese as Teacher,
Mentor, and Friend

Sheila O'Connor-Ambrose and Douglas Ambrose

Catholic apologist G. K. Chesterton once wrote that the great scandal of Christian theology is that "you matter. I matter. Every single man matters."[1] This indispensable teaching that attributes dignity and worth to every person—the born and the unborn, the rich and the poor, men as well as women, the exceptional and the ordinary, the vigorous and the frail—best describes the unflinching spine of Elizabeth Fox-Genovese's life and work even before her formal conversion to Catholicism in 1995. As well as anyone, Betsey—as she was known to us and myriad others—grasped how this core teaching of universal human dignity challenges us "to define our attitudes towards the purpose of our own lives and of the society to which we belong—towards life, death, and our responsibilities to others."[2] Betsey's firmly held belief that everyone's dignity and worth was equal to her own was not by any means an easy or cheap ordering vision of human community. She embraced this challenging belief, however, throughout her life as a scholar. Planted and nurtured in her in early childhood by her academic father, her commitment to universal human dignity was carefully cultivated during her years of penetrating scholarly analysis into the lives of both ordinary and extraordinary people. This idée fixe was honed, however, in the long hours of self-reflection, study, and theological conversations that

"Modeling the Dedicated Life: Elizabeth Fox-Genovese as Teacher, Mentor, and Friend." Previously unpublished.

marked her conversion to Catholicism. Betsey understood not only morally, but intellectually as well, how much this recognition costs us in profound and lasting ways. Indeed her ability to see all others as deserving of love, mercy, understanding, and instruction deeply shaped Betsey as scholar, mentor, wife, neighbor, citizen, and teacher. *Especially as a teacher.*

Pope Benedict XVI, building upon a long tradition within Catholicism that recognizes and respects the inherent dignity of all human vocations, has written that in order to live a successful life, "not everyone has to be a Mother Teresa." He goes on to explain that if we understand that "each life has its own calling"—its own code and its own path—then "a great scientist, a great scholar, a musician, or a simple artisan, [or] a laborer" can equally "represent a successful life, people who live their lives honorably and faithfully and humbly." Modern mass society and culture pose special challenges to this fundamental understanding of vocation, as twentieth-century Catholic intellectuals from the philosopher Jacques Maritain to the novelist Walker Percy recognized. Similarly Benedict XVI warns against living one's own life in a cheap "imitation, stamped-out along with a mass of other identical ones," which thwarts a mature and living sense of vocation. To live a genuinely successful life—what we are calling *the dedicated life*—demands "the creative courage to live one's own life, and not just to turn oneself into a copy of someone else."[3] It is with this deeply Christian understanding of vocation—the notion that one is called to find and embrace a life that fits, with its attendant vocabulary of grace, courage, work, meaning, dignity, transformation, love, and suffering—that we share our remembrance of Betsey.

We came to work with Betsey at different points in her academic career and in our lives, but her influence was profound in shaping both our lives and the deep and enduring blessings we have gathered as her students, her friends, and—finally—as her family.

Like many others, I (Douglas) came to know Betsey through her husband, Eugene Genovese. As an undergraduate at Rutgers in the 1970s with an interest in slavery, I quickly learned about Gene's scholarship and about his controversial days on the Rutgers faculty a decade earlier. Upon graduation I took a position as a high school history teacher in Elizabeth, New Jersey. In an effort to keep abreast of Gene's work, I purchased a copy of *Fruits of Merchant Capital* and there encountered Betsey's scholarship for the first time.[4] The power and eloquence of her mind complemented Gene's, making their work together an example of what Ecclesiastes meant when it taught that "two are better than one; because they have a good reward for their labor."[5] After their marriage, all of their work, even that published

under their individual names, became collaborative, but it also remained complementary: each brought different gifts to their joint effort. In my particular case, Gene's books brought me to him and Betsey, and Betsey's mentoring brought me through graduate school. She was the teacher, the one who could see in her students the particulars of their selves that made them unique, and she used that knowledge to guide them, to help them cultivate their own gifts and so become what they, as distinct persons, were called to be. Although when I met her she had yet to embrace the Christian notion of vocation, she already understood its essence: that each person had a specific calling and that in answering that call one found and fulfilled his destiny and achieved the happiness God intends us to derive from our work in this world. This understanding gave her the wisdom and insight and authority to know, early on and better than I, what *my* vocation was.

Shortly after reading *Fruits of Merchant Capital* in 1983, I decided to leave my secondary school teaching position and pursue graduate studies in history at the University of Rochester, where Gene taught. Before I even arrived in Rochester, I had become a student of Gene and Betsey. Gene invited me to their house in Ithaca for dinner, assuring me that his wife, "in addition to being a fine historian, is an excellent cook." The meal was wonderful, but the conversation was fascinating. I remember being impressed not only by Betsey's erudition—it would be hard for a twenty-six-year-old high school teacher not to be—but also and especially by her interest in me. From that first encounter, she recognized that I wanted to remain a teacher and not simply become a scholar. Once I settled down in Rochester, I saw Betsey only on those infrequent occasions when I would visit her and Gene in Ithaca, which was about a two-hour drive. But Betsey gleaned even from these brief and sporadic visits that however much I enjoyed the intellectual challenges and rewards of graduate school, I missed teaching. I never said a word to make her or Gene think that I had any intention of leaving graduate school and returning to secondary education, but somehow she knew that I was considering taking my master's degree and returning to the classroom.

In my second semester at Rochester, Gene approached me after our seminar and asked me to come and have a drink. Finding that an invitation I could not refuse, I accompanied him to the faculty club. After some initial chitchat, he proceeded to the business at hand. Gene, as anyone who knows him will attest, always credited Betsey when she deserved it. He began by saying that Betsey was concerned about me. I was floored. Concerned about what? Gene moved quickly—another basic characteristic of his—and told me that Betsey feared that I might not be especially happy in graduate school and might be contemplating leaving and returning to high school teaching.

That was, of course, exactly what I was thinking. *But how in God's name had she seen that?* I mumbled something that I'm sure was incoherent to Gene, who quickly saved me from further embarrassment by reassuring me that although we certainly needed good high school teachers, I ought to think about continuing on toward my Ph.D. and that I ought to do so at SUNY Binghamton with Betsey. I never again thought of quitting graduate school and returning to high school teaching. In just a few short months and even fewer face-to-face meetings, Betsey had discerned my vocation and helped me to recognize the work I was to do. She helped me recognize and follow my own best life.

My years as one of her graduate students at SUNY Binghamton were among the happiest of my life, in large part because I knew, however inchoately, that I was supposed to be there. Neither Betsey nor Gene ever reminded me of the dismal market for historians in the 1980s and early 1990s. They instead counseled, even as unbelievers, that I should do my best "and leave the rest to God." Betsey was a marvelous mentor. I sought her advice on everything I wrote, and she showered me with time, a patient ear, and just enough prodding. But it was as her teaching assistant that I learned the most. I was amazed—but not surprised—at how seriously she took her undergraduate teaching. She *never* saw teaching undergraduates as merely the price she had to pay in order to teach graduate students and to conduct her research and writing. Undergraduate education was a central priority for her, not a distraction or a burden. She recognized it as a vital part of her vocation. In the acknowledgments section of *Feminism without Illusions,* Betsey thanked "the undergraduates at Emory [who] constantly remind me that teaching is one of our great privileges as well as our main responsibility."[6] Watching her teach the course Sex and Power in American Culture at SUNY Binghamton in the 1980s taught me how a teacher crafts a course, how one makes it into a coherent, purposeful intellectual exercise, how one makes it a gift of one's self to one's students. Nothing I did in graduate school, including my dissertation, mattered more to me than the lecture I gave in that class, with Betsey in the audience. I teach nothing like Betsey; our styles differed like night and day. But she encouraged me to teach in the way that fit me, that allowed me to share my unique gifts with my students. She did not teach me skills; she taught me teaching—teaching as vocation, as an activity that enriches ourselves and others, and, fundamentally, as an activity that glorifies God, although neither she nor I recognized that until later. Betsey's conversion to Catholicism changed some things about her, but it only added to other aspects of her character and her life. It gave a deeper and higher meaning to her teaching, but it did not qualitatively change how she taught. She always understood that the dignity of the

teaching vocation, the inherent dignity of all vocations, consisted of seriously and sincerely devoting oneself to one's work.

I (Sheila) first remember hearing about Gene's visionary scholarship on slavery in a class on southern literature taught by Dr. Louise Cowan at Thomas More College, but it was not until completion of my master's thesis on Eudora Welty at the University of Dallas that I heard about Betsey's work. Knowing I was interested in Emory University and wanted to continue to study southern women writers, Dr. Melvin Bradford, one of my thesis readers, strongly encouraged me go meet Betsey. "She and Gene are Marxists," Dr. Bradford explained, "but they are *reasonable* Marxists."[7] Entranced by the notion of what was to me a previously unimaginable category of scholars— bear in mind I had studied at seriously Catholic institutions—I made an appointment to meet several professors while visiting Emory, including two professors—one from the Institute of Liberal Arts and one from the English department—who clearly shared a deep commitment to postmodern literary theory; and Betsey, who was in the process of creating from scratch a first-rate women's studies department that included an undergraduate major, a graduate-level certificate program, and a Ph.D. program. Betsey had come from the women's history program and history department at SUNY Binghamton in 1986 at the invitation of Dean David Minter, who "felt that if Emory was going to be a world-class institution, it had to have women's studies."[8] Although Ph.D. degrees in women's studies were nonexistent in the 1980s, many colleges and universities had developed women's studies programs, most if not all sharing a strong commitment to ideological purity and political activism instead of intellectually rigorous content and the essential cultivation of an "open interchange of conflicting ideas."[9] Betsey insisted that Emory's program be intellectually serious and rigorous and capable of strengthening women as intellectuals. Her vision for women's studies at Emory firmly rested on three points: "that women's studies encompass women, gender, and feminist theory; that it be comparative in ambition; and that it be ideologically open."[10]

The day we met, Linda Calloway, Betsey's stalwart assistant, somehow squeezed me into Betsey's hectic schedule, and as I waited outside the small, dark, book-lined room that served as Betsey's office, I began to grow nervous about our appointment. I knew already from Dr. Bradford's respectful description and from my own research that Betsey was universally acknowledged to be a distinguished scholar and outstanding intellectual, and after my own less-than-encouraging conversations and classroom experiences earlier that day with other Emory faculty, I began to wonder what

foolhardiness had brought me here to Atlanta to disrupt these people. And then I met Betsey.

From first sight, as she swept into the narrow office wearing a stunning short-skirted suit and holding the leash of a large, lean, and somewhat aloof dog, I recognized the presence of a woman of ponderable significance. I was right to be nervous. And yet even as my anxiety mounted, I made out—for the first time—in her eyes and in her astonishingly warm smile the true measure of Betsey's worth: her heart glowed. Her obvious kindness and goodwill at once quieted and opened my own heart. As we sat down to talk about my work on Welty, my desire to study southern women writers, my undergraduate education at a tiny Catholic liberal arts college in the woods of New Hampshire, and her vision for women's studies, I found Betsey to be *simpatica,* a warm and careful listener who soothed my nervousness while seeming to relish a conversation about all sorts of things. As I sat there with her, I had the remarkable feeling as though I mattered to Betsey, that she actually believed that I had something important to contribute to women's studies and to the Emory community, that she saw something valuable and interesting and significant in *me.*

When Betsey spoke plainly about wanting me to apply to women's studies, I quite literally froze. That's not exactly the word, but I remember recognizing—even as I protested to her that I was not at all sure as a serious Catholic that I belonged in women's studies—that Betsey was inviting me to see myself and my life in a way I had never heretofore imagined. Listening to her explain to me why she did indeed have reason to believe this was exactly where I belonged, I felt as though I was looking onto a vista—an interior vista—infused with what was for me an extraordinary and exciting sense of possibility. And in that moment I felt at home in that vista, at home enough to say yes, at home enough to think I might make this vista my own. Betsey helped me to see something new about myself, something she saw in me that I had not seen, or had not been able to embrace, in myself. I was not a girl, but twenty-seven, with a large, supportive family, an excellent education, and a deep faith life, a young woman who had lived, studied, and traveled in Europe, who had worked in advertising sales in New York City, and who had earned an advanced degree in Dallas. This is all to say I wasn't an ingenue but rather someone who was used to thinking about—and working out—what it means to live a dedicated life. This is what happened in the first twenty minutes of our almost sixteen years of friendship.

In short I moved to Atlanta, made lots of friends, studied hard, and felt at home. Betsey made that more possible than anyone else by creating a department and an academic culture that welcomed all students of serious

intent. There were three nutshell moments I remember clearly from that first eventful year, when both the women's studies Ph.D. program and I were brand new. The first was Betsey's almost indescribably challenging and genuinely tolerant—and jam-packed—feminist theory courses, offered in fall 1991 and in spring 1992, courses she herself called "extraordinary." As she later described, the "classes were made up of a mix of fields and persuasions—women and men in history, English, comparative literature, anthropology, from very conservative to radical lesbian. There were undergraduates, first-year graduate students in women's studies, advanced graduate students in other fields; even some faculty members sat in on classes." Betsey required that each student had to lead class discussion for a week. One week, a conservative undergraduate, "very much interested in family issues," raised the "questions of strengthening the family, of the conservative perspective on the family, and talked of women's needs within that context." As "surprised" as his classmates were by the introduction of a conservative perspective, "they treated him with respect," and one feminist student went so far as to say to the group, "We've got to go back to the points that he was making."[11] Betsey hated the thought that women's studies, in a push to become more ideological, would lose that civil exchange among persons with diverse ideas.

Betsey's commitment to genuine diversity and intellectual rigor attracted me to Emory, and I will always be grateful for the good life I found there in the libraries and classrooms. I took advantage of Emory's impressive physical, cultural, and academic largesse. But at the same time, my mind and soul were battered daily by witnessing ignorance of and hostility toward everything that I believed and held dear, especially the Western tradition and my faith. With an open mind and a lot of prayer, I lurched my way through Emory, silently flinching as I encountered in most classes and in many conversations an almost watertight hegemony of liberal assumptions and perspectives. Betsey was different. On some level she—a Marxist, a feminist, a nonbeliever—should have seen me, a devout, classically educated, pro-life Catholic, as many did: the enemy within. But she seemed to see me—and to understand me—not only as who I was but as who I was called to be.

I remember one day—in another nutshell moment—I ran into Betsey near the women's studies office. I asked if we could talk, and Betsey, dropping everything, calmly invited me into her office and listened. After my miserable ranting died down, Betsey, with wise words and real affection, booted me back out her door and told me to get back to work. I cannot imagine what would have been a better, more loving and encouraging response than to hold my hand for a minute and firmly send me back to do the real work. She was like that with students, especially women students,

revealing to an interviewer that she told her "students with great affection that the most important thing I can do for them is to kick their butts."[12]

The third nutshell moment occurred at the end of that first semester, when Betsey set aside two or three hours for a departmental open house. Few students showed up. Those who did redeemed the time well, sitting and talking and remembering and listening at the end of a frightfully hectic semester. She spoke of her childhood and education in Ithaca, Concord, and Paris. She told us more about Gene. We talked about clothes and books and wonderful teachers. The one topic she never broached was the political turmoil—still undetected by most students—poisoning the department, threatening its vulnerable but genuinely diverse intellectual climate, and calling into question the very future of Betsey's leadership and association with women's studies. Instead of burdening those gathered at the open house with tales of woe and anguish, Betsey did what she always did best: made her students—especially her women students—feel part of a larger, more interesting world than simply the women's studies department. A short time later, defending her founding vision of women's studies, Betsey acknowledged that some of the women's studies students at Emory would have liked "to have more emphasis on contemporary problems and consciousness-raising." Betsey resisted this intellectual and social belittling of women students because she strongly believed that "a part of women's studies, not the whole thing, is to strengthen women as intellectuals." Betsey was not unsympathetic to the challenges faced by women students. Indeed she recognized the "risk" that "even the more enlightened, responsible, and decent men frequently have difficulty looking at women as their intellectual and professional heirs. They'll treat them fairly, but that extra edge of asking a student to be the best—I don't think women get that as frequently as men do. And it's something senior women can do for younger women. But it's not nurturing in the normal sense. It can be done with empathy, with sympathy, with compassion, but the bottom line has to be: 'Honey, if you really want to be out there, you don't want me to encourage you in your self-pity. What you really need from me is the push that will give you the confidence and the ambition to work up to your potential.'"[13]

Betsey's intellectual honesty, dedication, generosity, high standards, courage, and humility shaped and nourished her palpable love both for *what* and *whom* she taught. Her life outside the academy was no less vibrant and touching. The almost measureless boundaries of her dedicated life encircled many loves: literature, history, art, religion, theology, cooking, needlepoint, bread making, cats and dogs, friends, beautiful clothes, and good detective novels. Most of all she modeled for me—for all her students—what it means

to live a dedicated life, that elusive combination of lasting love and meaning-ful work. Betsey found, in her loving marriage, in her lively intellectual life, in her gift of faith, and in her love for so many others, a sense of deep and wide human connection that sustained and shaped her soul, giving her a sense of joy that transformed her sorrows, sufferings, disappointments, and limitations.

Recalling her entrance into the Catholic Church, Betsey noted that she did not "experience conversion as a radical rupture with my past." She believed that her conversion "fit neatly—almost seamlessly—into the continuum of my life, and, from this perspective, it was a natural stage in the journey rather than a new departure."[14] Throughout her career Betsey was never one to engage in glib, let alone irrational antireligious sentiment; she respected the assertions of believers even when she herself was an unbeliever. Her vocation as a scholar, her commitment to scholarly integrity, and her sincere dedica-tion to truth discovered through scholarship led her to approach questions of faith with humility and open-mindedness. As a result of her childhood and the exemplary education she received, she knew that minds as nuanced and perceptive as Augustine, Aquinas, Newman, and Maritain were not to be dismissed out of hand. Her extensive study and subtle understanding of both history and literature suggested that religion was something more than epiphenomenal.

Her call to Catholicism followed the same pattern that she had encour-aged among those whom she mentored: responding to a call of one's heart often means defying expectations of others in order to be who one is meant to be. For a graduate student contemplating a return to high school teach-ing and for another fearful of revealing her religious and political beliefs, Betsey reminded them of the need to be true to who they were, knowing that only by being true could they ever be genuinely happy. Pope John Paul II once acknowledged that following one's vocation "often calls for great courage in going against the trends of fashion and the opinions of our world. But this—I repeat—is the one requirement for a truly success-ful and happy life."[15] When Betsey confronted the truth of Catholicism, she did not permit the "trends of fashion and the opinions of the world" to deter her. She answered God's call with "great courage" and with un-speakable joy, beautifully illustrating John Paul II's belief that one's "voca-tion is a breathing of the Holy Spirit, who, at the same time as he genuinely shapes our fragile human reality, shines a new light into our hearts. He instills an extraordinary power that merges our existence into the divine enterprise."[16]

The "new light" that filled Betsey's heart did not turn her into a qualitatively different person, although it did qualitatively change her. Her conversion did not so much transform as complete her. It joined her various vocations—teacher, mentor, scholar, wife, neighbor—into a coherent whole and made her a shining example of the person who, through her vocation as a Catholic, sought what John Paul II called "the sanctification of one's life." Betsey understood that by "remaining in the world at one's place of work and profession," she would seek "to live the Gospel in the world, while living immersed in the world, but in order to transform it and to redeem it with one's personal love for Christ."[17] Her love for Christ informed all of her work, for she knew that "there is no vocation more religious than work. A Catholic layman or laywoman is someone who takes work seriously."[18]

Betsey herself wrote that "our world does not welcome a high sense of vocation, which, more often than not, it will conspire to extinguish. In a climate in which 'go along to get along' ranks as the preeminent code of conduct, dedication to the truth, much less to the truth of Christ Jesus, figures as a liability of the first order."[19] Betsey paid a high price for her "dedication to the truth," but she recognized both before and especially after her conversion that, in the words of John Paul II, "to rediscover and make others rediscover the inviolable dignity of every human person makes up an essential task, in a certain sense, the central and unifying task of the service which the Church, and the lay faithful in her, are called to render to the human family."[20] She modeled what she preached: "Our touchstone and mooring," she insisted, "must ever be respect for the dignity of the human person."[21]

Betsey called herself blessed to have heard a homily by the late Cardinal John O'Connor about a certain rich man and a certain beggar named Lazarus. "The condemnation of the rich man," Betsey recalls Cardinal O'Connor suggesting, "did not result from his being rich or from his being insufficiently generous to Lazarus. His condemnation resulted from his failure to see Lazarus at all. He saw poverty, he saw a bundle of rags and sores, he may even have seen a beggar. What he did not see was a human person, created, like himself, in God's image."[22]

The Cardinal's homily stayed with Betsey, "a constant reminder to stretch myself always to see—to try to see—the human person. For only if we force ourselves to see can we begin to think faithfully about what respect for the dignity of the human person requires of us in our specific vocation."[23] In all of her vocations—scholar, teacher, wife, neighbor, friend—Betsey faithfully understood what was required of her. She modeled the dedicated life, one in which her work, her faith, and her love both provided personal joy and bestowed invaluable gifts upon others. In living

that dedicated life with unshakable courage and grace, she acknowledged and affirmed the dignity of the human person in the people she studied, in the undergraduates she taught, in the students she mentored, in the husband she loved, and in the friends she treasured and transformed.

Notes

1. G. K. Chesterton, *The Father Brown Omnibus* (New York: Dodd, Mead, 1951), 846.

2. Elizabeth Fox-Genovese, "How Abortion Has Failed Women," *Crisis: Politics, Culture, and the Church,* March 2000, 32.

3. Joseph Cardinal Ratzinger (Benedict XVI), *God and the World: A Conversation with Peter Seewald* (San Francisco: Ignatius, 2002), 279.

4. Elizabeth Fox-Genovese and Eugene D. Genovese, *Fruits of Merchant Capital: Slavery and Bourgeois Property in the Rise and Expansion of Capitalism* (New York: Oxford University Press, 1983).

5. Betsey used this passage from Ecclesiastes 4:9 when she dedicated her first book, *The Origins of Physiocracy: Economic Revolution and Social Order in Eighteenth-Century France* (Ithaca: Cornell University Press, 1976), to Gene.

6. Elizabeth Fox-Genovese, *Feminism without Illusions: A Critique of Individualism* (Chapel Hill: University of North Carolina Press, 1991), ix–x.

7. Bradford, who had commented critically but respectfully on Gene's work since the late 1960s, became a close friend of Gene and Betsey. For their appreciation of Bradford's friendship and scholarship, see Elizabeth Fox-Genovese and Eugene D. Genovese, "M. E. Bradford's Historical Vision," in *A Defender of Southern Conservatism: M. E. Bradford and His Achievements,* ed. Clyde N. Wilson, 78–91 (Columbia: University of Missouri Press, 1999).

8. "How Politicized Studies Enforce Conformity: Interviews with Julius Lester and Elizabeth Fox-Genovese," *Academic Questions* 5, no. 3 (1992): 56.

9. Ibid., 58.

10. Ibid., 56.

11. Ibid., 58.

12. Ibid.

13. Ibid., 58–59.

14. Elizabeth Fox-Genovese, "A Conversion Story," *First Things: A Monthly Journal of Religion and Public Life,* April 2000, 39. Betsey also discussed her conversion in "Caught in the Web of Grace," *Crisis: Politics, Culture, and the Church,* November 1997, 42–50.

15. John Paul II, address of May 18, 1988, Asuncion, Paraguay, in *The Meaning of Vocation in the Words of John Paul II* (Princeton, N.J.: Scepter, 1997), 18.

16. John Paul II, address of March 17, 1982, Rome, in *Meaning of Vocation,* 16.

17. John Paul II, address of August 19, 1979, Rome, in *Meaning of Vocation,* 26.

18. John Paul II, address of May 31, 1982, Edinburgh, in *Meaning of Vocation,* 26.

19. Elizabeth Fox-Genovese, "Faith, Fashion, and the Vocation of the Laity in a Secular, Postmodern World," *Voices: Women for Faith and Family,* Pentecost 2003, 25, italics added.

20. John Paul II, *The Vocation and Mission of the Lay Faithful in the Church and in the World: Christifideles Laici; Post-synodal Exhortation, December 30, 1988* (Washington, D.C.: Office and Publishing and Promotion Services, United States Catholic Conference, 1989), section 37.

21. Fox-Genovese, "Faith, Fashion."

22. Ibid.

23. Ibid.

Index

This index includes only names, titles, and places, as they appear in the text.